THE
BOYS

THE
BOYS

A Memoir of Hollywood and Family

RON HOWARD &
CLINT HOWARD

WM
WILLIAM MORROW
An Imprint of HarperCollinsPublishers

FIRST EDITION

Designed by Elina Cohen

Library of Congress Cataloging-in-Publication Data has been applied for.

ISBN 978-0-06-306524-6

21 22 23 24 25 LSC 10 9 8 7 6 5 4 3 2 1

To Rance and Jean Howard

CONTENTS

FOREWORD BY BRYCE DALLAS HOWARD ix

INTRODUCTION xiii

1 THE ACCIDENTAL ACTOR 1

2 MOM AND DAD: A LOVE STORY 8

3 BECOMING CALIFORNIANS 22

4 THE NEW KID IN TOWN 37

5 INTRODUCING OPIE 49

6 THE TRUTH ABOUT MAYBERRY 68

7 HOT LIGHTS, REAL TEARS 83

8 TOUGHENING UP 99

9 BUT FIRST, THE TRANYA 115

10 MOM, IN HER ELEMENT 132

11 ONE ROLE, THREE BEARS *151*

12 THE INJUSTICE TO SANDY KOUFAX *164*

13 FAKE BLOOD AND OPIE-SHAMING *179*

14 WILD TIMES IN JACKSON HOLE *195*

15 DATING GAMES, REAL AND STAGED *212*

16 THE EDUCATION OF R. W. HOWARD, DIRECTOR *229*

17 GROWTH VIA *GRAFFITI* *245*

18 CRUISING, BOOZING, SCORING *261*

19 CLOCKING IN TO THE NOSTALGIA INDUSTRY *275*

20 FONZIE-MANIA *290*

21 ROGER THAT *307*

22 RANCE TO THE RESCUE *322*

23 FILMING, FLYING, CRASHING, BURNING *336*

24 RICHIE GROWS UP *355*

EPILOGUE *359*

ACKNOWLEDGMENTS *373*

INDEX *377*

FOREWORD

BRYCE DALLAS HOWARD

I've always been confused by how fathers are portrayed in American popular culture as out-of-touch bumbling idiots. Because my only experience of male parenting is that of an incredibly engaged father.

My grandfather Rance Howard came from a generation of men who were not traditionally involved with their kids' lives in any meaningful way. That didn't prevent him from accompanying his boys on set, not just as their guardian-manager but as their ever-present moral and ethical compass. He was a modern, progressive, dedicated dad, and that intentionality and legacy, along with my grandma Jean Howard's smarts and leadership, laid a multigenerational foundation for my family.

All families have extraordinary stories. As my dad says in these pages, the success our family has achieved is something none of us takes for granted. It wasn't destined, and we could've just as easily ended up Oklahoma farmers as Hollywood creators. As is so often the way, a few breaks in a different direction, and what might feel like fate would have unfolded along a now-unrecognizable path. How our family differs is that our twists and turns have played out more publicly than usual.

While the relationship between my dad and my uncle Clint marks an unbreakable bond between two wildly different people—one that I marvel at—it's a sibling story that so many of us can relate to. My dad and uncle are bonded by the love of their parents. Through all the ups and downs, they have remained close, far beyond the obligatory birthday and holiday phone calls. They hang out, talk baseball and movies, watch games, shoot hoops, golf, walk, and laugh a lot. No one makes my dad laugh harder than my uncle Clint. Classic big-brother/little-brother stuff. Yes, blood and genetics connect us, but as we so often witness, that connection isn't guaranteed. It takes a commitment to nurture family relationships over years and decades: work and a grounding force. My grandparents were that force.

Granddad and Grandma Jean established a very specific Howard family culture, one of warmth, encouragement, and gratitude. Being decent to your fellow humans has always been our driving principle. They taught us to take responsibility for our actions and support one another unconditionally, even when we disagree, not by preaching but by modeling. We were constantly reminded that we're a family of equals, a collective in which pretense is frowned upon. We were taught that fame is never a substitute for family.

Storytelling as a craft is taken seriously in our family, and a committed work ethic was modeled for us. As my uncle Clint says, we are "grinders and scrappers." Hollywood is as brutal as it is glamorous, and the only way to survive is through discipline and sticking together. That's something my grandmother and ultimate role model instilled in all of us. My grandmother's vision and belief in what was possible for our family—as well as her joie de vivre—are what made it all possible. I never once heard her complain, despite enduring many real ailments and challenges that would have warranted more than a little griping on her part. Her relationship with my grandfather was the picture of

partnership and teamwork, setting an example for the kind of symbiotic relationship I wanted in my own life.

Like my father, uncle, and grandparents, I, too, am a storyteller—a privilege I also never take for granted. And while much of my family is connected to Hollywood, we are fortified by the grounded, down-to-earth "midwestern Zen" values and life habits my grandparents set for us.

As I read through the pages of this book, I expected familiar stories, but before long I found myself on a surprising adventure. To hear the tale of my grandparents through the words of their two boys and get a peek into their spectacular and unique childhoods, navigating the wilds of the film and TV industry in the 1950s, '60s, and '70s, transported me. These pages capture a turning point in the entertainment industry, as told through the personal lens of one family.

If I were to tell the story of my life, it wouldn't start with me. My story and identity are the culmination of several generations, starting with my grandparents. They continue to inspire me and inform my own path. My siblings and I want to be better people, not to course correct the legacy but to live up to it. The bar is high, and we don't want to fall short.

When I was six, we were living in England as my young father prepared to shoot *Willow* and my mom prepared to give birth to my brother, Reed. We have a home video that shows my dad expressing concern that these two momentous events were happening simultaneously: "Movies! Babies! *MOVIES! BABIES!*" He then asked me to predict the day Reed would be born (which I did, with eerie accuracy). This dynamic of a concerned, involved father including his children in these family discussions was similar to how his parents brought their boys into the fold. Granddad and Grandma Jean showed him it was possible to grow up on a movie set *and* have a childhood. They even put my dad in a crib while they were performing summer stock, attending to him between scenes.

Unconventional? Sure. But inclusive and family-centric nonetheless. Like his own parents, my dad protected us from the craziness while still giving us a firsthand look at the circus.

In my documentary feature directorial debut, *Dads,* I, too, was drawn to the subject of family. I hoped to interview an expecting father, and as luck would have it, my brother and his wife were about to have their first baby. I remembered Dad expressing to me several times over the years that his greatest fear was not measuring up to his own father as a parent. I shared this memory with Reed while filming and, surprised, he replied, "He said that? That's *my* biggest worry—not living up to Dad." And so, the tradition continues . . .

INTRODUCTION

RON

As I write this, I am sitting in a car in Queensland, Australia, getting driven to the set to begin the second week of shooting on my twenty-sixth feature film as a director. I am multitasking, jotting down notes for this book while framing shots in my head and glancing at the call sheet to remind myself of the work that's scheduled for today. Now, I have been looking at call sheets in the back seat of a car since the 1980s. But this time, I really *look*. My name appears in three different places. Director, producer, cofounder of Imagine Entertainment . . . Ron Howard. That's *me*.

I've never been one to take for granted the eventful life I have led. Still, seeing my name in print triggers something in me—a feeling of stepping outside of myself. It could all have been so different. My name could easily have been Ronny Beckenholdt, had my Oklahoman parents not made the brave, crazy decision as young lovers to move to New York to become actors. Dad wouldn't have changed his name from Harold Beckenholdt to Rance Howard. Mom, the former Jean Speegle, would have become Jean Beckenholdt. And today, I would be . . . what? Wait, I

know! How about a farmer in north-central Oklahoma, where my dad's folks were from?

As Farmer Ronny, I grow corn and soybeans on the forty acres that my family didn't have to sell to a conglomerate to keep the lights on. I use some of this yield to fatten up the few pigs I still raise. It's long hours and hard work, but fortunately I have the company of my brother, Clint, five years my junior. Clint and I also have a side business cleaning out and repairing independent oil wells in the area—anything to squeeze a buck out of the land. When commodity prices are up, we do okay. Every day at dusk, we wearily call it a day, taking off the ballcaps that protect our bald Beckenholdt heads.

I'VE ARRIVED ON set and it's time to start setting up the day's first shot. But another what-if strikes me before filming gets underway. Suppose my folks *did* stick with show business? Suppose they followed their dream to California, driving cross-country in 1958 with all their earthly belongings packed into a '52 Plymouth, including four-year-old me? In this scenario, some things turn out the same as they did in real life. I become a successful juvenile actor, playing Opie Taylor on *The Andy Griffith Show* and Richie Cunningham on *Happy Days*. I am a household name in the 1960s and 1970s.

But here's the twist: those roles are what I am best remembered for. I never pursue my teenage ambition to become a director. I simply keep on acting into adulthood, with mixed success—though I do enjoy the warm notices I've been receiving lately for playing "the grandpa" in various Christmas movies on the Disney Channel.

NEITHER OF THESE scenarios is a bleak one; I would have considered them positive outcomes. As a matter of fact, the Beckenholdt

farm is still in the family, run by my cousins, and I have plenty of actor friends my age who, though they've had their ups and downs, wouldn't trade their experiences for anything. But I have been fortunate to see my life turn out incredibly well—to not only realize but surpass my dreams of making a living as a storyteller.

Until recently, I was not particularly inclined to contemplate the "why" of this. But when my father died over Thanksgiving weekend in 2017, at the age of eighty-nine, his passing kicked off a round of introspection on my part. Clint and I were now orphans; our mother had died in 2000. It was a sad time but also, in the big picture, a time when we found ourselves counting our blessings. For both of us, life was good and fulfilling in all the ways that mattered most.

Clint and I made a pilgrimage to Dad and Mom's now-unoccupied house—our old house—in search of photos and home movies to use in Dad's memorial service, which was held two months after his death. As we went through Dad's personal effects, Clint and I shared family stories in a verbal shorthand unintelligible to outsiders: "Mom and the paint cans." "The bathroom graffiti at Desilu." "Bicycle-pump blood."

Our parents' story had come to an end, a lot for us to process. As we contemplated this reality, we experienced a shock of recognition. Their journeys were rich and strange, in ways we hadn't realized until that point. That made our journeys rich and strange, too.

I had never before viewed my life this way. For years, my stock answer, when people asked me "What was it like to grow up on TV?," was that it seemed utterly normal, because it was the only childhood that I ever had. Clint, who was still a grade-schooler when he starred in *Gentle Ben,* another hit television series, would tell you the same.

My answer was too pat, though. To us, our childhoods *seemed* normal, but they were really anything but. We grew up in circumstances that were profoundly unusual, dividing our time between attending public schools, being tutored on set, and working in an industry

fraught with way more snares and traps than we were aware of in our innocence.

Our parents' own show-business aspirations were never realized as fully as ours, yet neither of them ever articulated or even telegraphed any bitterness or resentment toward us. They were show people but they weren't narcissists. They were stage parents but they weren't monsters. And Clint and I, even though we were as familiar with soundstages and makeup artists as we were with playgrounds and Wiffle Ball, grew up in their down-to-earth image.

Mom and Dad managed this feat with remarkable grace, navigating their boys through terrain that, by all rights, should have left us psychologically damaged. And make no mistake, Clint and I didn't get through our childhoods unscathed. We both have our share of emotional scar tissue. But like Indiana Jones in that famous scene where he narrowly escapes getting crushed by a giant rolling boulder, we somehow made it through intact, ready for the next adventure.

As the parent of four children (now thankfully all grown), I wonder: How the hell did Mom and Dad pull this off? How did *we*?

CLINT

Ron talks in positive terms. He's a glass-half-full guy. But if we're playing the alternative-realities game, some unsavory outcomes pop into my head.

I'm not sure I would've handled those harsh Oklahoma winters particularly well. As Granddad Beckenholdt once wrote to Dad about the local weather in a Christmas letter, "Wind blow, rain, snow." Frigid temperatures and sideways hail don't hold much appeal to me. There's a good chance I might still have become a familiar face as a young man—to the Oklahoma State Troopers. Any speculative "Clint

Beckenholdt" conversation should factor in the potential for brushes with the law.

As it is, I don't know if I'd even be here right now if it weren't for Dad. Even when we were kids, the term "child actor" was shorthand for "future fucked-up adult." Then as now, Hollywood was littered with cautionary tales. Carl Switzer, who played Alfalfa in *Our Gang,* died the year I was born, shot to death at age thirty-one in a dispute over money. Bobby Driscoll, who starred in such 1940s Disney movies as *Song of the South,* fell into heroin addiction when the industry no longer had any use for him. I didn't spin out as tragically as those guys, but it wasn't for lack of trying. I put Mom and Dad through their unfair share of hell in my teens and early adulthood by getting loaded and carrying on like an idiot. Yet Dad never bailed on me. He drew me in closer, using his salt-of-the-earth sensibility to right the ship and get me on the path to sobriety.

Like Ron, I experienced a whirlwind of thoughts and emotions the day we went back to our old house after our pop died. Staring out at the lifeless backyard, I pictured Dad doing his antiquated 1940s-style calisthenics in the sun, with his loyal dog, Sheriff, waiting for him to finish so that he could curl up under his master's feet for a nap. Then my mind went further back, nearly fifty years earlier, to when Ron and I were young. Like lots of American brothers, we often spent our afternoons in the backyard shooting hoops. Unlike most brothers, we sometimes spent our afternoons in the backyard shooting movies, with Ron pointing his Super-8 camera in my face, directing me in his earliest attempts at narrative filmmaking. I sometimes demanded that he pay me, because I was used to getting paid to act. Yeah, I guess we were different.

What spared Ron and me from becoming Hollywood casualties are the values Mom and Dad instilled in us. It's true that we didn't become farmers, but we inherited the farmer's work ethic our folks brought with them from Oklahoma. We were grinders and scrappers. Showbiz may

seem glamorous, but each battle is won in the trenches with heavy doses of perspiration and preparation. We spent our nights doing two sets of homework: our assignments for school and our run-throughs of the next day's lines with Dad.

Not that he was any kind of joyless taskmaster. In our off-hours, we did fun, normal-family stuff: Little League, rassling on the living-room floor, dinners out at the Sizzler in our hometown of Burbank. My mother coined a term for herself and Dad: "sophisticated hicks." Worldly enough to broaden their horizons through travel and the performing arts, yet homespun enough to live simply and humbly—as if the next town over wasn't Hollywood but Duncan, Oklahoma.

Ron and I decided to share our story of growing up as the products of these sophisticated hicks: just your typical postwar tale of a tight nuclear family whose two kids happened to be on TV all the time . . .

THE
BOYS

THE ACCIDENTAL ACTOR

RON

"Look him in the eyes and really listen to what he's saying, Ronny. Don't look at the bucket," my father said.

He was prepping me for my first screen test. The bucket in question had come from my sandbox. Dad had drilled a hole in the bottom of it and knotted a rope through the hole, so that he could tie the bright-red bucket to the end of a broom handle, fashioning a homemade imitation of a boom microphone of that era. He did not want me to be distracted by the movements of the mic or of its operator during the screen test. A friend of Dad's swung the "mic" around our living room to simulate what I would soon experience. Another friend sat opposite me, serving as my dialogue partner; Dad thought I should get used to reading with a stranger. For good measure, my mother pretended to be a camera operator, using one hand to shine a desk light in my face and the other to hold a large cereal box, which represented a 35 mm Mitchell Camera. Dad left nothing to chance. At my audition the following day, I would be ready to comport myself before the MGM people in a professional manner.

By the way, this was in the fall of 1957. I was three and a half years old.

MOM AND DAD, Jean and Rance Howard, never planned on being the parents of child actors. They harbored no Barrymore-like expectations of founding an acting dynasty. We lived in a modest walk-up in Queens during the golden age of live television. Dad was struggling to make ends meet as an actor himself. Mom had a steady job working as a typist for CBS.

Dad's biggest break to date was a small part in the touring production of the Tony Award–winning play *Mister Roberts,* whose original Broadway star, Henry Fonda, still held the title role. My father gained not only the experience of working with first-rate actors but also the clout to direct summer-stock productions of the show.

During one of these productions, somewhere in Maryland in the summer of '57, Dad noticed my aptitude for acting. While the actors rehearsed onstage in an outdoor theater surrounded by open fields, I sat alone in the first row of seats, observing. Rather quickly, I picked up the dialogue and started repeating it back to Dad at home, much to his amusement.

Soon, we worked out a routine. He played Lieutenant Roberts (the Fonda part, if you've seen the movie) and I played Ensign Pulver (the Jack Lemmon part):

ROBERTS/DAD: Whatever happened to those marbles you were gonna put in the captain's overhead, so they'd roll around all night and keep him awake?

PULVER/ME (*glowering*): Now you've gone too far. Now you've asked for it. (*Rattling an imaginary canister full of marbles.*) What does that

look like? Five marbles. Got another one in my pocket. *Six* marbles! I'm lookin' for marbles all day *long*!

Consider the visuals: my dad, a grown man, engaged in an intense conversation with a forty-pound pipsqueak with freckles and red hair who wore a striped T-shirt, shorts, and blue Keds. We turned this scene into a little parlor trick that we performed for Mom and Dad's friends in New York, where it always brought down the house. Little did we know that my Ensign Pulver bit would serve as my first audition material.

In those days, a hustling actor like Dad had to physically make the rounds of the casting agencies, all concentrated in a cluster of buildings in Midtown Manhattan. As a matter of routine, my father went from one casting director to the next, dropping off a résumé and a headshot, reading for whoever would hear him.

One day, Dad poked his head into the office at MGM, where he knew the casting director, only to discover a waiting room jam-packed with little kids. This gave him an idea. He said to the receptionist, "Tell them that Rance Howard stopped by, and that, by the way, I have a son who is a fine actor." He left our phone number—not with any great expectations, just as an extra flourish that would make his message stand out from the others.

But they did call the next day, asking Dad if he could bring his little boy in. Next thing I knew, I was performing my Ensign Pulver set piece for MGM's casting director. I am told that I slayed, though I honestly don't remember. They asked Dad if I was capable of doing anything else. To his credit, he confessed that he honestly didn't know. That's when they gave me a new scene to learn and scheduled me for a screen test, for a movie called *The Journey*.

· · ·

I RECALL LITTLE of our time in Queens, just some sketchy details. A butcher store down the street. A neighbor kid whose house I played at when my parents needed a babysitter. A snowman that Dad built in our little patch of yard by piling snow into a yellow plastic trash container and flipping it over.

The screen-test prep is the one thing I remember vividly: Dad coaching me about working with his actor friend, saying, "Look him in the eyes, stay focused, really *listen* to what he's saying." The bucket on the broomstick, the lamplight in my face. It sounds intense, like Earl Woods trying to shake the teenage Tiger Woods's concentration by trash-talking him on his backswing. My father was gentler, though—more like Obi-Wan schooling Luke Skywalker in the ways of the Force.

In my case, the Force was a simplified, preschooler's version of the Method, the set of acting techniques developed by the Russian theater guru Konstantin Stanislavski and practiced by such actors as Marlon Brando, James Dean, and Paul Newman. Dad embraced the Method's emphasis on emotional sincerity, the idea of putting yourself in the character's shoes while channeling your own feelings. He never nudged me to do anything performative in a cute-kid way, like flash a big smile or pull a goofy "Oops!" face. He simply told me to stay present in the scene, to take it moment by moment.

Not until I was an adult did I appreciate how radical this approach was for a child actor. Dad never once talked down to me or treated me as a performing seal. Other kids, I would discover when we moved to California, were not so lucky—they were their parents' meal tickets. But when I went out for auditions with Dad at my side, he put no pressure on me to win the part. He focused on execution, not end results.

If I just concentrated, he said as we practiced in the apartment, I would grasp the essential logic of the scene, and the performance would take care of itself. This was my first and most important acting lesson,

and, in many ways, it remains the foundation of my creative process to this day.

When I walked onto a soundstage for the first time the following day to audition for *The Journey,* I saw real lights, a real boom mic, and a real camera. The assistant director instructed me to step onto a T-mark on the floor—something I hadn't practiced in Queens. But none of it threw me. I was new at this, but, honestly, I felt pretty comfortable, like I already belonged.

And my comfort and preparation paid a huge dividend: I got the part!

THE JOURNEY WAS a Cold War drama directed by Anatole Litvak. I played the son of two Americans trying to flee Communist Hungary. E. G. Marshall and Anne Jackson played my character's parents. Yul Brynner and Deborah Kerr, reunited for the first time since *The King and I,* led the cast, which also included Jason Robards in his feature-film debut. Thirty-one years later, I directed Jason in my film *Parenthood;* we kidded about how we broke into the business together.

Principal photography for *The Journey* was to take place in Vienna: a beautiful setting for a young kid's first paying job. Better still, Mom and Dad were coming with me, compliments of MGM. The studio made a family deal, casting my father in a bit part and hiring my mother as my official on-set guardian.

For my parents, this stroke of good fortune presented itself as a once-in-a-lifetime opportunity. They were too poor even to contemplate a European vacation, and my paychecks would be set aside and earmarked for college. No one in the Howard family thought of *The Journey* as anything but a one-off for me as an actor.

In the spring of 1958, we took off from Idlewild Airport for Europe, a first for all of us. We stopped at Shannon Airport in Ireland so the ground crew could refuel our propeller plane. While we bided our time in the terminal, the Irish airport workers took notice of my red hair and teased me affectionately. "Ya look like you've come home, lad," they said. "Ya shouldn't really be gettin' back on that plane, should ya?"

But get back on the plane we did. On March 3, just two days after my fourth birthday, we landed in Austria. The final descent was glorious, with Vienna resplendent in a blanket of newly fallen snow.

The Journey is a heavy picture. A bunch of international travelers, including my character, are trying to flee Budapest by bus during the Hungarian Revolution of 1956, only to be detained by a fearsome Soviet commander, played by Brynner. To me, though, the whole experience was pure joy, a stress-free first job.

When I wasn't in a scene, I climbed up onto the army tanks that guarded the film's "Soviet checkpoint." The film's prop master gave me a Whee-lo, that little toy with a spoked wheel that rolls along both sides of a magnetic metal track, which kept me mesmerized for hours. The wardrobe people dressed me up in a smart plaid jacket with matching earflap cap. I loved this outfit for how cool it made me look, even though the accompanying scarf itched my neck.

When the shoot was over, my pragmatic Oklahoman parents, believing this trip to be the only chance they would ever have to visit Europe, piggybacked some vacation travel onto our stay in Europe. We toured Venice, Paris, and London.

My favorite part, though, was directly tied to the work. In a pivotal scene in *The Journey,* Yul Brynner's character, Major Surov, intimidates the hell out of his captives by taking a bite out of the shot glass from which he is drinking vodka. Yul, with his shaved head and severe features, looked convincingly fearsome in his Soviet officer's uniform. But he was a kind and gregarious man who noticed that I was fascinated by

the scene and didn't want me to get any dangerous ideas. So, between takes, he invited me to sit in his lap. He held the prop glass to my face.

"Taste this, Ronny," he said. "This is *sugar,* not real glass. It's pretend, for the movie. You would never bite real glass." He encouraged me to chomp on a little shard. It tasted just like rock candy. *Whoa,* I thought, *this is amazing.*

This marked the beginning of my fascination with the process of how stories are told on the screen. I had learned a secret of the trade. I was in on the magic trick. And wow, did I *like* being in on the magic trick.

THE JOURNEY WRAPPED in June 1958 and came out to good reviews the following year. But it wasn't a game changer for the Howard family. After we returned to New York, I settled back into my preschool routine, Mom resumed her typing duties at CBS, and Dad continued to go out on auditions, without much success. TV acting work in New York had pretty much dried up by then. As the '50s came to an end, so, too, did the golden age of live television, most of it shot on the East Coast. Dad's agent suggested that he move west, to Los Angeles, where a raft of new detective shows and westerns were in production. When your own agent tells you to move, that's a pretty good sign that it's time to get out of town.

So, in the summer of '58, we packed up the old Plymouth, bade farewell to Queens and my parents' New York friends, and pointed the car in the direction of California. *The Journey* was my breakthrough, but this cross-country drive marked the beginning of my real journey.

MOM AND DAD: A LOVE STORY

CLINT

Generally, there are two categories of child actors. The first is the trained animal. He is basically given his line readings by an adult and asked to copy them down to the last detail, including facial expressions. It's not really acting, more like performing a trick. If this kid has a crying scene, he is not challenged to reach within and summon real emotion. Instead, someone in the makeup department comes out with a dropper of glycerin and puts some tears on his face. The director instantly gets the result he's after and everybody's happy.

The second category is the child who is allowed to be a child. The director encourages him to behave naturally so he doesn't get stiff or self-conscious. The kid does several takes of the scene, and later on, in postproduction, the editors cut away everything but the prime sirloin.

Dad devised a third way. He taught Ron and me how to understand a scene in an emotional language we could wrap our brains around. He started out by asking us three fundamental questions: Where do you think your character just was? Why is your character entering the scene? And where is it he would like to go?

We would build a little backstory for the character and then apply it to the material. This process gave my performances an honesty that the trained-animal kid could never deliver. Was I entering the room excitedly? Hesitantly? Was I hoping that we would get to eat ice cream for dinner? The viewers were oblivious to these interior monologues, but they benefited from a fuller, richer performance from me. You know who else benefited? The director. He didn't have to settle for Category 1, a cutesy but superficial performance, or for Category 2, trying to catch lightning in a bottle.

When Ron was little, Dad was still figuring this stuff out, jerry-rigging that pretend boom mic and feeling his way through the teaching process. By the time I came along, though, Dad had a *system*. Preparation was the key. He had us so well drilled that we created none of the hassle with which child actors are associated—fits of temper, trouble reciting lines, incontinence. Ron and I rarely required retakes. No production ever slowed down on account of a Howard brother.

DAD WAS THE child whisperer, with an innate grasp of how to motivate a young actor to succeed without applying undue pressure. Mom was the child whisperer's whisperer, bucking up her husband as he weathered the ups and downs of his own show-business career. As good as they were in these roles, they did not anticipate playing them.

Both my parents graduated from high school dreaming of stardom. They met in a drama class at the University of Oklahoma. Dad, an underclassman still going by his birth name, Harold Beckenholdt, had found a mentor figure in a senior theater major named Dennis Weaver, later to become the star of the long-running NBC series *McCloud*. One day in 1947, for a two-person scene study, Dennis decided to pair Harold with another drama student: a young woman named Jean Speegle.

Harold was green and unsophisticated. He grew up enamored of

Roy Rogers and Gene Autry movies, but he never saw them in a proper movie house. In Shidler, Oklahoma, the little town nearest to his family's farm, you sat on your coat and watched a picture as it was projected onto the side of a building. Dad fancied himself the heir to Rogers and Autry, the next singing-cowboy star. At one point he had a plan, and I mean a *serious* plan, to ride his horse, who was named Lucky, from Oklahoma all the way to Hollywood. He told Ron and me years later how it was supposed to work: he would camp out along the way, live off the land and by his wits, and finally arrive in Tinseltown on horseback, rugged and resplendent in his cowboy hat. The industry's grandees would be bowled over at the sight of a *real* singing cowboy and sign him up right quick!

There was one big issue that kept him from pursuing this plan: Dad couldn't sing. Could not carry a tune to save his life. This trait would not prove unique to him in our family. No one has ever mistaken the Howards for the Osmonds. Our group renditions of "Happy Birthday" were unlistenable to outsiders.

Jean Speegle was more polished, from a merchant family in the booming railroad town of Duncan, Oklahoma. She was considered by her peers to be one of the most gifted actors at OU and was nearly two years older than Harold. Dad had seen her in a campus production of Garson Kanin's *Born Yesterday* in which she knocked 'em dead as Billie Dawn, a sleazy tycoon's floozy who blossoms into a strong, independent woman. Country-boy Harold was intimidated by his scene partner's charisma and talent. He was also instantly besotted.

Nobody likes to think of their parents as passionate young lovers, but, from everything that Ron and I know, Cupid's arrow struck, and Harold and Jean quickly embarked upon a torrid romance. Dad was tall and lean, a rangy, good-looking young man who carried himself like a real-life cowboy. Mom was petite, not much over five feet in height, with a round, porcelain-doll face and wavy red hair.

Their love was too big for the college town of Norman, Oklahoma, to contain. Not long after becoming a couple, Harold and Jean ditched school to chase the dream of becoming professional actors. After a period of struggle and penury, they booked a steady gig as members of a touring children's-theater troupe, traveling from town to town in a repurposed school bus, playing venues as big as four-hundred-seat theaters and as small as rinky-dink school auditoriums.

Composed of around a dozen actors, the company included six adult little people who played the dwarves in *Snow White* and other fairy-tale characters. Mom played ingenues and princesses, including the title role in *Cinderella*. Dad played the Huntsman, the Prince, and any other role that was required of him. When they needed an extra dwarf, he would kneel behind the scenery upstage, pacing back and forth on his knees to the point that they turned black and blue. He earned an additional five bucks a week driving the prop truck, which followed behind the bus. This job granted him the extra benefit of scoring some alone time with Mom, who rode alongside him in the cab.

DAD DESPISED HIS name growing up. He hated the way "Harold" sounded and the nerdy image it projected. He would do imitations of people whining, "*Harr*-old, *Harr*-old!" As for "Beckenholdt," it was a mouthful and an albatross—Dad lost too many hours of his precious childhood spelling it out for people. On top of that, this surname was way too German-sounding for an aspiring star of stage and screen in the post–World War II era.

Sometime after he and Mom left school, Dad became Rance Howard. He never told us exactly where his new name came from, but our aunt Glee, Dad's younger sister, says that he played a character named Rance in a play somewhere and liked how it sounded when his fellow actors addressed him by that name. And our surname? Shortly after

Dad ran off with Mom, his folks, who had owned several farms over the course of his childhood, settled for good in Moline, Kansas, in Elk County, east of Wichita. Contiguous to Moline is the town of . . . Howard. In fact, Howard, Kansas, is where Dad's youngest sibling—his brother Max—still lives. "Rance" from a play plus "Howard" from Kansas equals Rance Howard. That's our best guess.

Aunt Glee also says that our grandparents' feelings were bruised by Dad's name change.

Granddad Beckenholdt told Glee that he had spoken about the situation with a prosperous friend, a local car dealer, and the friend said that if it had been *his* son, he would have written the kid right out of his will. But Grandma understood Dad's reasoning and told anyone who asked that Harold had become Rance to better his odds in "the show bidness."

RON

I used to wonder why Dad didn't simply shorten his name to something like Hal Beck. As a kid, I sometimes wished that my name was Ronny Beck—it sounded cooler than Ronny Howard.

Dad was a quiet, low-key person. But Mom, when she met him, somehow saw in this innocent farm boy's eyes a fire to match her own. Jean Speegle was a free-spirited child of the 1940s. Much of the war effort was powered by women on the home front, which proved liberating to girls like her. She had the brassy, bold spirit of Rosie the Riveter or the Andrews Sisters executing the intricate harmonies and tight choreography of "Boogie Woogie Bugle Boy." Mom was a natural leader at Duncan High School even though she wasn't a good student. I've seen her old report cards and they're terrible—lots of D's. Still, she was voted president of her class. When I asked Mom how a D student managed to

achieve this, she gave me a wry smile. "I got along with everybody," she said, eyes twinkling. I see a lot of her in my eldest daughter, Bryce: people are magnetically drawn to her, and she assumes the mantle of chief taskmaster organically.

The University of Oklahoma was not Mom's first stop after she graduated from high school. She persuaded her parents to let her apply to the American Academy of Dramatic Arts in New York, a storied acting school whose alumni included Lauren Bacall, Hume Cronyn, Grace Kelly, and Kirk Douglas. Duncan–to–New York was not a common trajectory for a seventeen-year-old girl from the middle of the country, but Mom had drive and proved herself worthy—she aced her audition and moved east.

For the few months that Mom studied at the Academy, she thrived. She fell in love with New York City, the start of a lifelong affair. But early one morning back in Duncan, her mother, our grandma Louise, sat bolt upright in her bed and said to our grandfather, "Butch! Something has happened to Jean!" Whether this was a sign of her oracular powers or an indication that mothers are always in a panic about their teenage daughters, Louise was right. Mom had been hit by a truck while crossing the street, shattering her pelvis. She was in a coma for ten days.

Against all odds, Mom healed up, and she and her family received a sizable insurance settlement. But the accident put a temporary hold on her acting dreams. Mom came home to recuperate and attended a junior college for a year before finally attending OU.

Jean Speegle arrived at college hungry, keen to make up for lost time, yet also vulnerable; she was rusty from her time spent on the disabled list. Just as she electrified Dad with her charisma and very presence, so did the attentions of this handsome young Harold fella give her a much-needed boost. Meeting Dad rejuvenated Mom's acting ambitions and joie de vivre. She had found her partner in crime.

Dad never knew what hit him. He soon discovered that Mom was

a frisky, rambunctious girl who fell in love fast and hard. She revealed to him that she'd had two or three fiancés before they met. Mom used the term "fiancé" more loosely and impetuously than most people did. Still, these fiancés were more than just casual boyfriends. Dad actually met one of them, a fellow actor named Bill Curran, who paid them a visit at their first New York apartment on Manhattan's Upper West Side.

CLINT

We need to come clean about our parents here. The story they told us for most of our lives was that they first went to New York together after their wedding. Nope. In the 1990s, Dad finally 'fessed up that they had moved into an apartment with a bunch of other young actors *before* they got married. Yes, these two lovebirds were messing around.

When they first ran off from college, they went to Nashville, where one of their friends had made it as an actor in that city's small theater scene. Mom and Dad struck out there. Their next stop was New York, Mom's happy place. The gig with the traveling children's-theater troupe began there, administered by a Manhattan-based outfit called Penthouse Productions. One other thing: before they set out on that tour, Dad found out that one of Mom's engagements was still semipending!

While she was back home in Duncan after her accident, she fell for an Italian American soldier stationed at Fort Sill in Lawton, Oklahoma, about thirty miles away. This fellow, whose last name was D'Angelo, was from the New York City area. The brash young Jean Speegle, even as she was living in sin with Rance, called D'Angelo to let him know that she was in his neck of the woods. She accepted an invitation to a dinner at D'Angelo's parents' home in the outer boroughs, a subway ride away. At dinner, she noticed that her old flame wasn't saying much.

Finally, D'Angelo's little sister could keep her secret pent up no more. "He's engaged to marry another girl!" she blurted out.

The table went quiet until Mom calmly replied, "Well, we'll just have to have some more potatoes on that, won't we?" Everyone laughed in relief and continued eating. But probably no one was more relieved than Dad when Mom came home and told him what had happened.

RON

Dad later told me that part of his urgency in proposing to Mom when he was only nineteen years old was that he wanted to get the other guys—or "contenders," as he called them—out of the way. His proposal was accepted. This proved to be, fortunately for Clint and me, Mom's final engagement.

As they toured with the children's-theater troupe during the summer of '48, their desire to marry as quickly as possible grew ever more urgent. Dad revealed to me in my adulthood that he and Mom had no moral issue with living together unmarried, but society still frowned on couples who cohabitated without a wedding certificate. To my parents' frustration, they discovered that in most of the states that they visited, marriage required that both parties take a blood test and then endure a three-day waiting period. That wouldn't work—the troupe never stayed in any state for as long as three days. But as summer turned to fall, fortune smiled upon the young couple. At a diner in Ohio, a nosy but friendly waiter happened to hear Mom and Dad discussing their plight and butted in: Kentucky, the waiter said, had no such waiting-period policy. Eagerly, Mom and Dad checked the schedule: their next show was in the town of Winchester, Kentucky. Perfect. They could get hitched right away!

And so, on the morning of October 5, 1948, in the lobby of the

Brown Proctor Hotel in Winchester, Jean Speegle and Rance How-
ard were married. The officiant was a Methodist minister who they
fortuitously met in the hotel the day before. The groomsmen were the
troupe's six little-person actors, who opened the ceremony by improvis-
ing a tap routine performed to the tune of Wagner's "Wedding March,"
better known as "Here Comes the Bride." Dad was five weeks shy of
his twentieth birthday. Mom was a comparatively mature and worldly
twenty-one. He wore a plaid suit. She wore one of her costume dresses,
her Cinderella ball gown temporarily denuded of its theatrical sequins.

The company put together a modest reception for them in the hotel
lobby. The company manager, an older woman named Mrs. Lawton,
improvised a wedding cake by having a local bakery stack three regular
cakes and refrost them. Everyone danced to the jukebox in the lobby and
drank through the afternoon and into the night. In Dad's telling, the
groomsmen drank more and carried on later than anyone, undaunted
by the call to be on the bus at 5 A.M. the following morning.

The wedding was not entirely free of drama. Mrs. Lawton initially
believed that Rance and Jean were being too rash. A couple of days before
the ceremony, she asked my parents if Mom was pregnant, and if that
was the reason for the hurry. Even when Mom explained that she wasn't
knocked up, Mrs. Lawton still tried to head off the ceremony, fearful
that the young lovers were making a terrible mistake. Mom turned
on her patented charm and brought the older woman around—to the
point where Mrs. Lawton not only procured the cake but also gave the
bride away.

When the news of their marriage reached the Speegles in Okla-
homa and the Beckenholdts in Kansas, the reaction wasn't entirely rap-
turous. Granddad Beckenholdt went to a lawyer to see if he could get
the marriage annulled. The lawyer, citing the fact that Dad was of legal
age, talked Granddad out of it. Dad was hurt but unsurprised by his
father's actions. He anticipated that his parents would flip out over his

sudden wedding, yet he was unwavering in his commitment to Mom and their shared pursuit of a life in show business.

The Speegles were caught by surprise but not entirely shocked, given their daughter's romanticism and determined disposition. When the theater troupe rolled into Oklahoma, Granddad Butch and Grandma Louise magnanimously held an open house in Duncan that served as the new couple's proper reception. Dad was in black tie with a white dinner jacket. Mom was dressed in a beautiful off-the-shoulder gown with a billowing skirt of diaphanous white tulle. They looked fantastic.

Granddad Beckenholdt begged off from attending the Duncan reception, but Dad's mother, Grandma Ethel, made the drive to Oklahoma with her sister. This was a show of good faith and also a fact-finding mission, to see, as my aunt Glee put it, "what kind of outfit Rance had married into."

When the children's-theater tour ended, my folks paid their first visit as a married couple to the Beckenholdts' farm in Kansas, where they were received politely if stiffly. The Beckenholdts withheld their full approval of Mom for a long time. Not until Clint and I came along did their wariness evaporate completely.

With some savings from their theater work, my folks bought a used Willys-Overland Jeepster soft-top. After they were done visiting the Beckenholdts, Mom and Dad pulled away from the farm in Kansas, headed to the highway on-ramp, and paused for a moment to ponder which way to go: east or west? New York or Los Angeles?

Mom didn't have to think for long. "East!" she said. New York it was.

LIFE IN THE big city was no cakewalk for the newlyweds. Mom quickly discovered that, for all the joy that acting had brought her at school and on the road, the treadmill of auditioning in New York wasn't for her. She got some parts in some regional and off-off-Broadway

productions, but the constant rejection inherent in a young actor's life was more than she could bear, as was the prospect of taking on work that would require her to be geographically apart from Dad. This issue came to a head when she was offered a role in a touring production of a play. My parents took a long walk along the Hudson River to discuss the matter. Dad encouraged Mom to accept the job, but she decided that she couldn't bear to part from her husband in this early stage of their marriage. When they got home from their walk, she called her agent and declined the role.

This marked the end of her pursuit of an acting career. Beyond the odd role here and there in a regional production in which she and Dad could act together, Mom essentially retired from show business in her early twenties. At that point, she redoubled her efforts to help her husband succeed. If she wasn't going to act, by God, she would do her damnedest to earn enough money for the both of them to live on while Dad went out on auditions. To that end, she took a job at Macy's, spritzing perfume samples on the wrists of lady customers, and another as a hatcheck girl at the Copacabana nightclub.

For a while, even this wasn't enough. Dad wasn't landing any parts, so he, too, took on nonacting work. He loaded fresh fish and produce onto refrigerated trucks at the docks. He worked as an usher at a seedy grindhouse theater in Times Square, his job really more akin to a bouncer's. The theater was open all day and all night, playing the same double feature over and over again. Many indigent men more or less lived at the theater. There were constant fights, and it often fell to Dad and his fellow ushers to break them up, armed only with their flashlights.

Dad was a pretty good fighter himself. He had boxed competitively in his teens in Oklahoma. In New York, he started working out at a gym favored by pro fighters. His sparring sessions impressed a trainer

there, so much so that the trainer offered to develop Dad as a light heavyweight. Needing the money, Dad announced to Mom his intent to train for his pro debut. Mom, horrified, extinguished that plan before it went any further.

Fortunately, Dad soon got the break he had been waiting for: a call to audition for the touring company of *Mister Roberts*. The show had been a hit on Broadway for more than two years. For part of the tour, Henry Fonda was going to step back into the title role, which he had originated. Fonda was one of the biggest movie stars in the world, known for playing the title role in *Young Abe Lincoln* and Tom Joad in *The Grapes of Wrath*. He was also to become a significant figure in our lives, offering counsel both to Dad and me as our paths crossed with his in the decades that followed.

At his audition, Dad read for two theater legends, the producer Leland Hayward and the director Joshua Logan, the team that brought Rodgers and Hammerstein's *South Pacific* to the stage. This was the big time. All the actors had to take off their shirts to prove that they were, quite literally, in shipshape condition. Dad easily passed that test. But he didn't win the colead part that he coveted, of Ensign Pulver, the role that I would later act out as a precocious three-year-old. Still, Logan took a liking to Dad and found a part for him, as a crewman named Lindstrom. The pay was one hundred dollars a week for the run of the tour—not Hollywood money, but a princely sum for a working actor, especially given that the tour was to last nearly a year. He and Mom were ecstatic.

By this time, they were living on their own, at last with no roommates, in an apartment in Chelsea. They spent much of Dad's off-hours from rehearsal sunning themselves on their building's roof, to ensure that Dad would look convincingly like a sailor who has spent months in the South Pacific. When the *Mister Roberts* tour began, they gave up their apartment and Mom joined Dad on the road in such cities as

Boston and Chicago, occasionally parting from him to visit her family in Oklahoma.

My folks were happy and in love, and Dad believed he was on the cusp of making it in the business. When the tour arrived in Los Angeles, he took a meeting with Republic Pictures, a prolific producer of westerns and B movies, and the incubator of Roy Rogers's and Gene Autry's careers, about possibly becoming a contract player—a prospect that excited him no end.

But then fate intervened: the Korean War was on, and Uncle Sam wanted him. So much for his prospects. So much for Hollywood.

At Mom's suggestion, in 1951, Dad proactively enlisted in the air force to avoid conscription into the army, where the odds were greater that he might find himself in combat. He excelled at basic training at Lackland Air Force Base in San Antonio. The military brass even offered him an opportunity to attend Officer Candidate School. But he had no aspirations to become an officer—he just wanted to put in his mandatory four years of service and be done with it. He requested to be assigned to Special Services, the entertainment branch of the U.S. military. Hank Fonda, Joshua Logan, and Leland Hayward wrote letters of recommendation to the sergeant in charge, attesting to Dad's suitability. That did the trick.

AS WARTIME ASSIGNMENTS went, life in the Special Services was as good as it got. The assigning sergeant helpfully advised Dad to put in for off-base housing. This allowed him and Mom to find their own place and receive a living allowance—a small sum, but one that gave them the freedom to lead a semicivilian life while Dad served. His job played to his strengths: he was in charge of staging shows on the base to keep his fellow airmen in good spirits. Better still, Dad would never see combat or travel overseas.

Still, he was tremendously frustrated. He was finally getting somewhere in his acting career, and he would forevermore maintain that his four long years away from the business derailed whatever professional momentum he had built up. What's more, he was already a grown man, and he bristled at the enforced loss of individuality that the air force demanded. During basic training, he couldn't believe that he had to spend hours upon hours of his day marching in formation. His drill instructor barked out the commands: "Flight, forward *march*! Flight, *halt*! Flight, *about face*!" (A flight was a group of sixty airmen.)

Dad viewed this period as a regression into an earlier part of his life. Legally, he was still Harold Beckenholdt, and he winced at the sound of his birth name, especially when it was mangled by his commanding officers. One drill sergeant, who had both a strong Boston accent and some kind of speech impediment, would shout, "Breckenbruck! Keep ya tums lahng da teems ah ya trou-sahs!" Dad looked at the man blankly, which only prompted a more furious recitation of the command: "Gah-dammit! Tay an' keep ya tums lahng da teems ah ya trou-sahs!" It took Dad three weeks to figure out that the sergeant was saying "Try and keep your thumbs along the seams of your trousers."

Dad had lots of other funny stories about the air force. He respected his peers and recognized the benefits that many of them reaped from this regimented way of life. But he never romanticized his military service. He considered it a duty, not a passion.

That said, he was not totally bereft of passion in his air force years. A year into Dad's time in the service, he and Mom received the news that their first child was on the way.

BECOMING CALIFORNIANS

CLINT

On January 31, 1953, Dad was on duty at the Service Club at Chanute Air Force Base, outside of Champaign, Illinois. He and Mom lived in a little rental bungalow in the nearby town of Rantoul. Mom called Dad to report that her water broke, and that she needed to get to the hospital in Champaign ASAP.

Dad was excused from duty and immediately picked up Mom, who already had her bag packed. They calmly drove to the hospital, where the orderlies wheeled Mom in. And then Dad waited. And waited. And waited. In those days, fathers were kept away from the delivery room, in suspense. Dad's mother had told him that she was in labor for a day and a half before he was born. So, while he was antsy, he wasn't particularly worried.

But late that night, Mom's doctor came out to the waiting room and struggled to find his words. Finally, he put his hand on Dad's shoulder and said, "I'm sorry. I just couldn't get that boy of yours to breathe."

Dad's first impulse was to ask after Mom. She was fine, the doctor

said. When Dad reached her room, she burst into tears at the sight of him. She already knew.

Mom blamed herself. Dad told her that nothing was her fault. Mom vowed to have another baby as soon as possible.

An autopsy revealed that the baby, who they named Mark Allan Howard, had a congenital heart defect and would not have lived long even if he had been delivered alive. Dad arranged to have him buried in the Speegle family plot in Duncan. Mom didn't want to see the body, but Dad did. "He was perfect in every way," Dad told me. He looked just like his father-in-law, Butch Speegle.

January 31 also happened to be Mom's birthday. Forever after, she never much enjoyed it. Ron and I didn't know why when we were kids, though. Our folks rarely discussed Mark with us. He was simply too painful a subject for them. Not until we were adults—after Mom had died, in fact—did Dad tell us the complete version of what happened.

Dad said that not dwelling on the stillbirth was their mechanism for coping with grief. "The future was ahead of us, and that was what we focused on," he said. My parents did not attend Mark's burial, but my Speegle grandparents did. He is still buried in the Speegle family plot, with a marker that reads BABY HOWARD.

RON

Mom was serious about her vow. At the beginning of summer, she learned she was pregnant again.

This time, she would do things differently. She would get prenatal checkups from the doctor in Champaign, but when the birth date approached, she would move temporarily to Duncan to give birth in the town's Lindley Hospital, where she herself was born. This guaranteed

her the support system of her family, and that she would be tended to by the same ob-gyn doctor who had delivered her and her sister.

In January 1954, Dad drove Mom to Chicago, where she caught a flight to Oklahoma City. Her father picked her up at the airport. Over the next few weeks, in the bitter cold of that winter, Dad spent many lonely, nervous days at the Chanute Service Club. He was, naturally, worried about going through heartbreak all over again. Meanwhile, his programs for the airmen—plays, concerts, and revues—had a new competitor in the television set that the club had just purchased. This didn't bug him as much as the fact that he recognized some of his New York friends on TV. He could see that a new frontier in entertainment had developed in his absence, and he was missing out. Still, as he wrote in a letter to Mom, it was better than being in a foxhole in Korea.

One day in late February, a runner from my father's battalion delivered an urgent message: he had been granted emergency leave, effective immediately, because his wife was being prepped for a Cesarean section. Though she had long ago recovered from her accident in New York, her pelvis was still sufficiently damaged, the doctor determined, to make dilation difficult for her.

Driving like a maniac in the Jeepster, Dad blasted through southern Illinois and Missouri to the brand-new Turner Turnpike in Oklahoma, which delivered him safely to his bride. Expecting to find a woman wailing in pain and/or hooked up to tubes and wires in the OR, he instead found Mom propped up in a regular hospital bed with a cigarette and a Coke, calmly watching TV. (Hey, it was the 1950s.)

The C-section, Mom matter-of-factly explained to Dad, allowed her to choose the date of delivery based on her doctor's availability and other factors. She had chosen the first day of March. My father's nerves settled and they fell into a discussion about names. They decided that the baby would be named Tammy if she was a girl and Ronald William if he was a boy. Ronald was simply a good, solid name. William was for

Mom's father, better known by his nickname, Butch, because he was . . . a butcher.

On March 1, 1954, Butch and Grandma Louise accompanied Dad to the hospital. My Speegle grandparents, never the most health-conscious of people, chain-smoked furiously. Dad, blessedly, did not smoke. Soon enough, Butch made his excuses and begged off, citing urgent butcher-shop business. Louise and Dad stationed themselves in the observation window, where they watched as Mom, knocked out by anesthesia, had a red antiseptic liquid brushed on her exposed belly. As soon as the doctor's scalpel broke through skin, Louise, too, was out of there.

Dad watched the remainder of the procedure by himself. At 9:03 A.M., the doctor removed the baby from Mom's womb and handed "the little fella," as Dad fondly described me when he told this story, to a nurse. The first thing I did was squirt a stream of pee right at the nurse as she held me upside down.

Ronald William Howard had made his entrance, hair the color of carrots, yowling but healthy and content.

MY PARENTS SENT out a birth announcement for me in the form of a theater program. The "show," entitled *Life Begins at 9:03 A.M.*, took place at the "theater" of Lindley Hospital. I was billed as Leading Man, Mom as Patient Mother, and Dad as Distracted Father. The production notes included a warning: "In the first scene, the star appears in the nude, creating quite a sensation."

I spent the first five weeks of my life in Duncan with my mother and her family. Dad, back to work on the Chanute base, spent all his off-duty time scrubbing the floors spotless and scouring the walls and ceilings of the little bungalow in Rantoul. In that part of Illinois, everyone heated their homes with coal, consequently coating every surface with a thin layer of soot. His friends offered to help with the cleaning,

but Dad wouldn't allow it. This effort was a personal tribute to his wife and newborn.

I remember nothing of that bungalow. We lived there for all of five months before Dad transferred to Keesler Air Force Base in Biloxi, Mississippi. Shortly before the move, my parents adopted a russet-haired spaniel-mix puppy they named Gulliver. My very first memory is of sitting under the kitchen table with Gulliver in our apartment in Biloxi, when I was two years old. I had discovered some chewing gum under a table and put it in my mouth. Neither of my parents chewed gum and the table was a holdover from the family that had previously occupied our crappy air force housing. On many levels, this was not a wise move.

Worse still, I took the gum out of my mouth and fed it to Gulliver, who eagerly gobbled it up . . . and then started retching, puking all over the floor. The memory ends with my dad marching into our apartment in his uniform and getting very angry. He reminded me that we'd had this discussion before—I shouldn't give the dog gum under any circumstances. I guess I was a repeat offender. Dad rarely flashed anger, then or at any other time of his life. Maybe that's why the scene remains so vivid to me.

Another early memory: watching a C-grade western called *Frontier Woman* at a drive-in, also when I was two. A year earlier, Dad had somehow hustled a plum role as the movie's heavy even though he was still in the air force. He actually went AWOL for a week to shoot it! (And luckily faced no repercussions.) Mom and I accompanied him to a patch of countryside near Meridian, Mississippi, where the producers had constructed a convincing replica of a rustic Old West village.

Since the film was an all-hands-on-deck kind of operation, Mom duly dressed up in a period costume and joined the cast as a villager. I became this villager woman's baby. The script happened to call for a scene in which a blowhard politician's speech is comically interrupted by

a baby's cry, so my role expanded! The problem? I was too good-natured to cry on cue. Mom had befriended some of the teenage Choctaw Indians from the Pearl River Reservation who participated in the shoot. These boys were fascinated by the red-haired baby in their midst and enjoyed engaging me, pulling funny faces and tickling me. One of them handed me his miniature tomahawk. But when he tried to take it back, I became upset and cried out. Aha! Problem solved.

The timing needed to be perfect, but when the director shouted "Action!," the politicians' debate ensued, and, at just the right moment, the Choctaw boy, off-screen, yanked the tomahawk out of my hand. On cue, I let out a cry that echoed through the hills. *Frontier Woman* is technically my first film, though it was an uncredited walk-on. Or crawl-on, if you like. I'm told that I got the laugh.

Dad industriously mounted show after show at the base's theater, Keesler Playhouse, in the process honing his directing chops—skills that would prove useful to him both in his own career and in overseeing mine and Clint's. He directed and starred in productions of William Saroyan's *Time of Your Life,* Moss Hart and George S. Kaufman's *George Washington Slept Here,* and Sam and Bella Spewack's *My Three Angels.* My mom temporarily came out of retirement again to take the female lead in many of these plays. She brought me to rehearsals in a portable canvas bassinet. By osmosis, I was already soaking up the vibes of show business.

YET I TRULY did not seem destined for the business until two years later, when my parents recognized how much fun I had in filming *The Journey,* and how adept I proved as a juvenile actor. Why not see if I was up for more? In the summer of '58, when we moved to California from New York, Mom typed up a résumé for me and glued onto it a black-and-white two-by-four photo of my smiling, freckled

face: my first headshot. In L.A., I became a client of the same agency that represented Dad.

Our cross-country journey took four days, pretty quick for back then. Dad had traded in the Jeepster for a hardtop Plymouth Cranbrook, a big, bulbous four-door sedan shaped like an inverted bathtub. Its roomy back seat—which, this being the '50s, had no seat belts—was mine to stretch out on.

As we drove west, eventually hooking up with the famous Route 66, I sensed an urgency in my parents to *get there,* to begin life anew in California as soon as possible. So it wasn't much of a sightseeing trip.

We did stop in Duncan to call on Mom's family. Mom was born there in 1927, when Duncan was known as "the buckle on the Oil Belt." The Speegles, of German descent, were reasonably well-to-do. They owned the town's grocery store and meat market, as well as the mineral rights to a few oil fields. The brains of their business operations belonged not to our Granddad Butch, a bumbling, affable man who drank too much, but to his sister, our aunt Julia.

I met Julia for the first time during our brief stay in Duncan. She was a trip: an exuberant, charismatic woman who wore oversized cat-eye glasses and treated her voluminous white hair with a blue rinse, pinning it up high like Marge Simpson's. Julia owned and ran the Wade Hotel and Café in Duncan, a handsome three-story redbrick building on the main drag, and populated the lobby level with what she described as the world's largest collection of dog figurines. Every available surface was covered with little dogs, be they ceramic, wooden, or metal. When you entered the hotel, you were greeted by Julia's collection of talking mynah birds, one of whom said "Take off like a jet!" The birds also sometimes swore. If they got too raunchy in front of kids like me, Julia silenced them by throwing a drop cloth over their cage.

We made only two touristy stops on the trip. The first was to stop in Arizona to see the Painted Desert and the Petrified Forest National Park.

At the former, I picked up a little vial of colored sand as a souvenir, and at the latter, a chunk of petrified wood. The second was Las Vegas for a night, so Mom and Dad could see the famous Strip in all its gaudy glory.

CLINT

For the record: given that this cross-country trip took place in midsummer and I was born the following April, the prevailing family belief is that I was conceived in Las Vegas. This is one of those rare occasions in which what happened in Vegas did *not* stay in Vegas.

RON

It's something I prefer not to think about, since I am absolutely certain that I shared the hotel room with Mom and Dad.

The Howard Family Road Trip came to a close when, in August 1958, we pulled into our new hometown: Burbank, California. Dad had first glimpsed the town nearly a decade earlier when the touring production of *Mister Roberts* rolled into Los Angeles. Dad's roommate on the road was an actor named Lee Van Cleef, who had a small part as a military policeman. One night in L.A., the great producer and director Stanley Kramer caught *Mister Roberts* and was struck by Van Cleef's elongated face and dark, villainous looks. He asked Lee, my dad's best friend in the company, to audition for his next picture: the western *High Noon*, starring Gary Cooper. "Do you know how to ride a horse?" Kramer said. Lee didn't miss a beat. "Of course I do!" he said. An audition date was set.

The problem was that Lee had lied. He was from New Jersey and had never been on a horse in his life. Dad swooped in to the rescue. He was a genuine horseman and outdoorsman, the eldest of Engle and

Ethel Beckenholdt's three children, born on November 17, 1928. His folks raised hogs, cattle, and wheat, adeptly navigating the Depression by buying, improving, and flipping farms along the Kansas-Oklahoma border, each farm nicer and bigger than the last.

From the age of five, Dad carried out his daily chores: mending fences, feeding the hogs, setting traps for possums and raccoons. He was also entrepreneurial, skinning the critters he caught and selling their pelts at market for twenty-five cents apiece. As he grew older, Dad became an expert rider who rounded up his family's cattle at day's end. So he was particularly qualified to help out Lee.

But where could they rent a couple of horses, pronto? Some asking around revealed the answer: the stables adjoining Griffith Park in Burbank. So off they went, with Dad giving Lee a crash course in riding. Lee got the part in *High Noon,* and thereafter enjoyed a fruitful career, first as a Hollywood hood, and later, after he grew a mustache and crossed the radar of Sergio Leone, as a star of spaghetti westerns. As for Dad, he took a look at Burbank and decided he liked the place. It felt like his kind of town.

Before we arrived, Dad secured a lease on a two-bedroom rental in a small apartment building on Cordova Street. When we arrived, I couldn't believe my eyes—this place was nothing like our gray, wintry block in Queens or the endlessly flat plains that surrounded Duncan. The sky was a cloudless blue, and there were palm trees everywhere. The Verdugo Mountains rose to the north and the Hollywood Hills to the south. Just a few blocks west of us was one of the first Bob's Big Boy hamburger restaurants, complete with carhops on roller skates, and the very first International House of Pancakes, which was only a few months old. When I looked south, I saw something even more exciting: a big water tower with the Warner Bros. logo on it—the same logo that appeared with a "Boinggg!" at the beginning of the Bugs Bunny cartoons I watched compulsively.

The residential streets were chockablock with newly built ranch houses: middle-class realizations of the American dream, occupied by families whose dads might have worked in the entertainment business but just as likely were cops, teachers, salesmen, or engineers for one of the town's largest employers, the Lockheed Aircraft Company.

As visually stimulating as my new hometown was, it did not feel glitzy. Burbank sits due north of Hollywood, but it wasn't, and still isn't, particularly *Hollywood,* or Beverly Hills or Bel Air for that matter. Picture the tidy suburban neighborhoods of such 1950s sitcoms as *Father Knows Best* and *Leave It to Beaver.* Our block was like that, only the houses were much smaller and the yards weren't big enough to warrant picket fences. Everyone's kids ran together in a swarm, commandeering the sidewalks and front yards to play football, running bases, and army. It was the perfect place to start the school-going years of this boy's life.

DAD HAD A good look for the type of TV that was popular in the late '50s: westerns, military dramas, cop shows. Lean and handsome, he could credibly play a principled sheriff or, with a bit of stubble, a menacing heel. In our first couple of years in California, he scared up some decent roles on such programs as *Bat Masterson, Zane Grey Theatre,* and *Death Valley Days.*

His natural ease in rural and western programs was ironic given how motivated he was never to work on a *real* ranch or farm. Dad's breaking point had come at age sixteen, when, on a hot summer day, he mouthed off to his father, complaining that doing farm chores was a waste of his valuable time. Granddad Beckenholdt pulled off his hat in the heat. Fixing his son with a withering look, he said—this is Dad's exact quote—"Feller, you better goddamn find something you like to do and do it. Because you ain't never going to make a farmer." Grandma Ethel was a little more tolerant of Dad's aspirations to act and brokered a solution

to Dad's wanderlust: applying to the drama program at the University of Oklahoma.

CLINT

Granddad Beckenholdt—which is what we called him—was a tall, thickly built man of few words. When he did speak, it was with an Oklahoma twang. He was born in a log cabin with a dirt floor on a farm by the Arkansas River. Through sheer hard work, he lifted himself out of poverty. He intimidated the hell out of Ron and me. Even when he was getting on in years and had acquired a gut, he exuded physical strength. He wasn't going to beat you in a footrace, but the man was a tank.

RON

He could eat like no one's business. On one of our few trips back to the farm, Clint and I noted that, come the dessert course, Grandma Ethel set out two pies: one for the family and one just for Granddad. Grandma served us our slices on individual plates. Granddad received only a fork. Invariably, he'd have an empty pie tin in front of him before we had even finished our slices.

Dad's intermittent success as a TV actor wasn't bad for a newcomer to California. But the Howard who kept getting cast without fail was me. I got almost every part I auditioned for. Thanks to my freckles and red hair, I had the perfect wholesome, gee-willikers look for the late Eisenhower era. I also caught the eye of Ethel Winant, CBS's all-powerful casting director who would later became the first woman to hold an executive position at a major television network. My first big credit was in an episode of *Playhouse 90,* a prestigious, biweekly CBS anthology series. Each episode presented a ninety-minute staging of a

new teleplay. The show launched such great directors as Arthur Penn, John Frankenheimer, and Sidney Lumet.

The episode, entitled "The Ding-a-Ling Girl," was filmed live to tape for the West Coast and was broadcast *live*-live to the East Coast. Once the cameras rolled, there was no stopping for retakes. Years later, when I hosted *Saturday Night Live* in the Eddie Murphy era, the white-knuckle aspects of live television—the last-minute scurrying, the tension backstage, the constant countdowns—came flooding back.

Playhouse 90 was known for its heavy, often solemn material, and in this particular teleplay, my character drowned. The drowning, fortunately, took place off-screen. But there was still a scene where I descended into a pool.

Dad drove me from Burbank to CBS's Television City in Hollywood— the first of what would turn out to be hundreds of such journeys with him to a studio workplace. Bear in mind that I could not yet read, so it fell to Dad to explain to me, in a way that a kid not quite five years old could understand, what was going on in the script. A drowning was a pretty scary thing for me to process. Especially given that I didn't yet know how to swim.

On the studio soundstage, there was a pool that looked convincingly deep. But Dad allayed my worries by walking me right up to it. Kneeling down, he poked his finger into the water, revealing that it was only inches deep—the fathomless blackness of the pool was an illusion created by the production-design team. Dad encouraged me to follow suit. I laughed as a I plunged my hand repeatedly into the pool—the water was no deeper than the milk in a cereal bowl.

Suddenly, I was not only free of worry—I was excited! First Yul Brynner let me take a bite out of the drinking glass, and now Dad was showing me another trick of the trade. These were like initiation rites: little rituals I undertook to join the order of actors.

I could never have articulated this thought then, but I had no trouble

reconciling the artifice of TV and movie production with the emotional honesty that was expected of me in performance. Ethel Winant took notice of the aplomb with which I carried off my role, unflustered by the pressures of live television, and told my parents how impressed the network's producers were. Before long, I was all over CBS. In '59, I did two more episodes of *Playhouse 90*, "A Corner of the Garden" and "Dark December" (the latter a Holocaust drama in which I played a Jewish boy, and, again, died); an episode apiece of the western series *Johnny Ringo*, the military comedy-drama *Hennesey*, and the sitcom *The Many Loves of Dobie Gillis*; and two more CBS anthology programs, *The DuPont Show with June Allyson* and Rod Serling's *The Twilight Zone*.

By the following year, I was a semiregular on *Dobie Gillis*, playing various little-kid roles, and on *Dennis the Menace*, as one of the little boys in Jay North's posse. Ms. Winant also put me on the ratings powerhouse *The Red Skelton Show*, one of the most popular programs on television in the 1950s and 1960s, which virtually the whole of America tuned into on Tuesday nights. I was in a sketch featuring Skelton's signature character, Freddie the Freeloader, the hobo clown who wore a dented top hat. This guy was a comedy legend, and I made him laugh. The cameras weren't rolling, but there was a moment during rehearsal where I was supposed to be eating fried chicken, and Skelton, as Freddie, told me that I was eating fried cat. Without missing a beat, I improvised a response: "I guess I like fried cat."

I WONDER WHAT was going through Dad's mind at this time: here he was, in his first full year of living and working in California, expecting to at last fulfill a dream deferred by the Korean War. And then some good fortune broke his way—but it wasn't in the form of a bonanza of work for him, but for his little kid, of all people.

He never projected any sense of conflicted or wounded pride. It's

possible that he felt it—he *was* an actor and he did have an ego. But on the other hand, he was also a farm boy who began to take on major chores at the age of five himself. The concept of a child juggling school and work wasn't novel to him. And I suspect that he never wanted to be to me what his father had been to him: set in his ways, willfully blind to the possibilities that life held for his son.

Our Jedi training sessions continued, with him preparing me for the pressurized atmosphere of live television: the hot lights, the countdowns, the need to be fully present in the moment. I wasn't infallible. In one of my *Playhouse 90* appearances, I messed up. My character was meant to get into the back seat of a convertible, with his parents up front. There had just been a scene depicting a snowstorm, and some of the prop snow had settled into the car, where it wasn't supposed to be. This distracted me, and, with CBS broadcasting my actions out to the nation, I couldn't restrain myself. "Wow, snow!" I said, throwing handfuls of the stuff in the air during a scene that was meant to play solemnly. Dad must have been mortified, but the director said it was okay—he told Mom that it played as a terrific ad lib, a kid pulling stuffing out of a tear in the seats and pretending it was snow.

That was the exception, though. I think my precocious professionalism is what caught Ethel Winant's eye. I always arrived prepared thanks to Dad, who was in the process of discovering a skill he didn't know he had: a knack for teaching a kid how to be an actor. For *The Journey,* he gave me a crash course in how to deliver a performance in that particular role in that particular film. Now he was giving me the tools to construct a career in this business if I wanted it. His genius was in never talking down to me, despite my tender age.

DAD'S KNACK FOR plainspoken one-to-one talk was fully on display when he and Mom broke to me the news, early in 1959,

that Mom was going to have a baby that spring. She was showing, and they knew that I would start to wonder.

I was psyched to have a little ally, and to have a baby in the house. I was a little lonely in Burbank, still adjusting to a new town in a new state. That said, I also had questions, such as, *Where do babies come from?*

Dad didn't respond instantly. He took his time, sitting in the living room of our tiny one-bedroom apartment, thinking through his answer. I must have started with some reference to cartoons, because he disabused me of the notion that babies arrived in little bundles delivered by storks.

"Now, some people really do say that a stork brings a baby. That's ridiculous," he said. "I'm going to tell you how nature works. And this isn't just for people—it's the way animals make their offspring, too."

He got up and returned with a pad and a pen. He drew a naked man and a naked woman. There was a penis on the man. The woman's genitalia was not depicted in anything approaching vivid detail, just enough to get the idea across. He drew some little dots coming out of the penis and called them seeds.

"The man plants a seed in the woman. The woman has an egg," he said. "When the seed and the egg meet, that's how you make a child."

It was presented that plainly. He never mentioned the pleasurable aspects of sexual intercourse, nor did he go into any detail about penetration. He *did* note that the seeds come out of the same organ that pee comes out of, and he helpfully clarified that pee is totally different than seeds.

I didn't respond. But not because I was embarrassed. I was blown away: I had never heard a *thing* about seeds and eggs. Wow! And I was flattered that Dad respected me enough to give me the truth. I had the real scoop while other kids were getting the fairy tale.

What I was most excited for, though, was the pending arrival of my little buddy.

4

THE NEW KID IN TOWN

RON

Sweat. The prevailing sensory memory of my early acting career is of the smell, sight, and feel of my adult colleagues' on-set perspiration. Jesus, what a sweaty business it was.

With Gig Young, it was boozy sweat: the smell of alcohol seeping through his pores. This was in an episode from the first season of *The Twilight Zone* that is now regarded as one of the show's best, "Walking Distance." Young played a cynical big-city advertising guy named Martin Sloan whose car breaks down just outside of the town where he grew up. To kill time, he strolls through his old stomping grounds, only to discover that he has been transported back to his town at the time of his childhood. Sloan freaks out when he recognizes that he is an adult from the future, witnessing the comings and goings of his younger self and his parents, long dead but suddenly alive again and in their prime. I played Martin Sloan's little brother, who offers the first tell that things are amiss. When Gig sits down next to me on the curb and identifies himself as Martin Sloan, I get upset, protest "You're not Marty Sloan!," and run into the house.

It was mainly a fun day's work for me. We shot it on the MGM back-lot in Culver City, where I happily discovered a full-scale park with a real jungle gym and merry-go-round. I couldn't define Gig's smell. I clocked its pungency and noticed that he was perspiring so much that his makeup was dripping down onto his collar, which they kept having to touch up. Young was a good actor who inhabited his role perfectly, but I could sense in some intuitive way that this was a man who had some troubles. His unchecked alcoholism later caused his career to un-ravel.

Johnny Cash sweated like crazy, too. I worked with him in a low-budget crime potboiler called *Five Minutes to Live,* in which his charac-ter, a hard-bitten criminal, hauls me up like a sack of potatoes and takes me hostage.

Cash's perspiration was different from Gig Young's. He was nervous about acting, awkward and confused about what to do. Johnny's runoff sweat absolutely soaked me as we did take after take. In retrospect, I can diagnose this as a serious case of flop sweat. The producers were trying to capitalize on the fame of Johnny Cash the music star, but Johnny Cash the actor was out of his element. Between takes, he was gentle and soft-spoken, a kind man who made a point of showing me that the gun he was holding had a metal block in its muzzle that prevented it from firing bullets. Again, I loved being in on the magic trick. But it was strange to be in on something else: adult fallibility. I wouldn't have called it that then, but I recognized, on some level, that I was more com-fortable on a soundstage than Johnny Cash was.

The sweatiest picture I ever worked on was *The Music Man,* which came a little later. I played Winthrop Paroo, the little brother of Shirley Jones's Marian the librarian. I still have visions of the rivulets of sweat streaking down Shirley's and Robert Preston's faces, smearing the heavy makeup they wore.

They shot *The Music Man* in Technicolor. To get that rich, saturated

look in the early '60s, they had to blast the set with bright light, on aver-age about 250 foot-candles' worth. A foot-candle is an antique unit of il-lumination that gets its name from the theater, where, in the days before electricity, actual candles were used as footlights. You don't even hear about foot-candles anymore in the moviemaking business, but even for the era, 250 was a high number. A decade later, when I shot *American Graffiti* with George Lucas, which takes place mostly at night, George made waves by shooting at only eight foot-candles, and even four in some shots.

When we did close-ups in *The Music Man,* the lighting went from 250 to a ridiculous 500 foot-candles. That's actually how I knew when I was on my mark: when I could feel an abrupt temperature shift from hot to *unbearably* hot. If you look at any close-up in *The Music Man* in high definition, you can actually see the sweat beading above the actors' lips.

YOU KNOW WHO barely broke a sweat? Me. In those early days, performing came pretty easily to me. So much of the work seemed like play. They used me a lot on the sitcom *The Many Loves of Dobie Gillis,* a show that I enjoyed watching at home, even though its high school plot lines were mostly lost on me. My little-boy character was always returning pop bottles to Dobie's father's grocery store for a five-cent deposit, an action that—and man, this blew my mind—you could actually carry out in real life! Thanks to *Dobie Gillis,* I became serious about collecting and returning bottles for a while. I stashed my booty of nickels in an old cigar box from Aunt Julia's hotel, which I had covered with stickers from our travels to Venice, Paris, and London after *The Journey.*

Beyond that, it was simply cool to be in the presence of Dwayne Hick-man and Bob Denver, who played, respectively, Dobie and his beatnik sidekick, Maynard G. Krebs. (Bob later starred as Gilligan on *Gilligan's*

Island.) I was a genuine fan of theirs, and the vibe on that set was upbeat. When Dad got a call for me to be on that show, I went happily.

Dennis the Menace was different. My job, as a member of Dennis's troop of pals, was not demanding. But I was bummed on behalf of Jay North, who played Dennis. He was three years older than me, a seasoned vet in my eyes, but I could tell that he was tired. They really ran him ragged. I came to recognize, when I got *The Andy Griffith Show,* that it was lucky for me that Opie was a supporting character. He had some choice scenes in most of the episodes, but he never had to carry the show.

Jay did. He couldn't hang with us between scenes. That was the big thing. For me, it was always a breeze to shoot an episode of TV with other kids involved, whether it was *Dennis the Menace* or *Andy Griffith,* because you could talk and play with them when you weren't shooting. Poor Jay had to sit by himself under one of those 1950s "beehive" bonnet hair dryers that you saw in ladies' salons, forbidden from moving, all for his trademark hairdo.

Jay needed to have the same pointy cowlick on the back of his head that the cartoon Dennis wore in the Hank Ketcham comic strip. A weird-looking thing, Jay's cowlick was, like the stem of a pumpkin made out of blond hair. Whenever the director yelled "Cut!" and we went on break, a small team of people surrounded Jay, spritzing the cowlick with hair spray and covering it up in a wire-mesh net—cowlick scaffolding, basically—before sitting him under the dryer. While the rest of us kids were making paper airplanes and holding contests to see whose would fly the farthest, Jay was stuck in his chair, immobile in the service of this stupid hairstyle.

A couple of years later, when I worked on *Andy Griffith,* I watched *Dennis the Menace* with my father and we both noticed that they had done away with Dennis's cowlick. I felt relieved for Jay. Dad and I sat

there, commenting, like the pair of industry professionals that we were, about the producers' choice.

"Dad, they're not doing the hair thing to Jay anymore."

"No, I think it was too hard, too much of a nuisance. Good decision."

"Yeah, good move, losing the cowlick."

IT WASN'T LONG before we had a third Howard dude in the house, pitching in his two cents. I awoke the morning of April 20, 1959, to discover my maternal grandparents, Butch and Louise, in our apartment. They traveled west to help out with the childcare while Mom and Dad acclimated to a two-child household. Later that day, the phone rang and Grandma, still holding the receiver in her hand, announced, "You've got a brother, and his name is Clint."

It felt like Christmas morning—my protégé, comrade, and future playmate had arrived!

My mother needed some time to recuperate at Saint Joseph Hospital in Burbank, so I did not meet Clinton Engle Howard, to use his full name, until a few days after his birth, when Mom was discharged. I had an audition for one of the CBS shows that day, so my father drove me straight from Television City to the hospital, where we collected Mom and Clint in the Plymouth Cranbrook and brought them home. With no children's car seats back then, Clint rode home cradled in my grandmother's arms in the back seat. I sat next to her, looking on in awe at this little blond-haired baby. Like Mark, the brother I sadly never knew, Clint had the same circular face and high forehead as our granddad Butch.

The birth announcement my parents sent out for Clint a couple of weeks later included a little drawing of a blond baby in a safety-pinned

diaper and boxing gloves, with the words, "We've got a new lightweight champ—HE'S A KNOCKOUT!"

Ahead of Clint's birth, we had moved into a larger apartment directly across Cordova Street from our first one: the bottom half of a nice little two-unit house with a Spanish-tiled roof. Dad got the landlord to knock ten bucks off the monthly rent in exchange for maintaining the lawn. I doted on Baby Clint, holding him in my lap with a baby blanket draped over my dungarees to protect me in case his diaper leaked. Mom didn't nurse, so I bottle-fed Clint his formula, which I considered a big-brother privilege.

There wasn't much else I could yet do with my brother, but one benefit of his arrival was that I really got to know my grandparents for the first time, particularly Grandma Louise. She and I were the early risers in the house, me in my pajamas, Grandma in her housecoat, with her thin, wispy hair showing because she hadn't yet put on her wig. The Speegle side of the family was always sort of physically falling apart. They were fun and high-spirited people, but they made no effort to look after themselves. My grandparents and mother all smoked heavily. Butch was an alcoholic, albeit, thankfully, a nonaggressive one. As for Mom, she already had a mouthful of false teeth by the time that Clint and I came along.

In the kitchen, Grandma Louise would put the coffee on and tell me stories of growing up in Oklahoma in the olden days. The first automobile in Duncan, she said, was owned by a Cherokee chief who had struck it rich when oil was discovered beneath his land. He often rode into town with seven or eight men hanging from his car.

Louise had light-blond hair as a small child. One day, when she was four, the Cherokees, fascinated by her coloring, just scooped her up and drove her back to the reservation. She felt no fear, she told me, and actually had a good time playing with the Cherokee kids. But the townspeople of Duncan were alarmed, and the men formed a posse, riding

out to the reservation on horseback with their rifles and shotguns, ready for a confrontation. Fortunately, the matter was resolved peacefully—the Cherokee chief explained that they meant no harm, and my grandmother was reunited with her family.

MY FATHER, BEING both thrifty and handy, decided to build a play mat for Clint—today they're called baby gyms—rather than buy one from the store. He sanded down a big wooden board and attached fun things to it: a steering wheel, a light switch, various knobs . . . all the good stuff that will keep a baby occupied and out of trouble.

I so admired Dad's handiwork that I ended up using the play mat as much as Clint did. Clint was physically precocious, more so than I had been, and was walking not long after his first birthday. One day I was deep in concentration, fidgeting with the switches and knobs on the board, when I felt a warm stream of liquid hitting my arm. I turned around and Clint stood there in a T-shirt but no diaper, arms straight out, pelvis thrust forward, peeing on me. Catching my eye, he threw his head back and laughed an evil little laugh, saying, "Heee hee-hee hee-hee heeee!"

I was furious. I went to Dad and reported Clint's misdeed, pleading, "You should spank him!" Spanking happened in our house. Nothing bad, just three quick swats of the butt, *whack, whack, whack*. The spankings stung me emotionally more than physically, and they always scared me straight. But Dad said it would be wrong to spank Clint. "When I give you a spanking, I know that you understand what you did," he said. "Clint is too young to understand. He doesn't know. So he won't get spanked. I'm sorry that he peed on you. Now go get yourself washed up."

By the time I took a bath and returned to the living room, my mood had changed. Clint, with his squinty eyes and teeth coming in unevenly,

was still doing that laugh—"Heee hee-hee hee-hee heeee!"—and, I had to admit, the sight of him was pretty hilarious. I cracked up and thereafter started calling Clint the Hee-Hee Man. It's been one of my nicknames for him ever since.

CLINT

The Hee-Hee Man incident, of which I have no memory, is so representative of who we were and still are: Ron, the kid always on the straight and narrow, and me, the mischievous little guy toting the squirt gun, forever trying to see what he can get away with.

The five-year difference between us meant that I benefited from Ron's experience and even-keeled nature, while Ron enjoyed the go-for-broke spirit with which I embraced life. Later on, when he first attempted to make short films with an 8 mm camera, he cast me as his leading man, knowing that I was willing to do and try anything.

Ron and I were never in competition, as siblings so often are. I looked up to him. Coming along second gave me a great vantage point from which to watch and learn. I observed and took mental notes as Ron navigated tricky waters as a juvenile actor, a schoolboy, and as a child of Rance and Jean Howard, who were way more protective of him than they were of me. A classic second-child scenario.

In personality I was more like Mom, who had the gift of gab; she could make friends in an elevator in two floors. But I worshipped my dad. He was my teacher, my guide, and my moral compass. In fact, my first clear memory of him is one of those classic Rance Howard teachable moments. I observed as he took apart an old shed with a crowbar. All was going well until he reared back too fast with the crowbar and the damned thing struck him right in the kisser.

Suddenly, blood was streaming out of his mouth, along with a string

of words I had never heard before: "Shit! Fuck! Goddamn!" And who could blame him? He was an actor who had just messed up his face. But then he remembered that his toddler son was sitting right there on the grass, witnessing his cuss-fest. Dad checked himself. Wiping his mouth with a rag, he calmly explained what each of these words meant, and, correspondingly, why I should never, *ever* say them.

As Ron mentioned, I also took after Butch. I was his spitting image, though I didn't get to know him. He died only a year after I was born, at the too-young age of fifty-six. His drinking, smoking, and insistence that all foods must necessarily be deep-fried and smothered with gravy caught up with him fast.

When my Speegle grandparents came out to help when I was born, Dad and Butch drove to the supermarket for groceries. Butch was on his best behavior, under orders from Louise not to drink in the Howard house. But when they reached the grocery store, Butch asked Dad to buy him a pint flask of vodka. Dad obliged. "And it was the damnedest thing," Dad told me. "He opened the flask right there in the parking lot and drank it down in three swigs."

It turns out that I had more in common with Butch than just looks.

RON

With two little mouths to feed, Dad couldn't afford to get complacent about his craft. He took an acting workshop with a man named Sherman Marks, who also happened to be a television director. While Mom looked after Clint, Dad invited me to tag along and observe.

Evidently, Sherman Marks was also observing me. When he got a job in 1959 to direct a pilot for an NBC comedy series, he asked for Dad's permission to have me audition for it.

Mr. O'Malley was based on a 1940s comic strip called *Barnaby* by

Crockett Johnson, creator of *Harold and the Purple Crayon*. Barnaby was a five-year-old boy who, in a subversive inversion of traditional children's stories, had not a fairy godmother but a fairy god*father*. This fairy godfather, Mr. O'Malley, was a cantankerous little man who wore a porkpie hat, smoked cigars, and was borne aloft, just barely, by a set of four dinky little wings: a little bit like Clarence the Angel in *It's a Wonderful Life,* but more gruff. Barnaby was the only person who could actually see and speak with Mr. O'Malley, whose alleged existence exasperated Barnaby's parents. They took their son to a series of child psychologists to dissuade him of his delusions.

I passed the audition and got the role as Barnaby. On paper, it sounds like a difficult concept for a five-year-old actor to grasp: a boy with an imaginary friend and parents who disbelieve him. But Dad broke things down for me, walking me through the character's logic. With Gig Young in *The Twilight Zone,* I didn't understand that I was participating in a parable about a hardened city slicker who has lost touch with his hometown values. Dad just said, "You have no idea what this man is talking about, and you think he's crazy." That was all I needed to know. In *Mr. O'Malley,* Dad said, Barnaby believes Mr. O'Malley *is* real and should be treated as such. When his parents say there's no such thing as a fairy godfather—well, Barnaby's parents are just wrong.

I didn't think of the *Mr. O'Malley* job as any kind of big deal until I learned that the actor playing Mr. O'Malley was the man who played the Cowardly Lion in *The Wizard of Oz:* Bert Lahr. That was a big *whoa*. In person, Lahr was simultaneously bigger than life and kind of a disappointment. He had a huge, bulbous nose and a commanding presence, but no particular affinity for his costar, me. He wasn't rude, just transactional, exuding no warmth. And he seemed impossibly old, though I just looked up the dates, and guess what? He was slightly younger than I am now.

Once again, I was working opposite a profuse perspirer—Bert Lahr

sweated like a faucet was on. His sweat smelled like the cigarettes that he chain-smoked. Curiously enough, he couldn't stand cigars, so the prop department rigged up a fake cigar that could fit a cigarette inside it for Mr. O'Malley. God, the secondhand smoke that I inhaled as a kid! Between Lahr, my mom, my grandparents, and the *Andy Griffith* cast and crew, it's a wonder that I don't have severe lung issues.

What made up for the Cowardly Lion's indifference was O'Malley's invisible sidekick, a leprechaun named McSnoyd, played by Mel Blanc, the voice of Bugs Bunny, Donald Duck, Porky Pig, Sylvester the Cat, Tweety Bird, Foghorn Leghorn, and Elmer Fudd. When Dad told me who the balding man with the mustache was, I zoomed up to him, eager to shake his hand. Blanc was clearly used to awestruck kids like me and obligingly performed a highlight reel of his characters, saliva flying everywhere as I delighted in his repertoire.

And to Lahr's credit, he was amazing once the cameras were rolling. He provided my first exposure to an entertainer for whom the command "Action!" is like the flick of a switch. He rose to the occasion and transformed into the character, bringing a completely different energy to his performance than he did to his off-camera interactions with the cast and crew.

Mr. O'Malley was good television and I felt like I was a part of something special. Right before my eyes was a sight that *I,* at least, found entertaining and hilarious: Lahr floating into the frame with little pink wings on his back and Blanc off to the side, bringing his voice wizardry to the leprechaun character.

What I didn't yet understand was the relationship between the scenes that we were shooting beneath those hot lights and a living, breathing audience of viewers. I made no connection between my own passionate viewing of *Superman, The Lone Ranger, Popeye,* the *Heckle and Jeckle* cartoons, and Laurel and Hardy comedy shorts and the work that I was doing. As for prime time, it was past my bedtime—I didn't see myself

on TV until *The Andy Griffith Show,* which my parents occasionally allowed me to stay up to watch on Monday nights. I was not aware that the camera was a portal, and that people outside the studio were actually watching my performances, until I started hearing shouts of "Hey, Opie!" when I walked down the street.

The *Mr. O'Malley* pilot got its shot at winning over America when it aired one evening on *General Electric Theater,* yet another popular anthology TV series of the era. The program's host was a former movie star who was now in a career doldrum, reduced to being a television presenter. Give the guy credit, though: he liked what he saw in me. At the broadcast's conclusion, Ronald Reagan ad-libbed the line "And special thanks to little Ronny Howard, who did a wonderful job as Barnaby."

My performance also caught the eye of a major TV producer named Sheldon Leonard, the cocreator of the long-running hit sitcom *The Danny Thomas Show.* Leonard's great gift was tailoring a TV show to a specific actor's skill set. For Thomas, a successful nightclub comedian, he created a series in which Thomas played a family man who was also . . . a successful nightclub comedian. Leonard also helped Carl Reiner mold *The Dick Van Dyke Show* so that it played to Van Dyke's strengths as an expressive actor with an elastic face and physical-comedy chops.

When Leonard saw me play Barnaby, he was building yet another program around a seasoned actor-comedian: in this case, a folksy guy from North Carolina named Andy Griffith.

INTRODUCING OPIE

CLINT

My parents used to sit face-to-face at the kitchen table like it was a partner's desk, each of them pecking away at a manual typewriter, Mom on a big Olympia, Dad on an old, banged-up portable. In the days before copying machines and printers, everything had to be done manually, including addressing and stamping business envelopes. Lots of big companies contracted out this task to freelancers, paying a penny an envelope. It was tedious work, but Mom and Dad needed the cash. So this was a regular sight for me, the two of them with their heads down, making a mechanical racket.

This was an echo of their New York years, before Ron and I were born. Mom was a professional-grade typist, and when she gave up acting and took the job at CBS, she channeled her competitiveness into the typing pool. Every script for every CBS entertainment show had to be hand-typed. So if, say, *The Jack Benny Program* or *Arthur Godfrey's Talent Scouts* was about to be on TV, Mom was *on it,* her fingers flying across those keys.

But in our house in Burbank, the typing was an occasionally necessary source of additional income. Ron and I were disabused at an early age of any notion that acting is a glamorous profession. We understood that Dad was an actor, and we also understood that he and we did not have it easy. Mind you, Ron and I never wanted for anything. There was food on the table and there were toys all over the floor. But we saw Dad endure his share of dry spells and tense times, and, pretty early, we recognized what was going on.

A strict Howard-family policy was that one adult or the other had to be present in the house between 9 A.M. and 6 P.M. every weekday, without fail, in case the phone rang. A phone call could mean an audition or a job offer. A missed call could be *the* opportunity, squandered. And my thrifty parents didn't want to waste money on an answering service whose reliability they wouldn't trust anyway. So certain days felt like vigils, with Dad puttering around, doing his chores, but clearly waiting, waiting, waiting for the phone to ring.

RON

It was a big deal when the phone rang one day just before Christmas in 1959. Dad picked up the receiver to hear my agent, Bill Schuller, tell him that a Mr. Sheldon Leonard wanted to see me. This wasn't about a one-day job in yet another stock-serious *Playhouse 90* episode in which I played "the boy" and got killed off. No, Sheldon Leonard was developing a TV *series*.

Unbeknownst to me, Leonard had called Bill the day after the *G.E. Theater* broadcast to say he wanted to put a "hold" on me for the Griffith show he was developing, essentially guaranteeing me the role of Griffith's son if the show was picked up. Bill explained that I was committed to *Mr. O'Malley*.

Leonard was unfazed. "I don't think *O'Malley* is gonna go," he said. "I'd like to put a second position on the kid." With my father's consent, Bill obliged the producer's request—if *Mr. O'Malley* wasn't picked up as a series, Leonard had dibs on me for his new show.

Mr. O'Malley did not go. It was too weird and whimsical, probably, for 1959 America. But what if it had? It's one of the big what-ifs that still plays out in my brain. Suppose I had signed a long-term contract for *Mr. O'Malley*. It would have meant that people would have called out "Hey, Barnaby!" instead of "Hey, Opie!"

Dad and I met Mr. Leonard in his Hollywood office. A suave, dapper man who had been a busy character actor in his younger years, he had worked with the likes of Joe Mankiewicz and Frank Capra. Remember Nick the bartender in *It's a Wonderful Life,* who is a kind man in Bedford Falls and a disagreeable lout in Pottersville? That was Sheldon.

I knew nothing about Andy Griffith at that point and Dad knew next to nothing. Sheldon filled us in. Andy, a tall, commanding native North Carolinian from a working-class background, had broken into show business as a comic monologist. In one of his routines, "What It Was, Was Football," he played a rural preacher who happened upon a clearing where a football game was being played. Ignorant of the sport, he described the scene with bewilderment, as a bizarre fight between two groups of men over a "pumpkin," with a team of "convicts" (the refs) supervising the proceedings.

The football monologue catapulted Andy into a career in radio and on Broadway. In 1957, he got his shot at film stardom, debuting in Elia Kazan's astonishing *A Face in the Crowd,* written by Budd Schulberg. The movie, a dark, prescient take on American politics and mass media, is more appreciated now than it was at the time of its release. But even then, critics were mesmerized by Andy's fiery performance as Lonesome Rhodes, a small-time radio host who, as his popularity snowballs, transforms into a lusty, egomaniacal demagogue.

Many years later, when I was a young adult, Andy told me that play-ing Lonesome Rhodes had been a harrowing experience for him. Kazan was a brilliant director, he said, but he had manipulated and provoked Andy to summon his darkest, ugliest thoughts and impulses, and the process about wrecked him. "I don't *ever* want to do that again," Andy said. "I like to laugh when I'm working."

Andy had his pick of dramatic roles after *A Face in the Crowd,* but he chose not to go down that path—the psychological toll had been too high. To some degree, Andy said, Mayberry and the benevolent Sheriff Andy Taylor were a conscious response to Lonesome Rhodes, embodi-ments of rural America at its best.

In Sheldon Leonard's office, Dad and I also met a man named Aaron Ruben, another producer, who was to function as *The Andy Griffith Show*'s showrunner, the person who oversees the program on a day-to-day basis. Nominally, this meeting was my audition, but I think they had already decided upon casting me. All I remember is that I was small enough to stand without crouching underneath Aaron's wooden desk, a sight that made Aaron break into a wide smile. This moment would turn into a fond memory—as the years passed and each new season be-gan, I would measure my growth by lining myself up against Aaron's desk.

There was more good news: *The Andy Griffith Show* was a virtual lock for CBS's fall 1960 lineup. Unusually for the TV business, we wouldn't be shooting a pilot. Rather, there would be a special episode of *The Danny Thomas Show* near the end of the 1959–1960 season in which Andy and Opie Taylor were introduced. (In the industry, this is known as a "back-door pilot.")

We shot this episode in early 1960. Andy was only thirty-four years old when I met him but seemed much older, if still a hell of a lot younger than Bert Lahr. He was a big, craggy-looking man with a thicket of dark brown hair, a booming speaking voice, and a method

actor's intensity. He was proud of his roots in humble Mount Airy, North Carolina, a small town in the foothills of the Blue Ridge Mountains.

Mayberry was an idealized version of Mount Airy as Andy remembered it. He was not coy about this. The show was to take place in the 1960s, and Sheriff Andy Taylor drove a brand-new Ford Galaxie police car. But Andy, born in 1926, consciously set out to evoke the atmosphere of his youth in the 1930s and 1940s. People are nostalgic for *The Andy Griffith Show* now, but it's important to realize that even then, it was an evocation of a bygone era, and an idealized evocation at that. A little over a decade later, I would be at the center of a similar phenomenon when I played Richie Cunningham on *Happy Days*. Maybe it was my red hair, or the set of my jaw, or the way my otherwise regionless accent had the slightest touch of my parents' Oklahoma twang. Somehow, I was born to be bygone.

Andy was also keen to counteract Hollywood's prevailing stereotypes of southerners. He was no fan of such contemporaneous "southern" TV programs as *The Beverly Hillbillies* and *Petticoat Junction,* in which men were mushmouthed hayseeds and girls were buxom sexpots. He described these programs, pejoratively, as "burlesque."

"The South is plenty funny as it is without playing it like *Li'l Abner,*" he would say. Andy was proud of where he came from, spending his summers without ever putting his shoes on and living in a town where his neighbors looked out for him whether they were family or not. One of his major motivations for the sitcom was to portray his world with humanity and depth, and without the usual grotesquerie.

As a matter of fact, that tension was at the heart of our *Danny Thomas Show* episode. Danny Williams, Thomas's TV alter ego, runs a stop sign in the fictional town of Mayberry and gets pulled over by the sheriff, Andy's character. Too stubborn and patronizing to accept a ticket for a moving violation, Williams decides he would rather sit in the

town jail than capitulate. He literally says to Andy, "Go buy yourself a comb and rake the hay seed out of your hair!"

My debut scene as Opie, before a live studio audience, doubled as the moment in which Danny's attitude toward Andy starts to soften, when he sees how good a father Andy is to his boy. We wouldn't have a studio audience once we started *The Andy Griffith Show* in earnest, but in this case, we were playing by Danny's rules. I was too young to be fearful of performing before the audience. The property master gave me a toy turtle to hold, a cheap thing made of tin, with little legs that swiveled back and forth. The director told me to cup my hands around it as I ran in, so that the camera wouldn't pick up how fake the toy looked.

The premise was that I was distraught that my pet turtle, Wilford, was dead; some lady had accidentally stepped on him in the ice cream parlor. This was an opportunity to establish that Andy was a widower and Opie a boy without a mother. "We just have to learn to live with our sorrows, boy," Andy gently advised me. "I learned that when you was just a *leee*-tle bitty speck of a baby, when I lost your ma—just like you lost Wilford here."

"You did?" I said. "Who stepped on Ma?"

In retrospect, this was a pretty twisted joke to feed to a five-year-old. But I landed the punch line and got the big payoff laugh.

That year is a blur for me. Our *Danny Thomas Show* episode aired on February 15, 1960. General Foods, the sponsor of that program, immediately committed to sponsoring ours. Two weeks later, I celebrated my sixth birthday. Next thing I knew, it was late summer and I was walking barefoot down a dirt path in L.A.'s Franklin Canyon Park with Andy at my side and a fishing pole on my shoulder. We were filming the soon-to-be-iconic credit sequence of *The Andy Griffith Show*. I had not yet heard the show's catchy, finger-snappin' theme tune, "The Fishin' Hole," whose lead melody was whistled by one of its composers, Earle Hagen. I was focused on my task: to pick up a rock and throw it into the water.

This was a more complicated operation than you would think. Franklin Canyon Park was, and still is, the site of one of the major reservoirs from which the city of Los Angeles draws its drinking water. The rules for filming there were strict: I was only allowed three takes to throw the rock. The prop department had three rocks ready to go, carefully cleaned so that their presence in the lake would not affect the potability of the water.

We observed a similar protocol when we did fishing scenes for the show. A prop man would put a live catfish on the hook, and an L.A. Department of Water & Power regulator was present to monitor Andy and me as we dipped the fish into the lake and then quickly pulled them out as if we had just caught them. Like the precleaned rocks, these were special TV fish—stunt fish, if you will.

The problem with doing the credit sequence, which we discovered on the first take, was that my skinny little arm was not powerful enough to get that rock into the water. So, for the second take, they came up with a new plan. I moved my arm as if I was throwing Rock #2, but the prop master, Reggie Smith, who was strategically hidden behind a tree, tossed the actual prop rock from off camera. Reggie's throw completed my action, resulting in a picturesque splash in just the right part of the frame. That's the take that you see when you watch any episode from Season One. We didn't do a third take—it's TV, baby, we had it in the can, time to move on!

For me, that day in Franklin Canyon provided yet another lesson in the wizardly craft of creating moving-picture illusions—they turned a six-year-old suburban tenderfoot into a sturdy country boy who could hurl a rock sixty feet!

SOME FAMILIES MOVE to a new neighborhood to be near a good school. We moved from Burbank to Hollywood to be near

a good studio. Once CBS placed an order for a full season of *The Andy Griffith Show,* thirty-two episodes in all, Mom and Dad decided that it would be best for us to relocate to a home closer to my workplace.

The town of Mayberry was really three places: Franklin Canyon Park, where we did our fishing scenes; the old RKO Forty Acres backlot in Culver City, where we filmed most of our exteriors; and, most frequently of all, Desilu Studios Cahuenga, where our interior scenes in the Taylor house and the sheriff's office were filmed. This studio was the smallest facility in the constellation of studios owned by Desi Arnaz and Lucille Ball's production company, Desilu. It had no backlot, just eight soundstages, some offices, and a commissary that was called Hal's Diner. But in the '60s, that little complex was a hive of popular television: we coexisted there with, to name just a few shows, *The Dick Van Dyke Show, The Jack Benny Program, Hogan's Heroes, That Girl, Gomer Pyle, U.S.M.C.,* and *I, Spy.*

My parents found a two-bedroom bungalow on North Cahuenga Boulevard. It was a weird place to live, a mixed-use neighborhood with warehouses, stores, and not a whole lot of neighbors. There was no grass anywhere, and all we had for a backyard was a patch of dirt. But it was only half a block from Desilu Cahuenga. And, perhaps to make up for the lack of suburban creature comforts, Mom and Dad got us a dog—a Weimaraner who, like our last dog, was named Gulliver.

On my first regular day of work in September 1960, my dad took my hand, just as if he was taking me to school, and we walked from our house to Desilu—half a block north and then just around the corner to the back gate on Lillian Way. Inside, arrayed around a table, were the producers, Sheldon and Aaron; the director, Bob Sweeney; Andy himself; and my other costars-to-be, Don Knotts and Frances Bavier.

Don, like Andy, was a southerner; he was born and raised in West Virginia. He and Andy had worked together before, in both the Broadway and movie versions of a popular military comedy called *No Time for*

Sergeants, and hit it off. Apparently Don saw our appearance on Danny Thomas's show and instantly understood what it was that Andy was trying to achieve. So he called Andy and said, "Don't you think your sheriff could use a deputy?" Thus was born Barney Fife, the deputy so incompetent with firearms that Sheriff Taylor allows him to carry just one bullet in his shirt pocket.

Frances, a woman in her late fifties, was from New York City—like Mom, she had trained at the American Academy of Dramatic Arts. She had appeared in the *Danny Thomas* pseudo-pilot as a flummoxed Mayberry resident named Henrietta Perkins and had demonstrated a facility for playing a prim straight woman, kind of like Margaret Dumont in the Marx Brothers movies. Now she was going to play Andy's spinster relative Aunt Bee, who was to become our family's housekeeper and Opie's de facto nanny. That was the plot of our first episode, in fact: the Taylors' previous housekeeper, a young woman named Rose, was leaving to get married, and Opie had to overcome his attachment to Rose and his objections to Aunt Bee.

Dad and I joined this august group of seasoned show-business veterans at the table, me to Dad's right, my head barely clearing the table, my legs swinging above the floor. In TV, we call the first read-through of a script a table reading. This was a misnomer where I was concerned—I couldn't read, at least not beyond the preschool, board-book level. I watched as my father took out a pen and drew brackets around every line in the script that began with the word *OPIE*. Whenever Opie's turn came, he, rather than I, read these lines aloud, allowing me to learn my lines by ear.

SOMETHING REALLY IMPORTANT happened that day that I didn't know about until decades later. During a break, as the cast gathered in a little courtyard at Desilu to smoke, Dad pulled Andy aside and asked him for a word.

In his humble opinion, Dad told Andy, Opie was coming off as too much of a smart-ass. Andy asked Dad what he meant. Dad explained that Opie was written as a stock sitcom kid, the little wiseacre who comes off as smarter than his father—a lot like Rusty Williams, who, as played by the child actor Rusty Hamer, continually gave Danny Williams grief on *The Danny Thomas Show*. Dad believed that *The Andy Griffith Show* could try something different that might work better.

"Ronny can get laughs doing those kinds of lines, I get it," Dad told Andy. "But wouldn't it be more interesting and unusual if Opie actually *respected* his father? You could still mine a lot of humor out of that situation—just a different type."

Now, Andy could very well have told Dad, a much less successful actor who was only present in his capacity as the father of some kid who had never before done a TV series, to take his suggestions and shove 'em where the sun don't shine. But Andy liked Dad. They had a lot in common. Dad considered himself more midwestern than southern, but the two of them bonded over their shared experience as country boys who came to Hollywood from the sticks. They had left their hometowns behind but were keen to counter the coastal presumption that, to borrow a phrase from *Annie Get Your Gun,* folks are dumb where they come from. They were both, to use Mom's term, sophisticated hicks.

Andy's simpatico relationship with my father was one of those quirks of fate that made my mother declare, with some frequency during my childhood, that I was born with a four-leaf clover behind my ear. Every time something didn't break my way, she said, a superior opportunity presented itself. My parents had really been crossing their fingers in the hope that *Mr. O'Malley* would go as a series. It would have been prestigious, their son being on a TV show with the legendary Bert Lahr. But Andy Griffith proved a far better fit.

It wasn't until 1986, when I was thirty-two years old and already well

into my directing career, that I learned of that pivotal discussion between Andy and my father about Opie. And I heard about it not from Dad but from Andy, with whom I had reunited for what remains, to date, my last proper on-screen acting job, in the TV film *Return to Mayberry.*

Andy and I were preparing to film a scene in which Andy Taylor drives the now adult Opie and his about-to-burst pregnant wife to the hospital. We sat in a real car, with Andy pretending to drive, while it was towed by another vehicle mounted with multiple cameras, to capture our dialogue from various angles. This setup isolated us from the crew for hours and lent itself to deep conversation, since Andy and I had only each other for company as the director called for take after take. We had plenty to catch up on. I had established myself as a director (and even grown a mustache!), while Andy, now white-haired, was beginning work on his long-running legal series *Matlock.* It came as a great relief to find that my childhood perception of Andy was not romanticized; he was as wonderful and bighearted as I recalled him being in the 1960s.

In the course of our chat in the car, Andy told me the story of Dad's request in September 1960 for a little tête-à-tête, and how spot-on my father's ideas had been. After their talk, Andy said, he directed his writers to model the Andy-Opie relationship more on the Rance-Ronny one. I was flabbergasted to learn about this conversation; Dad had never breathed a word of it to me.

But I was also moved—more than moved. This was a key moment in my life, revealed to me years after the fact: in the distant past of my early childhood, when they still barely knew each other, the two men who effectively charted my future had held this conversation, and they had come to a mutual understanding derived from mutual respect. Out of this talk came a crucial creative decision that helped chart the course of a tremendously successful, era-defining show. I realized anew, from

an adult perspective, how artistically open and generous Andy was and how wise and shrewd Rance Howard was.

From where I sit now, Andy's story cheers me because it validated Dad as a creative person. It didn't occur to me as a kid how profoundly he and Mom reordered their lives on my behalf. Being the overseer and coach of a child actor was not Dad's Plan A when he and Mom upped stakes from New York to move to California. It wasn't even his Plan B, because the very notion of me having a career, as opposed to the occasional job, was not something that he expected to happen.

But Dad had this magnificent ability to roll with the punches, to not let career disappointments or unforeseen life circumstances bring him down. Since, as I mentioned, Dad always considered himself more midwestern than southern, I call this his midwestern Zen. There was something very heartland about it, the nonchalant way he just put his head down and carried on. Somewhere around the time that I got *The Andy Griffith Show,* he made a choice. His own passion for acting had, in a serpentine way, led to this moment—for me. He did not balk. In fact, I think he recognized that he would never have forgiven himself if he had stood in my way for his own careerist and/or egotistical reasons.

He chose to be a great parent—to support his children's opportunities with everything he had. His responsibility, and therefore his priority, became me, and, a little later, Clint. His own career would take its course given the circumstances that had presented themselves, and if that meant that he had less time to pursue his own goals, well, so be it. Midwestern Zen.

I should add that Dad never gave up on his own professional life. He still went out on auditions, took scene-study classes, and worked on screenplays with a variety of collaborators. But he was doing it around his sons' schedules.

Clint and I would provide a million opportunities in the years to

come for him to lay a guilt trip on us, to have at us with a vicious "Rose's Turn" moment. He never once did.

MY NEW WAY of life as a series regular led to some big adjustments. For instance, when we were shooting, from September through early February, I didn't attend school with other kids. This was a bit of a letdown, since I had really enjoyed kindergarten at Robert Louis Stevenson Elementary School in Burbank. Instead, I had studio school.

What is studio school, you ask? It's school . . . in a studio! At Desilu Cahuenga, this meant a rolling dressing room—plywood walls and a particleboard floor mounted on wheels—that had been kitted out with a blackboard, a teacher's desk, a student's desk, and even a little exterior awning and American flag, so that it looked like a one-room schoolhouse.

My teacher was Mrs. Katherine Barton, a rather stately woman in her fifties who wore her silver hair in an upswept bouffant. Ours was an association that would last for years, as *The Andy Griffith Show* ran and ran and I grew from a first grader to an eighth grader.

Mrs. Barton was my sole teacher, covering all the subjects in an elementary-school curriculum: reading, writing, math, science, and social studies. I was usually her sole pupil. Occasionally, though, I had classmates, like Keith Thibodeaux, who played Little Ricky Ricardo on *I Love Lucy* and had a recurring part as Opie's friend Johnny Paul Jason. I never developed off-camera friendships with my fellow child actors, mainly because we were all so busy and didn't live near each other. But I enjoyed the company of other kids on set. Keith was a good workplace buddy, three years older than me. He, too, had spent time under Mrs. Barton's tutelage while working in the Desilu Cahuenga facility. I

preferred studio school on the days when we were shooting episodes that Keith and other kids were in.

But this is no knock on Mrs. Barton. She was a wise and nimble educator, adept at shoehorning my lessons into breaks between scenes. The director would yell "Cut!" and I would sprint over to the schoolhouse to pick up where we left off. California state law mandated that I needed to be in school for a total of at least three hours a day, and that none of my studio-school sessions could be shorter than twenty minutes. But sometimes, twenty minutes was all the time that I was given before I had to be in another scene—and back I would sprint to the set. I guess that these sprints were what passed for P.E. With their sudden stops and pivots, they certainly helped me later on when I took up basketball.

Mrs. Barton never allowed me to dawdle, given how tight our schedule was. If I was having trouble focusing, she would check me: "You walk in this door and this is the schoolroom, Ronny. You shut the door and pick up where you left off." And I was *never* to slam the door. One day I walked into the schoolroom a little too pleased with myself. I had just gotten a big laugh doing a scene and came charging in on a performer's high, slamming the door. On a whim, I decided to do my Popeye impression for Mrs. Barton: "I yam what I yam and that's all what I yam!"

She was not amused. "I told you not to slam the door, Ronny," she said. And then she handed down my punishment: I had to write "I will not slam the door when I come back from the set" twenty-five times on the blackboard.

I get kind of wistful when I think about Mrs. Barton now. She was someone with whom I spent every weekday for about half my childhood, but once *The Andy Griffith Show* was over, I never saw her again. We had an affectionate if professional relationship, and she definitely broadened my horizons. She was a worldly woman who had been married, gotten divorced, and was, as far as I know, childless. Her passion

was Mexico, where she kept a house. She spoke Spanish fluently and loved the country's culture, people, and capital, Mexico City. One lasting lesson she imparted to me, lest I ever be fooled by tourist traps, is that "Tijuana is *not* Mexico, Ronny!" The minute we wrapped a season and went on hiatus, she was off like a shot, zooming down the 101 to her happy place south of the border.

Mrs. Barton was a calming presence amid the inherent bustle and drama of shooting a TV show. She was serious about boundaries. She kept to her schoolroom and never watched me film a scene. Nor did she ever talk shop about the show or, later on, acknowledge its success. The only recollection I have of her acknowledging show business at all was when she let slip that "Lucille Ball is a wonderful woman and Desi Arnaz was *terrible* to her."

Her firm hand in making me compartmentalize my time has paid off lifelong dividends. Those herky-jerky days of going back and forth between school and the set made me realize that I was adept at spinning plates, keeping a lot of things going at once—which is how I now spend my adulthood, usually with one picture in the shooting phase, another in prep, a few others in development, and an assortment of Imagine Entertainment projects happening on my watch.

In all our years together, Mrs. Barton got truly angry with me just once. This was in 1963, when JFK was assassinated—an event that, naturally, upset everyone at the studio, but no one more than Mrs. Barton, a devout Catholic. It was a Friday, a rehearsal day. When the news reached us that Kennedy had been shot, we all gathered around a radio, waiting to hear if the president had survived. Our somber vigil grew more so when we learned that he didn't. The men shook their heads in disbelief, taking long drags on their cigarettes. Mrs. Barton cried.

When we came back to work the following Monday, I offhandedly remarked to Mrs. Barton that it had bugged me that I had been unable to watch my usual slate of TV shows on Saturday morning—my beloved

Heckle and Jeckle cartoons and *Sky King* reruns—because the networks were showing nothing but news, news, news.

She rightfully upbraided me. "This is a *terrible* time in our country!" she said. "The president was shot, and that is much more important than cartoons!"

I RECEIVED ANOTHER kind of education entirely from spending day after day in an adult workplace. Mrs. Barton aside, *The Andy Griffith Show* made no concessions to the fact that a little boy was present. The crew members were salty old characters who swore like sailors and drank like fishes. Some of them dated back to the silent-movie era. All of them smoked so furiously and continuously that my eyes were always burning.

Reggie Smith, the prop guy who threw the rock for me in Franklin Canyon Park, was one such character. He lived up to his duties and was a dedicated craftsman, but he was quite often in his cups by noon. Today this pattern would raise serious concerns for his health, but in those less enlightened times, his condition was simply a source of amusement on set, something that made him kind of adorable to everyone else: "Oh, Reggie, you dropped the apple pie! C'mon, Reg!"

Our gaffer, the guy in charge of the lights, was a large, intimidating man named Joe Barnes. He had a swollen, veiny nose like W.C. Fields's and an anchor tattoo on his forearm like Popeye's. He had been in the navy and he wore one of those skipper's hats of the sort that Alan Hale Jr. wore on *Gilligan's Island*.

Joe always called me Obie. So did the rest of the crew that first season, because "Opie" wasn't yet part of the American lexicon and sounded strange, whereas "Obie" was a term of the trade in cinematography. An Obie light was a fixed light above the camera, three bright flood bulbs with a square of silk in front of them. It got its name from the actress

Merle Oberon, a beautiful star of Hollywood's golden age. She had been in a car accident in 1937 that scarred her face. In the '40s, her husband, the cinematographer Lucien Ballard, customized an arrangement of lights that would flatter Oberon and wash out her scars. The Obie proved so effective that Ballard's setup became an industry standard.

I knew precisely none of this when I began playing Opie on *The Andy Griffith Show*. And when I was standing on my mark at the beginning of a shooting day, keeping as still as I could while they tried to optimize my lighting, Joe scared the wits out of me. He was hovering more or less on top of me, his huge gut pressing into my side, holding a light meter directly in front of my face. As he worked through his adjustments, he shouted out to his guys, in his sandpapery voice, "Kill the Obie! Kill the Obie!"

There I stood on my mark, terrified, thinking, *What did I do?*

Dad must have recognized what was going on. He took me aside right afterward and explained the difference between the Obie light and the "Obie" character. He assured me that Joe had only meant "Turn off that light on top of the camera" and was really and truly a nice man who sure as heck was not asking to have me executed.

And the thing is, they all *were* nice men. They made me welcome on the set and treated me with empathy and kindness. These guys were just uninhibited in their language, behavior, and jokes, and no freckle-faced kid was going to change that.

Beyond that, Dad made me feel safe in that working environment. When we were shooting our very first episode, "The New Housekeeper," I had a big emotional scene at the end where I do a 180 on my negative attitude toward Aunt Bee and beg her to stay on with Andy and me. Sheldon Leonard was directing the episode himself—it was our proper debut and it had to come off perfectly. Sheldon was under a lot of pressure, and he wasn't believing my performance in that scene—my emotional honesty just wasn't there. So he conferred with Dad. As he

was walking away, he said, a little too loudly and sharply, "I might have to *spank* him into it."

The words jarred me, but I never believed them. "No one is going to hurt you," Dad said. Sheldon was just venting—in time, he became another guiding light in my life along with Dad and Andy.

DAD NEVER FLINCHED during episodes like this one or the "Kill the Obie!" one. He never rushed to cup his hands over my impressionable young ears. It was all life experience to him, and he was great at seeing to it that with this experience came instruction: as Clint says, a Rance Howard teachable moment.

In keeping with the rough, navy-frigate-like atmosphere created by the crew guys, the walls of the men's bathroom at Desilu were covered with raunchy graffiti. In one of the toilet stalls, there was a poem that I read and reread with fascination, so much so that I can still recite and type it from memory:

> Here I sit
> All broken-hearted
> I came to shit
> But only farted
> Those who read these words of wit
> Eat those little balls of shit

This, I am sorry to say, was my introduction to poetry. (That's a studio-school education for you!) But it did do the job of a poem: it made me reflect. *What does it all mean?*

The bathroom stalls were also full of obscene drawings—your standard stuff, depictions of cocks, balls, and blow jobs. I mentioned these to Dad, expressing curiosity about what they were meant to be. He reacted

just like he had when I asked him where babies came from. I saw him pause for a moment to think about what to say. Then he took action.

With a blank expression on his face, betraying no hint of being scandalized, Dad took my hand and walked me back to the stall. There, he clinically talked me through what I was seeing.

"Well, that's a man's penis, and those are testicles," he said. "You see, some men, when they sit on the toilet, they like to draw penises."

And that was that. Except for one last thing. "But Ronny," he said, his voice a little firmer than before, "you shouldn't ever draw penises on bathroom walls."

6
THE TRUTH
ABOUT MAYBERRY

CLINT

The Andy Griffith Show community extended itself to everyone in the Howard household. There were days when Dad had an acting gig of his own and couldn't be with Ron on set, so Mom would take over as his guardian, with me in tow. Many of my primordial memories are of the same stuff that Ron speaks of: the cigarette smoke, makeup melting under the hot lights, and the booming sound of Andy's voice.

I was a free-range toddler, roaming everywhere with few limits placed on me at Desilu Cahuenga. Parked in corners of the soundstages were what are known in our business as flats, lightweight timber frames with plywood "skins" that are used as sets. When not in use, the flats were folded up and pushed together, creating fun three-dimensional passageways, a Habitrail for a little kid like me. Even at home, *The Andy Griffith Show* provided me with play space. General Foods, the program's sponsor, sent us a massive supply of powdered Jell-O pudding mix. That was great, but the giant cardboard box that this stuff came in kept me occupied for hours.

I hung out with Mrs. Barton at times in Ron's one-room schoolhouse. And I loved to visit in the makeup room, the domain of *The Andy Griffith Show*'s larger-than-life makeup man, Lee Greenway. Lee was a proper southern gentleman from Andy's home state of North Carolina, with white hair and a stocky body that made him look like Colonel Sanders minus the goatee. He kept a beautiful shotgun in the corner of the makeup room, a gift from Andy, with whom he sometimes went hunting.

Lee was a polymath: makeup artist, marksman, musician, and practical joker. He once somehow tricked Andy into stepping into a pair of shoes that were nailed to the floor, causing Andy to pratfall. Everyone, including a slightly pissed-off Andy, laughed uproariously. And when the bluegrass group the Dillards made their occasional appearances on the show as the Darlings, the musical hillbillies, Lee took out his banjo and jammed with them, proficiently.

I loved Hal Smith the most. He played Mayberry's town drunk, Otis Campbell, and, more impressively, he performed a ton of voices for the cartoons that Ron and I watched, such as *Huckleberry Hound, The Flintstones,* and *Quick Draw McGraw*. But coolest of all: Hal was the spokesman for the holiest of places in my early-childhood universe, the International House of Pancakes. In this capacity, he made personal appearances in chef's whites and a puffy toque as the Pancake Man. He even hosted a local "Pancake Man" kids' show for a time. And I knew Hal personally. *The Pancake Man.* Are you kidding me?

Mom was no less delighted to be on set, befriending nearly everyone with whom she came in contact at Desilu Cahuenga. She and Helen McNear, the wife of Howard McNear, who played Floyd the Barber, really hit it off. Three seasons in, Howard suffered a serious stroke that immobilized his left side and rendered him unable to stand or walk—less than ideal traits for an actor who was playing a barber. But Andy,

ever magnanimous, didn't want to lose Howard or the Floyd character. So Helen came along to assist Howard in his comings and goings, appearing at the studio almost as often as Mom and Dad.

I picked up my acting chops and on-set savvy by osmosis. My clothing landed me my first job. Dad loved anything to do with the Old West. Knowing this, Mom dressed me up as a toddler in a perfectly sized cowboy getup: hat, kerchief, snap-button western shirt, fringed buckskin jacket, and boots. With my tousled blond hair and chubby cheeks, I looked friggin' adorable. Bob Sweeney, the show's director, certainly thought so. One day, Mom brought me to set in this outfit, and Bob instantly came up with a role for me. At first I was just an extra, but then the writers developed a running bit for my "character," such as he was, named Leon.

Leon, like Harpo Marx, never spoke. We never found out who his parents were or if he even had parents. But he always wore a cowboy outfit and was always eating a peanut butter and jelly sandwich, usually with about half its contents smeared all over his face. A generous soul, Leon would come across a grown-up and thrust his sandwich in the adult's face in a *Here, take a bite* gesture. The adult, usually flustered, would say "No thank you, Leon."

Leon's most common foil was Barney Fife, to whom he offered the sandwich at inopportune moments. The best-known one is when Barney is undercover in the sporting-goods section of Weaver's Department Store, hoping to apprehend a shoplifter by posing stock-still as a mannequin. Andy is fooled by Barney's disguise, but not Leon, who immediately recognizes the deputy and blows his cover by proffering the PB&J.

In another episode, we did a bit where Leon accidentally locked Barney in the jail cell. That day, I took a swig from Otis's jug, which was filled not with hooch but apple juice, my then drink of choice.

Just like that, I, too, was in the business. Like Ron's career, mine

began organically, as a matter of circumstance. The difference for me is that Ron had provided a blueprint. My folks now knew that if I wanted to go down the same route, they could manage it.

RON

The way Andy dealt with Howard McNear's stroke was such a lesson to me on multiple levels. Andy had the crew rig up a wooden support with a small backrest for Howard to lean against in the scenes that required Floyd to stand. To create the illusion of Floyd as a working barber, the wardrobe people draped his smock in such a way as to hide the stand that supported Howard's half-immobilized body, and made sure that Howard always clutched something in his nonworking hand, a comb or a newspaper. Then the cameramen framed the shot just so. This taught me yet again that there were almost no limits to what can be achieved in motion pictures through ingenuity. Where there's a will there's a way. And the illusion came off with viewers none the wiser, an accomplishment as humane as it was heroic. Pulling off this operation took grace and strength by Andy, and by Howard and Helen, too.

Another of Andy's attempts at accommodation didn't work out so well. In a 1963 episode called "A Black Day for Mayberry," a top-secret gold shipment passes through Mayberry en route to Fort Knox. Two U.S. Treasury agents come to town, on the lookout for a crook who has designs on the gold. For one of the agent roles, Andy cast an old friend. I could sense that Andy was both happy to see his friend and a little anxious. During rehearsals, Andy was not his usual relaxed, wisecracking self. His eyes were full of concern rather than their usual sparkle.

Opie was in the scene with the Treasury agents, so I was on set when they did the master shot, in which the agents sit on wooden chairs in the Mayberry courthouse, waiting to meet with the sheriff. Everything

went smoothly to that point. Then the crew repositioned the cameras for a closer shot on Andy's friend, who would explain the case and describe the suspect. In the first take, the actor fumbled his lines. No big deal. Bob Sweeney, the director, simply called for another take, and the makeup people attended to the actor's brow.

I sat right next to the camera during the second take, which went disturbingly wrong. Andy's friend began the agent's speech, performing it reasonably well at first. But then it drifted off course into something . . . personal, not having to do with the character or the episode. It was instead an apologetic monologue, delivered with a pained expression. He rambled on about Andy's success and his own personal and professional frustration. Then he broke into sobs.

Bob Sweeney whispered "Cut" to the camera operator. We were no longer rolling, and for a moment, no one knew quite what to do. Then Andy's friend literally slid off the chair he was sitting in and fell to the floor, curling up in a fetal position and bawling uncontrollably. Andy rushed to his friend's side, and, with Bob's help, got him back upright and loosened his tie. Then they gently walked him off the set.

Later, Andy told everyone that his friend had been struggling with emotional and psychiatric issues. He had hoped that giving his buddy a part on the show would help in the man's recovery. Alas, it seemed to have had the opposite effect. This incident marked the first time I was conscious of mental illness and its toll. I've carried the image of that actor's anguished, helpless face with me ever since. I drew upon my memory of him more than thirty years later when I made the film *A Beautiful Mind*. The film stars Russell Crowe as John Nash, a real-life mathematician and Nobel laureate whose schizophrenia led to his institutionalization. When we filmed scenes depicting Nash's mental unraveling, I innately understood not only his suffering but that of those who bore witness to it. I recalled the visceral fear and panic that rippled through the set that day back in the 1960s, the disruptive impact it had

on a roomful of people who couldn't fathom what they were seeing. These recollections influenced my approach to Nash's story.

Dad was a help to me in processing what had happened. Fortunately, he was on set that day, giving me someone to turn to after witnessing the man's breakdown. His presence also benefited *The Andy Griffith Show,* because they had a good actor on the premises who could immediately be pressed into service. Dad put on a suit of Andy's and learned the character's lines. We reshot the scene. Dad nailed it, and his close-up speech, too. But there were uncharacteristically few laughs that day. Everyone was shaken. This jarring introduction to the toll that our pressure-filled line of work could have on fragile people has stayed with me.

THE CRITICS NEVER much cared for us. "*The Andy Griffith Show* appears to be only mildly entertaining," said the *New York Times* in October 1960, our first month on the air. And that was one of the friendlier reviews we received.

But we were a ratings hit from the get-go. We finished at number four in the Nielsen rankings that season and never looked back, a top-ten program for all eight seasons of the program's life. Mayberry struck a chord. It was sweet without being hokey and funny without being farcical. In Andy Taylor, the sheriff without a gun, America found the gentle authority figure that it craved—an easygoing fellow with a humorously imperfect but ultimately viable approach to crisis management.

I've since come to believe that Sheldon Leonard's experience working with Frank Capra must have informed our show, since, tonally, it's the closest a sitcom ever got to *Mr. Deeds Goes to Town* and *It's a Wonderful Life.* I brought this up to Andy years later and he said that the subject of Capra never came up in his discussions with Sheldon. But I witnessed these great triangular conversations between Andy, Sheldon, and Aaron Ruben, who was brilliant in his own right—he had written

for Milton Berle, Sid Caesar, and Phil Silvers—and they were like al-chemy: out of the mix of these three sensibilities, one southern-rural and two urban-Jewish, came TV gold.

Andy, like all of us, learned on the job. He later said that he played Andy Taylor too broadly that first season, still steeped in the rubelike southerners he had played in the past. He progressively dialed down Sheriff Andy's theatrics and turned himself into the show's straight man and voice of reason. Me? I was a sponge, absorbing the intricacies of how television was made by observing all the different craftsmen at work. I regarded the set with a sense of mystery and excitement. What did all these people do? How did the camera actually work? Why did they have to change lenses all the time? What were the sets made of? Who painted them and made them look real?

In the Renaissance era, the artisan class put its children to work as apprentices young, enlisting their help to create devotional frescoes and sculptures. The kids started out at age five or six, cleaning brushes and tools, and slowly took on greater responsibilities as they began to better understand the craft, which in turn fostered a better under-standing of the artistry involved. That parallels my trajectory on *The Andy Griffith Show,* as I gradually figured out how and why television worked.

Howard Morris took notice of my curiosity. A frenetic comic actor, Howard had a recurring role on the show as Ernest T. Bass, the fast-talking, perpetually unshaven mountain man who always greeted Andy and Barney by saying "Howdy-do to you and you!" Howard was an out-lier among the cast, a Jewish guy from the Bronx who had been one of the repertory players on *Your Show of Shows* alongside Sid Caesar, Carl Reiner, and Imogene Coca. But the very fact that he had worked with such TV legends meant that his words carried weight. Howard observed me observing and offered up some pro tips.

One day he saw me squinting at a row of reflector boards, the large,

flat cards that redirect light onto the actors' faces. "Are those shiny boards hurting your eyes, Ronny?" he asked.

Wilting in the heat and barely able to see, I weakly nodded yes. "Good," he said. "If a TV actor is in a little pain, it means they're right on their mark!"

Howard then asked me how old I was. "Ten," I said.

"I noticed the way your eyes follow the camera when shots are being set up. And the way you pay attention to all the back-and-forth during rehearsals, whether it involves Opie or not. Ronny, I bet you're gonna be a director when you grow up," he said.

I can identify earlier moments that laid the groundwork for the path I would pursue, but Howard's actually saying it put the thought into my head. Twenty years later, I cast Howard in my third feature film, *Splash,* as an eccentric marine biologist with expertise in mermaids. I reminded him of his prediction. Howard smiled warmly and zinged me in customary Morrisonian fashion: "And this is what I get for my clarity of vision? A day on a Disney movie?"

My early years of apprenticeship in the trade were not without their disappointments. I was bummed, for example, to discover that I would not get to eat ice cream when Opie had an ice cream scene. The hot lights melted any frozen dessert in a matter of seconds, so my cones were filled with cold, lumpy mashed potatoes. I mean, try licking that and smiling ear to ear as a six-year-old. Now *that* is some acting to be proud of.

The fried chicken, at least, was real. Reggie the prop man cooked it to order. It was and remains the best fried chicken I have ever eaten. On the days when the script called for Aunt Bee to serve a fried-chicken dinner, a bewitching smell wafted onto the set from the prop room and I could barely focus on my lines.

To land on this show of all shows as a kid was the ultimate stroke of good fortune. Andy oversaw it all as the boss, but he thrived on

collaboration and welcomed the cast's input. My first few attempts at chiming in were politely rebuffed, but one day pretty early on, in the second episode of the second season, I piped up again. On a Friday, the day that we ran full rehearsals before committing an episode to film, I raised my hand to get the attention of Bob Sweeney, our director.

"What is it, Ronny?" he said. I explained that the line that I had just said—I can't even remember precisely what it was, just that it was an interjection of "Hey, Pa, something something"—didn't sound authentically kidlike. I pitched my little rewrite of the line, and Bob said, "Good, I like it! Say it that way."

A rush of satisfaction coursed through me. I guess I didn't make any effort to hide it, because Andy looked straight at me and said, "What're you grinnin' at, young'un?"

I said, "That's the first suggestion of mine that you've ever taken!"

Andy, not missing a beat, said, "Well, it was the first one that was any *damn good*! Now let's get on with the scene."

I doubt that Andy even remembered that moment. But I have carried this revelation, this discovery of my potential to influence others, ever since. My appreciation of how seriously I was taken, as a human being with ideas and agency—not only by Andy but also my own parents—has only deepened with time. Nowadays I am often the veteran on the set. I try to be conscious of the effect that my words and actions have on the people with whom I'm working, mindful of how one single comment could affect someone's life trajectory . . . just as Bob's and Andy's comments affected mine.

The shared-mission aspect of *The Andy Griffith Show* was a special thing to be part of. I learned that success didn't need to be painful or punishing, though it did require hard work. Andy made everyone run their lines until they flowed naturally. As soon as we finished one scene, he asked us to pull our chairs together in a circle to start running lines for the next one. This disciplined approach clearly paid off.

We had all been given those director's chairs with our names on them. No one ever cared about who sat in which chair—we just grabbed the chair nearest to us. So I might have been in Andy's chair, Andy in Frances's chair, and Frances in my chair, with no sense of hierarchical protocols and etiquette. I never understood how relaxed our set was until years later, when, post–*Andy Griffith* but pre–*Happy Days,* I did an episode of *M*A*S*H.* I grabbed a seat between Alan Alda and Wayne Rogers to catch up on my high school algebra during a break. Loretta Swit walked in and I didn't notice her glowering at me. I cluelessly said, "Hey, Loretta, how are you doing?" She replied, "You're in my *chair.*" I sheepishly made my exit. That chair clearly meant something to her that no piece of furniture had ever meant to any *Andy Griffith* actor.

Andy had a wonderful facility for getting everyone, actors and writers alike, to up their game for the cause. If he worried that our energy was flagging or that a scene wasn't coming together as it should, he summoned Carl and Ethel. Carl and Ethel were an imaginary couple watching at home, commenting on the show in real time as we filmed. Carl, who sounded like a cranky relation of Andy's back in Mount Airy, would butt in to say, "*Well,* Ethel, I think we can turn this off. It doesn't make any damned sense!" Or "*Well,* Ethel, I've been waitin' twenty minutes to laugh at somethin'. Shoot, I'm gonna go get me somethin' to eat!" Poor Ethel was never given the chance to speak. She just mutely endured Carl's rants about the slack moments in certain *Andy Griffith Show* episodes.

Carl (and Ethel) proved an effective means to get the writers cracking, working on the fly to sharpen jokes and scenes. Invariably, these rewrites paid off, improving the episode we were shooting. And Andy was not above calling himself out when his own material lacked punch. One day, he leaped up after we had completed a read-through to pitch a comedy idea that he had just come up with, acting it out in front of us. For all his enthusiasm, our reaction was tepid. Andy shook his head and

said, "I should've known not to break my own rule: never, *ever* stand up and move around to pitch a joke. Because it's a *loooonggg* walk back to your chair if it dies." *That* got a laugh.

A perk of working on a series, as opposed to my earlier, à la carte experiences with TV employment, was the amount of hang time on the set. It fostered a sense of family, in that we all really got to know one another. Andy turned our downtime into a talk show of sorts, feeding prompts to the various members of the cast. He egged on Don Knotts, three years older than Andy and a World War II veteran, to tell stories of his time in the South Pacific. Don told us he had performed as a ventriloquist for the Special Services, in a G.I. revue called *Stars and Gripes*. At some point, Don said, he grew sick of being upstaged by his own dummy, whose name was Danny "Hooch" Matador, and he tossed Hooch overboard into the drink. Don claimed that, as the ship sailed away, the dummy could be heard gargling his angry protests through mouthfuls of seawater.

Howard McNear regaled us with stories of his life in vaudeville and the U.S. Army Air Corps. Crucially, Andy included my father in these conversations, too—"Rance, your turn!" It speaks volumes of Andy that he considered my father a member of the Mayberry crew, not merely Ronny Howard's guardian. Dad's rural bona fides didn't hurt. We were unique among TV programs in that we had a lot of actors from that kind of background: Andy, Don, and the esteemed Pyle cousins, Gomer and Goober, whose portrayers, Jim Nabors and George Lindsey, came from relatively small towns in Alabama.

I later heard stories of friction between Andy and Frances Bavier, though I never saw anything of the sort. My picture of Frances is of an elegant, urbane woman who simply chose to stay out of the fray. She put on a slight southern accent to play Aunt Bee but she spoke completely differently in real life, like the conservatory-trained New Yorker she was. She generally spent her breaks reading the *New York Times* and

doing the crossword puzzle, with a thin, lady's-brand cigarette between her fingers.

As our storytellers went, Andy was the most uninhibited. I was mildly scandalized when he told everyone that he had been rendered sterile by a bout of mumps in his teens, so he and his wife had adopted their children. His candor was laudable, but the very subject of sterility was a new one to my virgin ears. I sort of understood what Andy meant from the context of the story, but Dad preemptively took the opportunity to explain the concept in greater detail in the car ride home that day. He explained that lots of people of his and Andy's generation came down with the mumps, but he was lucky not to have had a case as bad as Andy's.

"I'm glad you weren't sterile, Dad," I said, brimming with sincerity.

"Well, me too, Ronny. I feel very lucky about that."

Don Knotts fascinated me to no end. He was the least like the character he played, the high-strung, forever nervous Barney Fife. It's hard for most people even to picture Don as a normal human being, because the two characters for which he is best known, Barney and Mr. Furley from *Three's Company,* are absurd in the extreme. Off camera, though, Don was reserved and self-effacing. Whereas Andy was essentially playing a version of himself, Barney Fife was someone who Don had to *become.* I'd watch this amazing metamorphosis take place before my eyes, much as when Bert Lahr turned it on for *Mr. O'Malley.*

Still, Don could be drawn out. Andy adored him. No one could make him laugh more than Don could. In fact, as much as Andy sometimes called upon Carl and Ethel to liven things up when he felt we all needed a fire lit under us, he also nudged Don when he needed a personal pick-me-up. Andy was a religious man, and his usual approach was to start singing an old-time hymn in a deep, low bass: "When we allll get to heaven . . ."

Without fail, Don would pick up on Andy's intent and come in

with a high, yawping falsetto, engaging Andy in a gospel call-and-response.

ANDY: When we all

DON: WHEN WE AWL!

ANDY: Get to heaven

DON: GET TA HEAV'N!

Don would take it from there, screeching, "What a day of rejoicing that will BEEEEE!!!" It killed every time. He had us all in stitches, but no one more than Andy, who doubled over, crying tears of laughter.

THE ANDY GRIFFITH *Show*'s success was so huge and immediate that I had an up-close look at how fame and money affected people. It started with the cars getting nicer in the Desilu Cahuenga lot. Andy collected antique cars and was stunned when someone gave him a Model T Ford as a gift and the Ford Motor Company itself bestowed a new car upon him for driving a Galaxie on the show. "Now that I'm rich, people are giving me cars!" he exclaimed. "That's real nice 'n' all, but where the hell were they when I was dirt poor?"

Don became a Cadillac man, buying a new one every year. Frances splashed out on a Studebaker in 1961. Being a frugal, sensible person, she kept it for the remainder of the program's run, parking it in the space next to ours.

Sometimes, the adult conversations I overheard at work were more *adult*-adult, stuff that wasn't meant for my ears but wasn't censored. The cast was too accustomed to having little Ronny around. Andy and Don maintained an ongoing conversation about how they had essentially

won the lottery but weren't necessarily the happier for it. Both of them were in troubled marriages whose issues predated our show—Don got divorced from his wife, Kathryn, in 1964, and Andy finally split up with his wife, Barbara, in 1972. And both men were visiting psychotherapists to work through their stuff.

I often found myself alongside Andy and Don in one of Lee Greenway's makeup chairs, tissues tucked into my collar, while Andy described to Don at high volume his latest session with his shrink: "He started talking about *latent homosexuality*! I don't think I qualify for that one, but I don't know. What about *you*, Don?"

Andy was definitely the more forthright about personal stuff like this. Don would eagerly get into a back-and-forth with him if the conversation turned to subjects like tax shelters, which interested them both because the top marginal tax rate in those days, for which they newly qualified, was a whopping 91 percent.

But Don would just quietly nod when Andy declared, within earshot of the whole cast, "My psychiatrist told me that probably the reason I work so damned hard on this show is that I don't want to go home to my wife. And you know what, Don? I think he's right."

Andy wasn't saying these things to get laughs. As his marriage to Barbara was unraveling, I saw him endure genuine pain. He came back from Christmas break one season with his hand all taped up. He was blunt about what happened: "I got drunk, I got mad, and I put my fist through a door."

OF THE TWO Pyles, Gomer and Goober, I was closer to the latter, or, rather, the man who played him, George Lindsey. George was a tall man and an athlete who took me under his wing when he saw that I was getting into sports, baseball and basketball especially. He threw me batting practice and played games of H-O-R-S-E with me

under the hoop that had been nailed up on the inside of the Stage 1 door. Thanks in part to George's tutelage, I became a good-enough shooter to tie for first at a Burbank Parks Department free-throw contest, where I made forty-seven out of fifty shots.

I wasn't as close with Jim Nabors, though he was an extremely nice man. It took me until the '80s, when we did the *Return to Mayberry* reunion film, for me to discover that Jim was not just this friendly "Gollee!" goofball but a worldly, intelligent guy with whom I would enjoy having conversations. When I was a kid, though, Mom became friends with Jim. He adored her company and considered her a confidante, almost a second mother, though she had only two years on him.

In the workplace, Jim, while private about his private life, was not closeted. He didn't pretend to date women or insist he wasn't gay. Mom explained this to me when I grew a little older, in my post-Opie years: everyone in the cast knew the deal about Jim's sexuality, but it went uncommented upon—a Hollywood version of Don't Ask, Don't Tell.

The crew, unfortunately, was not as enlightened. Listening to their on-set chatter, I heard a word I didn't know: *homo*. That's what they called Jim behind his back, and not with any hint of kindness. Something about this word didn't feel right.

"Dad," I said one day, "what is a 'homo'?"

He instantly understood the context. And he offered his usual plainspoken response. "Jim is attracted to men instead of women," Dad said. "And they call that homosexuality."

The definition was framed this narrowly, only as it related to Jim, really. I didn't yet understand that there were gay people all around me, and all across the world. But this was my introduction to the very concept of queerness. Mayberry was a small town, but for those of us who actually spent our days there, it contained the whole of human experience.

HOT LIGHTS, REAL TEARS

RON

struggled a bit in elementary school. I'd rate myself academically as having been barely average. I later figured out, when my own kids were having some difficulties here and there, that I had what would today be diagnosed as learning disabilities. Mrs. Barton proved a boon in this respect; I responded well to one-on-one tutoring. But in the 1960s, my public-school teachers' diagnosis was pretty much "Well, he's a C student, but at least he's well-behaved." I flailed sometimes. Cursive, for example, did not come easily to me. But do you know what kicked me into gear to figure it out once and for all? Having to sign autographs.

Near the end of *The Andy Griffith Show*'s first season, *TV Guide* convened a bunch of child and teen stars to pose for a photo shoot in the swimming pool of the grand Roosevelt Hotel on Hollywood Boulevard, across the street from Grauman's Chinese Theatre. There were about twenty of us in total in our bathing suits: I waded near the front, in the shallow end. Jay North was also there, along with Rusty Hamer and Angela Cartwright from *The Danny Thomas Show,* Jon Provost from *Lassie,* and, for sex appeal, some older actors like the twins Dack

and Dirk Rambo, who were starring on *The New Loretta Young Show,* and Donna Douglas, who played Ellie Mae Clampett on *The Beverly Hillbillies.* (The term "teen" was used loosely: the Rambos were in their early twenties, and Douglas was around thirty.)

This was my first taste of Hollywood glamour, and the perks and perils it held. I'd never experienced the excitement of fans, gawkers, and paparazzi, calling out our names. But it was daunting to have kids thrusting pieces of paper and pens at me, asking for my signature.

Johnny Crawford, who played Chuck Connors's boy, Mark, confidently obliged everyone who wanted his autograph, which made sense—he was in his midteens. But I was still in first grade. I was sweating it out self-consciously, doing my best to sign my name for a fan in my slow, rudimentary scrawl—*R* . . . *O* . . .—when he grew impatient and just ripped the piece of paper right out of my hands. "There's the Beav!" he said, making a beeline for Jerry Mathers, who was six years older than me and consequently could write a whole lot faster.

I thought, *This is too embarrassing. I gotta figure out this handwriting stuff.*

AS IT HAPPENED, I didn't attend regular school at all in first grade. It was studio school all the way. With the first season of Andy's show coming to an end, my newfound fame presented an opportunity: Warner Bros. was adapting the 1957 Broadway hit *The Music Man,* by Meredith Willson, and they needed a little boy to play Winthrop Paroo, the lisping, much younger brother of the female lead, Shirley Jones's Marian Paroo.

I don't think I auditioned—*The Andy Griffith Show* essentially served that purpose. But my father left the choice of whether or not to take the part to me. Dad explained that the movie would shoot while *The Andy Griffith Show* was on hiatus, when I was supposed to resume

my schooling at Stevenson Elementary School. It would mean sacrificing the few months when I would get to live like a normal kid.

"You don't have to do this if you don't want to, Ronny," Dad said. "With *The Andy Griffith Show,* it's different—that's a seven-year contract. That means that if the show keeps going, you have to do it. But you don't have to do other things."

I was torn. I was looking forward to returning to Stevenson, where I had spent kindergarten. Though we now lived in Hollywood, my parents had wangled permission for me to stay in the Burbank school system. But I could tell that Dad wanted me to say yes. He knew it was a rare opportunity and he clearly had a bullish attitude about the movie's prospects, telling me, "This is a really good script, it's from a successful Broadway musical, and there'll be other kids in the cast."

I really mulled it—in fact, it's the only time in my childhood where I took my time and thought through the question of "Do I really want to do this?" Having seen Dad sit waiting by the phone for days, I already understood that, as an actor, you take what you can get while the getting's good. But I was on the fence. I wanted to go to school and play with other kids.

Ultimately, I agreed to do to *The Music Man*. A little bit more out of respect for Dad than for any career-building purpose. At that point, I still didn't really understand what a career was, nor did I think that what I was doing on TV and movie sets had any bearing on something as serious as my future.

But I sure am glad that I said yes. The experience proved to be a once-in-a-lifetime adventure, and, for me, a new frontier in entertainment-making, creative energy, and clockwork professionalism.

Andy Griffith was excited for me, too. He had been approached by Meredith Willson about playing the male lead, Professor Harold Hill, in the original Broadway production. He paid a visit to Willson's house, where the composer and his wife performed the whole show at the

piano. Andy said it was one of the most mesmerizing performances that he ever witnessed. But Andy withdrew from consideration. Though he had serious theater chops and a genuine musicality, he felt he lacked the slickness and dance skills to pull off the role persuasively. The part of Harold Hill went to Robert Preston, its rightful owner, then, now, and forever. And now Preston was about to bring his signature role to life on the big screen.

This being a big-budget studio picture, the studio invested some time and money preparing me to learn how to sing: a good move, since I had inherited the Harold Beckenholdt gene for being hopeless at carrying a tune. And Winthrop had two big musical spotlights, singing a verse of "The Wells Fargo Wagon" and his very own song, "Gary, Indiana."

While I was still finishing up the first season of *The Andy Griffith Show,* I was required to begin side sessions with a voice teacher named Mrs. Webber. She was something out of 1940s Hollywood, an Olive Oyl–thin woman with her own baroquely decorated bungalow on the Warner's lot. Frizzy cat-lady hair, oversized glasses, big, wide eyes augmented by elaborate press-on lashes, and bright red lipstick that never quite covered up the cracks in her lips. And the patience of a saint.

I did not take to singing easily. There was a *lot* of repetition, a lot of "Let's try that again, Ronny," as Mrs. Webber pounded out the notes on the piano ad nauseum, waiting for me to absorb the melody and rhythm of "Gary, Indiana."

Concurrently, my dad was teaching me how to do Winthrop's lisp. I wasn't aware of what a lisp was when I took the part. Dad explained, without judgment, "Some people have a speech impediment where the letter *s* comes out as a *th* sound." We worked it out methodically, line by line in the script. So much so that I can still recite from memory Winthrop's exclamation when he receives his prized cornet: "Thithter,

thithter! I never thought I'd ever thee anything tho thcrumpthyuth ath thith thcrumpthyuth tholid gold thing! Oh, thithter!"

(Translation: "Sister, sister! I never thought I'd ever see anything so scrumptious as this scrumptious solid-gold thing. Oh, sister!")

And it wasn't just a lisp. On certain *s*'s, for comic effect, I also had to turn the sibilant sound into a spit-spraying raspberry. For example, the little kicker to that speech went, "Oh, *thhh*-thithter!" There were also raspberries built into my songs: "If you'd like to have a logical ex-*thhhh*-planation" in "Gary, Indiana," and "*Thhh*-umpthin' *thhh*-pecial just for me!" in "The Wells Fargo Wagon."

This was a lot to absorb. But Mrs. Webber kept drilling and drilling me until we finally arrived at a reasonably in-tune, rhythmically acceptable version of "Gary, Indiana." The next step was to prerecord the song in a studio; once the cameras were rolling, I would lip-sync to this recording.

The recording session took place on the large scoring stage at Warner Bros. The major studios still employed in-house orchestras, and I arrived to find about eighty musicians sitting behind their music stands, attired not in formal wear but in casual clothes, smoking cigarettes, filling out crossword puzzles, and reading the trades. That is, until Ray Heindorf, the movie's music supervisor, arrived and tapped his baton on his stand. On cue, the musicians sat up straight, poised to begin. This was a few years before the development of sophisticated multitrack recording technology, so I sang live with an orchestra. *Me,* Ronny Howard, live with an orchestra, like I was Frank Sinatra or Ella Fitzgerald.

Except I was the furthest thing from them. After five or six takes, I could feel some tension emanating from Mr. Heindorf. A Warner Bros. lifer who had been in the business since the advent of the talkies, he had worked with Eddie Cantor, Jimmy Cagney, and Judy Garland. Now he was trying to get his orchestra to play in rhythm with a seven-year-old

kid who, while doing his darndest to nail the pitch and a fake lisp, had no innate gift for keeping time.

Mr. Heindorf conferred with Mrs. Webber, who coached me as best she could. We did a few more takes, but it still wasn't working. Then Mr. Heindorf hit upon an idea. He handed me his baton, positioning it in my fingers so I was holding it the correct way. An assistant brought out a box for me to stand on.

"Now, Ronny, you direct the orchestra while you sing," Mr. Heindorf said. So we tried that. The musicians were palpably exasperated, staring at me quizzically while barely hanging on, and I think that Mr. Heindorf was back-seat-conducting them from where he stood, a few steps behind me.

One way or another, we arrived at a take that was usable, and that's what you hear in the movie. I suspect that the powers that be, Meredith Willson and the director, Morton DaCosta, decided that my determined if off-key attempts to hit those high notes—"Not Louisiana, Paris, France, New York, or *Rohhhme*"—were, if nothing else, kind of adorable.

Still, my troubles with this number were not over. My first day on the set was the day that DaCosta was shooting "Gary, Indiana" on the front porch of the Paroo house—Shirley Jones and me, along with Pert Kelton as our mother. (Pert was wonderful, by the way—a stout, comically shrewd lady who, like Bob Preston, had been in *The Music Man*'s original Broadway cast.) The problem was that I was supposed to do a little soft-shoe at the end of the song in time with the music, a cute little tippety-tap that ended with a pirouette.

As has been previously established, I got no rhythm. Poor Mrs. Webber was also charged with getting me to master my dance steps. We practiced for hours, both of us in tap shoes. I wasn't going to be wearing tap shoes in the movie, but this way, I could hear my steps as

I took them, which provided confirmation of whether I was on or off the beat.

We thought we had the routine down, but before we shot the scene, Morton DaCosta asked us to do a rehearsal run. Mrs. Webber was there, as was Onna White, the choreographer. Despite their gentle encouragement, I kept messing up. After a couple of tries, I heard DaCosta sigh and tell the camera operator, "Dolly in and cut him at the knees."

Having weathered a season of series television, I knew not to be alarmed by such a turn of a phrase. DaCosta only meant that they were going to frame out my feet. With a hint of exasperation, he told me, "Just turn around in a circle at the end, and we'll put the steps in with sound." Onna then swooped in to teach me the shortcut. In the film, you only see me from the knees up. But thanks to some movie magic—specifically, some toe-tapping sounds that were added by the Foley artists in postproduction—it appears that I am totally crushing it as a child hoofer.

I don't want to make it sound like *The Music Man* was a harrowing experience. I loved being a part of something so brilliant, ambitious, and festive. There were discomforts, sure. They dyed my already very red hair even redder so that it would pop in Technicolor—and that coloring process actually burns the scalp a little. They made me wear period wool stockings under my shorts, which were held up by a garter belt and itched like a son of a bitch. And it was punishingly hot under those Technicolor-friendly lights; the crew kept giving the cast these iced, mentholated little chamois towels to apply to our necks so that we wouldn't faint.

But I was thrilled to participate in a big old-fashioned Hollywood backlot musical, and to watch the huge ensemble numbers come together. For "Shipoopi," the song that Buddy Hackett sings, they hoisted the camera to the very top of the soundstage so they could get those

Busby Berkeley–style overhead shots of the chorus-line dancers forming a circle and doing the cancan. The budding director in me took mental notes.

DAD DID HIS usual prep work with me prior to filming so that I had a good handle on my character and the plot. He read the whole script to me aloud. He explained that Professor Harold Hill isn't really a bad man, though he is up to no good at the beginning. Because the "Wells Fargo Wagon" number was such a centerpiece of the movie, he gave me a little rundown of how commerce was practiced in the days of yore.

"When I was a boy, there was no Sears store to go to, and no Albin's toy store," he said, referring to my favorite shopping destination in Burbank. "No, you had to send away for things you wanted to purchase." He reminisced about how he and his parents circled the items that they wanted in a thick Sears catalog, and when they had saved enough money, they ordered these items by mail. And when these things arrived, they arrived by truck, and his parents had to leave the farm and pick them up in town.

"This is like that, but even longer ago," Dad said. "So for these townspeople, it's like Christmas morning when the Wells Fargo Wagon comes." This explained Winthrop's pent-up excitement over taking delivery of his cornet, and his "Thithter, thithter" speech. I still have that horn, by the way, and can still, just barely, play "The Minuet in G" on it.

Morton DaCosta noticed how effective my father was in preparing me and offered Dad a part as one of the townspeople. It wasn't something that Dad had been angling for, but the powers that be recognized that having him around was good for me. He shows up in a lot of shots in *The Music Man* if you keep an eye out for him.

I returned to *The Andy Griffith Show* with a spring in my step, and I could sense that Andy, Sheldon, and Aaron were proud of me. I was proud of having earned some acting stripes somewhere else, and in a major motion picture, no less.

When my eighth birthday rolled around that season, the producers surprised me with a giant cake and a sing-along of "Happy Birthday." It was also Aaron's birthday—he was exactly forty years older than me—so we shared the cake. Planted in the icing was a little figure of Aaron, holding a megaphone, and another of me, holding a fishing pole. They served me the first slice, and it looked better than it tasted; privately, I craved my mother's devil's food cake with chocolate icing. She later admitted to me that she made hers from a Betty Crocker mix, straight out of the box. But, hey, *my mom made it*—and no chocolate cake has ever tasted better to me.

I had never had a birthday party before. Our peripatetic family life to that point had precluded it. My most memorable birthday to this point had been my fourth, when we still lived in Queens. My parents took me to FAO Schwarz in Manhattan and let me choose a gift. It was an easy call: a Zorro set, complete with a mask, a flat-brimmed gaucho hat, and a plastic fencing foil. I actually wore this outfit to my first Broadway show, a matinee performance of the *Li'l Abner* musical, based on the comic strip. I was bored and didn't really get it. It was apt that Andy would later disparage the play.

For this latest birthday, celebrated on set, Andy and Aaron gave me a Bell & Howell Zoomatic 8 mm movie camera—my very first. Aaron told me that I could now make my own movies. For the next eight years or so, that camera spent most of its time sitting idle in its brown leather case. But it was eventually put to vigorous use, and, even before then, my mentors' encouragement boosted my self-confidence.

Years later, when for the first time I was nominated for a Director's Guild Award, for *Cocoon,* Aaron and Sheldon attended the ceremony. I didn't win—Steven Spielberg did, for *The Color Purple*—but I sought out Aaron to remind him of his gift. I did not take for granted that this was a rare opportunity to thank a childhood benefactor for planting the seeds of my happy, productive adult life decades earlier.

ARMED WITH MY newfound confidence that second season, I started watching TV and movies differently. Dad took me to a screening of the original, 1931 version of *The Champ,* the King Vidor boxing picture that starred Wallace Beery in the title role and Jackie Cooper as his son. Cooper was incredible. I couldn't get over how believable he was in the movie's final scene, when his father is dead and all the grown-ups are trying to console him. His face alone does incredibly complicated work, mustering a range of faint smiles to oblige his consolers but not masking his actual state of profound grief.

Cooper's performance, along with my newly accumulated movie experience, triggered my competitive juices. When I watched a kid actor on a TV show, I evaluated his performance and compared it to what I was doing on *Andy Griffith.* I took inventory of my contemporaries: Johnny Crawford on *The Rifleman,* Jay North on *Dennis the Menace,* Jon Provost on *Lassie,* the *Leave It to Beaver* guys, the *My Three Sons* guys.

I concluded that, in terms of acting prowess, I was second only to

Johnny Crawford. Jay North I respected as more or less an equal. The rest? In my cocky state, I concluded that they weren't on my level. Johnny brought a truthfulness to his performance, an honesty that seemed lived in. The actors on *Leave It to Beaver,* which began in 1957, were hamstrung by how dated their format was. That show struck me as corny, synthetic TV that encouraged a forced, mannered brand of acting.

At this point, I realized that acting was more than an exercise in pleasing adults. It was my *job.* From *The Journey* through *The Music Man,* I had regarded work as an elaborate form of playtime. Now I paid closer attention to Andy and Don and understood that acting was, for them, a way of life, a *career,* and that the longevity of their careers depended on the quality and consistency of their performance. That was a thing Andy said all the time while we worked on the show: "It's not good enough. *I'm* not good enough. Let's make this better, funnier." He always pushed for excellence; ergo, I did, too.

THERE'S A FINE line between confidence and arrogance, and I crossed it in *The Andy Griffith Show*'s third season. We were shooting an episode entitled "Andy Discovers America," whose script was by John Whedon, the patriarch of a screenwriting family that includes his son, Tom, who wrote for *Captain Kangaroo* and *The Golden Girls,* and his grandson, Joss, of *Avengers* and *Buffy the Vampire Slayer* fame. To *Andy Griffith* fans, this episode is noteworthy because it introduced Aneta Corsaut as Helen Crump, the schoolteacher who would become Andy's girlfriend, and, later, his wife.

But for me, this episode was a big deal because it included some classroom scenes in which Opie and his pals tested the patience of Miss Crump. This meant I'd have company at Desilu Cahuenga for the week: Keith Thibodeaux as my sidekick Johnny Paul Jason, along with, among others, the child actors Dennis Rush and Joey Scott.

As the (relative) veteran among this crew of moppets, I felt like show-ing off. This was *my* hit show, *my* set. I took on the role of ringleader, strutting around like I owned the place, goofing off and telling jokes right up until the camera assistant clapped the slate. In other words, I let things go to my head and forgot about the process, the discipline, and the etiquette of the set.

I must have been hard to control that day, because Dad took me aside to remind me to concentrate, something he hadn't needed to do since the first season. But hey, I was feeling my oats, and even my father wasn't going to put me in my place. I continued to act the wiseass, wriggling in my desk chair, firing paper airplanes into the air, and showing off for a couple of the girls sitting next to me in the scene.

Then, between takes, Bob Sweeney, the director, took me aside, an uncharacteristically serious expression on his face. Very quietly, and without any harshness, he said words that are still imprinted upon my brain: "Ronny, I know it's fun for you to have all these other kids around, and that you want to make them laugh. But that's not what I want to talk to you about. Ronny, you're a good young actor. But you still have a lot to learn. In fact, you aren't even the best young actor in this scene today."

That honor he bestowed upon Dennis Rush, who was indeed doing a bang-up job. "It's not just that he is paying attention and behaving well, Ronny," Bob said. "It's that he is really thinking about the scene. He is *connecting*."

Bob had more to say. He noticed that I had been slipping into some sloppy acting habits, falling into the classic series-regular trap of phon-ing it in. He urged me to bear down, to focus my attention on some small real-life detail like the lint on my shirt or a chipped corner of my school desk, to put my mind in a place where I wasn't caught up in the lights and microphones, but, rather, grounded in Opie's reality. In short, Bob challenged me.

I still feel a twinge of queasiness just thinking about this gentle but firm dressing-down. Bob was right: I was falling into bad habits, such as reciting my lines in a lazy singsong way instead of linking them to the real ideas that the words in the script conveyed. One reason that so many child actors fail to evolve into adult professionals is that, under pressure, they default to a perky autopilot, an artificial cuteness that some directors are willing to settle for. Left alone, these kids never grow as actors, and they reach their young adulthood unable to react, improvise, make spontaneous discoveries, or develop multiple approaches to their scene work. And then one day they're no longer little and no longer adorable, and they have never really learned how to act. The business is done with them.

I pulled it together for Miss Crump's debut episode, and Bob told me that I performed . . . acceptably, if not superbly. He saved me that day from sliding further into bad habits—and, arguably, from becoming a toxic Hollywood brat, forevermore resting on laurels earned in short pants. I don't recall any other director ever having to crack the whip in my direction again.

Later on, in the 1970s, when I had the chance to work with some of the greats from Hollywood's golden age—acting with John Wayne, Jimmy Stewart, and Henry Fonda, and directing Bette Davis in a TV movie—I saw firsthand what separated them from the lower ranks: a remarkable work ethic and an unwillingness to brook substandard work, whether their own or someone else's.

I also had Dad. He set an example in two ways. First, he armed me with the fundamentals so that I had the tools with which to grow. Second, he kept hustling for parts in the face of constant rejection. His career struggles were a sobering reminder of just how rare a position I was in as a series regular.

· · ·

WE WERE STILL living in Hollywood when Clint and I experienced our first tragic death. Gulliver, our beloved Weimaraner, somehow broke loose from our backyard one day and ran into the street, where he was struck by a car. We were all home. I heard a horrible yelp and ran out to the street, a few steps behind Dad.

What I saw didn't seem real: my dog whimpering on the blacktop, his life draining out of him, his blood strangely dark and thick like motor oil. Dad cradled Gulliver and carried him into the house, still alive but fading fast. We Howards are not a particularly tearful family, but I lost it, sobbing as Gulliver breathed his last.

This sad moment came to bear on my Mayberry work not long afterward. We began the fourth season in 1963 with an episode called "Opie the Birdman." This was only about six months after my misbehavior during the Miss Crump episode, and a big test for me. The episode had two big emotional scenes for Opie. In the first, Opie is outside playing with a new slingshot he has made with Barney's help. Though Andy tells him to use it only to shoot stones at tin cans, Opie aims at a tree and accidentally kills a little songbird, which falls to the ground.

At first, Opie tries to talk the bird—and, really, himself—into believing that what just happened isn't so bad. "It's probably just a scratch," he says to the animal, which is lying still on the sidewalk. He picks the bird up and holds it in both hands, begging, "Fly away. Please! Fly away!" But when he opens his hands and gives the bird a little upward push, the bird falls back to the ground like a lead weight. In tears, Opie backs away in horror and then runs into the house, aghast at what he has done.

The second big scene is in the episode's resolution. Andy gives Opie the responsibility of raising the bird's orphaned chicks in a cage until they are capable of flying. At that point, Opie must let them fly free and rejoin nature, even though he has grown close to his little flock. For that scene, I thought of Jackie Cooper, layering conflicting emotions one on top of the other. And I was good.

But the scene where I realize that I have killed a mother bird required something more, an authentic portrayal of guilt, fear, and grief. I couldn't have described the challenge in those words, but Dad did his best to prepare me the night before the shoot, explaining the depth of Opie's feelings. Still, I went to sleep worrying and wondering: How was I going to find those feelings?

I was still searching for the answer to this question the next day, even after we had rehearsed the scene and the camera was positioned. Then Dad took me aside. "Do you remember how you felt when Gulliver died?" he said. "That's the way Opie is feeling now. That feeling of being scared and sad and disappointed. Think about that."

Richard Crenna, who directed that episode, must have noticed that I was in an intense emotional headspace, because he called out his usually robust "Action!" in a hushed, somber tone. They rolled camera. And as I picked up that prop bird and implored it to live, I thought of Gulliver. For the first time as an actor, I cried real tears and trembled real trembles. I'd come a long way from my subpar display of emotion in "The New Housekeeper," when Sheldon Leonard intimated that he might have to spank a performance out of me.

When Dick Crenna yelled "Cut!," I was still in my Method-y sad zone, but the mood around me was one of euphoria. Everyone had just watched me ascend to a new level. From every angle, big adult hands extended toward me to shake mine, or tousle my hair, or pat me on the back in congratulation.

Foremost among my congratulators was Andy. I told him what I had been thinking about as I was doing the scene—and broke into tears all over again. He gave me an empathetic hug and then gently reminded me that it was time to rehearse the next scene. We were on a schedule, after all.

I was on a roll that year. Vincente Minnelli cast me in his film *The Courtship of Eddie's Father,* adapted from a novel about a boy who tries

to play matchmaker for his widower dad. I played Eddie, Glenn Ford played the father, and Shirley Jones reunited with me to play the divorcée nurse next door, who ultimately turns out to be the ideal fit for Glenn's character. Though the movie was later adapted into a light-hearted sitcom, our version was more melodramatic. I consider my performance in this picture to be the best of my childhood career.

Eddie has a scene in which he discovers a dead goldfish floating in his tank and shrieks in fear. Shirley's character correctly intuits that Eddie has conflated the fish with his mother and comforts him as he breaks down. Once again, I summoned memories of Gulliver in order to place myself in my character's frame of mind, convulsing with grief, discovering emotional depths I was hitherto unaware of. MGM, the studio that produced the movie, was so impressed by my work that they considered mounting a Best Supporting Actor campaign for me. That didn't happen, but my confidence skyrocketed further.

Minnelli fostered an atmosphere of comfort on the set by seeing to it that I had a babysitter and playmate: his seventeen-year-old daughter, Liza. We passed the time between my scenes with a deck of cards, Liza teaching me all manner of sleight-of-hand tricks that I can still do today. Hanging out with the Minnellis was cool, but cooler still was recognizing my great leap forward. In "Opie the Birdman" and *The Courtship of Eddie's Father,* I had extended a part of myself into my performances. I had gone deep. I was no longer a child actor. I was an actor, period.

TOUGHENING UP

CLINT

Ron and I considered it a point of pride that we could deliver the emotional truth in our performances and bring genuine tears. Dad taught us that other people might need to fake it, but not the Howards. Glycerin? We didn't need no stinking glycerin! It became an us-against-them challenge. When I saw adult actors sit still while the makeup artist painted streaks of glycerin on their faces, I thought, *These people? They don't know what they're doing!* In my youthful bravado and arrogance, I considered their approach lazy.

In 1972, I landed a lead role in a TV movie called *The Red Pony,* adapted from a John Steinbeck novella. The film contains what I consider my best childhood work, not least because, using Dad's by then time-tested mini-Methodology, I summoned a whole lot of tears and anger.

In *The Red Pony,* I played a Depression-era farm boy who is entrusted with the horse of the title, a colt. The colt catches a respiratory disease known as the strangles. I fall asleep in the barn while keeping watch over him and he runs away. By the time I find him, my colt has collapsed

in a stream, and a bunch of buzzards have descended on him, pecking away at his lifeless body.

I'm still very proud of how nuanced and expressive I was in conveying my character's grief, yearning, and self-disgust at letting his horse spring free. But the film also occasioned one of the most traumatic episodes of my life. Its director, Robert Totten, was a family friend and a significant figure in the Howard family's lives—more on him later. As we set up by the stream, Bob announced that he wanted me to pick up one of the buzzards in anger and smash him to death on a rock. Not a prop buzzard; a real one.

This would never, ever be allowed on a film set today. But the ethical mores of the 1970s were different. Nevertheless, killing a bird did not sit well with me. I had worked with animals for the better part of my young life. My costar in *Gentle Ben* was a bear, for Christ's sake! I made my feelings known to Bob. He told me to man up and just do the deed. "The bird is going to take one for the team," he said. Dad reassured me, saying that a natural predator would likely eat the buzzard anyway.

We had an animal-welfare guy on location with us, and I still can't imagine how this was sanctioned. I was already worked up about the emotional aspect of the scene, as it was a climactic moment for my character. Now I also had to execute a bird, and in a single take, so that I didn't have to murder more than one.

Bob called "Action!" and everyone's eyes were on me. He staged the scene so that there was a conveniently protruding flat rock right where I stood in the stream. I picked up the buzzard by its legs and whacked its head on the rock. Mercifully, it only took a few whacks for the bird to die. You can watch the scene and see for yourself. But I can't. It's too painful. In what was otherwise the high-water mark of my juvenile career, that experience scarred my psyche.

As Ron has said, we were privileged to be treated respectfully as peers of our adult colleagues in the workplace. Occasionally, though, these

adults lost sight of our sensitivity and innocence. We were precocious and talented, but still very much children.

MOST OF THE time, fortunately, Mom and Dad zealously protected us from the dark and predatory aspects of the business. A lot of child actors weren't as fortunate; their own parents were the predators, withholding affection and frittering away their kids' earnings. Our folks were scrupulously honest about money. In the 1960s, as Ron worked on *Andy Griffith* and I had episodic work on such shows as *The Fugitive, Please Don't Eat the Daisies,* and *The Virginian,* we brought home some serious paychecks. Even so, Mom and Dad never lived outside of their means.

Let me emphasize, *their* means. As soon as we could understand, Dad explained to Ron and me what was happening to the money we earned. By state law, 15 percent of our earnings were automatically placed in a Coogan Trust Account, whose funds could not be accessed by anyone but us when we turned eighteen. These accounts were named for Jackie Coogan (not to be confused with Jackie Cooper), the child actor who had starred opposite Charlie Chaplin in *The Kid* and made boatloads of money in the 1920s, only to discover at the age of twenty-one that his fortune had been squandered by his parents. In the aftermath of Coogan's successful lawsuit against his mother, the State of California passed the Child Actor's Bill, which most people in the industry referred to as the Coogan Law.

As for our remaining earnings, Mom and Dad put every penny into savings accounts and U.S. bonds in our names, apart from a 5 percent managers' fee that they drew for looking after our careers. That's a bargain—most managers charge triple that amount. Much later on, Dad explained his reasoning to Ron and me. He said that if we kids had ever gotten the idea that we were the household's breadwinners, it

would have messed up the family dynamic. With Mom's help, he was making just enough as an actor and part-time manager to support the four of us. Preserving a sense of normalcy was a top priority for Dad.

IN 1963, WE moved from Hollywood back to Burbank, where Mom and Dad became homeowners for the first time. Three forty-six North Cordova Street was a small tract house just half a block from our old apartment: three bedrooms, one bathroom, and, best of all in my view, a pool. Boy, I loved to splash around in that pool. Ron and I shared a bedroom, and Dad used the spare as his office.

When the family car, the '52 Plymouth Cranbrook, finally gave out, Dad gave no thought to a Jag or a Mercedes. He splurged on a new car for the first time in his life, but it was a red Chevy Nova Super Sport in candy-apple red. Dad was proud to own a new car and even prouder that he paid for it in cash. Somewhere along the way, Mom got a new car, too, a big, bulky Plymouth whose yellow body was pocked with parking-lot dings within a few months of its being in her possession. She was a solid driver but the other Burbank moms who frequented the local supermarkets were not.

We rarely went on vacation, busy as we all were with work. When we did, our trips were austere affairs. One of our reliable destinations was the Apple Valley Inn, located in the high desert a hundred miles from Burbank. The resort was run by Roy Rogers, who tried to do for Apple Valley what Bob Hope and Frank Sinatra had done for Palm Springs. It never quite took. Maybe the cold, thirty-mph nighttime winds were too much for the Rat Pack. But Dad loved the inn's western kitsch, the decorative wagon wheels and wood paneling. He was in his element, and his happiness at Apple Valley was contagious.

. . .

CORDOVA STREET WAS nevertheless a big step up for us. Within a few blocks stood the entire world that Ron and I occupied when we weren't working and just being kids. Two blocks away was Robert Louis Stevenson Elementary School, a campus of low postwar buildings and wide-open asphalt and grass playgrounds. You name it, we played it at recess: softball, basketball, kickball, dodgeball. I never understood the appeal of dodgeball. It seemed unnecessarily cruel, with some poor kid, usually a nerd, getting whacked in the face with the ball.

A few blocks past Stevenson was a public parks and recreation center, Verdugo Park, which had a gym where Ron shot baskets at every opportunity. I still live a few minutes away from the site of our ancestral pile. With the exception of our house, which has since been torn down and replaced with a McMansion, very little has changed.

Mom didn't really like to cook, though we did eat at home most of the time. Meatloaf, ham, hamburgers, hot dogs, and fish sticks were the regulars in her rotation of entrées. The vegetables came out of a can, though Mom, to her credit, knew how to whip up some tasty mashed potatoes. Mac and cheese was a side dish almost every night. It's amazing that Dad kept his weight at a consistent 173 pounds, a number he proudly reported to us whenever he stepped off the scale.

We also dined out a fair amount, too. The local Sizzler, part of a chain that had only been founded a few years earlier in Culver City, was a go-to spot. Once in a while, we went to the Kings Arms, a medieval-themed luxury restaurant where there was a sword set in stone by the front entrance. Ron and I drank Shirley Temples there. Between the sugar high from those, the cartoons that I had seen about King Arthur's court, and the Olde English interior decor, I was often motivated to make a dramatic scene of trying to pull that sword out for laughs.

My fondest early memory of brotherhood is of jumping out of bed, before Mom and Dad were up, to join Ron in the hallway, where he lay stretched out near the wall heater, absorbing the *Los Angeles Times*'s

sports section. After our dog Gulliver died, Mom and Dad got us a cat, who we named Mitts because he had an extra pinkie claw that made him look like he was wearing a catcher's mitt. Ron woke up early to feed Mitts. After that, he brought the newspaper in. I liked to climb onto Ron's back as he studied the box scores aloud and recounted the highlights from the Dodgers game. Snugly in place atop my big brother, my blond head peering out over his red head, I listened intently as he narrated to me what Don Drysdale, Maury Wills, Tommy Davis, and his beloved Sandy Koufax had done the night before.

There was no safer feeling: the warmth of that heater, the softness of our PJs, the encouraging voice of my brother as he taught me how the game worked.

RON

I loved that sensation of Clint's weight on my back, and of having someone to evangelize to about my beloved Dodgers. Dad was athletic but never cared much for team sports, being a product of the lonesome prairie. His things were boxing, wrestling, and horseback riding.

I was so successful at explaining batting averages and other baseball statistics to Clint that the teachers at Stevenson Elementary believed that he was a math prodigy. He was bringing some of my lessons into the classroom at kindergarten level. Someone from the school called my parents and said, "He doesn't just know his numbers, he understands the concepts of multiplication, division, and percentages."

The school thought it had a legit math genius on its hands, a *Good Will Hunting* situation. They put Clint in some advanced classes, but then he sort of leveled off in terms of proficiency, and it was deduced, finally, that his facility for reciting baseball stats had created a misimpression.

Still, Clint had a sharp mind. As he evolved from the Hee-Hee Man into my walking, talking roomie, I began to appreciate him as a person. He was funny and irreverent in a way that I wasn't. As we lay in our beds, we both cracked up at his droll little observations about Dad's efforts to cover up his thinning hair, the comb-overs and the foggy applications of hold-it-in-place hair spray that drove Mom crazy. (Of course, karma would get back at us in a big way. Early in my *Happy Days* era, I noted the amount of red hair that was damming up the drain when I showered. I then contemplated the hairlines of every male I had met on both sides of our family and humbly accepted my fate right then and there.)

Clint was also highly coordinated for his age, good enough to play reasonably competitive games of Nerf basketball and Wiffle Ball when we were still little. We also wrestled, as brothers do. Or "rassled," because that's how Dad said it, in his otherwise faint Oklahoma accent.

One of our bonding rituals was watching pro-wrestling matches on Channel 5, a local station. We couldn't get enough of it: the flamboyant heels Freddie Blassie and Gorilla Monsoon, the pretty boys Buddy Rogers and John Tolos, the abnormally huge Haystacks Calhoun. Like lots of kids, Clint and I couldn't quite suss out if the violence was real. It *looked* real, but something about it felt a bit . . . theatrical.

Whatever it was, we loved it. Clint and I imitated the pro wrestlers, tackling each other to the floor. Sometimes, when I was pissed off at him for knocking down a Lincoln Log house I'd made or telling on me like a whiny little bastard, our fights turned real. I had a major physical advantage, being five years older, and I would pin Clint to the floor, my face flushed with anger and vengeance. He would scream, "Mommmmmm!"

It was always Dad who ran in and separated us. He had a stock speech that he gave us whenever this happened: "One of these days, you boys are going to be grown men living in different places, and you're going to

wish that you were friends. I hope you really cherish what you've got. Because you are brothers, but you have a chance to also be lifelong friends. And that starts *now*."

It was a good cooldown speech, but I realize that it was also rooted in a kind of regret. He and his brother Max had an eleven-year age difference and were not close. He didn't want history to repeat itself.

CLINT

The truth is, Dad loved wrestling as much as we did. He initiated the action by declaring, "C'mon, boys, let's do some rassling!" We'd move the furniture to prepare the ring, though this didn't always assure us safety. Doesn't every boy remember cracking his head on the sofa?

Then Dad would drop to his knees and do his best version of a ring announcer and introduce us as wrestlers, just like the guy did on Channel 5. He really turned it on for these matches, putting to use his skills as a former children's thespian. "Ding, ding, ding!" he'd announce. "*And now . . . the main event!*" I would grab a hold of his legs and he would humor me by falling to the floor. One of the reasons I made fun of Dad's hair loss was that his newly exposed forehead scrunched into these big lateral wrinkles when he was on the floor, and the sight of his head upside down was hilarious to me, a reconfigured face: the wrinkles looked like a mouth and his eyebrows were like a weird mustache and . . . well, you know, it's the kind of thing a kid gets obsessed with.

Dad always let us win. He played the defeated guy really well, groaning, "Aaagh, ohhh, ya got me again." And then he switched to the announcer doing the count and raising the victor's arm.

As Ron and I got deeper into pro wrestling, I took a liking to the greatest heel of them all, the Sheik. To simulate the head wrap that he

wore, I pulled a pair of my own tighty-whities over my head, the elastic at my temples. God, I hope they were clean.

<div align="right">RON</div>

My devotion to pro wrestling was put to the test when I took my first trip to Canada the summer after *The Andy Griffith Show*'s second season. Andy and Don were making good money during the show's hiatus by performing a variety act at carnivals and state fairs. With *The Music Man* compounding my fame, they invited me to join them for a two-week stint doing shows in the province of Ontario. Dad came along, and while it was initially frightening to perform before large crowds, some as big as twenty thousand people, I got over it fast and found it to be pretty easy work. We'd perform some sketches in character from our TV show, and then Andy would say, "You're not just Opie, Ronny. You're also Winthrop in *The Music Man*. Give us a song." I would sing "Gary, Indiana" with the exaggerated lisp and bring the house down. There were also old-time carny attractions like a so-called wolf man who was just a sweaty guy with an inordinate amount of hair on his face and a "Wall of Death," which was a large, barrel-shaped structure in which daredevil motorcyclists rode around in circles, defying gravity thanks to friction and centrifugal force.

One of our obligations was an appearance at a local daytime talk show in Toronto. While Andy, Don, Dad, and I were at the TV station, we were offered a tour. In an adjacent studio, we saw a setup for televised wrestling. It looked much smaller in person than it did on TV, with only three rows on each side for the fans, though careful framing made the audience look much bigger.

That was a little underwhelming and surprising. But what really

opened my eyes was the sight I caught of two wrestlers in the hallway, working out their routine. These weren't fit young Adonises. They were doughy guys who were long in the tooth, though nevertheless wearing only wrestling shoes and the brief, Speedo-like trunks that wrestlers wore back then. Both men had cigarettes dangling from their lips. One had the other in a headlock and said, "And then you reach up and do a reverse." They practiced their moves a few times: the headlock followed by the counterattack.

As I watched this, my heart sank. *Does this mean that pro wrestling is . . . FAKE?* I tugged at my dad's sleeve and asked him to explain what was going on. Sensing my disillusionment, he gently said, "They really make their moves and they really get hurt. But they're more like stuntmen than boxers."

I couldn't wait to reveal this discovery to my friends back in Burbank. But it troubled me. In a neat feat of mental gymnastics, I convinced both my friends and myself that pro wrestling was fake *only in Canada.* In America, a championship belt was real, earned fair and square.

CLINT

There was something else to Dad's roughhousing, his playful physicality with us. For one thing, we didn't just wrestle; he also taught us some of the fighting techniques that he had picked up in his amateur-boxing days. Dad felt it was important that we be able to defend ourselves. I remember shadowboxing with him, that long left arm of his coming into my face for a pretend jab, with Dad shouting, "Double up, double up! *Bam, bam!* Break his nose, Clint, break his nose!"

What went unspoken, though Ron and I figured it out, is that Dad knew that we would be perceived as different, being show-business kids. Our lives had a different shape than those of our peers. And he didn't

want us to live in fear or be intimidated by anyone or anything. He wanted us to be ready.

RON

Dad was right to be concerned. Because of my time away filming *The Music Man,* I entered the second grade not having been at Stevenson Elementary since kindergarten. Back then, I wasn't yet on *The Andy Griffith Show*. But now I was. And seemingly everyone in the world watched it. Certainly every kid at Stevenson did. And they all figured out that Opie rhymes with *dopey, mopey,* and *soapy.*

I joined Stevenson's second grade when it was already in progress, so there was automatically that pressure of being the new kid, feeling every pair of eyes following you everywhere you went. In my case, this pressure was compounded by being recognized as the kid from TV. I could see it plain as day: my classmates leaning into each other conspiratorially, mouthing *Opie.*

This sort of thing would dog me throughout my childhood, up to and including my high school years. I mean, to this day, people recognize me and call me Opie, and that's fine—I'm happy to be remembered in that way. But as a schoolboy, there was a malevolence to the way I was singled out. I found it demeaning and insulting when I got Hey, Opie'd, because there was an assumption that went with that, that I was wimpy and cosseted. Or that I was a braggart and a show-off. Or, when I was older, that I must be a rich dickhead with a fancy car, throwing money around, trying to buy friends. My rebellion was to be none of those things—which, by the way, didn't take much effort. More about that later.

But back to second grade, the time of my first experience with the downside of celebrity. What I felt primarily at that time was not anger

but fear. Not so much of physical danger, though there was an under-current of that. Mostly I feared the embarrassment of being singled out and picked on. And I was confused and disoriented by the fact that an aspect of my life that I loved, being a part of productions like *The Andy Griffith Show* and *The Music Man,* was the reason that I was singled out.

My first week back at school, I didn't feel safe going to the bath-room. The one time I did, I was harassed and hassled by the bigger boys while I stood at the urinal. But I didn't want to complain to my teachers or the principal—that would make me a snitch. So I just de-cided one day that I simply wouldn't use the bathroom at school. I held it in all morning. I held it in during lunch break. I held it in that afternoon, staring at the clock, waiting for the 2:45 dismissal bell, try-ing desperately to hold off the stream . . . until, with just a minute or two to go, I could hold it in no longer. I peed in my pants, soaking a whole pantleg. A few kids saw it happen and laughed at me. I ran home, humiliated.

I told my parents how miserable I was feeling. They heard me out and came back with a plan. First, Mom and Dad said, they hoped and predicted that things would settle down if I just hung in there and al-lowed the novelty of being "the kid from TV" to wear off. But if I was still unhappy at the end of the school year, they would enroll me in a smaller private school tailored to child performers.

Sure enough, by the time the school year ended and my folks checked in with me about whether or not I wanted to leave Stevenson, I made it emphatically clear that I wanted to stay. Their parental wisdom had borne itself out.

But it was a rough path to assimilating into the general student pop-ulation. For a few weeks, I was a marked man at Stevenson. The encoun-ters usually began with a snide, "Hey, Opie!" Then there would be an

escalation to shoving, with other kids gathering around to watch, point fingers, and laugh at me. Then my tormentor, whoever he was that day, would say, "Do you want to fight?"

I didn't think it was acceptable to back down, so I said, "Yeah!" And here's where the wrestling and sparring lessons at home with Dad came in handy. After school, my challenger and I would meet on the corner where I lived, Cordova and Oak. We'd start in the standing position, shoving and pushing. Then one of us would latch onto the other, we'd fall to the ground, and it basically became a wrestling match.

This scenario unfolded with distressing regularity in second grade— more distressingly to my mom, who looked on in horror through the front window. My training allowed me to hold my own, usually getting the other kid in a headlock or scissor lock before we called a truce. My challenger would pick himself up, dust himself off, and say something along the lines of "You're a dead man, Opie," and skulk home.

Dad never intervened in my front-lawn scuffles, though he saw them from the same vantage point as Mom. He'd done a lot of fighting as a farm boy, and his attitude, as he said to Mom, was "Let them fight it out." He saw this as a boyhood rite of passage. If blood had been drawn it would have been different, but to Dad, these scraps were just ritualistic displays of elementary-school preening.

I even had the occasion to fight in defense of someone else. I was the third-smallest kid in my grade. The smallest was a boy named Shep. One day, Shep was getting picked on by one of the tallest boys, who I'll call Jimbo. I said, "Jimbo, leave Shep alone!" You know how it goes from here: "Yeah, whatcha gonna do about it, Opie?" We squared up.

The Ronny-versus-Jimbo match was one for the ages. Well, not really, but it was a triumph for me, because I used my wiles to take him down with a scissor-lock pin. For good measure, I started rubbing his crew-cutted head in the grass, back and forth, back and forth, giving

his noggin a Dutch rub with my knuckles, just like Dad had taught me. Jimbo cried uncle. More importantly, he starting acting more kindly toward Shep. And, later on, he and I became friends.

STILL, I CAN'T say that I had a satisfactory relationship with violence. It proved a dead end. A few years later, around fifth or sixth grade, there was a new boy—I'll call him Skip—who had the look and affect of a 1950s hoodlum: short blond hair done up in a proto-Fonzie ducktail, eyes that were always squinted into slits, like he was looking at you with contempt.

I was riding my skateboard on his side of the street one day. We exchanged words, one thing led to another, and this time, *I* was the one who squared up and said, "Do you want to fight?" Skip gladly accepted.

He came out with two left jabs to the right side of my face and a right cross to my left cheek. He knocked me right on my ass. I dusted off my pants, got on my skateboard, and rolled home unsteadily, rattled and embarrassed. That's the last time I ever challenged anybody to a fight. Fortunately, Skip was not long for Burbank and moved away.

Playing the tough guy was not going to solve my self-confidence issues. One day in second grade, an alternative presented itself. We were doing a play in class. Not a class play for the whole school, just a drama exercise as part of our reading curriculum, where we broke into smaller groups and performed little skits. My group was sitting in a circle, reading the dialogue aloud. Our skit was about a birthday party. The read-through wasn't going well. The girl next to me was struggling with her lines, with no sense of what they meant or what the scene was about. So I explained it to her.

Then I asked the teacher if we would be getting a real cake for the proper performance of the skit in front of the whole class. She said no, it was going to be all pretend. At that point, I couldn't help myself. My

Andy Griffith Show training kicked in, and, like a mini–Bob Sweeney, I asked everyone to hop to their feet so we could block out the scene, choreographing our movements. I had the other kids putting on pretend party hats, blowing out make-believe candles, and using imaginary forks.

My teacher recognized what was going on, and, rather than rebuke me for bigfooting her, she indulged me. I sensed that she knew I was struggling as the new kid and the TV kid, and she granted me this latitude to give me the chance to build my confidence.

It worked. Our performance before the whole class was a hit, and that day marked the first time that I felt I had something to offer to the other kids, something that they appreciated. I started feeling better about myself.

Wow, I thought as I put the other kids through their paces, *I'm directing!* One kid in particular, a new boy from Alaska and a fellow redhead—his name was Don, I believe—was seriously good at acting. The pro in me allowed the thought to cross my mind: *If this Don kid wanted to get into the business, he has the goods.*

The rest of the kids were terrible actors, but I wisely kept that thought to myself.

BEFORE LONG I had my own posse of buddies. One nice thing about Cordova Street is that the lots were only fifty feet wide, so each block was packed with families whose kids were the same ages as Clint and me. Three second-grade boys who lived on Cordova, Noel Salvatore, Bob Wemyss, and John Matheus, became my best friends, with whom I bonded over our mutual love of baseball and basketball; sports was another great social equalizer. I am still close to Noel, Bob, and John. Every year, around Christmas, we reunite for a Cordova Street Boys dinner at the Smoke House, the swankiest joint in Burbank.

In our adulthood, I found out from Bob that during my early strug-gles at Stevenson, my mom, who was close to his, had approached Mrs. Wemyss to see if Bob might consider getting into acting. Mom offered to help set up Bob with an agent and walk Mrs. Wemyss through the ins and outs of being a child actor's parent. But Bob's mom shut the idea down, not wanting that life for her son.

Mom was just trying to give me a comrade in arms, a friend who understood what I was going through. Fortunately, such extreme mea-sures proved unnecessary. My friends were there for me as I returned to Stevenson from *The Andy Griffith Show* every February after our sea-son had wrapped. And mind you, I needed them to be there. Every year, not just at Stevenson but also at David Starr Jordan Middle School and John Burroughs High School, I would still be put through some sort of gauntlet, some sort of teasing and bullying by a group of kids who wanted to test me.

What's bizarre, when I think back upon it, is that my time in front of the camera is what gave me the confidence to get through the social trials of my childhood years. In Mayberry, as Opie, I was at ease. It was away from Stages 1 and 2 of Desilu Cahuenga that I had to prove my value and self-worth. Which is crazy: the tenuous, competitive, and of-ten merciless world of show business was actually a safer space for me than the familiar hallways and playgrounds that the rest of my genera-tion was inhabiting. This paradox is the crux of why so many successful child actors struggle in their adult lives.

BUT FIRST, THE TRANYA

CLINT

I was lucky enough to have Ron pave the way for me, so I avoided a lot of the grief he endured. With a big assist from Dad, my brother had already cracked the code of how to be a kid in show business—so I felt totally at home in that environment. And Ron always included me with his buddies when they played touch football, Wiffle Ball, and basketball on the mean streets of Burbank. That put me ahead of the curve when I started playing sports with kids my own age.

I also benefited from the simple fact of birth order. I wasn't kept in the same bubble wrap that Mom and Dad had put Ron in. They were overly protective of him. They didn't let him ride a bike until he was eight, and even then, he wasn't allowed to go beyond our block of Cordova Street—and only on the sidewalk. I was pedaling all over the neighborhood by the time I was six.

I got to do a lot of other normal-kid things several years earlier than Ron did, too. He was pissed about this, but he never took it out on me—he was mad at the system. After I got in the flow of working like Ron, Mom and Dad reconsidered some of their parenting choices

and gave their second-born a longer leash. And sometimes I just ground them down.

At school, I didn't face the harassment that Ron did. I was on TV a lot, but always playing different characters. He was Opie. Jeez, I felt bad for him. Later on, in junior high, after I'd been on *Gentle Ben,* I did have a taste of his experiences. My version of "Hey, Dopey Opie!" was "Hey, where's your bear?" Kids tried to provoke me into fights. There was a corner three blocks away from Burbank's David Starr Jordan Middle School where the boys my age met up: "Yeah? Why don't we meet at Beachwood and Oak? After school, Clint, Beachwood and Oak!"

You know what I did? *Not go to Beachwood and Oak!* I shrugged that stuff off. Everyone's hormones were firing like crazy at that age, and I was smart enough to recognize that taking their bait was stupid. While I never witnessed one of Ron's fights, I frequently saw him come home red-faced and flustered. I didn't like how he looked and avoided dustups at all costs.

But my parents weren't totally loose with me. They had certain strict rules that neither Ron nor I could circumvent. We weren't allowed to have sleepovers at other kids' houses. We weren't even allowed to have other kids' parents drive us to birthday parties. The kidnapping of the Lindbergh baby had been a major national story when Mom was a girl, and she was deathly afraid of something like that happening to us. She never put it that way, though. She and Dad always said it was about safety. If a friend's parents offered me a ride, she'd say, "I don't trust them to be as careful as I am. And I'm willing to drive you. That's just how it is."

RON

I had a lot of friction with my parents over the years about the tight grip they kept on me socially. I found it humiliating, and it exacerbated my

sense that there was something Other about me. I couldn't ride bikes with the other boys to the strip mall to buy baseball cards or get a soda. Dad thought bikes were dangerous. He didn't grow up in a suburb and couldn't quite process how normal it was to ride a bike in close proximity to cars—and this from a guy whose horse went down and rolled over him while he was crossing a stream at age twelve, resulting in a broken collarbone.

Still, there was nothing cynical about our parents' protectiveness. It was rooted in love and fear, not in any stage-parent concept of protecting their assets, their cash cows. Hell, they stood back and observed while I got into fights. But sometimes, their hard-line policies exasperated me.

It was a triumph of lawyerly argument for me to convince my folks to let me walk by myself the eight blocks to Verdugo Park to shoot baskets. *Walk,* definitely not bike. I promised them that I would be home no later than 7 P.M. They bought into the plan, reluctantly, because they had seen the park's gym and found it to be well-supervised. Those shoot-around sessions and pickup games became an essential outlet for me, a kind of therapy. But basically our block, the schoolyard, and Verdugo Park were my safe zones, the three places in which I was permitted to roam.

I was freer on set, especially on the days when *The Andy Griffith Show* was filming at the Forty Acres backlot, where we shot our exteriors. At home, I had a sleek banana-seat Sting-Ray bike but basically nowhere to ride it. Opie's bike at Forty Acres was a heavier, more old-fashioned Schwinn model with bigger wheels and fatter tires, but I was allowed to pedal it to my heart's content when I wasn't needed in a scene.

Forty Acres had so much scenery to look at—literal TV and movie scenery. I rode by the railroad tracks from *Gone with the Wind,* the marketplace from *The Ten Commandments,* Tarzan's jungle, the camp from *Hogan's Heroes.* These sets and villages mesmerized me. They seemed to hold stories, *secrets.* Dad used to tell me tales of his lonely farm-boy childhood, and how, in his isolation, he was forced to dream up his

own adventures, about knights in shining armor and heroic cowboys outdueling the black hats. In a way, my Forty Acres bike rides were my version of Dad's childhood experience—they fired up my imagination.

I delighted even in the junky remnants of old movie productions: shredded cables, coiled-up lengths of rope, the spent carbon rods of the old-fashioned arc lights that the studios used long ago. In these inert things I picked up on the vibrations of decades of film and television history: something much bigger than me, something *important*. And something that I was now a part of.

I've never outgrown this habit of wandering. I did it when I was on *Happy Days,* pacing alone through the historic Paramount lot as I grappled with big decisions about my future as an actor and director. And I do it now. Whenever I have a creative meeting at a Hollywood studio, I make a point of stealing some time afterward to walk around the soundstages and what is left of those backlots. (Forty Acres was itself sold off and bulldozed in the 1970s. Today it houses office parks and light industry.)

On these walks, I find myself soaking up the ghosts and the atmosphere—and, if it's a place where I have acted or directed, enjoying the personal memories that flood my mind. I think of the people who worked in these places, the conversations they had, the creative problems they solved, and the range of intense emotions that the talent and crew must have felt in these spaces. It's soothing and settles my nerves. It reminds me of the calm and joy that Forty Acres brought me fifty-plus years ago.

CLINT

I was basically born into a world of lights, cameras, and boom mics, so I, too, am in my comfort zone on a set. Same with filming on location, for that matter. The first time I traveled was when I was six. I was cast as

the guest lead in a 1965 episode of *Bonanza* entitled "All Ye His Saints."
This was no small thing. *Bonanza* was the top-ranked show on televi-
sion that year.

Dad and I got to fly up to Lake Tahoe, where they filmed the Pon-
derosa Ranch scenes and other exteriors. I thought it was the coolest
thing in the world that you could just step off a plane and play slot ma-
chines right there in the airport. Dad was conservative about betting
and gambling, but he couldn't resist—he put about a buck's worth of
nickels into the machine. No jackpots were hit. Dad just said, "Yeah, it's
true, you can't win on these things," and that was pretty much the only
time I ever saw him gamble.

More importantly, this was my first time working with Dad inten-
sively on dialogue preparation. I played a kid named Michael Thorpe
whose rancher dad is accidentally wounded, potentially fatally, when his
own gun goes off in a barn. Michael hears the doctor say "Only God can
save him now," and the rancher's right hand, a sage Indian named Lijah,
points to a mountain in the distance and tells the boy that God lives
"high in the mountains, all alone." Michael takes a mule from the barn
while all the adults are sleeping and sets out for the mountain to seek
out God and plead for his father's life. He encounters a mysterious man
who looks the part—wavy white hair, long white beard—but the man
is actually a hateful, murderous fugitive, played by the character actor
Leif Erickson. Little Joe and Hoss, played by Michael Landon and Dan
Blocker, get on their horses to find and save Michael.

This was heady stuff for a six-year-old. In one scene, I had to say "I
hate God!" when Lijah explained that everything that happened in life,
including Michael's father's injuries, was a part of God's plan. Beyond
that, I simply had a ton of screen time and dialogue in this episode,
which also required me to ride the mule and execute a clean dismount
like a High Sierra kid who'd been around horses and mules his whole
life. Dad was my tutor in that technique as well.

The producers cast Dad in the show as a member of Hoss's posse—a nice twofer for them, because they filled a role and got their child whisperer. I was not yet able to read, so he helped me embed the dialogue in my head with his usual strategy of building a backstory with me for the character. The more I understood Michael Thorpe's interior landscape, the better I delivered my lines. A few years later, my dad's director friend Bob Totten teased him about this technique. "Well, Howard," Totten said, "you're not really a dialogue coach, so what are you? I know! You're an *inculcator*!" And he was right: to inculcate is to instill ideas by persistent instruction. That was Rance Howard.

Most of the time, the child whisperer literally whispered. When I had those big emotional scenes where I had to question God, metaphorically and literally, Dad put his arm around me and took me aside. In his softest voice, he said to me, "Think about if your father was hurt and you thought that he might die, and you don't want him to. How would you behave?" He helped me find the character's truth. In fact, I never felt closer to him than in moments like these, my head pressed against his thigh as he spoke quietly into my hair.

"We're going to get to that emotion and you're really going to cry, but don't be scared," Dad said reassuringly. "I'll be right here when you finish."

With any location shoot, there's a sense of bonding that you don't get on a soundstage. Landon and Blocker drew close to me, impressed by this tiny kid who could honestly bring the feels. I have a photo of me sitting on Dan Blocker's knee. It's funny because our faces are the exact same shape, but he was six four and well over three hundred pounds. In his lap, I look like a chihuahua.

I also dug learning a cool trick of the trade. My character was saved from Leif Erickson's when the Indian, Lijah, who was played by Rodolfo Acosta, a fine Mexican American character actor, snuck up behind the villain and stabbed him in the back. To pull off this scene, they put a

wooden plate under the back of Erickson's shirt and jammed a knife into the plate. Then a prop guy applied "blood" to the stab area. On-screen, you see Leif fall forward in shock, with the knife sticking out of his back. I loved discovering how all this was pulled off; like Ron says, it's the joy of being in on the magic trick.

This was my first major acting gig and I enjoyed it—the camaraderie and the time spent with Dad. I was already comfortable enough in my own skin as an actor to pass judgment on others. Michael and Dan were strong actors, capable of intensity and nuance. But I flagged Lorne Greene. No disrespect to the white-haired Cartwright patriarch as a person, because Lorne was as nice to me as the others. But as small and inexperienced as I was—with four front teeth missing, no less—I couldn't help but think to myself, *This guy's acting is a little stiff, a little cheesy.* Did I mention that I could be an arrogant little bastard sometimes?

I WAS SO busy as an actor in the mid-1960s that pretty soon, my life assumed the rhythms of Ron's earlier in the decade: riding shotgun with Dad in the Chevy Nova Super Sport as we drove to and from the studios. Mom took over shuttling Ron to work unless he had a particularly weighty *Andy Griffith Show* episode to do, in which case Dad accompanied him to Desilu Cahuenga.

Dad and I almost never talked on the outbound ride to the job. We had done my homework the night before, running my lines, and there was nothing more to do but the work; I often grabbed a little extra sleep in the car. But on the ride home, things were looser—we talked about baseball, school, the auditions that he was going on, life in general.

We continued to do a version of this round trip, up and over the mountains into Hollywood and back, pretty much right to the end of Dad's life. Sometimes it was for a function, other times for a script

reading. Sometimes the configuration was the opposite of what it had been in my childhood, with me behind the wheel and Dad riding shotgun. No matter what, I cherished those private moments with him in the car.

Around the year 2000, not long after Mom died, we were coming back from some meeting or other, taking the usual route home on Cahuenga Boulevard. Dad was somber. At the interchange of Cahuenga and Barham Boulevards, where our chunk of the Valley comes into view, he said, "You know what I miss most about your mother? It's that I don't have anybody to talk to when I come home from an audition."

RON

That one-to-one time with Dad in the car was precious to us. On that same stretch of road, coming home from Desilu one day, I talked to Dad about the work he was doing as a screenwriter. Though his acting career hadn't led to the stardom he had hoped for, he was proud of his ability to branch out, directing shows in community theater and, especially, writing scripts. He had a regular writing partner named Hoke Howell, a tall, drawling actor from South Carolina who had achieved the same level of success as Dad, taking on character parts and supporting roles in a series of movies and TV programs.

Apart from a single episode of the ABC police drama *The Rookies,* none of Dad and Hoke's spec scripts were ever realized as productions. But Dad was immensely validated by the fact that *The Flintstones* had accepted and produced two of his solo scripts in 1964. In the car, he let me know that he was putting together a new round of story ideas that he would soon be pitching to Mr. Joe Barbera himself, of Hanna-Barbera.

I knew the *Flintstones* backward and forward, and as Dad talked through a couple of his notions for new episodes, I was suddenly struck

with one of my own: What if Fred convinced Wilma to let him get the used car that he coveted, but when he does, he finds out that there is something that's been hidden in the car by gangsters, thereby putting Fred in danger?

This was just a jumping-off point, not a fully realized idea. But Dad said that he would include my pitch in his meeting with Mr. Barbera, and if it sold, he would share the story money with me. A few weeks later, I was pretty damn proud of myself when Dad informed me that Mr. Barbera liked my idea, and that my half of the story money would amount to five hundred bucks. Not bad for a casual conversation on a car ride home! My idea became the germ of a 1965 episode entitled "Fred's Second Car."

In the long term, my exposure to Dad's writing ambitions and achievements meant as much to me as his acting guidance. If I hadn't grown accustomed to seeing him plugging away alone or with Hoke, working on plays, movie scripts, and TV episodes, I would not have had the understanding of storytelling and sweat equity that prepared me so well for being a director later in life.

CLINT

Before my star turn on *Bonanza,* I landed a job as a regular on a CBS series called *The Baileys of Balboa.* The show was cocreated by Bob Sweeney, Ron's most frequent director on *The Andy Griffith Show* and the man who "discovered" me in my cowboy outfit and turned me into Leon. *The Baileys of Balboa* was set at a marina and starred Paul Ford, formerly Phil Silvers's straight man Colonel Hall in the *Sgt. Bilko* series, as a charter-boat captain, and Sterling Holloway, the voice of Winnie-the-Pooh, as the Ford character's first mate. I played a little wisecracking neighbor named Stanley.

The Baileys of Balboa turned out to be a one-season misfire, not a juggernaut like Ron's show. But I shed my disappointments quickly as a young boy. Besides, the gigs kept on coming, even voice-acting jobs. I got to work with Holloway on one of Disney's animated Winnie-the-Pooh shorts, voicing Kanga's little joey, Roo. I was also in Disney's *The Jungle Book*. I played the baby elephant bringing up the rear of the pachyderm parade in "Colonel Hathi's March," a bouncy, Sousa-like military-style song. That was my one sung line, by the way: "In the military style!" Only at my age, "military" came out as "mili-telly." I also advised Mowgli, "Don't talk in ranks. It's against regga-lations."

My garbled pronunciations posed no problem to Walt Disney. I know this because he showed up at our recording session with the Sherman Brothers, who wrote all those amazing songs for the 1960s Disney pictures—"A Spoonful of Sugar," "It's a Small World (After All)," "Supercalifragilisticexpialidocious," you name it. Walt ducked his head into the studio, waved at me, and said, "You're doing a fine job, Clint."

This was simultaneously mind-blowing—*the* Walt Disney knew my name!—and entirely of a piece with our life in early-'60s Southern California. I was a Disney baby. Disney was headquartered in my hometown, Burbank. We Howards started going on day trips to Disneyland in Anaheim when I was still in a stroller.

The Jungle Book didn't come out until the fall of 1967, more than a year after I met Walt. He had passed away in the interim. It was the last great animated Disney movie to be overseen by the man himself. And he liked me.

RON

loved watching Clint act. I envied his confidence. I was always conscious of hitting my mark, not making mistakes, pleasing the director.

Clint didn't give a damn! He had a go-for-broke quality that worked because he was so well-prepared and naturally talented.

In 1966, I did a guest spot on *The Danny Kaye Show,* a CBS variety show that ran in the way-past-my-bedtime slot of 10 to 11 P.M. We shot it at CBS Television City, the site of my early work in *Playhouse 90* and *The Red Skelton Show.* The premise was that I had my own show within Danny's show, called, unsurprisingly, "The Ronny Howard Show." It was pretty corny. My entrance was heralded by six little tap-dancing chorus girls. Then I did a monologue. Then I introduced a fellow child star, a nine-year-old girl named Donna Butterworth, who, in a Louise Brooks bob and a mod minidress, sang a medley of standards. My follow-up line was "It's always a pleasure to hear an old pro belt out a tune."

But the pièce de résistance was a sketch in which I played a James Bond–like character in a spy thriller called "The Spy Who Sucked His Thumb." For this, they cast Clint as my boss, the grumpy old chief who gives the dashing spy his assignment. Clint sat at a desk wearing a fedora and a rumpled suit, completely inhabiting the part as if it was rooted in life experience, slamming a phone down as he said, "Good grief, that diabolical archfiend must be captured!"

We had a lot of eye-to-eye, quick-fire, absurdist dialogue, the kind that often makes actors break and collapse into laughter. But not young Clint Howard. He nailed his part in one take.

Danny Kaye was impressed by the Howard boys' professionalism. We were impressed that he was a fellow baseball freak. When he learned of our mutual interest, he brought out some gloves, a bat, and a rubber ball, and we took some batting practice right there on the soundstage. Clint smacked one high into the catwalks that nearly took out a spotlight.

Clint and I never took our work home. Though we shared a bedroom and atypical lives as young kids with flourishing acting careers, we

simply didn't talk shop at 346 Cordova Street. There was no discussion of our "craft" or even of mundane stuff about our workplaces. Home was where we were simply brothers, not actors.

CLINT

The next big job for me after *Bonanza* was a new NBC sci-fi program that was to make its debut in the fall of 1966. Dad read the script and thought it was pretty good, if eccentric: I was cast as an alien! I was excited because the show was set in outer space, and what kid wouldn't want to pretend he was on a spaceship? The episode was called "The Corbomite Maneuver." The show was called *Star Trek.*

Neither Dad nor I had any inkling that "The Corbomite Maneuver" would have resonance beyond the week it aired. In 1965, NBC commissioned two different pilots for *Star Trek.* The first one, which didn't even star William Shatner as Captain Kirk, proved unsatisfactory to the network. But the second one did the trick; *Star Trek* was picked up as a series. Ours was the first-ever "regular" episode of the show to be filmed, in May of '66, though it was broadcast out of sequence, as the tenth episode of the first season.

None of this was of any concern to me or Dad. We were too busy prepping, because everything about this gig was strange. We were told by the producers that I would speak my lines in my own little seven-year-old voice, but my lines would then be processed through a synthesizer—a very new toy at the time—to create an otherworldly, "alien" effect. Furthermore, for the first time in my career, I was not playing a child. If I remember correctly, Balok had some kind of Yoda-like backstory that revealed that he was something like six hundred years old, though they never used that information in the episode.

In "The Corbomite Maneuver," the USS *Enterprise* is threatened

by a giant, spheroid ship called the *Fesarius* and its belligerent com-
mander, Balok. Leonard Nimoy's Mr. Spock manages to pull up a vi-
sual of the commander on-screen. Balok is revealed to be a terrifying
humanoid alien with a long face, a protruding forehead, and a perma-
nent scowl—he sort of resembles one of those bitter old Hollywood
moguls who've had too much plastic surgery. I won't get deep into the
weeds of the plot, except to say that Captain Kirk keeps his cool, and
a landing party of Kirk, McCoy, and a one-off character named Lieu-
tenant Bailey teleport to a tiny pilot vessel that has dispatched itself
from the mighty *Fesarius*. They are intent on making peace with the
evil commander.

Once they are inside the vessel, they are surprised at how cramped and
low-ceilinged it is, and they discover the scary humanoid to be merely a
puppet, inanimate and unthreatening. Then they hear a chipper voice
say, "I'm Balok, welcome aboard!" That's when things get weird.

The camera zooms in on the source of the voice, a smiling, hair-
less little figure sitting on a throne in a futuristic robe ensemble and a
Roman-style headpiece, clutching a goblet: me!

It turns out that Balok is actually a friendly little alien who runs
the entire *Fesarius* operation from the pilot vessel; he was merely test-
ing the *Enterprise*'s intentions before making a generous overture of
friendship. He pushes a button, and a punch bowl slides out on a tray,
with three more goblets. "We must drink!" he says. "This is tranya. I
hope you relish it as much as I."

"Commander Balok," says Kirk, eager to get down to business.

"I know, a *thousand* questions," Balok says. "But first: the tranya!"

BEFORE WE GO any further, I'll answer the question
that Trekkies throughout the decades have always asked me. What was
tranya, the mysterious, civilization-bridging elixir?

Grapefruit juice. That's all. And not even the fresh-squeezed kind, but the kind poured from a punctured can. More on that in a bit.

I have to credit the *Star Trek* guys—Gene Roddenberry, who created the show, and Joseph Sargent, one of the all-time great TV directors and someone who Dad always held in high regard—for hiring a child. If I were producing this episode and it called for an alien of diminutive stature, logic would tell me to hire an adult little person and make him up accordingly. I would hire someone over eighteen so I wouldn't be burdened with the added expense of a child-welfare observer on the set, or the possibility that the kid would screw up his lines and blow up the shooting schedule.

That they went with that crazy Benjamin Button approach, with a guy who looks like a baby but isn't—*that's* the reason that the episode, and my role in it, are still remembered and celebrated today. It's *so* surprising, so unlike anything any viewer of a sci-fi series would ever have expected.

Some of Balok's lines were a mouthful—he was a superintelligent alien life-form, let us not forget—and demanded that Dad be at the top of his game as a dialogue inculcator. For example, Balok describes the puppet as "my alter ego, so to speak. In your culture, he would be Mr. Hyde to my Jekyll. You must admit he was effective. You would never have been frightened by me!"

Dad and I talked things through so that I had at least a basic understanding of the term "alter ego" and the archetypal Jekyll-and-Hyde story—which, incidentally, is based on a novel by Robert Louis Stevenson, the namesake of our elementary school.

On the day of the shoot, they situated me in a corner of the soundstage where Balok's lair had been built. I waited as they concluded shooting a scene where the bridge of the USS *Enterprise* stood. In the studio, they ring a buzzer and flash a red light to indicate when a scene is starting, so everyone on set knows to shut up, keep still, and not mess up

the shot. They do the same when they're finished. So, when the previous scene was done and the buzzer buzzed, the shadows of several adults—the crew, Bill Shatner, DeForest Kelley—advanced toward me. I perked up—the grown-ups were coming to *my* space. Showtime!

What didn't feel good was my costume. My robelike garment was made of stiff, glittery material, and they didn't even bother to put a lining in it. They never measured my feet for the shoes, which were some kind of uncomfortable hybrid of boots and slippers, with appliquéd sequins. And the crownlike headpiece was really tight and pinched my bald head.

Which, by the way, was *not* really bald. A few days before we shot the episode, Dad and I went into the studio for a full day of makeup prep, supplemented by a few hours of studio school with a tutor. *Star Trek*'s producers asked Dad if I would mind if they shaved my head for the role. My answer was basically, *Yes, I would very much mind! Are you insane?*

Besides my desire not to be made a fool of in school, I loved working, and being a bald seven-year-old would have taken me out of the running for a lot of jobs. For similar reasons, I never bothered to get braces. My teeth came in funky when I was little. When I was nine or ten, the age when kids start to get braces, I resisted the idea. I didn't want to park my career and have a lot of metal in my mouth for a year or two, and maybe not work. Vanity didn't mean anything to me, and my dentist said that my teeth were perfectly healthy—just crooked.

Besides, I didn't consider my teeth to be a burden. To the contrary, they were a blessing—I really stood out. Joe Sargent, the *Star Trek* director, told me to have fun with Balok's laugh, to play it big, and the combination of my hearty "*Ha*-ha-ha-ha ha!" and my crooked teeth was really effective in creating a surreal, WTF vibe.

But back to Balok's bald head. Dad, with my vigorous support, asked the *Star Trek* producers if they could give a skullcap a try. And so they did. A makeup man fitted a latex cap matching my skin tone over my

hair and applied a pair of thick, bushy eyebrows, too. I was transformed before my very eyes—and pretty stoked. I looked funny as a bald kid and I liked the acetone scent of spirit gum, the adhesive they use to fasten wigs and prosthetics to actors. I still do. Above all else, I was relieved that I wasn't going to meet Mr. Razor.

When we shot the episode, I spoke all my lines aloud in my own voice. But for whatever reason, the voice-synthesizer idea was nixed, and they ended up having a talented adult voice actor, Walker Edmiston, loop my lines. Edmiston, who later became the voice of Ernie, the lead Keebler Elf, did a really good, painstaking job, too. If you watch the scene, you can see how he carefully patterned his locutions after mine, such as when Balok invites his guests to sit and "be COMF-table." He nailed my laugh, too.

It was a fun, pretty easy job. The only part that I was not thrilled about was drinking that tranya. When the prop guy popped open a can of room-temperature pink grapefruit juice, I turned to my dad and said, "Can't I have apple juice instead?" I thought grapefruit juice was disgusting. Dad simply walked over to the prop man, asked him to pour a big glass, and drank it down in front of me, pretty much in one gulp. Message received.

In the end, it served *Star Trek* well that tranya wasn't a drink I liked, such as apple juice or orange juice. Had it been, I might have guzzled it down with abandon. But if you watch me in "The Corbomite Maneuver," I take only a gentleman's sip, as a true connoisseur of a fine brandy or liqueur would. It looks like Balok really does relish his tranya. And, in the episode's happy ending, his visitors do indeed relish it as much as he.

THE WHOLE EXPERIENCE was over in a single day. Little did I know that Commander Balok was destined to follow me

around—or, perhaps, precede me—for the rest of my life. As *Star Trek* mushroomed into a cult and finally an epic TV and movie franchise, my "Corbomite Maneuver" notoriety turned me into a canonical figure in the Trek universe. I have since appeared in almost every TV-series itera- tion of *Star Trek—Deep Space Nine, Discovery, Enterprise*.

But as a seven-year-old, playing Balok was just another job. These gigs fell off me instantly back then—on to the next thing, always.

MOM, IN HER ELEMENT

CLINT

How do you get a bear to kiss you? Simple. Put an orange-flavored Life Savers candy in your mouth and pucker up. No American black bear will be able to resist planting his snout smack upon your lips.

Caution: Do not try this at home.

My ursine expertise is hard-earned, having spent three years in the company of Bruno, my furry costar in the feature film *Gentle Giant* and the TV series that followed it, *Gentle Ben*. Bruno, true to his species, had a sweet tooth. His handlers gave me a handful of cookies, grapes, and Tootsie Rolls to keep in my pockets so that he would follow me around and do my bidding. The orange Life Savers were more of a Clint thing than a Bruno thing—I just happened to love them—so I used them for the scenes where the bear and I needed to be affectionate.

The movie *Gentle Giant,* which kicked off this phase of my life, came on the heels of my *Star Trek* job. I auditioned for the part, which led to me taking a screen test at Africa U.S.A., a safari park north of Los Angeles that was run by an animal trainer named Ralph Helfer.

That's where I first met Bruno. I was one of six kids invited there to do a screen test in which our acting partner was the bear—not an easy assignment.

I was the last boy to audition. By that point, late in the day, the bear was tired and hot from working under the lights. As I later learned from working with them, bears, when they are hot, sway back and forth in place, paws on the ground. That's how they cool themselves off. But I did not know that then. I was just a kid actor persevering through the dialogue that I had rehearsed with my dad. There was no way for us to anticipate or replicate the experience of working with a six-hundred-pound animal who stood over seven feet tall on his hind legs, and whose head was now swinging back and forth like a pendulum. The cameras were rolling and I had a problem.

I finally broke from the script, but I guess not from the character. I grabbed the bear's steel chain close to his neck and gave it a yank. "Ben," I said, "you knock it off and listen to me when I'm talking to you!"

At that, the bear held still and I finished the audition. A few days later, Dad got a call from Ivan Tors Productions, saying I had won the part of Mark Wedloe, a boy who befriends an orphaned bear cub against the wishes of his father. Ivan Tors was a Hungarian immigrant who had started out in Hollywood producing sci-fi B pictures but had made his name and fortune with family-friendly movies and TV shows starring animals. He created *Flipper*, the TV and movie juggernaut that featured a trained dolphin, and *Daktari*, the TV series about a veterinarian who looked after lions and chimps in East Africa. Apparently, Tors had watched my screen test and was impressed by my handling of Bruno.

This was big news for little me. Also big: The actor cast as Tom Wedloe, my character's father, was—and this seemed too good to be true—Dennis Weaver. The same Dennis Weaver who had introduced Dad to

Mom at the University of Oklahoma twenty years earlier! He had since become an Emmy-winning actor beloved for playing the funny sidekick, Chester, to James Arness's Matt Dillon in *Gunsmoke*. This was his moment of transition into leading-man roles. In a few years, he would star in the TV series *McCloud* and the TV movie *Duel,* the directorial debut of Steven Spielberg.

The actress Vera Miles, a favorite of Alfred Hitchcock and John Ford, was cast as my mother, Ellen. And, as with *Bonanza,* the producers gave Dad a little part as a villain so that he could be doubly useful to the production.

The filming was to take place in Florida. Thanks to the success of *Flipper,* Tors had built a four-stage studio complex in Miami for his ever-expanding roster of animal-themed productions. For this reason, *Gentle Giant,* the movie, had a different setting than its source material, Walt Morey's novel *Gentle Ben*. The action was relocated from Alaska to the Florida Everglades, and Ben was changed from a grizzly—which is native to the upper latitudes of the United States and Canada—to a black bear. Which is just as well. Grizzlies are bigger and meaner.

Dad and I flew first class to Miami from Los Angeles on National Airlines, a routine I would come to cherish over the next few years. In those more elegant days of travel, the flight attendants conducted trivia quizzes and raffles for which the prize was a bottle of champagne. I won it an inordinate number of times. Never drank the bubbly, but it was momentous to be sitting in first class with a bottle of champagne.

Once we arrived in Florida, the trainers reintroduced me to the bear, Bruno. We had met fleetingly at the screen test but now we had to get to know each other as peers. Bruno was in a large chain-link cage with a cement floor at the Ivan Tors complex. The first thing the trainers did

was toss a steak to Bruno. He sniffed it and turned away from it. Lesson: I am meat, and the steak is meat, but the bear doesn't like steak, ergo the bear will not try to eat me. I am not a meal.

Next, the trainers threw a box of doughnuts into the cage. Bruno tore the box apart as if in a diabetic frenzy, consuming its contents as fast as he could. Lesson: Bears love things that are sweet. Sweets will be used to incentivize the bear to do stuff.

Bruno's trainers, Vern Debord and Monty Cox, then stepped into the cage and playfully wrestled with him. No injuries incurred. In fact, it looked like a lot of fun. I was too little to wrestle with big bears, but later on, I did get to tangle with some of the cubs in the Tors menagerie. Everything was cool. I saw that Bruno wasn't going to hurt anybody, and Vern and Monty were really comfortable with the animals. They were always going to be on set, ready to assist me and bring Bruno under control should anything ever go awry. Furthermore, they had declawed Bruno and removed his incisors so that he posed no deadly threat—measures that would be considered inhumane today but were routine in show business back then.

I am still asked if I was ever afraid of the bear. I just wasn't. The trainers and Ivan Tors saw to that. It was a different story when the big cats were around. A big cat is a natural adversary of a bear, and once we went to series, they occasionally brought in a cougar to play the heavy in an episode. On those days, it was like having the Secret Service around. There were men standing there with tranquilizer guns at the ready, and the guest animal was doped up a little to keep him off his predatory game. Suffice it to say, they never let me get too close to the kitties.

Bruno really was gentle. When we were making the movie, I was still so small that I could climb onto his back and ride him. He didn't respond to affection the way a dog or cat does, with purrs and big-eyed

tenderness—bears have small eyes, which inhibit their expressiveness as actors—but he was always fine with me petting and hugging him. The only negative I could hang on my costar was that he smelled. He also took prodigious dumps due to his equally prodigious diet. Every day, he consumed a dozen loaves of bread, a few heads of lettuce, some carrots, a couple of bags of Purina Monkey Chow, and several boxes of day-old sweets. If I had that diet, my poop would smell bad, too.

The shooting itself took about six weeks. Dad had a great time hanging out with Dennis again and everyone was pleased with the outcome. That's when CBS reached out to Tors about turning the film into a series that would pick up where the movie left off. Dennis's character, who started out as a pilot who spotted schools of fish for fisherman, would now be a game warden in the Everglades, looking out for poachers and such. Ben the bear would move in with the Wedloes, setting up the premise that he was constantly thrust into the position of rescuing little Mark from peril.

A series of my own. Sweet! Nothing against Ron, but I was competitive, and I can't pretend that I didn't want to give him a run for his money. Opie was already a household name. Why not Mark Wedloe?

The TV show, though, would require Dad and me to be gone for four or five months of the year, every year for as long as the series ran. Not every actor wants to pull up stakes and live somewhere else for that amount of time. Vera Miles, for example, bowed out, citing her kids, who were going to school in California. Her role was recast, with an actress named Beth Brickell stepping in.

Dad saw the opportunity as too good for me to pass up, and Dennis used his pull to ensure an expanded role for Rance Howard the actor, as Tom Wedloe's comic sidekick, a swampland local named Henry Boomhauer. Ivan Tors magnanimously agreed in writing that Mom and Ron would be given airline tickets so that whenever *The Andy Griffith Show*

was on hiatus, they could come stay with us in Florida. It wasn't like Dad and I were going off to war. We were a tight-knit family, and this arrangement posed no obstacle. Or so I thought.

RON

I don't know that I totally agree. This was precisely the scenario that motivated Mom to get out of acting in the early 1950s—she never wanted to be apart from her husband for a significant length of time.

On top of that, Clint's getting *Gentle Ben* coincided with my entrance into puberty. When I was thirteen, my parents gave me the go-ahead to move into the third bedroom in the Cordova Street house, the one that Dad had been using as an office—probably because they didn't want to expose my impressionable little brother to the behaviors of his confused, newly horny older sibling.

It was a good call. Let's just say that around that age, I became very . . . active. Dad and Clint were away in Florida when I approached Mom, full of questions. I was used to Dad's forthrightness and imperviousness to so-called taboos. So I thought it was perfectly okay to inform Mom of my nocturnal emissions and my more conscious bedroom activities, and to ask her if this was all normal, and, if so, if I was going about it the right way.

The scene unfolded like one in a sitcom. Mom literally put her hands to her ears, horrified to be put in this position. Speaking in a booming "La-la-la, I can't hear you!" voice to drown out any further disgusting revelations that I might have been sharing, she said, "You're going to have to wait until your dad gets home to talk about that. Ask him, not me!"

So wait I did. When Dad finally did return home for Christmas

break, he gave me the usual no-frills, no-thrills Rance Howard expla-nation: "Some people call it jerking off. But masturbation is the actual term. It's all very normal. It's not dirty. Don't worry about it." For good measure, he bought me a subscription to *Playboy* for my birthday, with a gentle warning never to leave an issue around where Clint could see it. Or Mom, for that matter.

BEYOND MY SURGING hormones, Mom had a lot of other stuff to deal with. With Clint and I both working a lot in the mid-1960s, her discretionary time dwindled down to almost zero. It be-came her duty to shuttle me to Desilu Cahuenga and the other *Andy Griffith* locations, and to be my guardian on set. She was also a compul-sive undertaker of ambitious projects. She organized the PTA pageants at our schools, flexing her show-business chops to convince the other moms to perform intricately choreographed, elaborately costumed mu-sical routines as the Tap-Dancing Mamas, complete with kick lines. An excellent seamstress, she became known in Burbank for the perfectly rendered doll outfits that she turned out for the school fair every year—couture for Barbie, basically. She loved sewing those costumes, and they always sold out.

On top of all this, she had to keep house. Our parents' partnership was truly a marriage of equals, a fifty-fifty deal in terms of love, mutual respect, and the division of labor. But in practice, it hewed closely to old-fashioned gender roles, with the Howard men going off to work and the sole woman holding down the home front. Mom wasn't a super-duper Donna Reed–style housewife. She was the first to admit that she hated cooking, even though we all loved her burgers, steaks, and Spam sand-wiches. And she took no joy in the uphill battle to keep our house clean. Who could blame her? Both of her sons were slobs, and she didn't want to press us, given our school and acting workloads. Dad pitched in with

some dishwashing and vacuuming but was otherwise monomaniacally focused on writing and acting.

CLINT

Ron was the far bigger slob. He was allergic to performing even the smallest of chores, like picking his clothes up off the floor. In fact, when Ron graduated from high school, Mom hired a professional fumigator to de-skankify our house's upstairs, such was the damage that Ron and his cat, Tiger, had done. It wasn't until he moved in with his bride, Cheryl, that Ron was house-broken. And just barely.

RON

I plead guilty.

The bottom line is, Mom needed reinforcements. The solution, for a few months anyway, was to have our dad's mom, Grandma Ethel, come stay with us and help out. She was an altogether different sort of person than our other grandmother, Louise. Whereas Grandma Louise had been raised in material comfort in a bustling town, Ethel grew up on a farm, riding horses and tending to the family's hogs and chickens. She had the lean, weathered face of a woman in a Walker Evans photograph. And she was reserved where Louise was talkative. The only thing that our two grandmas had in common was that they preferred to eat their meat the same way: fried and smothered in gravy.

Grandma Ethel had a confidently steely air. While she was supportive of her son's journey westward, she still called our dad Harold and was markedly indifferent to Disneyland, Grauman's Chinese Theatre, and anything to do with "the show bidness," as the phrase came out in her flat, Oklahoman voice.

Still, she was truly impressed by the nearby desert and the mountains that surrounded us in Burbank. And by the ocean, which she got to see for the first time in her life, in her sixties. Most importantly, she was always warm toward Clint and me, in her quiet way. She got a kick out of our suburban, baby-boomer way of life, which was exotic to an Oklahoman born in 1904, and I got a rare guffaw out of her when I modeled one of my most prized possessions, a Beatle wig.

Mom had a tumultuous relationship with her own mother, but she really bonded with Grandma Ethel. Their favorite joint activity was to drive deep into the San Fernando Valley and beyond to check out the model homes in the new housing developments that were going up in the old orange groves. It's all built-up now—Agoura Hills, Thousand Oaks, Westlake Village—but at the time, the area was wide open and the air still carried the scent of oranges. In the mid-1960s, the Ventura Freeway, the segment of Route 101 that cut through our area, ended in Calabasas, twenty miles west of Burbank. For the remainder of the ride, it was just a dinky little two-lane road. Which could make for a long ride if we got stuck behind a semi.

Did I mention that we were dragged along on these excursions, too? When Clint and Dad were around, we all piled into the Super Sport, with Dad behind the wheel. Clint and I found these outings boring as hell. But Dad was gracious and tolerant. He understood that this was an escapist release for Mom, who dreamed of a bigger, airier place than our increasingly cramped house, where we all shared a single bathroom. Given Mom and Dad's frugality, there was no chance that they would ever pull the trigger and buy a new-build home out in Westlake Village. They didn't believe in taking out mortgages, nor did they want to live farther away from the studios.

But Mom and Grandma Ethel liked to walk around the showpiece houses that anchored these rising developments, imagining what it would be like to live someplace so modern, so roomy, so expensive.

Ethel, a pragmatic woman who knew a lot about construction, had a good eye for structural strengths and weaknesses, which Mom admired. When Ethel noted a sign of shoddy work or substandard quality—poor drainage planning, cracks forming prematurely in the walls because the houses were settling on fill dirt—it offered Mom some consolation. Yes, it would be amazing to live out here, far from the intensifying, cough-inducing L.A. smog—if only these fancy builders had any idea of what they were doing.

We were lucky to have the time with Grandma Ethel that we did. A few months after her stay with us, she passed away in Oklahoma, suffering a heart attack after making a long drive in a snowstorm to visit her sister, who was hospitalized at the time. Dad took the news stoically. We didn't travel east for the funeral, because, as far as Dad was concerned, we couldn't. *The Andy Griffith Show* was in the middle of production.

CLINT

Mom had her own serious health issues to contend with. She was in constant pain from rheumatoid arthritis, an autoimmune disorder, which made her hands and feet swell up. Dad showed me a picture of the character actor John Carradine, whose hands were gnarled by the condition, to explain what Mom was going through. She wasn't as bad off as Carradine, but she really struggled.

There were mornings when Ron and I found her still in bed with a heating pad, sadly looking up at us and saying, "I've had another attack." Then she would somehow pull herself up to get her boys off to school or the set, suffering with every step, waiting for the aspirin to kick in. That she could participate at all in her beloved PTA shows was an act of sheer willpower. The mornings after those Tap-Dancing

Mama routines were particularly brutal, with Mom blinking through the pain like a pro running back on a Monday morning. Jiminy Christmas, was she stoic.

Mom did herself no favors with her personal habits, an inheritance from the health-be-damned Speegles. She was a two-pack-a-day smoker for much of our childhoods, and she drank four or five cups of coffee in the morning. And then she'd drink more coffee still at her favorite hangout, Albin's Drugs on the corner of Magnolia Boulevard and Hollywood Way, owned by the same family as our beloved Albin's toy store.

The drugstore had a classic, 1940s-style, Formica-topped lunch counter and a staff of chatty, salt-of-the-earth waitresses of the same vintage. For Mom, a half hour at the counter at Albin's was like a microdose of the escapist joy that she got from looking at the model homes in Westlake Village. One of us boys or the other often accompanied her there, kept occupied eating a hot dog or a grilled cheese while she took drags on her cigarette and gabbed with the waitresses.

She was happy and in her element with these ladies, and I could see how these moments with them sustained her. She had been a hell of a waitress herself in her younger years, she told us, bragging about the tips she earned. Albin's, she said, reminded her of the greasy-spoon coffee shop that her family had run in Duncan. Burbank was still a small town, and Mom, for all of the pain she endured and the responsibilities she shouldered, was one of its linchpins. She was always at the center of the waitresses' chitchat, prompting them to explode into laughter at punch lines I never quite understood.

But her physical ailments caught up with her. Though she was only in her late thirties, she was aging fast. She dyed her hair for a while before deciding "to hell with it" and letting it go white. Like her parents, she was fitted with dentures before she turned forty. Her dental and respiratory issues were partly a product of the advice of a Duncan doctor who told her when she was a teenager that if she wanted to be an actress,

she should take up smoking to keep her weight in check. Mom finally quit smoking when she was forty-two, in 1969, but by then the damage was done. She dealt with emphysema and shortness of breath for the rest of her life.

Mom was also self-conscious of the weight that she put on as we boys grew. Dad was naturally disciplined in terms of physical fitness. He watched what he ate, seldom drank, and performed a set of calisthenics that he learned in his air force days: leg lifts, knee bends, crouches, jumping jacks, and other old-fashioned exercises that, he pointed out, could be done anywhere and didn't require an expensive gym or trainer. Ron and I dubbed this workout routine "Hick-ercise." We were busting his balls, but Dad proudly and defiantly embraced our term, taking the steam out of our suburban-boy jive. Dad occasionally tried to gently cajole Mom into looking after herself by improving her diet and inviting her to join him for an after-dinner walk. It always disappointed me when Mom begged off. But Dad betrayed no frustration or hard feelings. He loved Mom without reservation or critique.

I wish that Ron and I had been as kind. We were dumb, insensitive kids sometimes. In the same way that we joked to each other about Dad's receding hairline, we snickered about the loudly patterned muumuus that Mom took to wearing to conceal her body. We also teased her about her worrywart tendencies.

As the sole woman in the house, she had to deal with a ton of male energy, which translated into roughhousing, nicks, bruises, and many close encounters with lamps and the corners of coffee tables. Mom lived in a constant state of worry that Ron and I were going to hurt ourselves tragically. This dated back to before I was born, when Ron was filming *The Journey* in Vienna and they toured a castle. As they walked along the low, ancient parapets, Mom was too concerned with Ron's safety to enjoy the outing, constantly reminding Dad to hold Ron's hand. Dad jokingly responded, "All right, Jean, I'll hold his hands and you hold

his feet." This became a go-to callback in our family that even I picked up on. Every time Mom overdid it with the maternal fear, we would say, "I'll hold his hands and you hold his feet." We laughed. Mom didn't.

She also had a tendency to pick at sores on her face, making them worse. This has now been classified as a disorder called dermatilloma-nia. But back then, we wrote off such behaviors as the result of bad habits or character defects. To us, this was just a nervous tic and another thing that Ron and I teased her about, along with needling her about her smoking.

Dad was the arbiter of how far we could go in razzing Mom. If we overstepped, he shut us down, telling us firmly that Mom would quit smoking when she was ready to quit smoking.

RON

When Cheryl, my girlfriend and future wife, entered the picture in my teen years, she witnessed us winding up our mom and scolded me. It upset her, for good reason, that we took pleasure in making fun of our own mother. I needed that lesson in maturity.

I also didn't fully grasp what she was up against. Were she alive today, Mom might be diagnosed with obsessive-compulsive disorder. As proficient as she was at sewing the doll clothes, managing our finances, and in general serving as the Howard family's chief operating officer, she worked herself up into a lather of worry as a deadline loomed—which, again, was an occasion for Clint and me to give her grief.

There were times in my childhood that I was embarrassed about the visual disparity between Mom and Dad. He always looked the same, trim and handsome, while she started to look like a little old lady, with her white hair and pallor. One time, when we were all out Christmas shopping at the Woodland Hills Fashion Center, an early shopping

mall, a woman recognized me and approached us with an Instamatic camera. She asked for a photo, and my parents, who taught me to be friendly and accommodating toward fans, encouraged me to oblige. As the woman lined up the shot, she turned to Mom, gesturing toward Dad and Clint, and said, "Can I get your older son and his boy to be in the picture also?" She thought that Mom was my grandmother, Dad my brother, and Clint my nephew.

Dad immediately put his arm around Mom and said, good-naturedly, "I'm her husband, and you don't want me in the picture." Mom laughed off the woman's faux pas with an improvised joke about being a cradle robber. The woman, flummoxed, dug herself in deeper with an extended apology before slinking off. That was that. But I was mortified for Mom and, in the moment, mortified that my mom could pass for a grandma.

I am ashamed of these feelings now. I am also ashamed of how we teased Mom, and of the part of myself that thought she was to blame for her health woes and anxiety. Knowing what I know now, I am in awe of her fortitude. She underplayed the extent to which that New York City street accident, suffered when she was only seventeen, shaped her adulthood. Yes, she made what the doctors called a "full recovery," but realistically, she was never the same physically afterward. The accident affected how she carried her babies, gave birth, went about her day, and raised her children. OCD or no OCD, she had every reason to be fearful of her kids getting badly hurt—because *she* had gotten badly hurt.

I SHOULD MAKE it clear that Mom was not a complainer. A chronic worrier, yes, but never a moaner or a groaner. Quite the opposite, in fact: she was a glass-half-full person, an acolyte of Norman Vincent Peale's *The Power of Positive Thinking*. Her default mode was cheerful pragmatism no matter the reality. Let's not forget that, while

Dad had the will and the gumption to dream of riding into Hollywood on his horse, it was Mom who had the actual horse sense. She was the one with a head start in show business and a practical knowledge of how to go about getting into it. It was her can-do spirit that propelled Rance and Jean Howard forward.

In 1984, when I directed my third feature film, *Cocoon,* Mom made her first tentative noises about returning to acting, having forsaken it three decades earlier to focus on her family. I put her in the movie as a key extra, a background actor who has no dialogue but appears in a lot of scenes. True to form, she charmed everyone in the cast. She had some heart-to-heart conversations with Maureen Stapleton, Jessica Tandy, and Gwen Verdon in which they, for all their success, voiced regrets about their life choices. They all expressed to Mom that they envied her for having spent the amount of time she had with her children. There is no one correct way to achieve work-life balance, of course, and the conditions for doing so as a working actress in the twentieth century were brutal. But Mom was buoyed by her talks with Maureen, Jessica, and Gwen. "They made me realize that, for me, I did it right," she told me.

Mom opened up to me further in 1988, on the eve of what would be the first of her three heart surgeries. We were talking in her hospital room, whose every surface, from her bed to her tray table, was covered in ledgers, notebooks, and boxes of receipts. She was feverishly working against the clock to get her and Dad's books together for tax season. There was an unspoken subtext to her urgency that frightened me. She was clearly concerned that she might not make it through the surgery. If she died, though, Dad could at least take solace in the fact that Mom had filed that year's returns and left him a road map for how to do the filing himself in the future. Typical Mom—she was more worried about Dad's having to do the taxes than her heart.

That evening, though, Mom moved the conversation in a direction that was, for her, unusual. She spoke about her youth, which she

was seldom inclined to do. With sobering candor, she described the ill health that had followed her around from the New York accident onward: the constant pain, the onset of arthritis, losing her teeth, getting hooked on cigarettes because of that ill-informed doctor in Duncan. This was all related matter-of-factly, without an ounce of self-pity. And then she said, with a smile and complete sincerity, "But I had a wonderful childhood."

I've turned this conversation over in my head for years. It made me recognize that, for all of Mom's optimism and charisma, her adult life had held its share of disappointments. I didn't understand this when I was young, because I was just a kid and she wore her setbacks and ailments lightly, at least for her kids' benefit. After our talk in her hospital room, I came to realize that it wasn't her family life with us that she leaned on to make her feel grateful and fortify her will to keep going. It was her memories of an idyllic time unviolated by struggle or physical pain: her childhood.

I had underestimated my mother: not only how giving and selfless she was, but also how tough she was.

I WAS ALLOWED a rare glimpse of a more carefree version of Mom when, in the mid-1960s, CBS sent me to New York on a promotional junket for *The Andy Griffith Show*—just me, not Andy or Don. Dad was otherwise occupied with Clint, so this became an opportunity—the only opportunity, as it turned out—for me to spend some leisure time with Mom in her favorite city. That's what she kept saying as we were flying there: "New York is my favorite city in the world!"

The network put us up in the St. Regis, one of the grande-dame hotels along Fifth Avenue. This animated Mom in a way I hadn't seen before. She told me why: in her and Dad's scuffling days, she often

took walks past the St. Regis, looking longingly at its ornate facade and arched entryways. On these walks, she fantasized about what it would be like to stay at the hotel. Now her fantasy was coming true.

We ordered room-service breakfast, a first for me and a major departure from Mom's normal, frugality-minded ways. With CBS footing the bill, Mom cut loose. She took me to Sardi's, the show-business hangout in the Theater District, and delighted in pointing out all the caricatures of famous people on the walls and telling me about each figure. While we were there, I had an in-person celebrity sighting—for a baseball-mad little kid, anyway. Right before my very eyes, sitting at a table eating a steak, was Ford Frick, the commissioner of Major League Baseball. With Mom's prompting, I introduced myself to Mr. Frick, and he kindly engaged me in some baseball talk. I have no idea if he recognized me as Opie.

CLINT

Some years later, I, too, enjoyed a one-to-one work trip with Mom. Along with three other child actors—one of whom was Maureen McCormick (Marcia on *The Brady Bunch*)—I was selected to participate in an NBC special produced by Art Linkletter entitled *A Kid's Eye View of Washington*. It was basically an educational travelogue about the nation's capital, with the four of us as hosts, culminating in a scene where we all met the president in the Oval Office.

Nixon left a lasting impression on me. He had wrinkles upon wrinkles and was sweating profusely. He also had a certain scent, one that I would later come to recognize as the acrid odor of a heavy smoker and drinker. I wasn't so much scared of him as concerned. To Mom, I raised the question, sotto voce, "Is he *sick*?" Mom assured me that he was just . . . himself. And then we went to visit the Smithsonian.

The best part of my New York trip with Mom was the cheapest. She took me to the Horn & Hardart automat in Midtown, which was already a relic of bygone days, a reminder of the times when she and Dad, at their most penurious, could still get a cup of coffee and a slice of pie for a nickel. By the time of our visit, the going rate had risen to fifteen cents. I placed some coins in a slot and pulled out a cheese sandwich that was totally underwhelming—cold and dry, with a limp leaf of lettuce and colorless slice of tomato on top.

But that wasn't the point. The aura of the place, with its still-packed tables and art deco design, sucked me in, and I understood the pleasure that Mom took in being there. While we were eating, we heard a voice say, "Jean? Jean Speegle?"

This was unusual. I was by this point used to hearing people call out "Hey, Opie!" in public places, but this was the first time that I ever heard someone call out Mom's name—her *maiden* name. We turned our heads. The words were coming from a diminutive man with dark, slicked-back hair and flashy rings on his fingers, a real Damon Runyon character, complete with a fat cigar.

"Felix!" Mom cried, beside herself with excitement. The man was one of the little people with whom she and Dad had acted in the children's-theater troupe a lifetime ago. She introduced him to me: "Ronny, this is Felix. He was one of the groomsmen at our wedding! And he played Grumpy in our show!"

To Felix, she exclaimed, "I can't wait to tell Rance I saw you!"

Felix shook my hand firmly and looked palpably relieved to hear the name "Rance." It hit me later that he might not have been optimistic about the long-term chances of the young couple whose wedding he witnessed.

"Where are you two living these days?" he asked Mom.

"California. Rance is getting work out there."

"That's great," he said. "Yeah, I think about doing that, too. But I keep putting off the move because I do the Christmas show at Radio City every year. What brings you back?"

"We're here on a publicity trip."

As I nibbled on my cheese sandwich, Felix cocked his head sideways, studying me with a squint. "Is this . . . is this *Opie*?" he said.

Mom nodded, beaming.

"Well, that's terrific. You kids turned out just great."

It was bizarre to hear someone describe my parents as kids. But as Felix and Mom gossiped and reminisced, I felt like I was traveling back in time. Here was Mom as she was before motherhood: playful, brassy, funny, and girlish, the feisty runaway bride.

When we finished lunch and began putting on our coats, Felix positioned himself next to me so that we stood side by side. At four foot nine, I was just a tad taller than him. "I could be a stand-in for you!" he said, forever hustling, as actors will.

After Felix and Mom said their goodbyes, she was on a high: her beloved New York City had delivered as it always did. It was at that moment, in fact, that she told me, for the first time, the bizarre, storybook circumstances in which she and Dad had tied the knot—the hurried ceremony in the Kentucky hotel lobby, the repurposed Cinderella dress, the joyful reception with their theater-troupe comrades.

ONE ROLE, THREE BEARS

CLINT

When the family reunited in Florida, it was always a blast. Miami had tons of recreational activities and I had a brother to play with again. Ron even appeared in a couple of episodes of the show, though it was hard for him to work outdoors in Florida. I tan easily, but I am not a pale redhead. The South Florida sun burned poor Ron to a crisp. I don't know how Andy Griffith and Sheldon Leonard felt when he returned to work pink and peeling.

We also hung out as a family with Dennis Weaver's family. It was an easy fit. Dennis had his college ties to Mom and Dad, and Dennis's wife, Gerry, was a lovely, down-to-earth woman. On top of that, they had sons our age. The Howards and the Weavers aligned perfectly except in one way: they were vegetarians.

Dennis was the original tree-hugger and health-food nut. The man had eight-pack abs until he died in his eighties, God bless him. When the Weavers invited us to a barbecue, Dad solemnly spoke with Ron and me beforehand. "Now, boys," he said, "there are going to be hamburgers

and hot dogs, but they won't be normal hamburgers and hot dogs. They'll be made of soy."

Plant-based food products in the 1960s were not what they are today. So I struggled to choke down my soy dog. Where the hell was my PB&J when I needed it?

RON

As I mentioned, Dad and Clint's long stays in Florida were a challenge to Mom. But *Gentle Ben* also brought her joy—joy in seeing her second son succeed like her first, and joy simply in the time that she got to spend with her family in the Sunshine State. The moment *The Andy Griffith Show* went on hiatus, Mom and I dashed off to Miami.

The very first time we went, we were bowled over by Dad and Clint's sweet setup: a large, sprawling rental house right on the Intracoastal Waterway. If we'd had a boat, we could have docked it in our backyard.

Unfortunately, I had a bout of food poisoning on our first night there. It unfolded the usual way: suddenly, a few hours after a nice dinner. I rose slowly from my bed and crawled my way through the unfamiliar house to the bathroom, where I puked. Then I knocked on the door of Mom and Dad's bedroom. "Mom, Dad," I said, "I'm really sick."

There was no answer. So I knocked a little louder and repeated that I was unwell. Still no answer. But then, as I put my ear to the door, I heard sounds—sounds of moaning, of ecstasy. It took me a while to figure it out: my parents were doing it! In the moment, as deathly ill as I felt, I actually stepped back from myself to think, *Wow, is it possible that when you're having sex, it temporarily ruins your hearing? Creepy!*

I decided not to disturb them further. I wobbled my way back to the bathroom, where I ended up falling asleep on the floor by the toilet, waking up every hour or so to throw up.

I was fine by morning, so I kept my nocturnal activities to myself. Mom and Dad did the same.

CLINT

Gentle Ben gave me the kind of work family that Ron enjoyed on *The Andy Griffith Show*. Beyond Dennis, there was Ricou Browning, our fearless director, and I mean *fearless*. For a while, he was Hollywood's leading underwater stuntman and coordinator. He played the Creature in *Creature from the Black Lagoon* and coordinated the underwater sequences in the James Bond film *Thunderball*. He was also Ivan Tors's partner in creating *Flipper*. Later on, in the early '70s, I worked with Ricou on another project, a family movie called *Salty*, which was an attempt to re-create the *Flipper* magic with sea lions. It didn't take, alas.

Ricou epitomized what I loved about working in Florida. In L.A., everyone took their prescribed roles seriously, adhering to Hollywood's rigid, hierarchical structure. When we shot *Gentle Ben*, I heard a lot of drawls and noted that everyone dressed in loose-fitting Hawaiian shirts—when they had shirts on at all. And it was all hands on deck. Ricou was equally comfortable doing menial stuff with the crew as he was shouting "Action!" He had a fantastic work ethic and tremendous patience, no doubt the product of working with dolphins on *Flipper*.

Our team was rife with eccentrics. My stand-in, Murray Wood, was sixty years old. He was proud to have played a Munchkin in *The Wizard of Oz* and was quite the dandy. He had an impressively groomed curlicue mustache and Vandyke beard, both snow white. Dad tailored a guest-star role specifically for Murray in one of the *Gentle Ben* episodes that he wrote, as a carnival promoter.

In our off-hours, Sig Walker, the man in charge of maintaining the airboat that Dennis's character drove, introduced us to a distinctively

South Floridian pastime: frog-gigging. You know what gigging is? It's hunting for bullfrogs in the dead of night. You go out with flashlights and headlamps, trawl in very shallow water, and use your gig—which is like a trident, but with four prongs—to impale the biggest, fattest frogs you can find.

Sig was a local legend: a rugged master mechanic who raced airboats and hunted when he wasn't working on *Gentle Ben*. One weekend, he invited the entire cast, along with Dad, Ron, and me, to a gigging retreat at the hunting and fishing lodge he kept in the Everglades, which was accessible only by boat. This suburban Burbank kid found the whole thing fascinating—watching Sig and his buddies pull frogs by the dozen out of the swamp. We celebrated our catch with a late-night frog-leg fry. I wasn't squeamish. The frog's legs were pretty good, though, really, anything tastes good if you dunk it in enough breading, butter, and garlic.

But unlike Ron and friends on *The Andy Griffith Show,* the *Gentle Ben* gang had little time on the set to hang and trade stories. We were on a tight schedule. We did a lot of outdoor shooting on location, most frequently at Fairchild Garden, a botanic wonderland in Coral Gables, and sometimes as far away as a dinky but beautiful town in central Florida called Homosassa Springs. And we worked fast: nine or ten script pages a day, which translates to three days per episode. We did twenty-eight episodes per season.

Given this work rate, Dad and I were bushed by the end of the day. During our first season, the drive "home" from the set to our house on the Intracoastal Waterway was just too far—I conked out in the car before I could eat my supper. So, for the second season of *Gentle Ben,* Ivan Tors rented us a penthouse apartment in a Miami high-rise complex called the Brickell Towers. It's since been torn down, but it sat right at the beginning of the Rickenbacker Causeway, which leads out to Key Biscayne.

Dad was keen to ensure that I still got to be a kid, so as soon as we got the Brickell Towers apartment, he swapped out our dining-room table for a Ping-Pong table. On our days off, we played for hours. Every morning on workdays, Dad rose before me to prepare our three-minute eggs. "Always show up at work having eaten breakfast," he admonished me. On a lot of gigs, craft services puts out an elaborate spread of morning donuts, eggs, bagels, and what have you, almost encouraging you to spend your first hour schmoozing and grazing on the clock. But Dad was firm: "You show up ready to work. You don't show up ready to eat."

On the ground level of our building was a little sundries shop that also had a tiny counter manned by a short-order cook who was known, accurately, as Fat Jack. He was our dinner chef. We arrived home so exhausted that we counted on Fat Jack to whip us up some omelets or toasted sandwiches. He was a garrulous, salt-of-the-oyth Noo Yawk guy who had moved south, and—bonus points!—he knew sports. It was so soothing for me to spend the end of the day in his and Dad's company, talking about the Miami Dolphins as that sleepy feeling descended. After dinner, it was up the elevator to our apartment for a run-through of the next day's lines, followed by a bath and bedtime.

GENTLE BEN MARKED a fulfilling time for Dad as much as me. Ivan Tors and Ricou Browning valued him as a writer as well as an actor, having Dad write five episodes of the show. One, "Ben the Champ," has Ben briefly become a pro wrestler—a nod to his sons' love of the fake sport. Another Rance Howard–written episode, "Flapjack for Breakfast," was conspicuously plot-heavy for the Henry Boomhauer character. Can you blame him? Actors are always trying to give themselves more material to chew on.

The Boomhauer character drove a vehicle that on the show was called a swamp buggy but was, in effect, a pared-down monster truck.

So when I wasn't blasting around with Dennis or by myself on the show's awesome airboat—watch *Gentle Ben*'s opening credits on YouTube, you won't be disappointed—I was joyriding with Dad in the buggy. Oh, and Ivan Tors loved having celebrity guests on the show, so I got to act with the St. Louis Cardinals pitching great Bob Gibson. In that episode, Gibson was in Florida for a fishing vacation prior to spring training when his little boat swamped. Dennis's character happened to be in the neighborhood and rushed in to save him. In gratitude, Gibson offered young Mark Wedloe, a Little League pitcher, some private coaching sessions. It was a lesson in morality: Mark was resorting to unsportsmanlike tricks, such as looking to the sky to distract the batter and then throwing a quick pitch for a strikeout. Bob set Mark straight. The *Gentle Ben* writers really made out Mark to be a greedy, selfish little asshole. But in this instance I didn't complain. I was an eight-year-old boy in the 1960s hanging with one of the game's greats. Another episode featured the great Green Bay Packers quarterback Bart Starr. I was in paradise.

A very humid paradise, however. That was the one thing that really took some getting used to, despite my having grown up in Southern California. To live and work in South Florida was to exist in a constant state of totally drenched sweatiness. And Dad had a certain peculiarity: a deep aversion to air-conditioning. He had grown up on a farm and considered air-conditioning to be an invention for the weak.

He was also primarily concerned for my health. In his view, shuttling between an air-conditioned dressing room and 90-degree weather with high humidity would be a recipe for disaster. He was probably right. He never turned on the air-conditioning in our apartment; he just opened the windows. And he forbade the *Gentle Ben* people from firing up the air-conditioning in our dressing room in the show's honeywagon.

A honeywagon is a long trailer that movie and TV productions use when they are shooting on location. It contains dressing rooms for the cast and a couple of bathrooms, men's and women's. I don't know why

they are called honeywagons, because they usually smell like shit, and those little cubicles that we had for dressing rooms got really, really hot. Beth Brickell availed herself of the honeywagon's AC, and so did Dennis Weaver, the environmentalist and health nut. But Rance and Clint Howard? Never. A fan and an open window would suffice. Nowadays I am the first guy to turn on the air-conditioning—I don't share Dad's philosophy. But it did help me acclimate to working in those conditions.

The show learned its own lesson about the perils of air-conditioning thanks to its marquee star, Bruno. South Florida is not an ideal climate for a black bear with thick fur. When we returned for the second season, having done well in our first, everyone had received a raise. In Bruno's case, this translated into a new dressing room that Ivan had custom-built for him, complete with, yes, air-conditioning. They basically took a flatbed truck and put a huge, climate-controlled box on it, so that Bruno would be comfortable during his breaks.

Well, the very first day of shooting, we had a problem. When Bruno went on a break, he liked the air-conditioning so much that he refused to leave, even with the trainers gently coaxing him with doughnuts. And you can't just pull a 650-pound creature out of a room, or politely invite him to the set.

After a brief confab, the powers that be landed upon a solution. Five or six of the crew's sturdiest guys lifted the back of the trailer off the ground, tilting Bruno's dressing room forward. With gravity doing the rest of the work, the bear slid out and hit terra firma. That trailer was promptly driven away, never to be seen again. Bruno returned to taking his breaks the old way: by hanging out in the shade.

GENTLE BEN THE character was actually played by three different bears. Seventy percent of the time, my acting partner was Bruno, the money bear, the trained thespian. There was a slightly smaller

black bear named Buck who spelled Bruno. And we had a brown bear named Drum who performed all the water scenes. For whatever reason, Bruno, atypically for his species, had an aversion to getting wet. So Drum did the water stunts.

He was a smallish, tame brown bear, but he was still brown. So they sprayed him black. I'm not kidding. They used about a dozen cans of Streaks 'N Tips, a temporary-color spray frequently used in show business, to turn Drum into a black bear for the camera.

Bruno didn't do action stunts, either. Any time Ricou and Ivan needed to depict a bear riding on the back of a truck or jumping off a bridge, they resorted to dressing some stuntman in a bear suit. It looked terrible up close, so visibly fake, but if they shot the stunts at a sufficient distance, they didn't look so bad on TV. Dennis and Dad, and I, I am proud to say, performed our own stunts.

I had no mishaps of any consequence with Bruno. The only time there was ever any drama was when we were shooting a scene in an episode where Mark started collecting junk. He pulled Ben on a chain while Ben pulled a red wagon; he was basically serving as Mark's pack mule, a visual gag. They had Bruno in a harness and it was an extra hot day. I jerked on his chain and Bruno objected, just this once, to having a kid tell him what to do. He reared around, bit my hand, and then pounced on me, pinning my shoulders to the ground like he was waiting for a wrestling ref to count him down to victory. I was scared to tears. The trainers were instantly upon Bruno, and I was rushed to the hospital and x-rayed: negative. I was more stunned than anything. As I said, his chewing teeth had been removed, so the bite was more like a gumming. I never felt anger toward Bruno for this incident; I was mad at the script for putting us in that situation.

The one real injury I incurred on the show was not the fault of a bear but of Mark's pet raccoon, Charlie. Charlie, like the bears, had

his sharper teeth removed, but the trainers had not removed his claws because raccoons need them to hold their food as they eat it. We were shooting a scene where Charlie was supposed to walk up to me, and I would pick him up. Raccoons, unlike bears, go for savory snacks rather than sweet, so I had a dog biscuit in my shirt pocket to draw him near me. We did a couple of takes that worked well, but they wanted to do one more. "Roll camera!" Charlie, now understanding the scene, trotted toward me but instead of letting me pick him up, he climbed me to fetch the tasty morsel out of my shirt pocket. I am not a tree, and his claws cut right through me like X-Acto knives. My pants fared okay but my shirt was shredded. It hurt like the dickens and my chest was covered in blood from all the scratches.

The next day, the wardrobe lady, Peggy Kunkle, outfitted me in a leather under-vest that I was to wear whenever I worked with Charlie. I only wish it had been invented a day earlier. Charlie never hurt me again.

GENTLE BEN WAS given a primo time slot: Sunday nights at 7:30 P.M. on CBS, sandwiched between *Lassie* and *The Ed Sullivan Show*. It faced stiff competition against the first half hour of *Walt Disney's Wonderful World of Color,* but we more than held our own, surprising everyone in the industry. We finished the first season as the number 19 show in the Nielsen ratings. The top-rated program that season was *The Andy Griffith Show*.

I internally wanted us to leapfrog Ron and Andy's show. That's just my nature. I love Ron, but I friggin' wanted *Gentle Ben* to top the charts. Alas, we never got over that hump. But something almost as exciting happened: one week, *Andy Griffith* and *Gentle Ben* finished one and two in the ratings. It was a good week to be a Howard.

RON

I was bursting with pride that week. The ratings were published in *Variety*, and I ran all over the soundstage holding a copy of the latest issue, showing it to Andy and the rest of the cast.

Gentle Ben was wholesome bordering on corny sometimes, and the critics condescended to us just as they did to *The Andy Griffith Show*. But I was proud of the end product. We never pretended to be anything other than what we were advertised as, family entertainment. We did an excellent job and our fan base loved us. In the 1990s, I attended a party hosted by Brian Grazer, Ron's business partner in Imagine Entertainment. One of the guests was Eddie Murphy, then at the peak of his fame and Hollywood heat. He was surrounded by swarms of people and I figured that it wasn't worth trying to introduce myself. To my surprise, Murphy excused himself from his clique of friends and hangers-on to walk up to . . . me!

We spent about fifteen minutes talking. The upshot was that Eddie loved *Gentle Ben*. When it was on, he told me, he was going through a rough time in his childhood. His family was poor, his father died, and his future felt uncertain. What gave him comfort, he said, was that every Sunday night, *Gentle Ben* took him somewhere else. He escaped to Florida and played with the animals. He imagined himself as that little boy—me.

What moved me about this moment at the party wasn't that it was Eddie Murphy. It was his tone—the warmth and honesty, and the way he conveyed how meaningful our show was to him. I hear similar stories from nonfamous people of Eddie's vintage when I'm in an airport or making a public appearance. Much as Balok has followed me around, so has Mark Wedloe, reminding me, over and over, of the lasting impact of good TV.

RON

Mom gave Clint and Dad a hero's welcome whenever they came home from one of their long stretches in Florida. This was especially true when they came home for Christmas.

Christmas was sacrosanct in the Speegle household of Mom's up-bringing, requiring elaborate lights, decorations, and festivities. She brought this spirit with her to Burbank. Every year, as soon as Thanks-giving was over, she would festoon the house with tinsel and bunting that she pulled out of storage. Our tree always dripped with shiny or-naments. Every tabletop was covered in Santa figurines, and two replica toy soldiers from *The Nutcracker,* each about three feet high, stood sen-try outside our front door.

Mom's enthusiasm was contagious, and Clint and I got as hyped up for Christmas as she did. We helped her with the decorations and an-nually visited Santa at the May Company department store to tell him what we wanted.

Inevitably, there came a year when I began to question whether or not Santa Claus was real. I put this question to Dad, who was ready with a considered but no-nonsense Rance Howard answer.

"Well, no," he said, "there is not actually a Santa Claus who lives at the North Pole and drives a flying sled. That's just a legend. And that man whose lap you sat in at the department store? That was just an actor pretending to be Santa Claus."

Hearing these words was a lot like coming upon those wrestlers working on their routine in the hallway of a TV studio: the truth was mind-blowing and kind of cool to know about, but it also hurt.

"Yeah," I said, trying to maintain my composure and stifling the urge to cry, "I thought I could see the fake beard. And I think I saw a Santa suit like that for sale at Western Costume."

"But it's a great story that people tell to get in the spirit of Christmas,"

he said. And then he added pointedly, "And we want Clint to enjoy it for as long as he can."

I kept mum for Clint's sake. But I won't lie; I was shaken by the definitiveness of Dad's debunking of my belief in the sleigh-driving Santa. In the end, however, I felt respected. Dad had honored me with an honest answer.

If you'll forgive the diversion, allow me for a moment to cut to a generation later, when it was the 1980s and I was the father of young kids. Christmas was nearing, and my eldest child, Bryce, asked me the same question that I had asked Dad: "Is Santa real?"

Here was my opportunity to uphold the Howard-family tradition with integrity and dignity. With not a little smugness about how open and frank I was being with my daughter, I launched into pretty much the same speech that my father had given to me.

Disaster. Bryce burst into tears, fled the living room, and ran to my wife, Cheryl, screaming, "Mommmm! Dad told me Santa's not real!"

Once she finished consoling Bryce, Cheryl stormed into the living room. "Why did you *do* that?" she asked me.

"That's what my dad did when *I* was her age," I said, raising my hands in innocence. "What was I supposed to do, lie?"

Cheryl was firm: "Yes, Ron. *Lie!* She wants us to keep the lie alive!" She then announced to Bryce, "Your dad doesn't know what he's talking about. There *is* a Santa."

I was ordered to walk back my words. Which I did.

Bryce, who I suspect was already wise to the entire charade and was enjoying the exercise of emotionally manipulating her parents, simply looked at me and said, "Oh, good."

ANYWAY, THE FIRST year that Clint and Dad were returning for Christmas from Florida, Mom was determined to double

down on the decorations. I was conscripted to be her lieutenant. We got the tree up, put all the seasonal tchotchkes out, and hung some lights in the bushes in front of the house.

But the night that Clint and Dad were landing at the airport, Mom's probable OCD kicked in, and she decided that we had not made a grand-enough statement. She wanted to outline our porch in string lights the way that Dad usually did. I tried to talk her out of it because this would entail getting up on a ladder to nail hooks into the house's facade, and the weather outside was uncharacteristically rainy, chilly, and slippery.

Mom remained adamant. I grew worried. "Mom, let Dad do it when he gets here," I pleaded as she dragged our stepladder into place and gingerly began to climb it. "Mom, I'm taller than you now, I can do it, please!"

"No!" she barked back at me. She was atop the ladder now, her flower-patterned blue muumuu whipping in the wind, a lit Kool clenched between her lips. This was no joke. She was getting emotional. "Your dad and Clint love Christmas," she said. "Rance is going to be here any minute and the decorations are going to be finished and it's going to be the best Christmas we've ever had."

Rain was now falling heavily, streaming down her face and extin-guishing the cigarette. I had no choice but to step off the porch and stand beneath her, ready to catch her if she fell. But she objected to this, too. "Stay on the porch and feed me the lights, Ronny!" she said. "I don't want you to get sick."

None of this made any rational sense. But I did as I was told, and, by God, Mom finished the job, stepped back, and beamed at the out-come. She then ran into the house to dry off and quickly pull herself together. When Dad and Clint arrived, she looked fantastic. She ran out and embraced her husband, and they shared a long welcome-home kiss under the twinkling lights.

THE INJUSTICE
TO SANDY KOUFAX

CLINT

Mom up on a stepladder. That image endures in our heads for a lot of reasons beyond the holidays. Our parents were do-it-yourself people. We never had a cleaning woman or a handyman. If something needed doing, Mom and Dad did it. Including house painting.

We always had cans of paint in the garage, ready to go should Dad feel like taking on a home-improvement project. But these served a purpose beyond sprucing up 346 Cordova Street.

See, Mom had a superstition. Sometimes, Dad struggled to get acting work. Unlike Ron and me, who were working constantly, he had cold spells where he simply couldn't land a part. We'd hear him mouth off to Mom about "that son of a bitch" actor who beat him out for a role in *The Big Valley,* or that casting director who was "going on my list, Jean," for not putting him in *Mannix*. If the cold spell was short, a matter of a few weeks, Dad bided his time writing scripts, and that's when we'd see Hoke Howell come over to hang with him and bat ideas back and forth. But when things got *ice* cold, and Dad went months without an acting job, Mom did the most ingenious thing: she broke out the paint cans.

Mom recognized that idleness was Dad's enemy, and she never wanted him to drift through a day without purpose. So she would get out the paint and the brushes and tell him, "The service porch needs painting, Rance." That sprung him out of his funk.

These painting jobs were never a ruse; the service porch really did need a new coat. But they were also the product of superstition. Mom genuinely believed that if she pulled out the paint cans, an acting job would come Dad's way, leaving her holding the brushes. The amazing thing was that this trick worked! The clanking sound of those cans coming out was almost always followed by the sound of the phone ringing—Dad's agent telling him that he was wanted for *The Monroes* or *The Virginians*.

Next thing you know, Dad would be off working on the Universal backlot, and when Ron and I got home from school, it was Mom we found doing the painting, up on the stepladder with a mentholated Kool in her mouth. It was a sight that never failed to crack us up.

These house-painting jobs didn't do Mom's lungs any favors, between her nonstop smoking and the fumes she was inhaling from the thick, oil-based paints that they used. But there was a sweetness to how this scenario played out over and over again. Mom loved the power-of-positive-thinking messaging of her superstition: if she took out the paint cans, Dad *would* get a part. It was only a matter of when.

I'm sure that Ron and I glimpsed only a fraction of the psychological support that Mom gave Dad to keep him going in our tough, unforgiving business. But I'm glad we have this memory of her on the stepladder. As hilarious as we found it then, it was a picture of love.

RON

As Clint mentioned, the *Gentle Ben* period was a good one for Dad professionally. He wrote and acted on Clint's show, and right before

he began work on it, he landed a recurring role on an ABC program called *The Monroes,* which starred a young Barbara Hershey. That show was a sort of western precursor to *Party of Five,* about five frontier kids who are left orphaned in the Grand Tetons and forced to make their own way. Since the younger kids were child actors, and since Dad had a proven track record with us, ABC hired Dad to serve also as *The Monroes'* dialogue coach.

It was also a time when Dad and Mom were pulling in about twelve grand a year as our managers, in addition to what Dad was earning from his acting and writing. These weren't earth-shattering sums of money, and my parents were extremely cautious investors, but they were disciplined about budgeting and saving. So, in 1968, after five years on Cordova Street, we moved to a larger house. We didn't move far—all of a mile and a half, to the town immediately west of Burbank, Toluca Lake. But physically and symbolically, it was a big step up. Toluca Lake carried an air of prestige. It was where Andy Griffith lived, as well as Bob Hope and Frankie Avalon.

Our new house, on Clybourn Avenue, had four bedrooms, three bathrooms, and a two-car garage. It was surrounded by leafy, mature trees. It even had a guesthouse in the back, which Dad commandeered as his office. The house had a brick facade and its handsome shingled roof had three dormers, each the front window of a bedroom. Mine was the one on the right, Clint's was the one on the left, and the middle bedroom became Mom's sewing room. She and Dad had the master bedroom downstairs.

By today's standards of L.A. showbiz living, our house would be considered modest. But Clint and I couldn't believe our good fortune. We had room to roam! And on Sundays, in a huge victory for our autonomy, we were allowed to walk by ourselves to Patys Restaurant, a diner that we loved and a Toluca Lake mainstay, still in operation today. Clint and

I enjoyed sitting at the counter and watching the short-order cook in action while we ate breakfast, just the two of us.

For Dad and Mom, the house on Clybourn represented the summit of their material aspirations. It was their kingdom and castle. Though they both lived into the twenty-first century, they never moved again. And they so loved the house that, for the first and only time, they took out a mortgage, for $62,000. It took them only a few years to pay it off in full. "We own it free and clear," Mom told us with pride.

Toluca Lake was a little ritzier than Burbank, but our way of life remained fundamentally unchanged. Dad kept driving his Chevy Nova Super Sport—all the way through the 1970s, 1980s, and 1990s, by which time it was a certifiable road hazard. Mom drove a series of Buicks and Oldsmobiles. We never had an imported car or anything that could be described as a luxury vehicle.

It's a sign of our parents' integrity that this was their version of moving on up. As possibly the most ethical talent managers in the history of show business, they were significantly underbilling their clients, Clint and me. Managers usually collect up to 15 percent of their clients' earnings, but Dad felt that most of what he and Mom did fell under the rubric of parental responsibility rather than professional management. They found the idea of taking anything more than 5 percent to be immoral, though Clint and I would not have objected in the least.

Mom and Dad were concerned about the damage it might do us boys if we were taught to think of ourselves as the family breadwinners. And they simply didn't hunger for a flashy life or a Beverly Hills address. They were sophisticated hicks. They had all that they wanted.

BECAUSE DAD ADHERED to a policy of transparency about money, I was aware pretty much from the outset of *The Andy*

Griffith Show of how much I was making. I was also alerted by Dad to the offers that came my way outside of the show. Pretty early on, for example, a manufacturer approached my agent about launching an Opie Taylor line of children's clothing, for which I would serve as ambassador and spokesmodel.

The agent really pushed hard on the offer, telling Dad that it would be lucrative. But Dad told me that he turned it down because it would have entailed frequent travel and in-store personal appearances that would have cut into my time being a kid. "You need to play," he said. "Promoting clothes is not acting. You're not going to learn anything by doing that. You might be upset with us later that we turned this down, but your mom and I don't think it's worth considering." I've never once regretted their decision, and I appreciate that they let me know about the opportunity in the moment rather than have me learn about it years later.

It never really kicked in that I was earning serious money until one day in 1966, when I was doing my usual routine of reading the sports pages of the *Los Angeles Times* first thing in the morning. The paper contained troubling news: Sandy Koufax and Don Drysdale, the future Hall of Fame pitchers who anchored the rotation of my beloved Dodgers, were holding out of training camp for more money.

This was in the days before free agency, when players had little leverage or negotiating power. Koufax and Drysdale, the *Times* reported, were making $85,000 and $80,000 a season, respectively, and wanted to be paid about twice that amount. This seemed fair to me. The previous season, Koufax had gone 26–8 with a 2.04 E.R.A., pitched a perfect game, and swept the Cy Young and World Series MVP awards for the second time in three years. Drysdale was right behind Koufax, having gone 23–12.

Hmmm, I thought, *this makes me wonder: What do I get paid relative to these guys?* Sitting down with a pencil and a piece of paper, I did some calculations. We had just completed shooting the sixth season of *The*

Andy Griffith Show. I knew that I was earning $1,850 an episode. That season, we shot thirty episodes. Okay, that tallied up to $55,500. Plus, I was already earning residuals from summer and daytime reruns of *The Andy Griffith Show*, in addition to residuals for other things I'd been in. When I added all these sums together, I discovered that I was—*what?*— outearning Sandy and Big D.

My first reaction was mortification. It just felt unfair, flat-out *wrong*, that these grown men, who were the best in the world at what they did, were making less money than me, a kid actor. I cycled through emotions of embarrassment, confusion, and anger. But what I finally landed upon was gratitude. I had to acknowledge that I had been blessed with good fortune and a wealth of advantages. This marked a moment of maturation for me. First, I learned a harsh lesson: the world isn't always fair. Next, I felt a new sense of responsibility. How do I live up to this good fortune and not squander it?

Now, think about it: I was a twelve-year-old boy. I could have reacted entirely differently. I might have figured out that I was earning six figures and thought, *Hell, yeah, I'm rich, baby! Suck it, Sandy!* I could have undergone a personality transformation and started strutting around school like a James Spader villain in a 1980s teen movie.

But I didn't. Because I looked to my parents. I saw how they chose to live and how happy they were. And I redoubled my efforts to keep on working, to stay in show business beyond my boyhood. Not just because the money was good, but because I recognized how much I truly loved acting and learning about directing.

As for Koufax and Drysdale, their holdout ended after a few weeks, when they got raises to, respectively, $125,000 and $110,000 a season. It was less than what they had been asking for, but still, I was relieved. Justice had been served.

• • •

BY THE TIME I was fourteen, in 1968, I was desperate to chart my own fate, to be *in charge of something*. I was by then a huge Los Angeles Lakers fan, and my fame as Opie had provided me with an opportunity to meet my favorite player, Elgin Baylor, at an Easter Seals fundraising event. We stood together for no more than thirty seconds as a photographer took our picture outside of the Lakers' locker room at the Los Angeles Memorial Sports Arena. But simply standing next to the man known as Rabbit—me pointing upward to the basket while Elgin pretended that he was about to shoot—had a huge impact on me. I knew that I had no hope of ever playing basketball on his level, but I was crazy about the game, and it became my best sport.

As a player, I was an undersized but dogged, pesky little shooting guard. Well, to be honest, I was terrible when I started out in sixth grade. My friend Noel Salvatore was legitimately good at basketball, though, and when we discovered that we had missed the cutoff date to sign up for the Burbank Parks and Recreation Center's Bantam League, Noel audaciously proposed that we take the unusual step of putting together our own team. We went door-to-door to local businesses, cold-calling them, until we found a sponsor, a local bank called Surety Savings and Loan. Then the league found a grown-up who was willing to be our coach.

Once again, I was subjected to ridicule. The very first time I caught a pass, I nervously dribbled the ball out of bounds; I didn't understand the court layout. Can you imagine Opie making such an ass of himself, losing track of court boundaries, and then taking too many steps to the basket and getting called for traveling? It was hideous.

But I practiced and practiced until I got pretty good. And by the time I was in eighth grade and jonesing to be a leader, I hit upon the idea of being Clint's coach. What if I put together a squad composed of Clint and his third-grade buddies and molded them in my image? This time,

I went straight to Dad: Could he be the sponsor and nominal coach of a Bantam League team?

He wrote a check, and thus, Howards Hurricanes were born. Dad was the figurehead and disciplinarian, but he left the actual coaching to me. We had HOWARDS HURRICANES uniforms made up, with green T-shirts and yellow shorts.

There was nothing subliminal about why I was so driven to do this: it was to prepare myself to become a film director. I actually said the words aloud: *If I can learn how to handle a bunch of unruly eight-year-olds, I could one day probably figure out how to cope with a temperamental actor.* I won't name any names, but I have since discovered that, behaviorally, there are times when Category 1 and Category 2 are almost exactly the same thing.

In the Bantam League, the hoops were lowered from ten feet to eight to give the kids a better chance at scoring. I ran practices once or twice a week and we played the games on Saturday. Clint was a good player and he had a couple of friends who were natural athletes, authentically skilled. But the others ranged from average to downright uncoordinated. What I'm proudest of about my tenure as the Howards Hurricanes coach is that I molded our strategies to the kids' abilities. At John Burroughs High School, where I was playing roundball, I was nagged by a feeling that my coach was too systematic and inflexible, running patterns and setting defenses that stifled our players' individual talents. I didn't want to duplicate his approach.

The Hurricanes were, for the most part, an undersized team. I thought that we stood a better chance if we played in a wide-open run-and-gun style, allowing our players more freedom to shoot from the outside and cover their opponents one-on-one. I set out to maximize the abilities that each kid brought naturally to the court. We had one kid who was gangly and couldn't shoot to save his life, so I made him

our defensive enforcer and rebounder. Another kid was tiny but proficient at dribbling, so when we were trying to run out the clock, I told him, "We're gonna pass it to you and let you do your thing." Over time, through repeated practice and regular playing time, these kids would transcend their limited roles and become more well-rounded players. That was another thing: at Dad's insistence, every boy had to play at least half the game. So I couldn't just ride my best players and keep the less skilled on the bench.

Despite these limitations, the Hurricanes were a consistently decent team for our first two seasons, and we won the league championship in our third season. I flat-out loved being a coach. One time we played a team that outclassed us by far in talent, coached by Bill Burton, the father of the future director Tim Burton, who was Clint's age. Mr. Burton was a former professional baseball player who served as one of the administrators of the Burbank Parks and Rec department. He had a buzz cut and looked like a marine. We were all kind of scared of him.

Despite his militaristic appearance, Mr. Burton had boys on his team with hair down to their shoulders, including his son Tim, who, improbable as it may sound, had some deft moves on the court. There was a chance that we could get slaughtered. But not too long before this game, USC's coach, Bob Boyd, had made national headlines by nearly beating John Wooden's powerhouse UCLA team, featuring the all-world center Kareem Abdul-Jabaar, then known as Lew Alcindor, by slowing down the game to a crawl: a strategy known as stall-ball.

Like the NCAA, the Burbank Bantam League did not have a shot clock. So I ordered the Hurricanes into a stall against Mr. Burton's team. By the end of the first half, the score was 4–2 in favor of the Burtons. My strategy was working: we were behind but just barely, well within range of taking the lead.

But the parents in the stands were furious at me. Some of them shouted, "Ronny, let them play!" Others yelled less polite things. Dad

let me stick to my guns until the fourth quarter, when I did indeed let the kids run and shoot. We lost 12–6, a respectable margin, but I still believe that we could have stall-balled our way to victory.

I coached the Howards Hurricanes all the way until I turned twenty, moving up through the age brackets with Clint and his friends. By the time they were in seventh grade, they had graduated from the Bantam League to the Junior High League, playing with hoops mounted at the regulation ten feet.

I occasionally got temperamental. There was a game where we were behind and the ref was a guy my age who I knew from playing baseball. I felt that too many calls were going against the Hurricanes. "You're killing me, Ed," I shouted at the guy, pacing the sidelines like a madman. "You're blowing it, over and over again!" Ed, very sensibly, told me to sit down.

"Yeah?" I said, going full Bobby Knight. "Give me a T!"

"Fine, T," Ed said.

"Give me another T!," I shouted.

"T!" said Ed.

My face nearly as red as my hair, I screamed, "I'm gone!" and stomped off. Dad had to follow me out and place a hand on each shoulder to calm me down. The best I can explain this uncharacteristic outburst is that I had seen a coach go ballistic on TV, and the actor in me overtook the coach. I never let this happen again.

It's extraordinary, how well my stint coaching these kids prepared me for my directing career. I have found that I work best and achieve the most by tailoring a plan to the strengths of the people with whom I am collaborating, rather than rigidly adhering to some preconceived Ron Howard Method. There is no such method. In fact, that's one of the reasons that I don't have what you'd call an authorial signature, and why my films have been so varied in tone and subject matter. Coaching also taught me one of the most important attributes for a filmmaker: patience. I saw kids struggle through half the season before suddenly

emerging as quality players once everything clicked for them. I saw my strategies fail in multiple games before they succeeded. It's the same when I develop and direct a film. The first few drafts of a screenplay can seem hopeless until the writer suddenly turns a corner. A challenging scene bedevils the actors and me alike until we hit upon a solution. Intuitively, I still apply the lessons in leadership I learned fifty years ago to the movies and TV shows I make now.

CLINT

Ron could easily have become a head basketball coach at the high school or college level. It wasn't just that he was good at teaching the dorkier guys specific skills, like how to box out your opponent when you're going for the rebound. It was how he encouraged his players and celebrated their successes. When our second-string center grabbed a rebound in a live game, Coach Ron was the first to slap the kid's hand as he ran up the court on offense, saying, "Now that's how you do it!"

Ron and I benefited in another way from our Howards Hurricanes exploits besides enjoying the competition and the teamwork: we established ourselves in the community as citizens rather than as child-actor curiosities. We never heard "Dopey Opie!" or "Where's your bear?" on the court during Hurricanes games or in the three-on-three pickup games we played at the rec center. Our teammates and opponents knew that we had this odd other life, but it didn't matter to them. For Ron and me, this was meaningful. It furthered the idea that we had identities independent of who we were on soundstages and the backlots.

THE CORRELATION BETWEEN coaching and directing turned literal when Ron asked me to recruit some of my buddies to

join me in the cast of Ron's earliest attempts at directing. The first short we did was called *The Ball Game*. It was simply a dramatization of a Wiffle Ball game. The film begins with me waking up in the morning in my underwear, getting dressed, and calling up my friends on the telephone to invite them over to our place.

The Clybourn Avenue house had a great setup for Wiffle Ball. Its previous residents were a Chinese American family whose kids were a singing group, a sort of Chinese-language Osmonds who performed at fairs and festivals. The parents had torn up part of the backyard and replaced the grass with paved concrete, creating an outdoor rehearsal space. For Ron and me, this became our sports arena. Dad put up two basketball backboards, and we also configured the space for Wiffle Ball, putting down bases and defining outfield boundaries that were vaguely modeled on Boston's Fenway Park.

RON

The Ball Game ended up running about twenty minutes. It was hideously boring: no sound, and I included every pitch of every inning. But it was a great exercise in experimentation, way more creative than the rudimentary home movies that I'd shot using the Bell & Howell 8 mm camera that the *Andy Griffith* guys had given me years earlier. My most artful effort on that camera was a short in which I had Dad playing a hobo trying to break into the house. He peered through the window for one shot and climbed on the roof for another. It was shot in order so that I wouldn't have to edit it.

By the mid-1960s, Standard 8 mm was replaced by a new format called Super 8. Dad bought a Kodak Brownie Super 8 camera for his own use. I borrowed it to make *The Ball Game*. I planned my shots, tried different angles, and pointed out to Clint's buddies where their

marks were. Then I edited the picture myself. With my own money, I purchased a primitive Super 8 home-editing system that consisted of two cranks, a view screen, and a splicer. To edit a scene, I had to hand-crank the film back and forth, manually cut it on the splicer (sometimes nicking a finger in the process), and then bind together my edited scenes with adhesive tape lined with sprocket holes, more or less in the same way that you would apply a Band-Aid to a cut.

Editing this way was incredibly time-consuming, but it became my favorite part of the filmmaking process. The intensive labor soothed me in a Zen way; I never cared much for erector sets or model airplanes, but I could edit for hours on end. That said, for *The Ball Game,* I clearly didn't edit aggressively enough. Still, I was pleased: I considered it my debut as a filmmaker. Twenty years later, my memories of that film inspired the Little League scenes in my movie *Parenthood.*

My next film was the product of my resistance to doing household chores. Dad asked me to mow the lawn one Saturday. Rather than flat-out refuse, I pitched him an idea: "Dad, I have this idea for a short film. It's about a military veteran, a man about your age. Not an air force guy like you, a guy who was in the army." This detail came to me because we owned a combat helmet that Dad had bought for us at an army surplus store. I used it when I played World War II with the Cordova Street boys.

"This vet, he doesn't just mow the lawn," I said. "He puts on his helmet, he salutes, and he *attacks* the grass with his manual mower like it's the enemy. It'll be a satirical film, Dad. I'll use lots of ground-level shots of the mower coming right at the camera, with grass flying all over the place!"

Dad smiled. "That sounds like a strong low-angle shot. Could be pretty good," he said.

And so we set to work on my next film. Dad was no easy mark—he knew damned well that I was finagling my way out of a chore. But

he admired my initiative in wanting to make movies, and he enjoyed hamming it up in the army helmet, taking direction from his son. I kept coming up with different camera angles until the lawn was completely mowed.

We watched the finished product together as a family, using our two-speed Bell & Howell projector and one of those stand-up screens that 1960s families had, where you hoisted up the screen from a tripod base. Dad was delighted at the finished product. I was delighted that he was delighted.

CLINT

Life was good and it was about to get better: not long after we moved to Toluca Lake, Mom surprised Ron and me with the news that she was expecting. I was over the moon. I wanted to experience what Ron had experienced: being an older brother. I imagined the baby in my mother's womb as a boy, because that was all I knew. But I would have been equally happy with a sister. I was eager to have my own protégé and acolyte.

Ron was as happy as I was. But we noticed that Dad, normally full of energy and good cheer, seemed down. He talked about our pending sibling in sighs and shrugs—not with any negativity, but definitely with a sense of resignation. One day, when Dad was out, we brought this observation to Mom. Her explanation to us was as shocking as it was masterfully and gently delivered. Dad, she said, was happy that we boys were getting older and more independent, requiring less oversight and handholding. Because of this, he was looking forward to spending more time pursuing his own passions.

But this new baby was a surprise, unplanned. And raising him or her would turn back the parental responsibility clock to zero—hard news

for Dad to swallow. "He loves having children, and he loves you boys," Mom told us. "But he thought it was time to get started on *his* career again."

RON

Clint and I had not really understood until that point how much Dad had intentionally deprioritized his aspirations to do important work as an actor and writer. This was the first time that I recognized that he had paid a toll of sorts for our success and our rich education in the business. Rance Howard was only forty years old, with the better part of his adulthood ahead of him. But forty is a tough age if you're still trying to break through as a leading man. For how much longer would he have to wait for his own moment in the sun?

Dad's worries turned out to be moot. Sadly, we never got to meet the new little Howard; Mom suffered a miscarriage a few weeks after they broke the news to us of her pregnancy. Dad rose to this moment: he was loving and gracious toward Mom, comforting her in his arms. Very little was said to Clint and me about the matter, then and ever afterward. But I could tell, without any words being spoken, that Dad was relieved.

13

FAKE BLOOD AND OPIE-SHAMING

RON

I will forever owe a debt to Opie Taylor. The experience of inhabiting that character, walking a mile in his Keds, defined my early life. But being associated with Opie didn't serve me particularly well in adolescence. Especially an adolescence whose kickoff happened to coincide with the Summer of Love.

I didn't really do the 1960s. I loved the Beatles—still do—and approvingly noted the rise of my female classmates' hemlines. But I was never part of the drug culture, never had long hair, and never participated in political protests, though I often sympathized with their aims. I was the son of an Oklahoma farm boy whose 1930s childhood wasn't that different from an 1890s childhood, and I was on a TV show set in the 1960s that for all intents and purposes really took place in the 1940s. With my freckles and prominent ears, I looked uncannily like one of those kids who modeled for Norman Rockwell when he was painting covers for *The Saturday Evening Post* during World War II. By accident more than design, I lived at a remove from the era in which I grew up.

But the '60s proceeded nonetheless. David Starr Jordan Middle

School went up to ninth grade, so when *The Andy Griffith Show* wrapped its seventh season, I was anxious about my reentry into the school system. Justifiably so, it turned out. On my first day of junior high, in February 1967, I was in culture shock. Some of the ninth graders were old—as in *fifteen*!—and had long hair and muttonchop sideburns. My reputation as Opie preceded me, and wandering through the halls that day, I felt eyes boring into me from every direction. Meanwhile, my own POV seemed distorted, like I was looking out at everyone else through a fish-eye lens, with myriad faces poking grotesquely into my view.

Some super-sideburned kid who was already six feet tall and as burly as a linebacker leaned into me and said, "Hey, Opium. You wanna buy a lid?" I wasn't fluent in his terminology, but I knew that it had something to do with illegal drugs and was meant to intimidate me.

Fortunately, there was the safe harbor of my friend Noel and the game of basketball. Noel invited me to join him in a pickup game of hoops during lunch break. I was in my element, hitting one shot after another, regaining my confidence. But then I noticed that some of the spectators—girls, no less—were pointing at my groin and laughing at me. I glanced down. The zipper to my jeans was completely unzipped. I blushed inwardly, but I did not want to give anyone the satisfaction of showing how embarrassed I was. So I acted like nothing was wrong, made no effort to zip up, and simply continued playing.

After the game was over and I had discreetly rectified the situation, a ninth-grade girl waved me over to where she and some of her classmates were standing. She was wearing a very short skirt. She raised one leg up on a step, motioning to her bare inner thigh, and said, "Hey, Opie, will you sign my leg?"

Total internal panic. I don't think she was coming on to me, but instead using her power as an older, popular girl to fluster me. She succeeded. I stammered, "No . . . No, I-I'm not gonna sign your leg!," and scampered away.

I survived that day and actually had a fine time at Jordan over the next three years, with lots of friends and basketball teammates who liked me for who I was. But right to the end of my public-school education in Burbank, which concluded at John Burroughs High School, I was dogged by what today might be called Opie-shaming: the desire among my peers to get under my skin by taunting me as "Opie" rather than treating me as Ron. My father's choice to train me to fight proved justified. Though I renounced violence in middle school, I benefited from toughening up.

By my senior year, I had grown into a confident young man, with a girlfriend (more on her later) and a *C* on my letterman's jacket because I had been named a cocaptain of the Burroughs varsity B team. (I was too short and just not skilled enough for the varsity A team.) My name sometimes got published in the local paper, *The Burbank Daily Review,* not because of my acting work but because I had scored more than ten points in a game.

That felt great, and the Opie-shaming had completely dissipated on my home court at Burroughs. But at an away game that final season, the opposing team's fans were out for blood. Every time I went to the line to shoot free throws, their band tried to psych me out by playing an abrasive, mocking version of *The Andy Griffith Show*'s theme song: "Da-da-dah, DAH-da-da-da, DAH-da-da-da . . ." This was punctuated by a chant of "Miss—it—Opie! Miss—it—Opie!"

I nevertheless hit five of my six free throws in that game. But I can't pretend that those kids' taunts didn't affect me. They pissed me off. The word that I would use now, which I didn't know then, is *reductive.* I resented that these mean-spirited teens were publicly mocking and ridiculing me for a role that I had played, and I resented the corresponding insinuations: that I must be a pampered TV star, a lame-ass, a wimp.

I've had a complicated relationship with that famous whistled theme song. By and large, I regard it positively: it evokes fond memories of Andy's warmth and the joy that we took in working together.

But there were times in my life when that damned song was the bane of my existence. I'd be in a public place, ballcap pulled low, calling no attention to myself, when I'd hear a faint version of the tune tootling from someone's lips—and that's when I'd know that I had been made. In school, I would sometimes be at my locker, minding my own business, trying to find a homework assignment that I had misplaced, when behind me I'd hear whistling along with derisive laughter—and that's when I knew that I was being mocked for some jerk's amusement.

FOR ALL THE aggravation that being Opie had occasionally caused me, I was devastated when *The Andy Griffith Show* came to an end. Truthfully, I knew that the finish line was in sight at the conclusion of the fifth season, when Don Knotts announced that he was leaving to make movies. Andy soldiered on for three more seasons, and they were good seasons—but it was apparent to everyone on set that he wasn't having as much fun without Don.

So, when the show wrapped its eighth and final season in 1968, it was downright destabilizing. We were going out on top, literally—the '67–'68 season was the first in which we were the number one show in the Nielsen ratings, drawing thirty-five million viewers a week. Some of my castmates, such as Frances Bavier and George Lindsey, were going to continue on with the *Griffith* show's sequel series, *Mayberry R.F.D.*, in which Ken Berry took over the lead role. But I would not be joining them. The producers had offered me a reduced role in the new series as a semiregular, but this excited neither me nor my parents. If Andy wasn't going to be in it, I wasn't going to be, either. I passed.

We had a big wrap party at Desilu to celebrate the end of our show's massively successful run. CBS pulled out all the stops, catering the affair and hiring Andy's favorite swing band, Les Brown and His Band of Renown. All the men and women with whom I had worked since the age

of six, in front of and behind the camera, were there. I was fourteen and determined not to cry. Then Andy announced through a microphone that he wanted to speak. "I want to thank y'all for your good work," he said. "You didn't just make a successful TV show. You brought the town of Mayberry to life. In doing that, you brought my childhood to life again, week after week. I can't tell you what that means to me."

At this, I started to lose the emotional battle. Andy's words jolted me, making me recognize something I had not yet come to terms with. *My* boyhood had taken place here, on this soundstage. Now it was coming to an end—or at least a major chapter of it was. I realized that I would never again see these familiar faces on a regular basis. I lost it—I started weeping inconsolably in front of everyone. It was so embarrassing.

Fortunately, my mom was there to help me put things in perspective. My emotions, she said, were a recognition of what the show and all its people had meant to me. But this moment also represented a new beginning, a door opening to the next phase of my life, which was full of promise. This "mother knows best" moment calmed me and allowed me to enjoy the party, at least a little.

Ninth grade marked the first time in my life where I was a student for pretty much the whole school year. I was called into a meeting with my guidance counselor, Mr. Cira, to discuss my future. He asked me if I wanted to go to college and I replied in the affirmative.

"Then I don't think that you should act anymore," Mr. Cira said. "Based on the grades and test scores you have now, you're not on a college track. So let's think about giving up the acting and working on school."

I did not appreciate what I perceived to be his condescension, but I held my tongue. It's true, I had been a mediocre student for most of my childhood. But I made plain to Mr. Cira that I had no intention of stopping acting. Then I doubled down on schoolwork, studied harder, and got straight A's for the first time in my life. I sure showed that Mr. Cira! Which, I realize now, is exactly what he wanted me to do.

When we came back for Season Two of *Gentle Ben,* we had every reason to believe that our show was going to be around for a while. We had a major sponsor in the Eastman Kodak Company, which took out a huge ad for us in New York's Grand Central Station: a backlit cast photo, sixty feet wide by eighteen feet high, that used Kodak's Colorama technology. There was more money in the shooting budget, we had better production values, and most of all, we had momentum.

But by the spring of 1969, after just two seasons, I was, like Ron, a boy without a series. Shooting the second season had been a great experience for me. I became a better actor and spent more time operating the airboat. We even recorded a *Gentle Ben* cast album, *The Bear Facts,* that was slated for release at the season's end. A hippie vocal group called the Good Time People backed us. I performed a spoken-word version of the show's theme song, which to that point had no lyrics, entitled "I Am the Way I Am." Dennis Weaver sang a psychedelic song called "Cobwebs of Your Mind." Dad did a goofy novelty song called "Don't Cry Little Gator." And he and I performed together my favorite of all the songs, a wiggy duet entitled "What's a Whatchamacallit?"

Alas, we slipped badly in the ratings. Disney made a point of knocking us off. We had caught them with their pants down when we became a hit, so, the second time around, they upped the ante, supplying *Walt Disney's Wonderful World of Color* with higher-grade programming.

This was also the beginning of the Rural Purge era, when CBS canned a bunch of shows despite their good ratings because they didn't reach the urban, high-spending demographic that advertisers coveted. So that meant the end of *Green Acres, Petticoat Junction,* and *The Beverly Hillbillies.* We weren't a broad comedy like those shows, but we were decidedly unhip and no longer a part of CBS's future plans. They

were moving in a more provocative, socially conscious direction, with such programs as *All in the Family* and *M*A*S*H*.

We had wrapped the second season thinking that we would head back to Florida in due time. The network had scheduled an in-store appearance by the cast at the new Tower Records shop on Sunset Boulevard in L.A. to promote *The Bear Facts*. But the album never went on sale—it was hastily withdrawn from circulation and is now a collector's item that can be found only on eBay.

I was out in the backyard playing basketball one day during hiatus when I heard the phone ring in Dad's office. A few minutes later, he beckoned me up the stairs. With a solemn look on his face, Dad said, "We're not going back to Florida, Clint. CBS decided to pull the plug."

I was confused but not devastated. I was ten years old and had already contemplated what it would be like if I worked on *Gentle Ben* all the way to age fourteen, as Ron did on *The Andy Griffith Show*. The more I processed this, the more I believed that I would look pretty silly pulling a bear's chain as a teenager. And I was accustomed to looking forward and moving on. I simply went back to a routine with which I was already familiar: auditions, scoring one-episode guest shots, running lines with Dad in the evening, and driving over the hills into Hollywood to shoot the next morning. Staying in Burbank also allowed me to focus on my passions, sportswriting and baseball. I pivoted to banging away on a typewriter and perfecting my curveball.

I never saw Bruno again in person—or in bear, I should say. But it made me happy when, a few years later, I was watching John Huston's movie *The Life and Times of Judge Roy Bean* in a theater and saw Bruno up on the screen, performing opposite Paul Newman. Every bear has a unique look, and I had become good at distinguishing one from another. I recognized Bruno instantly and felt a pang of pride for my guy.

RON

quickly discovered that I had overestimated the demand for my services as an actor. There was no "Opie bounce," no clamoring by the networks and the studios to get their mitts on the kid from *The Andy Griffith Show*. The work I was getting was pretty underwhelming: a Disney TV movie (yes, broadcast as part of the *Wonderful World* series that knocked off *Gentle Ben*) and guest shots on such long-running shows as *Lassie, The F.B.I.,* and *Daniel Boone,* as well as the fleetingly popular, of-their-time shows *Land of the Giants, Lancer,* and *Judd for the Defense*. These parts were perfectly fine as jobs but sobering as my new reality, in that I received no special billing or higher pay for being a household name.

I fared no better in the film world. I didn't come close to landing a part in any of the prestigious movies that I auditioned for, which included *Bless the Beasts and the Children, A Separate Peace,* and *The Last Picture Show*.

I didn't mind that I no longer had a regular gig, because I was, after all, a teenager in high school. I was absorbed in sports and the pursuit of girls, and I enjoyed the novelty of being able to spend an entire school year *in* school, with my classmates. But it stung to realize that the TV and motion-picture industry, which I had grown up viewing as a reliable source of validation, affirmation, and employment, did not believe that it owed me anything. It was not invested in my material comfort or emotional well-being. Right after *Andy Griffith,* I had the audacity to turn down one-off parts in *Bonanza* and *The Mod Squad* because I had made a commitment to the school basketball program that I had to keep if I wanted to play. I somewhat smugly assumed that the industry would always be eager to take me back. It wasn't.

To some degree, the industry is set up to fail and destabilize child actors. They're in demand when they're prepubescent and cute, but

less so as they enter adolescence. Just as these kids are entering the most vulnerable years of their childhoods—self-aware, awkward, and hormonal—their livelihood and sense of identity are pulled out from under them. This, naturally, only compounds the feelings of frustration and inadequacy that all kids experience as they go through puberty.

And don't think that it's easy to simply sit tight until your voice has changed and you can start playing teenagers. You may be fifteen, but you're still a minor, bud—and the studios have a lot of twentysomething actors at their disposal who can pass for teens and aren't required to have school breaks, guardians, or curtailed working hours. So your phone stops ringing.

For the first time, I began to understand from lived experience the psychological burden that my father carried from month to month, staring at that silent phone in hope and frustration. It's hard not to take this rejection personally.

CLINT

I didn't turn down *my* shot to be on *Mod Squad*. Dad and I jumped at the opportunity for me to play a little boy who is kidnapped and rescued by Linc, played by the prodigiously Afro'd Clarence Williams III. It was a memorable gig. We filmed my scenes the morning of the 1971 Sylmar earthquake, the first that I ever lived through. It tossed me out of bed at six in the morning. Next thing I knew, I was in the hallway and Dad was running toward me, stark naked, having bounded up the stairs to hustle Ron and me to safety. The telephone lines were knocked out and I presumed that we would not be filming that day. But Dad said that we had a responsibility to show up for work. Sure enough, the rest of the cast and the crew had assembled at the Paramount lot. We

worked the whole day, with people checking their transistor radios to find out the fate of their neighborhoods.

My acting career was still going great guns. I found a welcoming home on the westerns that survived into the turn of the decade, such as *Gunsmoke, The Virginian,* and *Lancer.* And I was getting sitcom work, too. One night, in fact, I was on two of them the same evening—as the jerk who tormented Johnny Whitaker in an episode of *Family Affair* on CBS and as Felix Unger's would-be protégé in an episode of *The Odd Couple* on ABC. The premise was that Felix had joined the Big Brothers program and I was the kid he was assigned to mentor. The complication, true to life, was that I preferred to hang out with his roommate, the sportswriter Oscar Madison.

Dad was so thrilled by my double occupancy in prime time that Thursday that he took out an ad in the trades with a big photo of my chubby-cheeked mug:

CLINT HOWARD
Guest stars . . .
as a Bully on
"Family Affair"
TONIGHT
7:30 CBS
&
then swing
back to a nice
Likable Kid
with a
problem on
"Odd Couple"
TONIGHT
9:30 ABC

The name of my agent, Marguerite Ogg, was helpfully offered at the bottom of the ad. The trade magazines were a serious force, read by every decision maker in our industry, so this was a big deal. And Dad's strategy worked. I kept getting parts in good TV shows: *Marcus Welby, M.D., Night Gallery, Nanny and the Professor, The Streets of San Francisco.* Puberty had not yet hit me, and no doors were slamming in my face.

But it was only a matter of time before I would go through the same thing that Ron did.

RON

One saving grace of this unsettling period is that it coincided with a great era in filmmaking. I was able to catch a new wave of American directors asserting itself. Mike Nichols's *The Graduate,* Arthur Penn's *Bonnie and Clyde,* William Friedkin's *The Boys in the Band,* Robert Altman's *M*A*S*H*—I took 'em all in with Dad. From a storytelling perspective, movies worked differently than TV. Whereas *The Andy Griffith Show* earned its viewers' interest and built long-term loyalty through simple stories and deep, cumulative character development, these films were rigorously planned to transport their audience in a single immersive viewing.

Dad was permissive about what I watched. Some of these movies were explicit in their depictions of violence and sexuality. Andy Griffith was mildly scandalized when, in our show's later years, I told him that I had seen *Bonnie and Clyde* with my father one weekend. But Dad thought that my viewing such pictures would be useful in my maturation process as an actor, aspiring filmmaker, and young man. I wasn't one of those kids who cringed at watching a sex scene while seated next to his father. I knew what movies were, art created through illusion.

And Dad knew that I knew. These excursions to the movies became a nice way for us to hang out and talk about life in general, not just storytelling and filmmaking.

I also got into the great antihero movies of the time, such as Sergio Leone's *The Good, the Bad, and the Ugly* and Sam Peckinpah's *The Wild Bunch*. And I loved the exploitation flicks that Roger Corman churned out by the bushel through his New World Pictures production company. Dad and Hoke Howell actually wrote a script tailored to Corman's sensibilities called *Arkansas Wipeout,* in which a pair of country-boy moonshiners outwitted some stuck-up city sophisticates. Corman didn't go for it, but this shows you how aligned Dad and I were in our tastes.

I lost myself in movies and became an ever more dedicated student of them. In that prestreaming, precable, pre-VCR era, I was a particularly avid watcher of *Million Dollar Movie,* a syndicated program that over the course of a week ran the same vintage movie over and over, like a repertory cinema house. This allowed me to study *King Kong* (the 1933 original), *Damn Yankees,* and *The Time Machine* the way that Egyptologists study hieroglyphs, decoding them and breaking them down into their component parts.

It was on my third viewing of Henry Levin's 1959 movie *Journey to the Center of the Earth* that I first stumbled upon an exercise I still use today. I had left the living room with the TV's sound turned low, and when I returned for the "exciting conclusion" that the program's announcer always promised, I came upon my favorite action sequence, in which the protagonists encounter a convincingly real-looking dimetrodon dinosaur. I had long wondered how the filmmakers pulled this off. With the sound down, I could more easily decode the techniques and effects at work. I noticed that the monstrous dinosaur was actually an iguana of some kind with a spine sail glued to its back. I figured out that the ruins of Atlantis were really carefully rendered matte paintings.

I identified the camera setups that the filmmakers used to stage the sequence and make the audience believe every second of it. Thereafter, I lowered the sound whenever there was a scene that I wanted to study closely.

With my own money, I bought a Bauer Super 8 camera, intent on putting my newly accumulated filmmaking knowledge to use. I would make a Peckinpah-style splatter pic with a few Old West nods to Leone and a killer title: *Cards, Cads, Guns, Gore, and Death.*

The plot of this two-minute silent masterpiece-in-the-making was simple. Three cowboys are playing poker in a dusty saloon. One takes exception to the other's winning hand and shoots the winner dead. Then the third guy shoots the shooter dead. A fourth guy, the sheriff, comes upon the scene and shoots the third guy from behind, killing him. Then he shakes his head in disgust, lamenting the waste of it all. The end.

That was the easy part. The hard part was authentically portraying the carnage on a nonexistent budget. In my curiosity about filmmaking, I took to bending the ears of everyone with a specialized job on the sets I worked on. A special-effects guy gave me the intel on how they did gunshot wounds in *Bonnie and Clyde* and *The Wild Bunch.*

They put a patch of leather on the bare skin of an actor, he said, and, on top of that, a steel plate. They wired a small electrical charge to the plate and fed the wire down through the actor's shirt and pantleg. The length of wire that trailed out of the actor's pants was buried in the dirt so the camera wouldn't pick it up. Then they put a little balloonlike blood packet on top of the plate and made a small, unnoticeable tear in the actor's shirt where the packet was, so that when the effects guy sent a current through the charge, the shirt would give when the packet exploded. Result: a convincing splatter!

I had neither the pyrotechnic equipment to duplicate this system nor the capability to try anything involving wires without electrocuting

myself. So I worked out an alternative. Clint and I had a Mattel Switch 'N Go, a really cool set of battle tanks that came with an air pump and slender, flexible yellow tubes. The tubes, when hooked up to the pump, allowed us to fire little plastic missiles from the tanks. I rigged up a system in which I fed watered-down ketchup into the tubes and then concealed them under the actors' shirts. The other end of the tube was attached to a bicycle pump, which, if you slammed it down hard, would sorta-kinda spurt out the ketchup solution in gory fashion.

All good. But I still needed actors to play my violent, doomed cowboys. Guess who I called upon?

CLINT

Yep, big surprise. I reported for duty, the Robert De Niro to Ron's Marty Scorsese. I played Card Player #3, the one who got shot in the back. My friend Scott Greene manned the bicycle pump. His brother, Steve, played the sheriff. The other two cardplayers were Hoke Howell's sons, Scott and Stark.

Dad sometimes included me in his moviegoing outings with Ron. When we went to see *The Wild Bunch,* I witnessed in real time the idea for Ron's splatter pic sparking in his brain—an expression of excitement came over his face. At home, I helped him work out the logistics of using the tubes and the pump. Then we scrounged up hats, bandannas, ponchos, and sunglasses so that the cardplayers looked convincingly outlaw-like. But our attempts at authentic period costuming were compromised by budget constraints. We all wore white T-shirts because we needed cheap clothes that we could sacrifice to the ketchup-stain gods.

Cards, Cads, Guns, Gore, and Death is a good piece of guerrilla filmmaking. Ron's opening shot is an impressive piece of camerawork. Starting close on a pile of poker chips, Ron then pulled back and followed the

action from player to player. It's like a kid version of the crane shot that opens Orson Welles's *Touch of Evil.* And the splatters turned out really well. We nailed the "gore and death" part.

I sometimes grumbled about being in Ron's little movie projects because I'd grown accustomed to getting paid to act and I wanted to play with my friends. Still, these were good times. I have since worked with a hundred adult directors who couldn't hold a candle to the sixteen-year-old Ron Howard. I could see that he had the goods: a knowledge of camera angles, the discipline to light scenes correctly, a facility for directing his actors. In some regards, nothing has really changed. I'm still acting in Ron Howard movies, with a full understanding that he is the general and I am a private. I have my opinions on how I would do a scene, but ultimately, you do what the director says. That's part of the discipline that Dad taught us.

It was during this time that Ron decided that he wanted to be called Ron instead of Ronny. Actually, he decided initially that his directorial name would be Ronn Howard, with two *n*'s.

However the hell he wanted to spell it, I respected his choice. Being called Opie all the time was one of the worst things he had to endure as a kid. I thought that "Ronn" looked weird in the credits, but he wanted to shed his little-kid image, so I fully supported him.

RON

I tried on a few different identities. One was Ronn Howard, and another was R. W. Howard. My middle name is William and "R. W." to my young mind sounded directorial and authoritative, like D. W. Griffith. I was also worried that my *Andy Griffith Show* identity as Ronny Howard might work against me in terms of being taken seriously.

I had a lot of time to think about this. The four years between the

conclusion of *The Andy Griffith Show* and my next big break, a part in *American Graffiti,* are a fraction of my life, but they seemed to go on forever at the time. I was experiencing an adolescent identity crisis that was typical in many respects but atypical in its somewhat public nature and its implications for my career. Fortunately, a job came along in this period that really helped me sort myself out. It's not one that most people know about: a G-rated Disney picture called *The Wild Country.* But it meant a hell of a lot to me, not least because it marked the only time that Clint and I got to act together as brothers while playing brothers.

14

WILD TIMES IN JACKSON HOLE

<div align="right">RON</div>

The Wild Country was right in the Howard clan's wheelhouse: a western intended for family viewing. In the 1880s, the Tanners, of Pittsburgh, seek a new start on a ranch in Wyoming. They are a father, a mother, and two boys, Andrew and Virgil—that would be Clint and me. When they finally arrive at their destination, the Tanners discover that they have been swindled into buying a dilapidated farmhouse that sits on arid land. To make matters worse, their water source is a river that flows first through the adjacent land of a rich, mean rancher named Ab Cross. It's basically *There Will Be Blood* for kids.

The Tanner parents were played by Steve Forrest, a handsome actor who later starred in the 1970s TV series *S.W.A.T.,* and Vera Miles, who had played Clint's mother in the *Gentle Giant* movie. The four of us were coleads, but my story was the through line: Virgil transforms from a city boy into a capable rancher who has the guts to shoot Ab Cross dead at the movie's climax, right when Ab is about to kill Virgil's father.

It was a coming-of-age story for my character and a coming-of-age summer for me. We shot the movie in July and August of 1969 on

location just outside the town of Jackson Hole, Wyoming. In a circumstance that was by now familiar, Dad was given a supporting role, as one of Ab's henchmen, and was hired in an official capacity as a dialogue coach for Clint and me. Quickly earning the trust of the movie's higher-ups, he also became an informal script consultant, drawing upon his ranching background and knowledge of the western frontier to correct certain turns of phrase that the writers got wrong.

Mom came along for the duration, too. We had all been together in Miami for *Gentle Ben,* but Mom and I were only visitors to Dad and Clint's show. This time, the entire family was in on the same adventure. Along with the rest of the cast and crew, we stayed in town in a two-story motel called the Grand Vu.

The director was Robert Totten, who was to become a significant figure in our lives. Totten was a Sam Peckinpah–like figure whose career didn't turn out as well as Peckinpah's. Like Peckinpah, who earned his stripes as a director on the TV western *The Rifleman,* Totten established himself directing episodes of *Gunsmoke.* He, too, aspired to create muscular, unsentimental neo-western movies, but he never quite turned that corner. He was too self-destructive, too prone to rage and heavy drinking.

He was only thirty-two when we met him, though, still full of promise. Totten was bearded, short, and stout, built like a fireplug. And a little intimidating. But that was part of why I liked him—he was the first director not to treat me with kid gloves. The second day of shooting, we filmed a scene where I unloaded some chickens in cages from our horse-drawn wagon. I wore a tweed traveling suit, and I noticed that some chicken poop had gotten on one of my cuffs and left a smear.

We were about to roll camera when I raised my hand to get Totten's attention. "Do we need to do something about this?" I asked, displaying my cuff.

Totten had no patience for my query. "What are you, a city boy?" he

said. "You got a little chicken shit on your arm. Get over it!" Then he
shouted, "Roll!"

This was more than a little moment—he issued a challenge to me
to toughen up and get on with my work like a man. And I dug it. I was
taken by Totten's swagger and the buzz that he clearly got from film-
making. He had been a working director since his early twenties, which
impressed the hell out of me. Suddenly, my mental timeline for when
I would direct my first feature was compressed from decades to years.
When Totten learned of my aspirations, he softened—a little—and
took me under his wing, explaining the ways he positioned his cameras
and composed his shots, and telling me how he varied his directorial ap-
proach from actor to actor, depending upon their psychological makeup
and the needs of a scene.

Totten was a good draftsman and occasionally sketched out his scenes
in advance. For example, the movie has a big tornado sequence. He drew
his vision of it on a large pad, plotting the series of shots he needed while
discussing his ideas with the cameraman. I watched and listened, rapt.
This was the first time I truly absorbed a director's explanation of the
options at his disposal and the choices he was making. The only other
director I had seen so deeply engaged in the cinematic process was Vin-
cente Minnelli, when we made *The Courtship of Eddie's Father*. But that
was way back in 1962, when I was eight years old, too young to appreci-
ate what I was witnessing. To teenage me, Totten was a film guru.

Also, I was struck by his wife, Sandy, who was petite, pretty, friendly,
elegant, and—file this away for future reference—had beautiful red hair.

CLINT

We were all enamored of Bob Totten. He called me Putt-Putt,
because whenever the movie required me to run across the fields and

corrals, I ran with determination but not a lot of speed. He said that I reminded him of a little scooter that putt-putts along the road.

As someone who has made a lot of B-grade movies, I can tell you that no director actually sets out to make one. Even if the budget is tiny and it's a slasher flick, the filmmaker believes from the get-go that he is making the ultimate, most top-shelf slasher flick. Totten was like that with *The Wild Country*. He was dealt the hand of directing a Disney B western, but he was going to shape it into an important piece of cinema.

It didn't quite work out that way, but it's a decent film with some strong performances. Ab Cross was played by Morgan Woodward, a serial Hollywood bad guy whose menacing presence on-screen belied how gentle he was in real life. The scary-looking but benevolent trapper who befriends the Tanners was played by Jack Elam, one of the foremost character actors in the western genre. If you look him up, you'll recognize him—he had a long face, bushy eyebrows, and a wonky eye that was his signature. Someone had stabbed it with a pencil was he was a kid.

Totten and Dad formed a bond, because they shared a pioneer work ethic and were most at home in westerns. Whenever I looked at Dad as an actor, I thought *cowboy, horseman, farmer* more than *private detective*. The western was already in decline by the time we did *The Wild Country,* but he and Totten were interested in seeing where they could take the genre.

The production was a real manly man's environment. Totten brought over a lot of wranglers and stuntmen from *Gunsmoke*. Elam was a serious gambler and he usually had a card game going near the dressing rooms. With a whiskey in his hand, he taught Ron and me how to play liar's poker and hearts. He gave us instructions that he took very seriously, such as, "Always bring the amount of money to a card game that you're prepared to lose."

The town of Jackson Hole was filled with pool halls and cowboy bars. The crew guys sometimes reported to work the next morning with

busted lips and black eyes, all in a good night's fun. It really was more like the Wild West than the affluent resort area it is today. For Ron and me, Jackson Hole meant liberation. Mom and Dad allowed us to do stuff in town by ourselves. So we spent our per diem money on silver dollars that we bought in tourist shops and bottle rockets that we set off in the open fields where we were making the movie.

The Wild Country's crew was an idiosyncratic mix of cowboys and hippies, bound together by a love of the great outdoors. In the latter category was an animal trainer named Dan Haggerty, before he became famous as an actor in his '70s TV show *The Life and Times of Grizzly Adams.* I spent a lot of time with him since the character I played, Andrew, had a menagerie of animals: a mare, a hawk, and some chickens, all of whom he named Ralph. Haggerty had a sidekick trainer, a fellow hippie named Bullet—just Bullet—and they had big beards and wore moccasins that looked homemade. I just thought these guys were really friggin' cool.

Maybe it was the serendipity of having already worked with animals and good ol' boys on *Gentle Ben,* but I had never felt happier than I did making *The Wild Country.* It was summer, so there was no studio school, no breaks for studying. And I was really in the pocket acting-wise, with my family around me. Ron and I had spent tons of time together at home, but never like this, as colleagues on a movie set. Our closeness only made our collaboration easier. And whenever I looked up, I saw Dad palling around with Totten and Mom chatting it up with Vera Miles. It was idyllic.

RON

That was a summer of sexual awakening for me, too. I met a cute local girl named Dion and went on a couple of dates with her. The rodeo was

in town, and we went together, watching with amusement as some *Wild Country* crew members recklessly volunteered and were thrown like rag dolls off a bucking bull.

I was woefully inexperienced with girls. I'd briefly had a girlfriend in eighth grade, but our "dates" were basically playdates sprinkled with pathetically tentative attempts at kissing. I had also been on a kind-of date with Donna Butterworth, the girl singer who had appeared with me on *The Danny Kaye Show*. Donna and I did a Disney TV movie together called *A Boy Called Nuthin',* and we junketed together to Disneyland for a promotional appearance when I was fourteen and she was twelve. I sensed an opportunity on that trip and leaned in for a kiss. Donna was amenable, but she had already started smoking, and her lips tasted of cigarettes. I was traumatized by my mom's struggles with smoking and the damage it had done to her health. So that romance never took.

Nothing happened with Dion, either. But sheesh, I was fifteen, my voice had broken, and I was growing impatient! My sexual antennae were up, and I picked up on a certain charge in the air at the Grand Vu Motel, an atmosphere of hanky-panky. Not that I needed to be that perceptive. The motel was like a navy warship hitting port—the adults involved with our shoot were real libertines after hours. And whereas I had always gone home to Burbank when I was shooting *The Andy Griffith Show,* this time I was on location, sharing barracks with the crew, privy to their extracurricular adventures. Clint and I had our own rooms at the Grand Vu, and the guy in the room adjacent to mine was a player. My sleep was frequently interrupted by his and his lovers' moanings and thumpings.

On top of that, one of our hairstylists, Jackie Bone, was in the midst of a long-term but secret affair with Burt Lancaster. I saw him one weekend, a tall man surreptitiously ducking into a room on the second floor. The following Monday, the other hairstylists were teasing Jackie and

she flashed a cat-that-ate-the-canary smile. *The Wild Country* taught me a lot about how adults went about their sexual business. The Wanton World of Disney. Who knew?

But there was a downside to this uninhibited environment that wasn't amusing at all. Though Clint and I weren't in school and our parents were present, California's child labor laws were among the nation's most rigid, and we were required during the making of *The Wild Country* to have a welfare worker on set. Let's call her Mrs. Baker. She was a middle-aged woman who was a stickler for following the rules to the letter. This drove Totten nuts, because we had to do a lot of night shooting. As we neared eleven o'clock, Mrs. Baker notified him that Clint and I were required to stop at eleven on the dot. Totten wanted to keep going until eleven thirty. Dad was inclined to let it slide and look the other way. But Mrs. Baker was inflexible.

This standoff was embarrassing to fifteen-year-old me. I had plenty of energy and was happy to keep working. Yet I was still a minor and therefore still subject to someone else effectively telling me, "It's time to go to bed, Ronny." California has since eased up a bit on these rules, but the limitations placed on actors my age were a big reason that I struggled to get hired over the next three years.

None of this is any excuse for what happened to Mrs. Baker. One night, when we were between setups, I heard a howl of terror. From the distance she came running, seemingly for her life. In pursuit was a male makeup artist on the film, inebriated. He tackled her, pinned her to the ground, and started kissing her. The crew members, rather than intervene, simply observed this scene and laughed, cheering the guy on. Mrs. Baker managed to get back up on her feet. She socked the guy in the face. Undaunted, he tackled her again and started dry-humping her in front of everyone. When Mrs. Baker finally broke free for good, she ran off, crying. I never saw her again. She was sent home in a car that night and replaced by a new welfare worker the following day.

I was shaken by the way Mrs. Baker had been treated. Totten and the other powers that be shrugged off her assault with a "boys will be boys" nonchalance. Even my parents, though they agreed that what happened was awful, took a cold view of the *why* of the incident. "Well, she made everybody mad," Dad said. Like that made it okay. Totten didn't fire the makeup artist or even discipline him. The responsibility for the assault never seemed to be assigned to its instigator.

At the time, I was left more confused than angry by what I had witnessed—how could people be so fun and seemingly good-hearted, yet sanction something so terrible? But since then I have come to recognize how toxic the culture of filmmaking was for women when I was a child actor. And it was too slow to improve. When my daughter Bryce entered the business twenty years ago, memories of this incident came rushing back and I shuddered. I had deep concerns for her emotional and, yes, physical safety. Fortunately, our industry has finally begun to evolve into a safer, more respectful one. But it took the #MeToo movement, and strong women like Bryce, to begin in earnest the process of bringing about wholesale change rather than incremental measures. This change has been too long in coming and can't become the norm soon enough.

OUR TIME IN Jackson Hole coincided with the Manson-family murders, in which seven people were killed in two separate attacks in Los Angeles. The news cast a pall on our team, since we were mostly L.A. people and we sensed that the violence that had taken the lives of Martin Luther King and Bobby Kennedy a year earlier had now come to our doorstep. We didn't yet know who the killers were. There was only a widespread sentiment, based on reports that they had written RISE and DEATH TO PIGS on the walls in the victims' blood, that "the revolution" was to blame.

For a relative innocent like me, this was another source of confusion. There were components of the 1960s cultural revolution that appealed to me, like rock music, the unapologetically transgressive films of Sam Peckinpah and Mike Nichols, and the antiwar movement. But was this part and parcel of a wider revolution that was killing people? I was also aware that the movie we were making was throwback entertainment, bearing little to no relation to 1969 cultural mores, despite Bob Totten's maverick intentions. Where did I fit into the new cultural wave? It was a lot to process.

No matter what, I was pleased with the performances that Clint and I turned in. Especially Clint's. His character, Andrew, carries the emotional weight of the film, dealing with the fallout as his family's unity is pushed to the breaking point by one setback after another: a tornado, Ab Cross's harassment, a fire. When Vera Miles fights with Steve Forrest in one scene, threatening to move back to Pittsburgh, Clint performs the most convincing childhood breakdown I've ever seen. He cries tears of fear and heartbreak as he witnesses the worst thing a kid his age can witness: his parents screaming at each other, apparently coming apart.

CLINT

Someone on *The Wild Country* set said that I was a little Method actor. That's the first time that I ever heard the term. I asked Dad what it meant, and he described it as "getting so inside the character that you really become him in the moment." One of Dad's great gifts was his ability to distill the Actors Studio approach into something that Ron and I could grasp and execute. But I looked at it the other way around— the character became *me*. Was this a child's egocentric view of himself as the center of the world? Sure. But it was an approach that worked. I believed that I was more interesting than any character that someone

might write, so I viewed the script as a set of parameters and circumstances dictating how I, Clint, might behave.

The resident Indian sage in *The Wild Country* was named Two Dog, played by Frank de Kova, an Italian American character actor whose dark skin and broad features earned him a long career playing Indians and Mexicans. This sort of casting would never happen now—the role would certainly and rightfully be given to a Native American—but that is not a rap on de Kova, who was a sweet person. He had played a Mexican colonel in *Viva Zapata!*, which starred Marlon Brando. On the set, Frank tousled my hair and said, "Clint, you remind me of Brando." I had no idea who Brando was at that point, but today I would happily accept the compliment.

Hanging with Jack Elam and Frank de Kova proved crucial to me, in that I saw something of myself in them. It was the first time that I understood that I was not the same kind of actor that Ron was. He was more of a leading man, bearing a certain weight of responsibility to carry a film. I was not. I was a character actor. In Elam, de Kova, and a hilarious old-timer in the film named Dub Taylor, I recognized my tribe, my peeps. I was not going to be the Steve Forrest of any given picture but the Jack Elam. This epiphany granted me permission to be more fearless, more off-the-wall—the actor I became as an adult.

Disney flew us home from Jackson Hole on the late Walt's personal airplane, a Grumman Gulfstream I that was known as *The Mouse*. The interior was beautifully done in mahogany wood and leather. We Howards had so much luggage from the multiweek location shoot that we loaded down that fancy plane like we were the Joad family. Walt's own wings! This was living large.

I was proud of the work I did in *The Wild Country* and displeased that I didn't get my due in the opening credits. The movie came out more than a year after we wrapped, in December 1970. Disney held an advance screening for the press in a big theater on its Burbank campus,

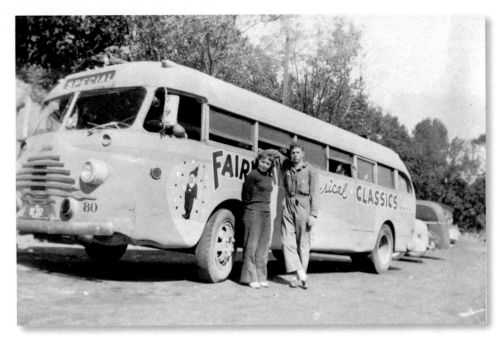

*Young lovers Jean Speegle and Rance Howard
in front of the Fairytale Musical Classics bus,
itchin' to get hitched.*

*Mom vamping it up for the camera outside
her childhood home in Duncan, Oklahoma.*

*Dapper Dad and gorgeous
Mom at the wedding reception
that her folks held in Duncan.*

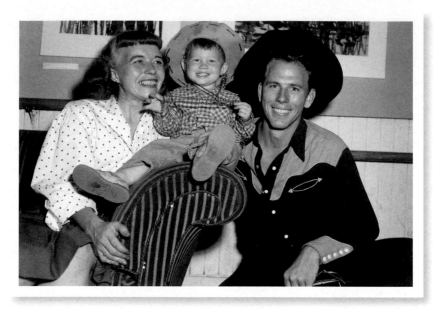

RON: Wouldn't you smile, too, if your parents dressed you up in cute western wear?

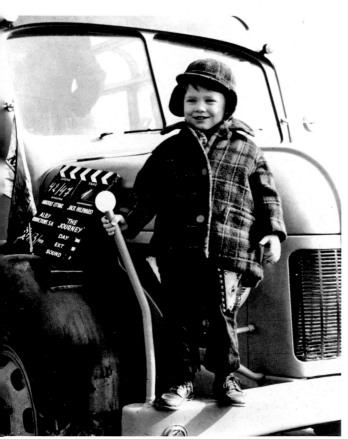

RON: Me on the set of my first film, The Journey, *in Vienna, Austria. I loved that hat with earflaps.*

RON: What might have been—with Bert Lahr on the set of Mr. O'Malley. *Had that show been picked up, people might have yelled "Hey, Barnaby!" at me instead of "Hey, Opie!"*

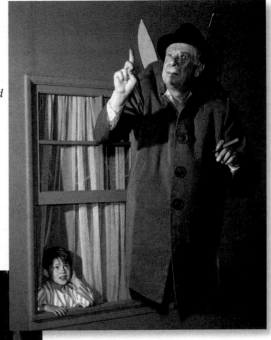

RON: With Dennis the Menace's Jay North and the TV comic Red Skelton. I was so psyched that I made Red laugh!

RON: Dad doing some last-minute touch-ups on me during the filming of The Music Man. *I was hopeless as a singer and dancer, but I'll never forget my one and only musical role.*

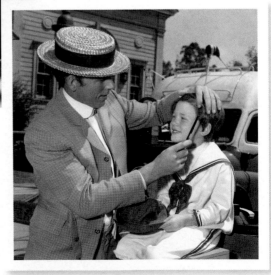

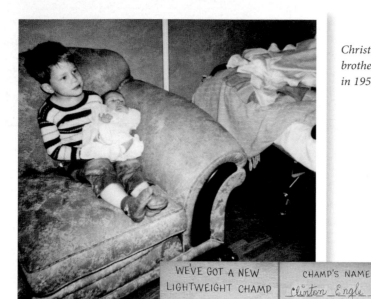

Christmas in April—a new brother! Ron holding Baby Clint in 1959.

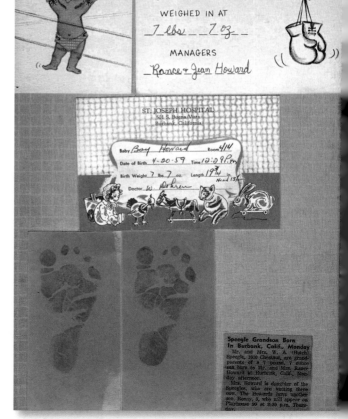

A page from Clint's baby book, including a birth announcement and Mom's hospital bracelet.

WE'VE GOT A NEW LIGHTWEIGHT CHAMP

CHAMP'S NAME
Clinton Engle

INITIAL BOUT
April 20, 1959

WEIGHED IN AT
7 lbs 7 oz

MANAGERS
Rance + Jean Howard

HE'S A KNOCKOUT

ST. JOSEPH HOSPITAL
501 S. Buena Vista
Burbank, California

Baby Boy Howard Room 414
Date of Birth 4-20-59 Time 12:29 P.m.
Birth Weight 7 lbs. 7 oz. Length 19¾ in. Head 13½
Doctor W. Dohren

Speegle Grandson Born
In Burbank, Calif., Monday
 Mr. and Mrs. W. A. (Butch)
Speegle, 1610 Chestnut, are grand-
parents of a 7 pound, 7 ounce
son born to Mr. and Mrs. Rance
Howard at Burbank, Calif., Mon-
day afternoon.
 Mrs. Howard is daughter of the
Speegles, who are visiting there
now. The Howards have another
son, Ronny, 5, who will appear on
Playhouse 90 at 8:30 p.m. Thurs-
day.

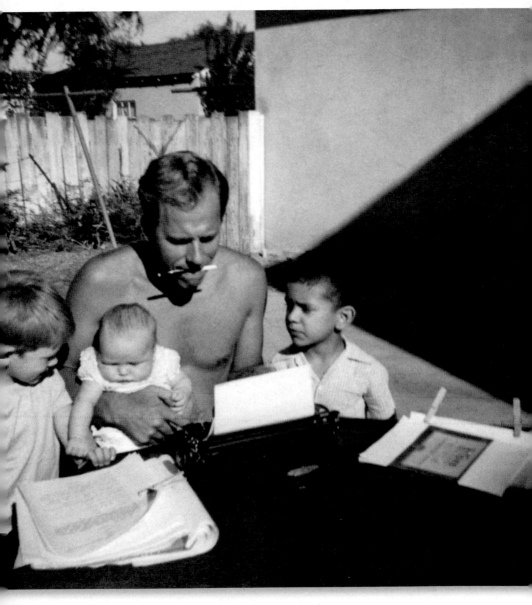

*Dad determinedly multitasking, writing even while
looking after us and our neighborhood friend Victor Diaz.*

RONNY HOWARD

AGENCY: COMORA-BERNBROCK
Hair: Red
Height: 44"

PHONE: CR 6-6285
Eyes: Blue
Weight: 48 lbs

FILMS: "THE JOURNEY", M.G.M. Release, Directed by: ANATOLE LITVAK
With: YUL BRYNNER and DEBORAH KERR (Played: BILLY)

T.V.: PLAYHOUSE 90.."THE DINGALING GIRL" (Played: DANNY)
LIVE PLAYHOUSE 90.."A CORNER OF THE GARDEN" (CLINTON ALLEN)
PLAYHOUSE 90.."DARK DECEMBER" (HENRI)

G.E. THEATRE "MR. O'MALLEY" (BARNABY)

RED SKELTON SHOW

POLICE STATION

T.V.: FIVE FINGERS "STATION BREAK"
FILMED
TWILIGHT ZONE.."WALKING DISTANCE"

DENNIS THE MENACE.."THE FISHING TRIP" (STEWART)
"DENNIS HAUNTS THE HOUSE" (STEWART)
"PARTY LINE" (STEWART)
"DENNIS BY PROXY" (STEWART)

THE MANY LOVES OF DOBIE GILLIS..
"DOBIE'S BIRTHDAY PARTY" (GEORGIE)
"ROOM AT THE BOTTOM" (DAN)

EMERGENCY WARD (PILOT FILM) (DONNY)

FANTASTIC LTD. (PILOT FILM) (BILLY)

HENNESEY "THE BABY SITTER" (MICKEY WALKER)

JOHNNY RINGO "THE ACCUSED" (RICKY)

THE JUNE ALLYSON SHOW "CHILD LOST" (WIM)

THE DANNY THOMAS SHOW "DANNY MEETS ANDY GRIFFITH" (OPIE)

*RON: One of my early résumés. Not bad for six
years old and forty-four inches tall!*

RON: I celebrated my sixth birthday at Desilu Cahuenga with Don Knotts and Andy Griffith, who always made us feel like we were part of a family. I shared my birthday with Andy Griffith Show producer Aaron Ruben, whose name also appears on the cake.

RON: Goofing around with Andy during a summer promotional tour in Canada. Don and Dad were with us, too.

RON: On the Andy Griffith Show set with Andy, director Bob Sweeney (center), and director of photography Sid Hickox (right). I was interested in the process from early on—keen to be in on the magic.

CLINT: *On the set of the short-lived sitcom* The Baileys of Balboa, *running lines with the man who discovered me,* Andy Griffith Show *director Bob Sweeney.*

RON: *"I'll point. You shoot!" With my basketball idol, Elgin Baylor of the Los Angeles Lakers, at an Easter Seals fundraiser.*

RON: Struggling to sign an autograph, a painstaking process given that I had barely learned how to write.

CLINT HOWARD

AGENCY: MARGUERITE OGG Phone: 766-94-91.
12069 Venture Pl. Studio City

Hair: Blond Height: 40"
Eyes: Hazel Weight: 40 lbs
Age: 4 (Born April 20, 1959)

FEATURES: THE COURTSHIP OF EDDIE'S FATHER, M.G.M.

T.V.: THE ANDY GRIFFITH SHOW "Leon""
"The Jinks"
"The Bank Job"
"One Punch Opie"

MY FIFTEEN BLOCKS (Pilot Film)

GOING MY WAY "Eddie"

*CLINT: My first résumé. Instead of a headshot,
Mom glued in a pic of me in my full Leon gear
from* The Andy Griffith Show.

CLINT: *In my happy place—I loved my big brother and literally had his back.*

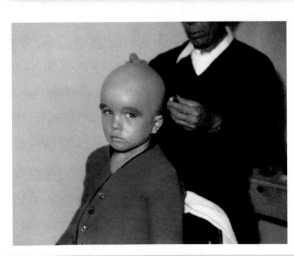

With our maternal grandmother, Louise Speegle, during one of her visits to Burbank.

CLINT: *Becoming Balok for* Star Trek. *I was none too happy to be fitted for a skullcap, but it beat having my head shaved.*

CLINT: "That's Commander *Balok to you!" Dad snapped this candid of me hangin' on the bridge of the* Enterprise.

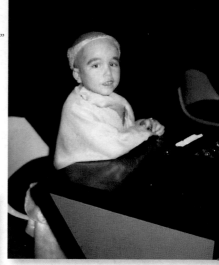

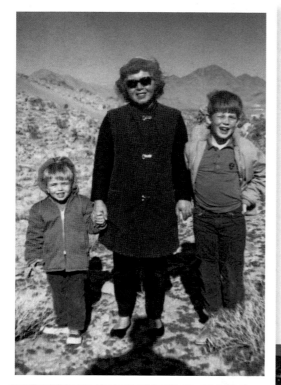

Out and about during one of our many trips to Apple Valley. Notice Dad's shadow in the foreground.

Poolside on Cordova Street.

RON: *At studio school with my stern-yet-devoted teacher, Mrs. Barton.*

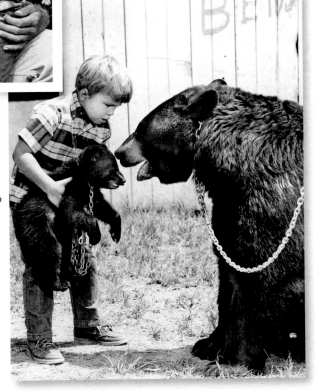

CLINT: *With Dad, my acting coach and dialogue whisperer, between takes of the film* Gentle Giant *in Miami.*

CLINT: *"Now you see here, Ben!" On the set of* Gentle Ben *with Bruno, who played the title role, and one of his little cub pals.*

RON: *My first organized basketball team, the Surety Savings Royals. Bookending the top row are my longtime friends Bob Wemyss (left) and Noel Salvatore (right). What I lacked in height, I made up for in hustle.*

Taking the Gentle Ben *airboat for a spin in the Everglades.*

CLINT: *With Dad, Ron, and my teammates on the Howards Hurricanes. In 1970, Ron coached us to the Burbank Bantam League Championship.*

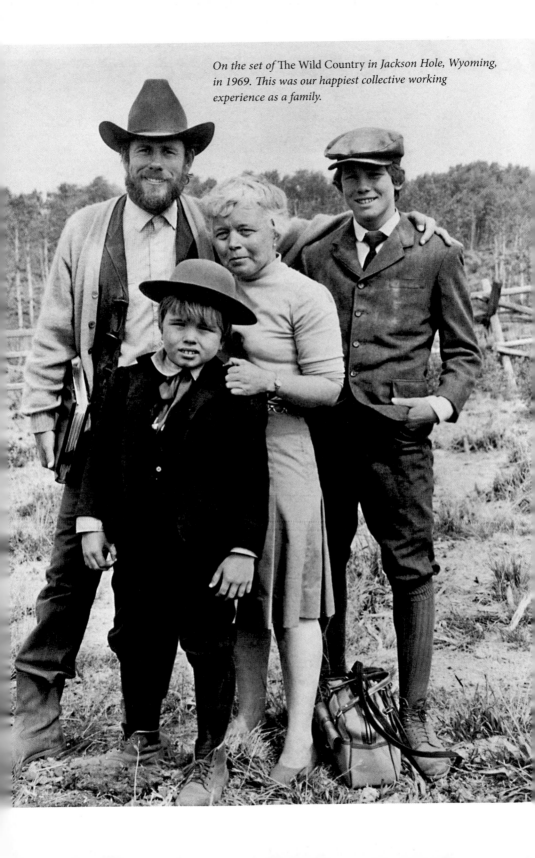

On the set of The Wild Country *in Jackson Hole, Wyoming, in 1969. This was our happiest collective working experience as a family.*

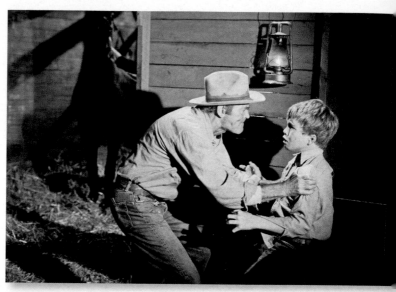

CLINT: *It was an honor and an actor's high to go toe-to-toe with* Henry Fonda *in* The Red Pony.

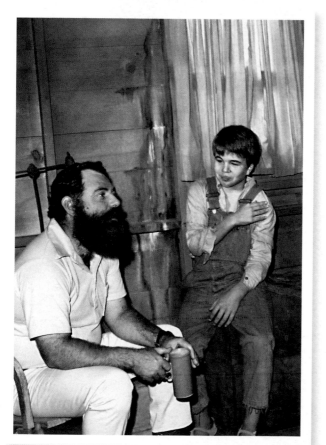

CLINT: *With director Bob Totten on the set of* The Red Pony. *He had a maverick's beard to match his personality.*

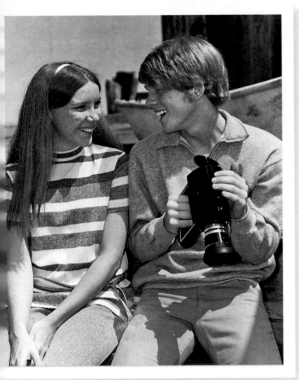

RON: *Showing off to my new girlfriend Cheryl Alley the Super 8 camera I used to make my first movies.*

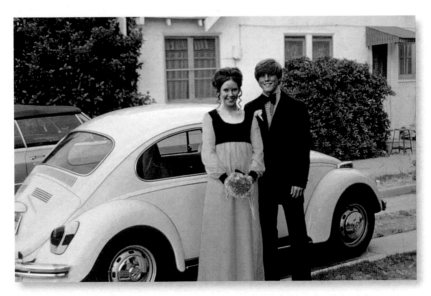

RON: *With Cheryl on the day of the 1972 John Burroughs High School prom. Cheryl made the dress herself. I still have that VW Bug—and the pretty redhead.*

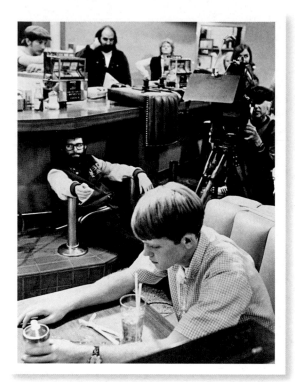

RON: On the set of American Graffiti, *with George Lucas lounging in the background. I look like a kid, but working with George was a coming-of-age experience.*

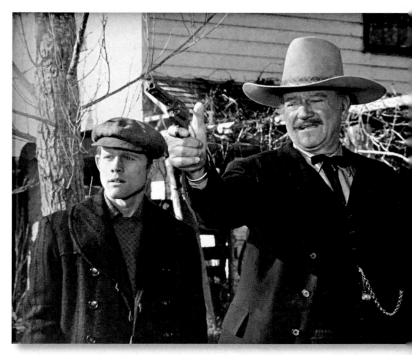

RON: With my chess partner, John Wayne, on the set of The Shootist, *the Duke's final movie.*

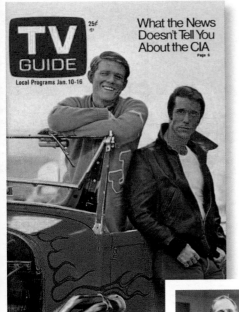

RON: *A rare shared magazine cover with Henry Winkler from 1976, Fonzie's annus mirabilis.*

The classic Happy Days *lineup (left to right): Al Molinaro, Anson Williams (kneeling), Marion Ross, Tom Bosley, Henry Winkler, Donny Most (kneeling), Erin Moran, and Ron Howard.*

CLINT: *With my pitching protégé, Henry Winkler. We two were a heck of a battery for the* Happy Days *softball team.*

RON: Henry caught a plane from a location shoot to make it to our wedding on June 7, 1975.

CLINT: The beautiful newlyweds being driven away from the church in their beloved red Volvo wagon by the sixteen-year-old best man (me), who had only a learner's permit.

RON: In a preproduction meeting with legendary iconoclast Roger Corman for Grand Theft Auto, *my directing debut.*

RON: Dad and I plotted every chase and crash for Grand Theft Auto, *using toy cars and our imaginations.*

RON: My marked-up Grand Theft Auto *script, complete with rudimentary storyboards. My film prep today is more sophisticated but ultimately not that different from what you see here.*

ANOTHER ANGLE 36.

new cars don't crash

The frenzied circling, swerving, and spinning, as the three net
cars attempt to pocket the Rolls Royce, churns up a tremendous
cloud of dust. View of all four vehicles is totally obliterated.
The LOUD IMPACT of a CRASH is HEARD! A few moments later the
Rolls Royce bursts into the clear, bounces across the ditch
onto the road and continues south.

NEW ANGLE - *dif. place*

As the dust lifts we see the three velvet net cars racked up and
tangled together in an unbelievable mess, absolutely totalled.
All three drivers are crawling out and looking at their wreck
in stunned amazement. Shadley pulls a flask from an inside
pocket and takes a drink.

AERIAL POV OF WRECKAGE THROUGH BINOCULARS
 BENNY (V.O.)
 (laughing)
 Yeah, the drivers are okay...
 but the cars are totalled. *just wiped*

INT. EAGLE I
 BENNY
 I wish you could see this, Ned. *close*
 SLINKER (V.O.)
 Shut up and stay with the quarry.

INT. MOTEL ROOM - DAY

Bigby is agitated and shouts into the mike.
 BIGBY
 How's the car?
 BENNY (V.O.)
 Couldn't be better man. That's
 a helluva set of wheels.
 SLINKER
 (into mike)
 We're going mobile, I'll stay
 in touch. Base I, out.
 (to Marsh)
 Pack the van.

 rips map off the wall and rolls it up. Bigby picks up the phone.
her gathers up papers at desk
 BIGBY
 (quietly)
 Your velvet net wasn't very effective,
 Slinker. As a matter of fact your
 velvet net didn't work at all.
 (exploding)
 Your velvet net couldn't catch crap!

 (CONTINUED)

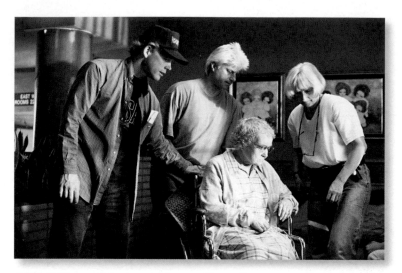

RON: "If they could get a washing machine to fly, my Jimmy could land it." Prepping the big scene with Mom, whom we aged to look much older than she was, on the set of Apollo 13 in 1994.

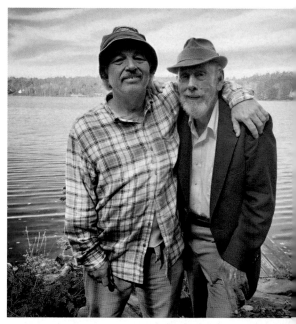

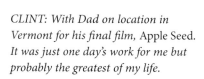

CLINT: With Dad on location in Vermont for his final film, Apple Seed. It was just one day's work for me but probably the greatest of my life.

and our whole family was there as the lights went down. Steve Forrest got first billing. Fine. Then the names of Ron—still "Ronny" then—and Jack Elam shared a screen. Fine. Then Frank de Kova and Morgan Woodward. Hmm. Then Vera Miles got her own title card. Fair enough, but still: Where was Clint? And then, at last, came my name . . . in small type, sharing a title card with four other actors' names. *What the hell?* I was a colead! I was a more mature kid than I had been when making the movie—when you're young, the difference between eleven and ten is not insignificant—but that didn't stop me from bursting into tears at my mistreatment. I felt like I had been shit on.

Dad escorted me into the lobby to cool off. Bob Totten ran out, too, consoling me and telling me that the crediting was unfair and a surprise even to him. I now understand that this was simply a matter of studio politics and power plays. The other actors' agents outjockeyed my agent. Fifty-odd years later, it doesn't matter one whit. I rate that movie as one of my best as a kid.

RON

I was totally on board with *The Wild Country* when we were making it, and Bob Totten's mentoring was a formative experience in terms of my filmmaking aspirations. Totten asked me what I was doing to further my dreams. I told him that I was making Super 8 movies in my backyard but that I hoped to make my first feature while still in my teens. He smiled wryly. "R. W.," he said, using the lofty *nom d'auteur* I was keen to use, "you need to ask yourself every day what you've done about being a filmmaker. Did you write something? Did you study a movie you like? Did you shoot or edit or do one goddamn thing to make yourself a film? Get the hell out of your backyard and get to it!" I gave Bob a sharp nod and pledged to him that I would heed his words.

But by the time of *The Wild Country*'s release late in 1970, I was a mere three months from turning seventeen—and frankly, I was embarrassed to be in a corny Disney movie. It felt like an extension of my Opie image, which I had finally managed to shake off at Burroughs High School.

The film stiffed at the box office. I was relieved. That meant that it was only around in theaters and drive-ins for about two weeks before it disappeared. That's a harsh thing for me to acknowledge, that I was rooting against my own movie. But such was the push-pull of adolescence, in which my gratitude for all that Opie had given me existed in tension with my desire to be a man.

Because I *was* a man, damn it. After all, I now had a car and a girlfriend.

I SHOULD EXPLAIN the car first. When I turned sixteen and passed my driver's test, Mom and Dad granted me permission to dip into my not inconsiderable savings to buy my own wheels. I had my eye on a muscle car, a Plymouth Barracuda—the very caricature of a teenage boy's he-manly ride. I even test-drove one. But unsurprisingly, my parents nixed that idea. So I settled for my Plan B: a Volkswagen Beetle, a brand-new 1970 model, with a white exterior and red vinyl upholstery. My pride and joy. It remains in my garage to this day.

Having a car was a big step forward for me. I had been the boy in the bubble wrap, the kid who wasn't even allowed to ride his bike in the streets. Now, Mom and Dad trusted me to drive to and from acting jobs by myself. They still placed a hell of a lot of restrictions on me, but the simple act of having that independence and some drive time alone with my thoughts did wonders for my sense of self.

Which brings us, indirectly, to the girlfriend. Going into my junior

year of high school in the fall of 1970, I knew that I was going to be away for part of the first semester. I had landed a promising job on a new ABC comedy-drama called *The Smith Family*. Its starred the legendary Henry Fonda, whose film career was in something of a lull at that moment. Fonda played a police detective named Chad Smith. I was cast as the middle of his three children, Bob.

Since you've probably never heard of *The Smith Family,* you already know that it didn't work out—we lasted for only a season and a half. But during the first week of school, I scrambled to get my assignments from my various teachers, because I knew that I would be out of school and on a soundstage for the better part of the next two months. On the Friday of that week, as I prepared to leave, I ran into some girls in Mrs. McBride's English class. As we chatted, my eyes locked on a girl who was off to the side, not part of the conversation. I recognized her—the redhead who sat in the front row. She was also on the drill team that performed flag routines at halftime during our basketball games. My first thought was *Wow, she looks a little like Sandy Totten.* My next was *God, she's pretty.*

And she was looking right at me. She raised her hand and curled a finger in a "Come hither" gesture. I left the girls I was talking to because *the* girl who most intrigued me had just shocked the hell out of me. I walked over to her. There was an awkward pause. Then she spoke.

"I know you're leaving, but are you still playing basketball this year?"

"Yes, I am playing. The B team," I responded.

Such was our momentous first conversation. But I couldn't get it, or her, out of my mind. Two weeks later, on a Saturday, I was taking the PSAT standardized test in our school library. When I turned in my test, I spotted the redheaded girl standing with some kids I knew.

I had recently made a guest appearance on Andy Griffith's new CBS series, *Headmaster,* whose life span would prove to be even shorter than

that of *The Smith Family*'s. Not that any of this mattered in the moment. What mattered is that I had another chance to engage with this girl.

I walked over and reintroduced myself. "I'm Ron," I said.

"I'm Cheryl," she said. "I saw you on *Headmaster*."

We talked a little bit longer and I told her that I was worried about falling behind on homework because of my TV obligations. "If I get behind on my assignments, maybe I could call you and you could . . . uh, explain them or something?" I said, planting the seed like the smooth operator I wasn't. She said that sounded good. But like an idiot, I forgot to ask for her number.

Cheryl, front-row redhead Cheryl, occupied my thoughts, all the time. At home, I looked her up in the yearbook and found out her last name: Alley. Then I checked the white pages of the phone book, looking for an Alley family in the Burroughs High School district. I found a listing for a Mr. Charles Alley on Evergreen Street in Burbank.

Then I . . . well, I guess I stalked Cheryl. Whenever I was done shooting *The Smith Family*, usually around three o'clock in the afternoon, I drove back and forth between her house on Evergreen Street and Burroughs, casing out the route that Cheryl most likely walked to and from school. I did this over and over again, hoping that I might somehow happen upon her in stride. I had it all planned out: I would roll down my window ever so casually and say, "Oh, hey, Cheryl, it's Ron. Ron from Mrs. McBride's class. Would you like a lift back to your place?"

It never worked. All I ended up doing was drive in a continuous, frustrating loop while James Taylor's "Fire and Rain," the song of that season, played seemingly nonstop on my VW Bug's tinny radio.

Finally, in late October, I gave up the stalking and decided that I would just call the listed number. I stared at the phone for a long time, sweating like Bert Lahr. Then I picked it up and dialed. A man I

presumed to be Mr. Charles Alley himself answered. "May I speak with Cheryl?" I said, trying to keep my voice from trembling.

"Who should I say is calling?" the man asked.

"Ron Howard."

Cheryl came to the phone. I bullshitted her about needing help with an assignment. We were reading Charles Dickens's *A Tale of Two Cities* in class, and I claimed not to know what that night's homework was. She told me which pages to read. Now it was time for me to put up or shut up.

"Thanks . . . and, um . . . Hey, would you want to go to a movie with me?"

"Yes," Cheryl said, "but let me check with my dad."

My heart pounded in my throat while I waited. She returned to the phone. "What movie would it be?" she said.

I told her that Stanley Kramer's 1963 all-star comedy *It's a Mad, Mad, Mad, Mad World* was playing at the Cinerama Dome in Hollywood, and that I had seen it and loved it. I thought that she might like it, too.

Once again, Cheryl said that she needed to check with her dad. This prompted another short wait that somehow felt like it lasted an eternity. At last, she got back on the line.

"Okay," she said.

Or should I say, *Okay, she said!*

I laid out my plan to Cheryl: I would pick her up, we would catch the Sunday matinee, I would take her to dinner at Barone's Pizzeria in Toluca Lake, and then I would drive her home.

AND THAT'S EXACTLY what happened on November 1, 1970. The night before, I had covered my face in green makeup with dark circles around my eyes and gone out trick-or-treating with my

six-foot-tall friends, still idiotically excited about free candy. This on the eve of my first date with the woman I would end up marrying. Again, the push-pull of adolescence.

But that Sunday afternoon, I combed my hair neatly and forswore my usual T-shirt and letterman's jacket, opting for a shirt with a collar and a V-neck sweater. I drove to Evergreen Street to pick up my date. Cheryl looked beautiful—she was wearing a lightweight white sweater, a navy blue skirt that was a few inches above the knee, and pantyhose that, because she was so skinny, bagged at the knees. Her long, lustrous red hair was held back by a hairband.

At the Cinerama Dome, I touched Cheryl for the first time, cupping her elbow in my hand to guide her into her seat. I had seen gentlemen do that in old movies.

At Barone's, we talked nonstop over our pizza, downloading the better part of our life stories to each other. Cheryl's parents were divorced and she lived with her father, an aerospace engineer and licensed pilot who flew a single-engine Cessna. Cheryl, too, knew how to fly and was in the process of receiving her certification. She was outdoorsy, she told me, a tomboy. She and her dad went camping a lot.

I told her that my dream was to direct movies. I yammered on excitedly about a screenplay for an independent picture that I was writing with my friend Craig Hundley. That's right: I was such a film nerd that doing a story pitch was my way of trying to impress a girl.

Being a gentleman, I moved to serve Cheryl a slice of pizza, maneuvering it from the metal tray to her paper plate. In my nervousness, I screwed up and flipped the slice so that it landed toppings down on the table, the tomato sauce splashing and just missing her skirt.

But Cheryl just laughed. I was utterly besotted. In my mind I couldn't believe it: *Wow, my ideal actually exists on this planet.* Henry Winkler later joked that I must be some kind of monstrous narcissist, because to him, Cheryl and I looked like twins.

I dropped her off on Evergreen Street, stood with her in front of her house, and bade her good night. I decided that I wouldn't try to kiss her, not this soon. But I wasn't sure about this. I worried that perhaps I wasn't being as forward as she wanted—maybe I was blowing my chance. It turned out not to matter. Cheryl strode purposefully to her door, opened it, and then, safe on the other side of the window screen, smiled at me and said, "Thank you." Perfect!

I drove home on cloud nine. A few years later, as Richie Cunningham on *Happy Days,* I would celebrate my dating triumphs by suggestively singing, "I found mah thrill . . . onnn Blueberry Hill!" I was possessed by that kind of giddiness that November night. I wanted to figure out a way to convey it to my parents and Clint.

Andy Griffith had a tendency, when he was in a good mood, to speak in loud, declarative sentences: "Well, *that* was out-*standing*!" I remembered this and literally did an Andy imitation. I walked into the house, leaving the front door open behind me. My folks were sitting in the living room. They looked up at me expectantly.

"Now *that's* a *date*!" I said. I reached behind me and swung the door shut with a loud slam. Then I bounded upstairs to my bedroom without saying another word.

I can only imagine what they thought had happened on this date.

15

DATING GAMES, REAL AND STAGED

RON

Cheryl and I had a few more chaste movie dates like this, with me curating the programming. We next saw *WUSA,* a political thriller starring Joanne Woodward and Paul Newman. And after that, *Airport.* She did not object when I held her hand and put an arm around her shoulder.

Still, I couldn't summon the nerve to kiss her. But on Burroughs High School's homecoming weekend, I sensed an opportunity. There was a dance scheduled for the evening after the football game. I went to the game as a spectator. Cheryl was there with the drill team. She had on her red-and-white Burroughs uniform, which included a short, fringed skirt that did disorienting things to my brain.

That night, we danced up a storm. She had good moves. I didn't. Then the dance was over. I drove Cheryl back to her house in my VW Bug. It was time to see her to the door and say good night. Damn it, I was still too nervous to pull the trigger.

But then, while we were still sitting in the car, Cheryl looked left,

right, up, and down with some concern. "I can't find my purse," she said. "I must have left it back at the school!"

So we drove all the way back to Burroughs, which was now virtually abandoned. We looked everywhere for her purse. No luck.

Well, no luck in *that* regard, anyway. We found ourselves standing alone in front of the high school. I went for it. I kissed her on the lips.

Cheryl did not pull away. In fact, she welcomed the kiss. Then we kissed some more. Our first kiss was quickly followed by our second, our third, our fourth, our fifth . . . probably in the neighborhood of our thirty-seventh kiss.

When we got back to the car, she rooted under the passenger seat and pulled something up: her purse. "It was here all along!" she said.

Cheryl later admitted to me that the "missing purse" thing had been a ruse. "I just didn't want the date to end," she said.

I WAS FULLY in love by Christmas. The more time I spent with Cheryl, the more I couldn't believe my good fortune. By that point in my life, I had developed a keen sense of who among the kids at my school was just curious about meeting Opie and who was genuinely interested in me. Cheryl was definitely in the latter category. More important than that, she had a quiet individualism and an energy for tackling challenges that I had never seen in someone my own age. She had already soloed in her father's plane, on her sixteenth birthday. She was well-liked by the popular girls in our grade at Burroughs, but she wasn't *of* them; when she was rushed to join the class sorority, she politely declined. She didn't give a damn about social status.

Cheryl's father, Charles, was a Louisiana native who looked and dressed like the aerospace-era scientist he was: crew cut, black horn-rimmed glasses, gray slacks, and a short-sleeved dress shirt with a pen

protector in the front pocket. Decades later, when I gave him a walk-on part in *Apollo 13* as one of the Grumman engineers who were advising the mission-control guys, I told my wardrobe department to leave Mr. Alley alone; his regular work clothes would do just fine.

But his tan, weathered skin betrayed that Mr. Alley wasn't as strait-laced as he initially appeared. As a teen, he hopped freight trains to get himself to the 1933–34 World's Fair in Chicago, and he later worked on icebreaker ships in the North Pacific and panned for gold in Mexico. Cheryl's mother, Vivian, had run away from her family's Wisconsin farm when she was only fourteen, fleeing abusive relatives. She made her way to California by working as an au pair and waitress. When she was only twenty-one, Vivian got pregnant by Charles, who was almost seventeen years her senior. They married as a result, with Cheryl being their firstborn. Two more girls, Cheryl's sisters Sondra and Floyce, came after her.

Her parents divorced when Cheryl was in her early teens. But she had inherited the best of them: her father's intellectual curiosity and her mother's kindness and heart. Though our households were very different—Cheryl was a remarkably self-sufficient latchkey child, whereas I was the highly supervised son of a tight nuclear family—I saw some similarities in our backgrounds. We were both the products of parents who took unconventional paths in life and didn't care what anyone else thought of their choices.

Cheryl had this trait, too, more so than me. She wasn't a follower. If anything, she was an agitator. She railed against Burroughs High School's policy of not allowing girls to take auto-shop class, because she wanted to learn how to repair a car. And she thought it unfair that Burroughs didn't have a track program for girls. She had been a skilled sprinter in middle school. With a friend, she lobbied the school administration to create such a program, which finally came into being shortly after we graduated.

CLINT

By the time Cheryl came along, I had begun to consider an adult career as a sportswriter. Fledgling journalist that I was, I looked up Cheryl's stats when she entered Ron's life. She held the record in the 220-yard dash at her junior high, Luther Burbank Middle School. Ron was impressed by Cheryl's athletic prowess. As they got more serious, I think he may have been harboring dreams of breeding jocks.

One evening as we walked to my car after a movie, I leaned in to kiss Cheryl and she pushed me away playfully and took off—while wearing suede saddle shoes. I gave chase. I was pretty confident in my running abilities. I was one of the quicker players on my basketball team and a base stealer on my baseball team. But as I chased Cheryl, I noticed that I wasn't closing in on her. So I decided, *Fine, I'll kick into high gear, catch up to her, and then swing her into my arms for that kiss*. As I accelerated, though, she turned on the afterburners and shot off like a bullet. My girlfriend, I discovered, had some serious wheels. She finally eased up and flashed a coquettish look over her shoulder. That's when, panting like a dog left out too long in the sun, I got my kiss.

As we got to know each other better, Cheryl told me that she was attracted to me because, unlike a lot of boys in our class, I didn't seem full of myself. She liked that, counter to expectations and stereotypes, I didn't act like a television star. I didn't drive a flashy car. (Thank goodness my parents nixed my getting the Barracuda.) If anything, my status as an actor was a potential detriment. Her father owned an apartment building. Some of his tenants were actors, and they were the worst about paying their rent on time.

Cheryl also told me that her father had never asked to approve my first-date choice of *It's a Mad, Mad, Mad, Mad World*. While I had waited on the phone with bated breath, she was looking up the movie in

the newspaper listings to see its rating, which was G. Cheryl was raised in a strict Southern Baptist household, and she wouldn't have gone out with a guy who proposed seeing a PG movie on the first date or, God forbid, wanted to sneak into a rated-R picture.

I spent the days before Christmas zipping around Southern California in my Bug, picking up the component parts of the present that I was customizing for Cheryl. She was a pilot, so I bought her some old-fashioned Amelia Earhart cockpit goggles, a leather aviator's cap, and a scarf. Over that holiday break, I gave her these gifts and told her that I loved her.

She wasn't alarmed by my saying this, but she was less ready to jump to conclusions. "My dad says that it can't be love now," she said. "It can only be infatuation. He says it takes years for real love to develop."

I was willing to accept this. She wasn't saying "I don't love you." She just wasn't ready to say those three big words yet. I got it. This might be hard to believe, but I was happy to wait. I was actually proud of myself for this, feeling wise beyond my years in my maturity and patience. Besides, we kept on dating and kissing.

But my parents were leery of this new relationship. They never demeaned my feelings or used that condescending phrase "puppy love." But they were concerned that I had fallen so hard for Cheryl that I might derail, either by getting my heart broken or by being so caught up in my relationship with her that my schoolwork would suffer. There was a sociopolitical backdrop to this: my eighteenth birthday loomed in the near future, and I would soon become eligible for the draft. The Vietnam War was still very much on, and we were all hoping that college deferments would keep me out of the military. Ergo, I needed to keep my grades up.

I thought that I had forever slipped off the Bubble Wrap that my parents had kept me in as a boy, but now it came back. Their protectiveness of me went into overdrive. They issued an edict that I could only

go on one date a week with Cheryl, believing that I was moving too fast. Forbidding me from riding my bike in the street when I was little was one thing. But this was a whole new level of controlling behavior. I was angry.

My response was to prepare a presentation for my parents in which I cited other boy-girl couples in my grade. I had conducted a survey of them and compiled the data, which demonstrated that every other couple besides Cheryl and me was spending more time together. This did little to persuade Mom and Dad.

"Look, Cheryl's a great girl," Dad said. "But you've got a lot going on in your life, and the more you hang around with a girl, that's how you end up with unwanted teen pregnancies. And you're not married. You're not even engaged. She's your girlfriend. That's fine, but these other couples you're talking about? They're acting like they're already married."

I knew that my parents weren't accusing Cheryl specifically of being a gold digger. As controlling as they were, they were acting out of love. They felt responsible for the fact that their son was famous, and they knew that fame could have ugly ramifications. They were also thrown by how serious I was about this, my first real relationship with a girl. They suggested that I should consider dating other girls before I got in too deep with this one. Which only made me angrier.

I felt humiliated and overly policed. As my weeks with Cheryl turned into months, her father, who was more accepting of our relationship than my parents were—which is saying a lot, since he was a conservative, religious man who was a registered Republican and a member of the NRA—invited me to join him and Cheryl for an overnight camping trip. Cheryl passed along the invitation and made the conditions clear: "My dad will be there, and it'll be fun, and you'll have your own tent, of course."

I presented this offer to Mom and Dad and got a flat no. Then I had the bright idea that maybe, if I had sweet, honorable, charming Cheryl

explain the setup to them instead of me, they would relent. Disaster. I could not have been more wrong. With an ingratiating smile on her face, Cheryl made her case to my parents in our living room. Mom, who was normally so easygoing and people-pleasing, issued a cutting rebuttal. "Why are you pushing us on this?" she told Cheryl. "We said no. We barely know anything about you, and we know nothing about your father."

For the first time, Cheryl got angry at me. She felt that I had walked her into a trap. That had not been my intention, of course, but it was the reality. And now she was convinced that her boyfriend's mother didn't like or trust her.

CLINT

Ron was kind of a nerd. It didn't matter that he was a TV star and a household name. He was a pimply-faced, straight-arrow sixteen-year-old. I was thrilled that he now stood a chance of getting some action.

So I had no separation anxiety about losing my big brother to his new girlfriend. I liked Cheryl right away and I saw how happy Ron was. I defended their relationship to Mom and Dad and resented on Ron's behalf the draconian restrictions that they had placed on his dating life. It just wasn't fair.

This doesn't mean that I was above being a pesky little brother. I was the Hee-Hee Man, let's not forget. We had a rec room in the lower level of the guesthouse out back, underneath Dad's office. Ron and Cheryl would inevitably gravitate toward there, looking for a place to be alone. But Mom made it known that she didn't want them to be in the rec room by themselves, lest they start necking . . . or worse.

For me, Mom's warning was like an invitation. I took it upon myself to be a busybody. One day when Cheryl was over, I scurried off to the

rec room and hid behind a couch. Sure enough, Ron and Cheryl walked in and started to kiss. I sprang up and said, "Guess what? Clint's here!" I was a sick little bastard.

Cheryl just giggled, but Ron was pissed. His limited time with her was sacrosanct. And, little-brother mischief aside, I respected that.

RON

As this tension over my dating life went on, I challenged Mom and Dad. What about it was bugging them so much? Mom told me that she was worried primarily about me getting Cheryl pregnant. I replied that Cheryl and I were not yet doing the thing that causes pregnancies.

She didn't believe me. She had clocked my furtive visits to the rec room with Cheryl and worried about how late my dates went. "Oh, come on!" she said. "How can you spend that much time with her without going all the way?"

Wow. This was rich coming from someone who, though she and Dad hadn't yet revealed this truth to me, had lived in sin with her boyfriend in New York City and eloped with him when they were twenty-one and twenty. But then, that was probably one of the reasons why Mom was so suspicious—she had been a free spirit at my age. And now it was the early 1970s, a much more sexually permissive time than that of her youth.

I was telling the truth, though. Cheryl and I weren't having sex. Sure, we were necking and petting, to use the terminology then still in use. But that was it. Intimacy was new for both of us and I didn't want to push Cheryl or rush ourselves as a couple.

As my relationship with her continued, Dad became more sympathetic, even though he and Mom remained united in their clampdown. Just in case I did choose to become sexually active, he wanted me to be

prepared. So, in the same plainspoken way that he explained mastur-
bation and the bathroom graffiti at Desilu Cahuenga to me, he sat me
down for another talk. First, he presented me with a copy of *Everything
You Always Wanted to Know About Sex* (*But Were Afraid to Ask)*. This
was a recently published book by a doctor named David Reuben that
had become an international bestseller, the first mainstream sex manual
that wasn't considered dirty or deviant.

"Listen, you don't have to be embarrassed by sex, and this book will
answer a lot of questions you may have," Dad said. "It's good to have the
answers because sex is a natural part of life. If you ever have other ques-
tions, let me know."

I never did hit up Dad for advice—that was just too uncomfortable
to contemplate—but I avidly paged through the book. Still, I couldn't
bear my parents' rules about how much time I got to spend with Cheryl.

So I developed some workarounds.

For starters, I pretended that I had found religion. We were not
churchgoers in our household. But Cheryl went with her dad every Sun-
day and was, in those days, pretty pious and hardcore—sufficiently so
that she was genuinely a little worried about my soul. So I told my par-
ents that I had become interested in Cheryl's Southern Baptist faith and
wanted to go to church with her. They couldn't object to their boy going
to church, could they?

Even this proved to be a difficult negotiation. Mom and Dad said
that I could go as long I came back immediately after church let out.
I managed to pry out of them an allowance of half an hour of further
time with Cheryl on Sundays beyond church.

Next, I declared that I was trying out for the cross-country team at
Burroughs. Not because I enjoyed running. I had a scheme. To try out,
I would need to train, right? Mom and Dad permitted me an hour and
a half in the afternoons to go running. So I put on my shorts and run-
ning shoes and jogged over to Cheryl's house, which was only a mile

and a half away. Then I would spend about an hour hanging out with her. When my time was almost up, Cheryl drove me back to within a couple blocks of my house. From there, I sprinted pell-mell up to our door so that my face was convincingly flushed and my hair sufficiently sweaty. "Whew, good workout!" I said when I walked in, bending over to rest my hands on my knees as I breathed deeply. I don't think my folks bought it for a second. But they tolerated it.

IT TOOK SOME time for my parents to reach détente with Cheryl, or with the idea of Cheryl and me as a couple. But simply by sticking together, Cheryl and I demonstrated that we were for real. It was one thing for Mom and Dad to have doubts about a pair of moony sixteen-year-olds and quite another to question our commitment by the time we were nineteen and still inseparable.

One notable moment in the thawing process involved our monkey. Yes, you read that right. Cheryl and her dad kept a pretty bizarre array of animals at their place: an anteater, skunks, a snapping turtle that lived on a diet of beef heart, and a mature woolly monkey named Willie. There was a local pet store that we enjoyed visiting, to check out the exotic birds and reptiles that they had for sale. One day, Cheryl and I dropped in and saw that the store had a new occupant: a juvenile woolly, a female. Cheryl swooned over this beautiful little creature with deep, soulful eyes.

So I decided to surprise Cheryl. I returned to the store alone and bought the monkey for $500. That's something I would never do now; doing so would support a black market of cruel animal traffickers. But it was perfectly legal then, and Sugar, as we named her, was a great companion, gentle and fun to be around. She lived well into the years when Cheryl and I got married and moved in together; she was basically our first child.

When Cheryl was still living at her dad's, I asked my parents if she could bring Sugar on one of her visits to our house. I promised them that Sugar would wear a diaper indoors, just in case she felt the urge to go. They said yes.

On the appointed day, I went to pick up Cheryl and drive her over. When we entered, she witnessed a sight that moved her no end. Mom and Dad had hung ropes and lines everywhere; they had effectively transformed our house into a play space for a woolly monkey. This was when Cheryl realized that things were going to be okay between her and my parents.

I STILL WASN'T feeling so great about my professional life. The period between *The Wild Country* and *The Smith Family* had marked the biggest slump of my career. For a nine-month stretch, I wasn't cast in anything. I disappeared from television. Factor in the adolescent rage that courses through a boy when he is in his midteens and you have a volatile situation. I was getting mad at everything my parents said to me. I was getting mad at myself when I had a bad basketball practice. I was getting mad at the phone for not ringing.

I felt a constant urge to put my fist through the sliding glass doors that led to the backyard. I never did so, but I did spend a lot of time angrily slamming a basketball against the garage door, making as much noise as I could. I felt diminished and betrayed by the entertainment industry. I kept shouting, "I'm missing the boat!" To this day, I can't articulate precisely what was on this boat that I was convinced I was missing. But I was inconsolable most of the time.

Poor Mom couldn't do anything right by me, but she tried. Mostly, she and Dad did their best to soothe me and assure me that this moment would pass. Inwardly, I recognized that my family was what kept me afloat: the big Christmases, going to the movies with Dad, coaching

Clint in the Howards Hurricanes. Dad and Hoke Howell let me hang out with them during their writing sessions, inviting me to help them crack an episode of a TV show that they were writing.

I appreciated all this even as I told myself that I never again wanted to be in this position. I began to imagine—pun intended—a future in which I would build my own company and have control over my creative output, so that I would never again have to wait around to be hired.

Part of what I loved about Cheryl was that she and I, as a couple, had nothing to do with show business. Sure, she listened to my war stories and was supportive of my ambition to graduate to directing. But she was in no way dependent on my dreams. She had dreams of her own. She was going to go to college and major in psychology. She was going to travel the world. I had no intention of co-opting Cheryl. We could dream our dreams together.

THE SMITH FAMILY was a dull, indifferent show. The guy who put it together, Don Fedderson, had struck gold when he built *My Three Sons* around a film star of yesteryear, Fred MacMurray, and he thought he could do the same with Henry Fonda. But the quality of the scripts just wasn't there, and after a few episodes, Hank Fonda's enthusiasm flagged. His work ethic remained and he remained respectful of the cast and crew, but he didn't have Andy Griffith's passion to elevate the material he was performing, to make every scene matter. I learned from this experience that the work doesn't just take care of itself—you need a leader and champion. We continued into a second season only because Fonda had a lucrative contract that he wanted to see through.

One lowlight of this period was an appearance on *The Dating Game,* which shared a network, ABC, with *The Smith Family.* I hated the idea. I was already committed to Cheryl and I found the whole concept ridiculous. But ABC's publicity department was adamant—kicking off a

decade-long string of embarrassments for me at the hands of those folks. In a few years, for *Happy Days,* I would be suffering my way through guest appearances on *Donny & Marie* and Captain & Tennille's variety show—which is not a knock on any of the aforementioned but on my hopelessness as a song-and-dance man. It's not fun being on TV when you absolutely know that your performance sucks.

I did *The Dating Game* twice. The first time, I was one of the three bachelors competing to win a date with a young lady. I wasn't picked, which was fine. Well, not really. If I was going to go to the trouble of putting on a suit and sitting there like a dork with an audience watching, I damn well wanted to win! As my dad used to say, "You can't separate the pleasure from the pain." So honestly, I was pissed not to be picked.

The second time, ABC told me that *I* was going to be the one asking the questions and doing the choosing. It was a special double-date episode where two lucky couples would go on a romantic yacht cruise to the beautiful island of Catalina! With lots of plugs promised for *The Smith Family,* Wednesdays at 9 P.M. on ABC.

Cheryl and I did not have an open relationship. And I was not shopping around for anyone else. So only grudgingly did I agree to go through the motions. Cheryl pretended not to find this showbiz work obligation to be demeaning and offensive. The costume department at *The Smith Family* helped me pick out a smart double-breasted blazer and a pair of chalk-stripe pants. I went on the show and asked questions that someone else had written for me. The girl I picked turned out to be a lovely young woman with long blond hair named Nola.

When it came time to enjoy my date of a lifetime with this comely lass who I didn't know, Cheryl drove me to the Port of Long Beach, where the boat to Catalina was launching. She was relieved when Nola showed up with a boyfriend in tow, seeing her off just as Cheryl was doing for me. The ABC cameras were assembled to capture this dewy new romance, but reader, *it was a sham!*

More than that, it was . . . sickening. Literally. Within minutes of leaving the harbor, the choppy seas had sent all of us—Nola, me, and the other couple—to the railing. There was no respite from the nausea. Whether we went belowdecks to the cabins or stepped outside for fresh air, we all puked our guts out.

Upon arriving at Catalina, we changed into evening dress for a luxurious dinner. While the cameras rolled, I held the chair for Nola, and we both sat down to perfectly prepared slices of roast beef served on fine bone china. We could not have been less hungry and made only gestural acknowledgments of the food on our plates. Which was just as well, because the captain of our boat announced that, on account of the high waves and the demand for moorings, we would not be spending the night, as planned, on the island. Instead, we were sailing back to Long Beach, right away.

Nola and I reboarded the boat as the cameras clicked and whirred. That was the last I saw of her until the wee hours of the morning, when we both disembarked, unsteady, exhausted, and green to the gills. I had called Cheryl ahead of time and asked her to pick me up. There she stood, waiting by her dad's Chrysler station wagon with a smirk on her face. I recounted to her the hardships that I had been through with this pretty, miniskirted girl in the name of network publicity.

"Awww," she said, her voice thick with sarcasm. "That's really too bad!"

CLINT

I also did *The Dating Game* twice, in this same period. They did a few "adorable" peewee editions in prime time, with child actors of my vintage and bigger prizes at stake. Like Ron, I was not picked the first time I appeared, losing out on a trip to Hawaii. I developed a little piss stain on my trousers at the moment we went out onstage and never recovered from that setback. I

was already self-conscious about my physical appearance, the way kids are as they enter puberty. When I sized up the competition, I was relieved that the bachelorette made her pick blindly. The dudes in the other two chairs were taller and prettier than me.

Miracle of miracles, the second time I went on the show, I got picked! The chooser was Eileen Baral, a flaxen-haired little beauty who was on ABC's *Nanny and the Professor*. I was nervous as hell. One of Eileen's questions was "Name a vegetable that you are like." I don't know where this answer came from, but I blurted out, "I'm like a tomato because I'm so juicy!" It brought the house down and won me a chaperoned trip to Alaska with Eileen.

Mom accompanied me and Eileen's dad accompanied her. Unlike Ron, I did not have a girlfriend and would not have minded going on a genuine date, whatever that meant for an eleven-year-old. But right out of the box, I discovered that Eileen was way out of my league. It turns out that, despite her diminutive stature, she was four years my senior and four times more mature than any girl in my school. She absolutely slaughtered me in games of checkers, chess, and Scrabble. We did enjoy some pleasant sightseeing in Nome and the Native village of Kotzebue. And it was cool that it stayed light for twenty hours a day. But no romance with the beautiful Miss Baral sparked.

Hank Fonda was a taciturn man. Between scenes, he spent his time on the *Smith Family* set crocheting, mostly floral patterns. Lots of throw pillows in the Fonda household, I guess. Fonda remembered my father warmly from the *Mister Roberts* tour and took a shine to me, giving me acting tips that he had picked up in the course of his four-decades-long film career. One was about pausing for dramatic effect. He caught me doing this before I began one of my lines and advised me not to do so

again. "If you take the pause *before* your lines, they'll cut it out, because they always want to tighten the film up in the editing," he said. "Start with a couple of words, *then* do the pause, and then finish your line. That way, they can't ruin your performance."

He also taught me how to eat efficiently on camera. Eating shots are problematic from a continuity standpoint. If the director cuts from a wide shot to a close shot and your chewing in the first doesn't match up with your chewing in the second, the shots aren't usable. The script supervisor has to take notes during the master shot and subsequently remind you exactly when you took your bite of toast and when you took your sip of coffee. Fonda taught me never to wing it. "If you plan it, you won't ever hear from the script supervisor," he said. For a breakfast scene, he would tell the property master in advance, "I'm going to eat the wedge of grapefruit when I sit down. I'll take a sip of coffee when I turn to my wife. I'll have a bite of eggs when I talk to Ronny. And I'll grab a bite of toast when I get up to leave." I followed suit, and the crew appreciated the time and the toast that I saved them.

About the only other thing that truly animated Hank on set was my interest in directing. His first love was the theater, but he could tell that I was different. "I love the theater, that's an actor's medium," he said. "But you love movies, that's a director's medium." He took a lot of pride in his son, Peter, who had cowritten *Easy Rider* with Dennis Hopper and was now directing a western called *The Hired Hand*.

Knowing how much I loved movie history, Hank happily regaled me with stories of working with John Ford, his most frequent director, and Preston Sturges. For my seventeenth birthday, he gave me two books, *The Film Director as Superstar,* a collection by Joseph Geimis of his interviews with iconoclastic filmmakers, and *Film Form: Essays in Film Theory,* by the pioneering Russian director Sergei Eisenstein. It was a magnanimous gesture and a confidence boost when I was having

my doubts about acting. So as depressing as it was to work on a medio-
cre, going-nowhere show, I came out of *The Smith Family* supercharged
to chase my dream. Like Bob Totten, Hank Fonda was a formidable
man who had sized me up as director material and issued a command:
Go for it.

THE EDUCATION OF R. W. HOWARD, DIRECTOR

RON

Making movies became my second love after Cheryl. Actually, I was able to combine my two passions. She became part of my R. W. Howard repertory company, joining my long-term collaborators Clint Howard and Rance Howard.

Heeding Bob Totten's advice, I got the hell out of my backyard and pursued a more ambitious brand of filmmaking. I decided to up the stakes and enter the Kodak Teenage Filmmaker's Contest, sponsored by the film company. Because of my *Smith Family* commitments, I didn't have time to make a lengthy film. So I entered in the contest's one-reeler category, which was a real test of discipline. Contestants were given an unexposed cartridge of Kodak Super 8 film that had three minutes and twenty-four seconds worth of footage on it. We were required to turn in our cartridges after filming, exposed but unprocessed—Kodak would do the developing and the evaluating. The biggest challenge is that this made no allowances for editing. The cartridge had to contain the whole film, shot in sequence.

I concocted a *Twilight Zone*–like fable in which a little boy in a

modern-day outfit of ballcap, sweatshirt, and shorts (played by guess who) wanders into the dusty remnants of an Old West town. Suddenly, his cap flies off his head: it's been shot off. A menacing outlaw from olden times (Dad) appears, challenging the boy to a gunfight. In the blink of an eye, the boy finds himself magically outfitted in a sheriff's uniform, with a six-shooter at his hip. His courage is fortified by a beautiful young pioneer gal standing off to the side (Cheryl, in a flowing period dress, with her hair pinned up), who winks at him. The boy draws his gun and kills the outlaw with a single shot. Triumphant, he reaches to touch the face of the young woman, only for her to disappear into thin air. He casts a glance at the corpse of the outlaw, which transforms in a flash into a tumbleweed. A moment later, the boy's sheriff costume is gone and he's back in his ballcap and tennis shoes. Was it all a dream?

I called this film *Deed of Daring-Do*. (I meant derring-do, but I've never been a great speller.) I didn't storyboard the film as I would now, but I plotted out thirty-nine camera setups and made a shot list, timing out each one to make sure that I stayed within the cartridge's limit. One nice variable was that the credit sequence at the end could be as long or as short as I wanted it to be, which allowed me to fill out the cartridge to three minutes and twenty-four seconds on the dot.

We shot it all in one day. I used my *Smith Family* clout to sneak us all onto CBS's backlot on Radford Avenue in Studio City, which was where we filmed the show and only a fifteen-minute drive from our house. This backlot had once been the home of Republic Pictures, the low-budget studio that launched the careers of John Wayne, Gene Autry, and Roy Rogers. It still had an Old West street, complete with a post office and a saloon with those swinging shutter doors, that was perfect for my purposes. (Twenty years later, it was reconfigured into a contemporary New York street for *Seinfeld*'s exteriors.)

I reveled in re-creating some Sergio Leone trademarks, such as framing a shot through the sheriff's straddled legs as he prepares to take on

the other gunfighter. Dad pulled some excellent, hammy villain faces when I did the obligatory close-up of the bad guy's squinty eyes. I was also pleased with how well we pulled off the special effect of Clint's hat being shot off his head. It was entirely analog. We hooked a wire to his ballcap, and as he sat down on the edge of a water trough, Dad was lying flat on the ground behind the trough, out of sight, and simply yanked the wire to make the cap fly off.

The tension mounted as we marched our way through the shot list. None of us wanted to be the one who ruined one of the last setups in my carefully programmed sequence, as a single screwup would mean having to start all over again with a fresh film cartridge. But we had rehearsed so well that we nailed every shot and got the film done on the first pass! Clint, Cheryl, and I were relieved. Dad was the only one who wouldn't have minded a do-over. He was having the time of his life, playing the heel while making a movie with his boys on that famous western backlot.

About the only complication I encountered was an issue with the talent . . .

CLINT

Hey, I immediately liked the concept Ron had for *Deed of Daring-Do* when he pitched it to me. I liked the gunfight and I liked that the film would be entered in a competition. But c'mon, I was the lead and this was going to take up some of my valuable time. More than just a lark in our backyard. I was used to getting *paid* for this amount of work.

We needed to have a talk. Kodak's Teenager Filmmakers Contest offered cash prizes to the top three finishers in each category and I knew that Ron needed me, so I was in a great bargaining position. Acting as my own agent, I told Ron that if he wanted me in his film, it was going to take what we in the industry call gross points—say, 50 percent of

them! Otherwise, he was welcome to scout out Toluca Lake for another boy to play his lead. I was not about to endure another *Wild Country*–style negotiation disaster.

My brother and I shook hands and he gave me a call time to report for work. Shooting in continuity made the process more thrilling and suspenseful; as we got close to the finish line, there was real pressure not to screw up. It felt like a two-minute drill, with Ron as the quarterback.

And guess what? Our little film cashed! Most of the other kids, intimidated by the time and editing constraints, did animated or claymation films. *Deed of Daring-Do* was one of the few live-action entries. The judges sent Ron a certificate lauding the film for its "good storyline," "effective use of camera angle," and "very good cuts." That's a better review than the one he got in his hometown paper for *Apollo 13*. Personally, I was pissed that we came in second, but still—not bad, given that there were thousands of entries.

Best of all, though, second place meant serious prize money: one hundred dollars. When Ron received the good news, he wasn't up in his room for more than two minutes before I bounded up the stairs and demanded, "Where's my fifty bucks?" Honestly, I was giving him a break, because he also won a case of Kodak Super 8 cartridges, which I had no interest in splitting with him. Ron resisted my petition for payment. I was forced to call in Dad to mediate. Our testimony lasted only a few minutes before Dad ruled in my favor. Ron forked over the greenbacks. I went out and bought baseball cards, while my big brother went on to have a billion-dollar filmmaking career.

RON

Clint's demand was ballsy, but a deal was a deal and we split the money. It wasn't as important to me as finishing in the top three. This wasn't a

local contest; the submissions had come in from all over the country. It was such a validation for me, a rocket boost precisely when I needed it.

R. W. Howard was determined not to let up. I used any excuse I could to make more films. For a school assignment about the Great Depression, I persuaded my history teacher to let me make a documentary rather than write a paper. This was my first talkie, albeit a primitive one. First, I recorded some audio interviews with adults who had lived through the Depression: Mom, Dad, Hoke Howell, Mr. Alley, and a few other people. Then I checked out some history books from the Burbank Public Library to scan them for good photos. I bought some diopter lenses, which allowed me to zoom in on faces and details and then widen out to reveal further visual information in the photo—basically, I was executing a crude, artless version of what later became known, justifiably, as "the Ken Burns effect." Then, for the presentation, I carefully synced the audio to the video, using a projector and a tape player. My history teacher so liked the result that he had me show my film to all five of his classes that day. That was another huge lift for me.

Next, I made a more "proper" narrative film, though the sound was still limited to voice-over audio. Once again, I concocted a movie to get out of doing a written assignment, this time for psychology class, where I would interview a subject about his or her life. I cooked up a completely phony story—let's call it what it was, a lie—that I told my teacher about an almost-one-hundred-year-old man at the senior home run by the Motion Picture & Television Fund. I explained he had been a real cowboy before getting into the movie industry during the silent era. What a subject for a school film!

Thereby granted permission to go forth and begin filming, I borrowed a 16 mm camera from the cinematographer on *The Smith Family*. Working with his fancy Canon Scoopic 16 mm rig was a huge step up for me. It allowed for more tricks, such as dissolves from one scene to another, and a soundtrack, albeit sound added in postproduction, not

while I was filming. The film stock cost me a bundle, too, five times as much as 8 mm. Being under eighteen, I still didn't have ready access to my childhood earnings, so I tightened my belt and spent less on date nights and gasoline. Fortunately, one four-dollar fill-up was all that my fuel-efficient VDub needed to get me around greater Burbank for a month.

The nonexistent nonagenarian was not to feature in my film, at least not on-screen. I would dramatize a sad story he had told me about a beautiful young woman he had been forced to leave behind. The old man would appear on the audio track, singing a baleful version of the traditional cowboy song "I Ride an Old Paint" that he had customized to describe his plight.

You'll remember that my dad had once dreamed of being a singing cowboy but couldn't sing. Well, now he got his chance. His singing voice still wasn't up to professional standards, but my bespoke version of "I Ride an Old Paint," sung by Rance Howard in a hushed, wheezy baritone and accompanied by my pal Noel Salvatore's accordion, sounded credibly like the musical lament of an ancient guy at death's door.

My dad had a good friend named Bob Jones, an actor turned assistant director, who lived out in Agoura Hills and was willing to loan me his two horses. Another of Dad's friends, a character actor named Bill Conklin, agreed to appear in my movie, now called *Old Paint,* as the stationmaster at my Old West depot. I scouted locations and found an abandoned train station in Piru, about an hour's drive northwest of us, that had the right look.

In the film, the cowboy, played by Dad, is seen riding one of his horses while leading his second one on a rope. As the sad music plays, the cowboy rides through a series of rural landscapes. In an open field, he comes across a mother and son (Mom and Clint) with their heads bowed in front of a newly dug grave. The cowboy saddles up his second horse for the farmer's widow and the boy. He escorts them to the depot,

where they will catch a train and start a new life. He then returns to his lonesome wanderings. As night falls, he sits at his campfire and fishes out from his saddlebag a cameo locket with a silhouette of his lady love from long ago.

There's a dissolve from the locket to an image of a beautiful young woman—Cheryl—crying as she waves goodbye to her man (me, as the young cowboy) as he departs on horseback. Then we return to the campfire and the film's present day, where the cowboy broods over the flames as we hear him singing on the soundtrack, "Shoulda had more sense than to leave her so."

Old Paint was no John Ford classic, but it did the job as a school assignment and furthered my education as a director. The staging and framing paid homage both to Ford and the muddy neo-westerns of Peter Fonda and Robert Altman, whose *The Hired Hand* and *McCabe and Mrs. Miller* had recently come out. I learned how to use natural light and make the best of my locations, which included not only Piru but some wilderness areas near Thousand Oaks. I prepared shot lists, became more adept at camera placement, figured out how to use the editing room, and gave better direction to the actors. And, for the first time, I presented human drama with something approaching authenticity, capturing bittersweet moments of love and grief.

CLINT

Shooting on 16 mm was a step up for Ron, but I had a couple of issues re: committing to *Old Paint*. First, it was just a school project for him, and I was going to be giving up a weekend of prime Wiffle Ball action with my buddies to drive up to friggin' Lake Piru to work on it. Second, my role was small and I was still required to whip up a bucket of graveside tears.

I started to object. That's when Mom got on my case. "You're going to do it, Clint," she snapped. "You're going to help your brother out." Dad was usually the family disciplinarian, but Mom had her own ways of appealing to the better angels of my nature. So I caved and followed my marching orders, giving the scene my full attention, sobbing like a baby when Ron called "Action!" *Glycerin? We don't need no stinking glycerin!*

It was clear to me by then that Ron's zeal to make films was more than a teenage obsession. I never really had his drive to direct. I was in love with acting and recognized that directors could never sneak off to their dressing rooms for a nap, then as now a nice perk of the trade. Acting was what I intended to keep doing as I grew up. That, or pursue my dream of becoming a big-city sportswriter. But Ron's passion for directing was obvious. So much so that it was causing Mom quite a bit of concern.

RON

While Mom was supportive of my filmmaking projects, she didn't love that I was all in on directing. It was strange, a little like when I fell for Cheryl: *Are you sure you're ready to make such a big commitment at such a young age?*

I didn't grasp how much this worried her until I bought my next camera. I was ready to move on from my Bauer Super 8 to a GAF Anscomatic, a camera that offered an 8:1 zoom ratio and two camera speeds, which would enable me to film in slow motion, just like Peckinpah and Penn in their signature films *The Wild Bunch* and *Bonnie and Clyde*. I believed that this added versatility would allow me to experiment more and make better films. When I idly mentioned my plans to buy

the GAF at the dinner table, Mom became upset. "You have a perfectly good camera," she said with surprising vehemence. "Don't waste your money!"

Money was not the issue, though, and Mom knew this. I was making around $2,000 a week on *The Smith Family*. I could easily afford the $179 purchase price of the GAF, which I did indeed buy. Mom was nervous that I was rocking the boat. I had already proven myself as an actor. Ironically, given the ups and downs that she had witnessed firsthand in my career and Dad's, she considered acting a safer bet. Or at the very least a known quantity. Acting was what the Howards did. Directing seemed like a risky thing to take on.

But I was seriously considering giving up acting forever. Though *The Smith Family* kept me gainfully employed, the slump that preceded it still stung, as did another humiliation. In the same period in which I auditioned for that show, my agent received a script for a TV movie entitled *The Homecoming: A Christmas Story*. Its author was one of *Gentle Ben*'s former writers, Earl Hamner Jr., and the teleplay was based on his childhood memories of growing up as part of a large family in Virginia's mountain country during the Great Depression. Hamner's proxy, and the oldest of the family's children, was named John-Boy Walton.

John-Boy seemed like a perfect fit for me. I had proven my country-boy bona fides in *The Andy Griffith Show*. I had made a minidocumentary about the Depression. I was just the right age. But I had not even been invited to read for the part.

This did not deter me. It so happened that my audition for *The Smith Family* was taking place in the same building where *The Homecoming*'s auditions were—just down the hallway, in fact. I saw the name of the film's producer, Robert L. Jacks, on the door. I paced back and forth, thinking about the stories Dad had told me of knocking on casting directors' doors in New York, and of the life-changing moment when he

walked in on the MGM casting session for *The Journey,* which led to my first acting role. I girded myself to make like Rance Howard and just go for it.

I poked my head in, introduced myself to the receptionist, and said that I would like to talk to Mr. Jacks or Mr. Hamner about auditioning for the John-Boy role. She seemed to recognize me, but her expression betrayed some discomfort at my request. She asked me to sit for a moment while she made a call. I recognize now that while doorstepping a casting director or a producer was commonplace in New York in the 1950s, it was highly unorthodox in Hollywood, where every meeting was coordinated through agents and managers. Spontaneous acts of self-promotion were frowned upon.

Still, Mr. Jacks graciously agreed to meet me right away. My guts were churning as I was led into his office, where a few people, including Earl Hamner, sat silently, looking at me. I awkwardly explained that I was in the building for another audition but had read and loved their script, and since I saw Mr. Jacks's name on the door, I figured that I should introduce myself. I told them that my father had told me many stories of his life on a farm during the Depression, and that I was sure that I could relate to the John-Boy character and deliver for them.

There was an ominous pause. Finally, Robert Jacks spoke up, reminding me that he had produced the episode of *Gunsmoke* that I had guest-starred in. He complimented me for the work I had done in it, which had impressed U.S. Marshal Matt Dillon himself, James Arness. With due modesty, I thanked Mr. Jacks for his kind words, assuming that, between this demonstration of familiarity and my long résumé in prestigious network TV, I was on my way to being rewarded for my audacity and bagging the part.

But there was another pause before Mr. Jacks finished his response. He broke it by saying, "Listen, Ronny. It's great to hear that you like the script and think it rings true. But we've been casting for a while, and we

think we know who we want in the John-Boy role. But we'll certainly keep you in mind if something comes up and we have a change of heart."

Unaccustomed as I was to rejection, I nevertheless recognized this brush-off for what it was. I said that I understood and thanked them for their time. With my heart pounding and a lump in my throat, I slunk out of the office and trudged back to my car in the off-lot parking to which I had been relegated as a nonstar. The John-Boy role went to Richard Thomas, and *The Homecoming* became the basis for the series *The Waltons,* which ran for nine seasons on CBS.

Richard was absolutely deserving of the part and flourished in the show, becoming a TV star. By contrast, I was on the precipice of irrelevance. Being rejected stung, but it also motivated me. It reinforced my already burgeoning belief that what I really needed to do was get on the other side of that casting table, as a director. By my junior year of high school, I had built up an impressive portfolio of student films that would act as a good calling card if I chose to seek admission to the University of Southern California. For the first time, USC was admitting rising freshmen to its school of cinema.

This was huge and fortuitous news for a film geek like me. USC's film school was the gold standard of undergraduate programs for aspiring filmmakers. Among its recent alumni was a rising young hotshot named George Lucas, whose name I had first seen in one of the books that Hank Fonda had given me, *The Film Director as Superstar;* Francis Ford Coppola had mentioned Lucas to the author as someone to watch. So, when I was a high school senior, I decided that my future lay on USC's campus in South Los Angeles and sent in my application.

While I endured the agonizing wait to learn if I had gotten in, I began to envision the freewheeling life that Cheryl and I would enjoy after college. Cheryl wanted to see the world and study foreign cultures. Maybe we would move to Australia or Africa, and I'd work as a documentarian and photographer for *National Geographic.* Or maybe I

would be a guerrilla independent filmmaker like John Cassavetes or Jan Troell, with Cheryl pitching in as sound person and editor, the two of us living as itinerant bohemians with no fixed address. Or maybe I could plunge into the artfully trashy world of grindhouse pictures and make something like *The Thing with Two Heads,* a recent sci-fi film starring Ray Milland and Rosey Grier that also served as a parable about racism. I kept spiral notebooks with lists of movie ideas, my febrile mind over-run with possibilities.

I dreamed up schemes to finance independent movies—perhaps by going door-to-door and introducing myself: "Hi! I'm Ronny Howard. You may remember me as Opie from *The Andy Griffith Show.* It is now my dream to make independent movies, and I'd like to ask you to sup-port my goal by donating to my moviemaking fund!" I was dissuaded from pursuing this early version of crowdfunding when someone ex-plained to me that I would have to pay taxes on the money I collected.

I sincerely toyed with an even more radical idea, one that I never dared share with Cheryl, though I wasn't entirely kidding about it. The year we graduated from high school, Gerard Damiano's pornographic movie *Deep Throat* became a sensation, earning $3 million in its first six months of release—a cinematic record at the time. A long-game, Hail Mary notion developed in my head: What if I self-funded a serious inde-pendent film by doing *another* kind of film first, casting aside all shame and industry goodwill by making an X-rated movie? This skin flick's title? *Opie Gets Laid.*

After a few days' consideration, I thought better of this scheme. Cheryl would never forgive me. Nor, probably, would any moviegoer who paid money for a ticket and then saw me naked.

ONE OF THE few things that kept me tethered to acting was the looming threat of boot camp and combat. I was opposed to the

Vietnam War on philosophical grounds, in that it seemed pointless, needlessly destructive, and unwinnable. More immediately, given my status as someone who was going to turn eighteen in the second semester of his senior year of high school, I didn't want to fight in it. Dad was equally vehement, notwithstanding his status as a military veteran. He still resented his four-year stint in the air force for the time it took from him as a young man and the career opportunities that he had missed out on. He found the justifications for our country's involvements in Korea and Vietnam hazy, unlike the unequivocal call to action that World War II presented. He had no desire to see Clint or me in uniform unless we chose to volunteer.

Distressingly for me, college deferments were abolished in September 1971. So even if USC accepted me, it wouldn't provide an out from the draft. Neither my parents nor I ever thought to consult a lawyer to see if there were loopholes or ways to game the system, as so many families of means did during that war. My parents were sophisticated hicks but not Hollywood hustlers. They knew the ins and outs of show business but didn't move in circles where special favors transpired. So I was on my own.

Then it occurred to me: performers were known to receive special dispensation from the military. As a baseball fan, I had noticed that a lot of pro players, such as Nolan Ryan, Johnny Bench, and Pete Rose, circumvented the draft by joining the Army Reserves. You still had to report to an army base periodically and serve your country in two-week increments. You might be called upon by the league to travel overseas on a USO tour to cheer up the troops. But these scenarios sure beat wearing a helmet and fatigues in the jungle, one ambush or errant footstep away from sudden death.

A regular acting job could put me in a similar position to these ballplayers. A network or a studio would have my back and figure out a way for me to perform some sort of service that didn't involve being a soldier.

As an independent film director, on the other hand, I would be on my own. This may have been another factor in Mom's wanting me to stick to acting. I can't know for sure, since talk of the draft was taboo in our household. None of us wanted to openly contemplate the unthinkable scenario of me going off to war.

But one day during my senior year of high school, the depth of Mom's concern revealed itself. We were having one of our set-tos about my slovenly ways. I had left my bed unmade, as per usual. Mom asked me if, just for once, I could pick up my room like a normal person. I responded petulantly that I didn't wanna. At this, she erupted.

"You're going to get *drafted,* and you'll go to Vietnam!" she said. "And then the army will finally teach you how to make your goddamned bed!" She burst into tears and ran out of my room, slamming the door behind her.

That was sobering. In my own self-absorption, I hadn't considered how much fear she was keeping inside. I never got any better at making my bed, but I did get better at being a son. I stopped laughing at Mom's expense and talking down to her. My teenage smart-ass phase ended right then and there.

IT WAS IN this context that I took a part in a TV pilot that was provisionally titled *New Family in Town.* It was set in the Midwest in the 1950s, and its central character was a clean-cut teenage boy named Richie Cunningham.

The pilot was written by Garry Marshall, a prolific comedy guy who had worked on *The Dick Van Dyke Show* and was currently with *Love, American Style,* an of-its-time hourlong anthology series on ABC that each week included three or four unrelated mini-episodes about love, sex, and grooviness. Tonally, *New Family in Town* was inspired by a movie called *Summer of '42,* a sleeper hit in 1971. Like that picture, our

pilot was a coming-of-age story that looked to a more innocent past. But it was gentler and more G-rated than *Summer of '42* or, for that matter, Peter Bogdanovich's *The Last Picture Show,* another '71 hit about high school kids in pre-1960s America. Our show wasn't going anywhere explicit or raunchy. The most risqué it got was when Richie's best friend, Potsie Weber, said that the newfangled invention known as a TV set was a surefire way to get action, because you could invite girls over and—cringe alert—"grab 'em right in the middle of *Kukla, Fran and Ollie.*"

I played Richie. Potsie was played by Anson Williams, an energetic, upbeat guy from my high school's crosstown rival, Burbank High. Richie's parents were played by Harold Gould and Marion Ross. It was a good ensemble, and our show was being produced by Paramount Television. By my logic, if this show went to series, Gulf + Western, the powerful conglomerate that owned Paramount, would find a way to keep the young star of its hot new sitcom out of the jungle.

Gary Nelson directed the pilot. He was a relaxed and experienced pro who had directed me in an episode of *The Andy Griffith Show* and Clint in an episode of *The Baileys of Balboa.* The pilot's story centered around the aforementioned TV set. Richie, at Potsie's urging, used it as a magnet to lure over the girl of his dreams for a date. I had particularly good chemistry with Anson and Marion. As a matter of fact, Marion was the first person with whom I shared my good news: I got into USC's film school! I happened to be on the set when I opened the envelope, and my TV mom hugged me and wished me the best.

ABC didn't bite, though. *New Family in Town* did not get a series order. Instead, the network dumped it onto *Love, American Style* in truncated form, as a one-off segment entitled "Love and the Television Set." (It has since been retitled "Love and the Happy Days" for the show's DVD release.) So there went that potential safety net.

I turned eighteen on March 1, 1972, and registered for the draft, as

required by law. I prepared to begin college at USC that September. I was convinced that I was done as an actor.

Then my agent got a call. Universal was financing a low-budget period feature about California teenagers in the early 1960s. It had a weird title: *American Graffiti*. The film's writer-director had seen me on *Love, American Style* and liked my look and performance. His name, when I heard it, rang a bell—he was the young hotshot out of USC that I had read and heard so much about. George Lucas!

GROWTH VIA GRAFFITI

RON

Dad hated the script. He didn't get *American Graffiti* at all. He thought it was too episodic and loosely structured. He was a strict formalist that way. He had taken a class with one of the eminent gurus of playwriting and screenwriting, a Hungarian émigré named Lajos Egri, the author of a revered book called *The Art of Dramatic Writing*. Egri believed in plot lines driven by a classic protagonist-antagonist conflict. *American Graffiti* had neither a clear protagonist nor anyone who truly fit the bill as a villain. It was so radically different from any other script that I had ever come across. Including the fact that it had the word *graffiti* in its title—I didn't know what it meant and had to look it up.

But I was excited by what I read. I saw something fresh and gently subversive in the script that Dad didn't, and I was fascinated by the way George Lucas had situated the story in 1962: a mere ten years in the past, but an eternity ago in terms of social mores, given how fast American culture was evolving in the '60s. George was looking to capture the lost innocence of the cruising culture that he and his friends had enjoyed as teenagers in his hometown of Modesto, about a hundred miles

inland from San Francisco in California's Central Valley. It was a world of souped-up hot rods and sleek Ford Thunderbirds, closer in feel to the 1950s than to the tumultuous years that lay ahead.

The whole movie took place in the space of one night near summer's end, the last one before a group of childhood friends went their separate ways—some off to college, others to work or points uncertain. I was exactly the right age for *American Graffiti*, eighteen, and I would be fresh out of high school when the production team was scheduled to film it, in the summer of '72. In fact, it would be my first acting job where I was no longer required to have a welfare worker on set, a freedom that I relished almost as much as the script.

For all his reservations about *American Graffiti*, Dad respected my enthusiasm and recognized that a job is a job. We were, at that point in our father-son dynamic, at a crossroads. He had held the reins to my career pretty tightly throughout my childhood; as long as I was a minor, he and Mom were going to be the primary decision makers about my career and future, though I was always respectfully looped in. But Dad drew a circle around March 1, 1972, on the calendar—the date of my eighteenth birthday. On that day, he promised, he would step back and let me become the architect of my professional life. And he was as good as his word. Dad made it plain that he was always available to me if I wanted to confer with him, but nothing he said was to be taken as an edict. So he did not stand in the way of my signing on to play Steve, a young man who is headed east for college and keen to persuade his high school steady, Laurie, that they should see other people while apart.

That said, my getting cast in the movie was not a given. First, I had to meet with George Lucas and Geno Havens, the film's assistant casting director. George was a slight, soft-spoken man with thick, curly dark hair and a beard. Geno stood less than five feet tall and walked with a crutch, having been born with brittle bone disease, a genetic disorder that impairs growth. In those days, George could be reticent and awkward

around actors, so Geno served a valuable role as his go-between, translating George's visions into directions that the actors could understand. He hung around for the duration as the film's dialogue coach.

I had not yet been given the script when I met with George, and I had a concern. My agent had informed me that *American Graffiti* was going to be a musical. So the first thing I told George was that, *The Music Man* notwithstanding, I had no musical talent and could neither sing nor dance. "That's okay," George said. "It *is* a musical . . . but nobody sings." He paused as I puzzled over what struck me as an incongruity. "It's a musical in that it's built *around* songs," George explained. "The songs are playing on the radio. They're part of the atmosphere, the setting for the characters. That's why it's called *American Graffiti.*"

This was my introduction to George's outlier thinking. But I was put through the wringer. Apparently, they were conducting a nationwide search for young actors. At that point, I had my sights set on the character of Curt, the part that ultimately went to a sharp little guy from Beverly Hills named Richard Dreyfuss. Maybe two auditions later, I found myself in a room reading in front of Fred Roos, Geno's boss. This was a good sign for two reasons. First, Fred was the hottest casting director around; he was an associate of Francis Ford Coppola, one of *Graffiti*'s producers, and had put together the unimpeachably great cast of *The Godfather.* Second, Fred knew me! A decade earlier, he had been the casting director for *The Andy Griffith Show.* So I felt like I had an ally.

I did a total of six auditions. There was one where I had to improvise with other potential cast members. There was another where I did a chemistry read with Cindy Williams, who they had in mind for Laurie, Steve's girlfriend and the head cheerleader. Then they convened the finalists for one last round that was filmed by George's friend and mentor Haskell Wexler, the great cinematographer and an Oscar winner for *Who's Afraid of Virginia Woolf?* We read in Haskell's little studio in Hollywood.

Finally, to my delight, I received good news from Bill Schuller, my agent. After months of callbacks, each one of which made me more pessimistic about my chances, Bill told me that I had won the part of Steve.

He laid on a caveat, though. "It's a very low-budget picture, Ronny," Bill said. "They're only paying the other actors $750 a week. I pressed hard and got you up to a thousand a week because you're the only one with any name value."

Fine by me. I didn't care about the money or my placement in the credits. Which was another issue that Bill brought up. "Credits are strictly in alphabetical order, and I took a shot at having them list you as Ron rather than Ronny, but they want people to recognize your name from the Griffith show," he said. "So I had to give 'em the Ronny." *American Graffiti* would mark the last time I used my childhood moniker.

Before shooting began, I had a one-on-one meeting with George Lucas where I mentioned to him that after the shoot, I would be starting film school at his alma mater, USC. "You're going to love it," George said. "Make sure you take some animation classes, because animation is pure filmmaking. You don't have to deal with the actors."

This was a strange thing for a director to say to an actor about to be in his next film, but hey—everything about George was unconventional.

As psyched as I was to have this job, I didn't regard it as a major career break. George, though he was a big deal to hard-core cineasts like me, was barely known to the public. At that point, he had directed one feature, a dystopian thriller called *THX 1138,* based on a fifteen-minute short he made at USC. It was critically respected but a box-office bomb. So, in my mind, I was making a cool little arthouse film by a visionary indie director from whom I might learn something. The movie's budget was only in the $700,000 range. By contrast, the

budgets for *The Exorcist* and *The Way We Were,* shot in the same pe-
riod, were $12 million and $15 million, respectively.

Money was the least of my concerns at that point in my life. I had
turned eighteen in March, whereupon my parents turned over to me
the custody of my bank account and bonds. My net worth, I discovered,
was well into the six figures—a sum that I was proud of, though I didn't
breathe a word of it to my friends at Burroughs High School, lest I come
off as a jerk. I *was* irked, I will admit, when I came in third in the senior
class's voting for Most Likely to Succeed. Third? *Third?* C'mon! Hadn't
I already frickin' *succeeded*?

No, what concerned me was uncertainty about my future. One day, a
few weeks after I registered for the draft, I checked the mail at our house
in Toluca Lake. Among the envelopes was one from the U.S. Selective
Service System, addressed to me. *Shit.* I opened it. Inside was a letter
notifying me that I was to report to a local military office for a physical.
I had heard from friends that this was how it worked: you got this letter,
you took your physical, and if you passed and were drafted, you were
inducted into the military on your nineteenth birthday. My friend Noel
was only a few months older than me but had a 1953 birthday, which
meant that he received his draft-lottery number a year ahead of me. His
number was . . . 6. I was sick for him.

The *American Graffiti* script carried another sting. One of George's
most brilliant, wrenching twists was that the movie's teenage high
jinks and poignant goodbyes were followed by a final beat: an end card
explaining what happened to four of its male protagonists. Mine, or
Steve's, was that I stayed local, presumably to marry Laurie, and I was
working in Modesto as an insurance salesman. Paul Le Mat's character,
John, died in a car crash. Rick Dreyfuss's character, Curt, was "a writer
living in Canada," the inference being that he moved there to avoid
the draft. And sweet, geeky Terry the Toad, played by Charles Martin
Smith, was reported missing in action near An Lôc, in South Vietnam,

just three years after the events depicted in the film. It was another re-
minder, not that I needed one, of the worst-case outcome for any young
man who was shipped over.

I told no one about the Selective Service notice. I simply folded it up
and put it in my wallet, where it practically vibrated in the back pocket
of my jeans. I figured that if I ignored the problem, it might go away.
If they somehow followed up demanding a reply, I could say that I was
away from home, shooting *American Graffiti*—that part was about to
be true!—and that I hadn't known about the notice.

Still, that piece of paper haunted me. Sometimes, when I was alone,
I took it out, unfolded it, and reread, hoping that its meaning would
somehow magically change in the process of rereading: an act of futility
if ever there was one. No matter what, I kept that damned notice to my-
self. I didn't want to upset anyone, least of all Mom and Cheryl, nor did
I want to make them complicit in a potential felony.

I was also still uncertain about acting. Maybe this little low-budget
picture would be my swan song, a respectable capper to my career as a
child actor. It's not like I was fighting off suitors for my services.

I never felt competitive with Clint, but I sometimes envied him. He
was getting interesting parts of the kind that no longer came my way.
The same year that I got *American Graffiti,* Clint was cast in a TV film
called *The Red Pony*. Its director was Bob Totten. The actor playing
Clint's father was Hank Fonda. These were *my* guys! So there was Clint,
working with the two men who had lit a fire under me to direct. Good
for him! But I felt like I was missing out.

CLINT

The Red Pony was, as I mentioned earlier, an NBC special based on
a John Steinbeck novella. It's the story of a Depression-era farm boy

named Jody who is caught in a confused state between boyhood and adolescence. His father rides him too hard about stepping up and becoming a man. His mom is more understanding and consoling.

I worked with two absolute legends in Hank Fonda and Maureen O'Hara, who played my parents. I was flattered that Bob Totten handpicked me for a role that entailed going toe-to-toe with the likes of Hank and Maureen. That gave me a ton of confidence. On top of that, Totten and Dad had become good friends since we shot *The Wild Country*. Totten hired Dad to be my dialogue inculcator and gave him a pretty good part as the town's sheriff. We shot the movie on location in Sonora, California, in the foothills of the glorious Sierra Nevada. With Jack Elam also on board, playing my grandfather, I felt surrounded by trust and goodwill. The script was strong and Hank was jazzed by the script and Totten's direction, making him more alive to the material than he had ever been on *The Smith Family*. I even experienced my first puppy-love crush: Totten's daughter, Heather, who was my age and had a small part in the movie. She was a cute redhead, just like Cheryl, with whom I enjoyed a few innocent dates and several hours of expensive crosstown phone calls.

So, while Ron had this storm of worry going on in his head— personally, I always figured that there was no way that the U.S. would ever put a gun in Opie's hands—I was feeling good about myself and loving life as an actor. *The Red Pony* felt like a step into a new, more mature phase for Clint Howard.

The Red Pony was not without its challenges. There was the buzzard-killing scene, which remains the stuff of nightmares and residual guilt. And for the purposes of period authenticity, I had to perform the entire movie without wearing shoes. A born suburbanite, I devoted several weeks to some pretty painful foot prep. This involved several spray bottles of Tuf-Skin antiblister spray and daily walks through dirt. But the complexity of the role excited me. Dad did his usual dialogue

preparation with me, and I was starting to spend more time on my own with the material, determining my own acting choices.

I couldn't just ease into playing Jody. The character is nothing like me: an only child, a solitary dreamer. I didn't possess these traits. In his isolated state, Jody spends a lot of time talking extensively with the pony of the title, the horse he is given to care for. Here, my experience working with Bruno on *Gentle Ben* served me well—Jody was more melancholy than Mark Wedloe, but I knew how to inhabit a kid who feels that animals understand him better than human beings do.

I had an intense scene with Hank Fonda on the first day of production, my character really tangling with his. I knew that Hank was friendly with Dad from way back in the *Mister Roberts* days and with Ron from *The Smith Family*. So I was surprised by how coolly Hank received me. We rehearsed our scene a few times. Hank never once uttered a word of small talk to me, never smiled or lent a fatherly hand. Were we off on the wrong foot? Was it something I said? I expressed this worry to Dad that evening. "That's just the way Hank works, Clint," he said. "It's his way of giving Totten his best performance." Jody's dad was frosty toward him, ergo Hank didn't turn on the warmth for me—not only on that day but over the course of the entire shoot.

But Totten, ordinarily so gruff, paid me a wonderful compliment. "I watched the dailies from yesterday," he said the following morning. "You did good, Putt-Putt. You did good. You just keep playing Jody the way you're playin' him."

At this, any anxieties I had about keeping up with Fonda and O'Hara melted away. Toward the end of the production, I performed a dramatic scene with Ben Johnson, the crusty old cowboy actor who had just won an Oscar for playing the pool-hall owner in Peter Bogdanovich's *The Last Picture Show*. The big leagues, Ma! To this day, I am buoyed by that day's work and the results I saw up on the screen.

The Red Pony received unanimously positive reviews and was nomi-

nated for eight Emmy Awards, winning two. It bummed me out not to be nominated for Best Supporting Actor. But that summer, I felt like I graduated from a kid actor to an adult one with nothing but success ahead of him.

RON

American Graffiti began filming precisely when I needed a boost in career confidence. I drove my Bug up the coast to San Rafael, where the cast and crew were staying in a Holiday Inn. San Rafael was supposed to stand in for Modesto, which George decided had become too modernized to plausibly resemble his hometown as he remembered it. But we ended up shooting mostly in the town of Petaluma, whose city council proved more willing to take on the disruptions of a film crew and a bunch of vintage cars cruising their main drag with cameras mounted on their hoods.

I immediately saw that there was something of a cultural divide between me and most of the cast. With the exception of Charlie Martin Smith, who was my age, the rest of the movie's principals were significantly older than me and much more worldly-wise. Rick Dreyfuss, Paul Le Mat, Candy Clark, Harrison Ford, Bo Hopkins—these folks were anywhere from six to twelve years my senior. I initially took Cindy Williams to be my age because she looked so young, but I soon found out that she was a seasoned, womanly twenty-four.

She sensed, correctly, that her eighteen-year-old acting partner was inexperienced at kissing scenes and a bundle of nerves about performing them. "We can't kiss for the first time on camera," she said. "We better practice." With the professionalism of Hollywood's intimacy coordinators, who supervise and choreograph sexually explicit scenes for film and TV, Cindy taught me how to make out convincingly for the camera

without overstepping. She was not interested in me romantically, nor was I in her. Cindy performed this service out of generosity, saving me from embarrassment and preemptively ensuring that our scenes did not end up on the cutting-room floor.

Cindy, Charlie, and Rick were the actors I ended up hanging around with the most. And Jeff Bridges a little, too, because he was seeing Candy Clark and occasionally came to visit. Harrison and Paul were the cast hellions. They treated that Holiday Inn like it was the Sunset Marquis and they were Led Zeppelin, trashing their rooms and generally raising a ruckus. One Saturday, when we had time off, they were drinking beers and pitching their empty bottles out the window, watching them crash in the parking lot. Then they tossed an unopened beer, which exploded on the blacktop in a gusher, which made them double over in laughter. I was concerned that the shattering bottles were getting just a little too close to my still-new VW Bug.

"Harrison, Paul," I said, "you can have your fun, but I have to go downstairs and move my car. Can you hold your fire while I do that?"

"Sure, Ronny, sure. Go ahead," said Harrison.

As soon as I got to the parking lot, a bottle exploded at my feet. Harrison and Paul poked their heads out the window. "Dance, Opie, dance!" Paul shouted. Then more bottles came flying in my direction, accompanied by the sounds of nefarious cackling from above. I somehow managed to pull away in my Bug before they did any damage.

That incident was the only Opie-shaming that I experienced, though I did occasionally endure some razzing because, at that point, I was the sole cast member who was recognizable to the public, and the locals liked to approach me for autographs. But this teasing was all in the spirit of fun, as was Rick Dreyfuss's penchant for calling me Ope, which rhymed with *hope*. For example, when he and I were trying out some improvised dialogue on each other, at George's urging, I noted that I had

never worked this way before. Rick smiled his mischievous smile. "You ain't in Mayberry anymore, Ope!" he said.

I SURE WASN'T. And it was exhilarating. I could just *feel* the generational shift taking place. We were all in our teens and twenties. Even George was only twenty-eight. The people involved in the production behind the scenes were mostly San Francisco–based, like George. They had long hair. They wore beads and bandannas around their necks. Some of them were *women*. I had to that point been exposed to nothing but old-line, hard-boiled, Anglo-Saxon male Hollywood. This was freer than anything that I had ever experienced. There were no executives milling around, as was the norm on the sets of *The Music Man* and *The Andy Griffith Show*. There wasn't a traditional hierarchical pecking order because George didn't operate that way. There was order, but it was communal order. And a collective belief that we were making *art* more than we were a product.

George boldly ignored the orthodoxies of traditional filmmaking. We had no makeup team or individual dressing rooms. We all got changed into our wardrobes inside a single Winnebago motor home that someone had driven to Petaluma for the shoot. The female actors applied their own makeup. The male actors didn't wear any. George shot most of the movie in continuity, as it plays on the screen, because he knew that we would look progressively more exhausted and undone after six weeks of night shooting, and he wanted us to come by our sunrise dishevelment naturally, in vérité fashion.

At least I wasn't melting under burning lights the way I had in *The Music Man*. George didn't even give us traditional marks to hit. He used extremely low light levels because he wanted to capture the slightly dangerous late-night feel of a boulevard teeming with teens

on the prowl for action and trouble. We had two young cinematographers on the film, Jan D'Alquen and Ron Eveslage, but George was also relying upon the guidance of Haskell Wexler. I don't know how he managed it, but Haskell essentially commuted nightly to us from L.A., arriving in time for our shoots and flying home first thing in the morning to do his regular job.

The camera team liked me because I was experienced and knew where to stand so that my face could catch a little light. I could look through their cameras' viewfinders, see what kind of shot they were after, and get myself into the right place in the frame. But George didn't particularly care about this sort of thing. He was all about spontaneity and honesty.

I was so rules-bound that this took some getting used to. At one point, my confusion got the better of me. We were shooting at Mel's Drive-In in San Francisco. Take after take, the only direction that George gave was "Action!," "Cut!," and "Terrific."

I approached him for a word. "George," I said politely, "you're saying, 'Action, cut, terrific' for every take and then you change angles and say, 'Action, cut, terrific' again."

"Mm-hmm," said George.

"Am I giving you everything you need?" I asked. "Is there something more I can do? Because I'm happy to take some direction."

George matter-of-factly explained, "I don't really have time to direct now. I'm just gathering up lots of footage, and then I'll direct in the editing room." He added, "That's why I cast you all so meticulously. It took me six months to find the right mix of people for what I want. And six months to find the right cars."

It was at this moment that it hit me: the cars were just as important to George as the actors. Or, rather, they *were* actors to him, playing characters just as his droids and starships would in the *Star Wars* movies.

Paul Le Mat's yellow Deuce Coupe represented the light side of hot-rod culture. Harrison Ford's menacing '55 Chevy One Fifty represented the dark side. Bo Hopkins's chopped '51 Mercury embodied the whole greaser culture. Suzanne Somers's white '56 T-Bird with porthole side windows was as dreamy and unattainable as she was.

My big ol' '58 Chevy Impala with tail fins was the aspirational car of a solid citizen, which Steve was—he had been his class's president. For most of the movie, the car was driven on loan by Charlie's character, Toad, who tried to impress Candy's character, Debbie, by boasting that it was his set of wheels, and that it had a 327 engine in it with "six Strombergs," as in carburetors—a drag-racing modification that sensible Steve would never have made.

We really didn't know what we had when we were filming *American Graffiti*. As George said, he was going to do most of the directing in the editing room. This included the matching of music to scenes. It was unclear during the shoot which songs the production could actually clear the rights to, so only occasionally did they pipe in the songs that you hear in the finished film, mostly '50s classics like "Almost Grown" by Chuck Berry and "Chantilly Lace" by the Big Bopper. The Platters' "Smoke Gets in Your Eyes" really was playing, though, when we filmed that heartbreaking scene where Cindy and I dance sorrowfully in front of the whole student body, having a whispered fight that no one else can hear.

CLINT

One evening during the summer that Ron was filming *American Graffiti*, Mom abruptly announced during a Slurpee run to 7-Eleven that she and I would be taking a little road trip up north to visit Ron. I was more than game. I enjoyed going on excursions with Mom—she always spoiled me

with treats and fast-food meals. Ron was surprised to see us when we arrived at his Holiday Inn. We never got to see George Lucas and gang shooting in Petaluma because of their night schedule. But we met Charlie Martin Smith, who was super nice, and Mom said it was reassuring to see Ron faring so well on his first movie shoot where he was on his own. I put two and two together, though, and figured out that the real purpose of Mom's trip—or at least her primary motivation—was to make sure that Cheryl wasn't shacking up with him.

RON

Mom had the right idea, but I threw her off the trail. One weekend, I so desperately missed Cheryl that I flew down to L.A. to see her for a day and a night. She told her dad that she was staying at a friend's house, but we ended up staying at one of those airport hotels. We left its premises just once—to go see Sydney Pollack's *Jeremiah Johnson*, starring Robert Redford.

Time moves more slowly when you're young, because life is still new to you, a process of discovery. Those six weeks felt more like six months, and all of us in the cast developed an extraordinary camaraderie—which was probably George's plan all along. We rooted for each other like teammates. I took particular joy in Charlie's scenes with Candy, whose comic chops and crazy wedding-cake bouffant wig transformed her into someone completely different from the down-to-earth person she actually was.

Part of the bonding process lay in the upside-down nature of filming all night. This required us to get our sleep during the day, so we became a strange pod of weirdos living outside the norms of conventional society. Most days, we would emerge one by one from our rooms and congregate around the Holiday Inn pool in the midafternoon. I was usually

the first one there, because I was terrible at day-sleeping. Generally, I could only go from 7 to 11 A.M., which compelled me to take catnaps later in the day and night in order to keep my wits about me.

This, in turn, developed into one of my signature life skills: the ability to conk out for fifteen minutes at any given moment in any given place. It has served me well ever since in my capacity as a director-producer-executive who always has a dozen projects going at once.

As the baby of the cast, I also received an education in the ways of life and letters as they existed outside of my happy but cloistered Burbank–Toluca Lake world. Rick Dreyfuss became my intellectual mentor. He was an avid reader who was always carrying a paperback. His favorite place in the world was City Lights Books in San Francisco, where we sometimes went in our downtime.

I confided to Rick my worries about being drafted (though *never* about the notice in my wallet) and told him that I was leaning toward voting for President Nixon over George McGovern, because Nixon had pledged that he would get us out of the war. This was before the Watergate story broke, and I had grown up in an apolitical household where we never really identified as Democrats or Republicans.

With a wiggle of his eyebrows and a pointed "Huh-huh-hoe!" laugh, Rick said, "You have a hell of a lot to learn, Ope." He lent me some books on politics and did his best to set me straight. At his instigation during filming, we watched some of the Democratic National Convention on a tiny, portable black-and-white TV, with Rick offering running commentary.

Some of the cast's activities were off-limits to me because I was only eighteen and the drinking age in California was twenty-one. When the *Graffiti* guys went en masse to a strip bar in the Tenderloin District of San Francisco, Charlie Martin Smith and I got the boot almost immediately for being underage. He and I took to passing our time instead in a dive bar in Petaluma where the manager, a friendly lesbian biker

chick, let us shoot pool and play Ping-Pong for as long as we wanted. It was the beginning of a friendship—with Charlie, not the biker chick—that still endures.

Cheryl came up for the wrap party, where George showed us all a fifteen-minute working cut of a few scenes that he had put together with music. George coedited the film with his wife at the time, Marcia Lucas, and a long-tenured legend named Verna Fields, who also introduced George to Steven Spielberg. At this screening, there was a collective gasp by the cast members, even the stoic Harrison. *THIS is what we are a part of? Wow!* It was riveting, seeing the vision in George's head coming to life. We still had no clue if our movie stood a chance at the box office, but we knew we had something revolutionary.

I drove home to Toluca Lake supercharged to start at USC and make as many films as I possibly could—provided that Vietnam didn't get in the way.

CRUISING, BOOZING, SCORING

RON

Fired up, I dusted off a story that I had written for English class my junior year, based on a true series of events. I was a reporter for my high school newspaper, and one of my fellow reporters was a bright, socially awkward guy who didn't run with the cool kids. A popular girl in our class led him on, making him think that she was into him. She lured my friend into kissing her in public, only for a bunch of the girl's friends to run out from a hiding place and laugh, humiliating him. It turned out that the girl was rushing a sorority, and kissing a dorky guy was her initiation rite.

I turned this sad tale of high school dynamics at their cruelest into a screenplay, entitled *The Initiation*. It was the first sound film I ever made in 16 mm, with the actors actually speaking dialogue. We shot it shortly before I started at USC, with the kissing scene taking place in Buena Vista Park, one of my childhood haunts. My friend and some-time writing partner Craig Hundley, who is now better known as the L.A. musician and composer Craig Huxley, was rail thin and gawky, so I cast him as the lead, an introverted piano savant. Susan Richardson,

a young actress who had a small part in *American Graffiti,* played the popular girl who seduced him. Charlie Martin Smith made a walk-on appearance as one of the girl's laughing friends.

My Burroughs friend Doug Degrazio was my cameraman, and we used some serious equipment. I rented an Éclair 16 mm camera, and Haskell Wexler was kind enough to lend me a small dolly that allowed us to maneuver the camera more smoothly. We filmed over three long days, and Doug and I edited the film at the postproduction shop where he worked part-time sweeping up and running errands. It was located on a seedy stretch of Western Avenue in Hollywood, in what was then one of the tenderloin districts of L.A., dominated by sex shops, triple-X movie theaters, and pizza joints that were fronts for drug dealers.

Nominally, the place where Doug worked specialized in nature films and industrials, but off the books, it was doing a ton of porno films. Doug and I had the run of the place provided that we worked at night, which I was now accustomed to, thanks to *American Graffiti.* Occasionally we heard the unmistakable sounds of grunts, moans, and bodily friction being mixed in an adjacent room.

The Initiation is technically weak, but it was an ambitious undertaking for me at the time and it gave me a nice running start at USC. Cheryl and I both chose to attend college locally. To save money, she spent her first two years at Los Angeles Valley College, a community college, while living at home with her dad. She got her requirements out of the way there and then transferred to Cal State-Northridge, where she majored in psychology. Unlike Steve in *American Graffiti,* I had no desire to see other people while at school. Instead, I became intimately familiar with L.A.'s freeway system while regularly commuting in my Bug to Burbank to see Cheryl . . . and, sometimes, when I got homesick, my parents and Clint.

I moved into a dorm room on the third floor of Trojan Hall at USC and happily assimilated into college life. My freshman roommate grew

marijuana under an ultraviolet light in the closet. I was not a pot smoker and always politely declined when it was offered to me. But plenty of people in the *American Graffiti* cast and crew were, so the sight and smell of weed didn't make me uncomfortable. I don't know how this happened, but a rumor took hold that my roommate and I were in business together. A couple of years later, when I was on *Happy Days,* Marion Ross said to me nonchalantly, "I heard that you were one of the biggest dope dealers at USC."

I'm afraid not. That is one "Dopey Opie" scenario that was too good to be true.

CLINT

If you're looking for the family dopehead, that would be me. I spent the majority of my teenage years learning how to catch a buzz. It all started when I was fourteen. One of my childhood buddies, a fellow Howards Hurricane I'd known since second grade, had hippieish older brothers who offered to kick us down some weed. But we would have to wait— they wouldn't be scoring for a couple of weeks.

Over the course of those two weeks, I was beside myself with nervous anticipation: *What's it like to smoke marijuana?* I had witnessed plenty of drinking: Dad always had a six-pack of Schlitz tallboys in the fridge and Bob Totten medicated himself with whiskey in the director's chair. But the only place where dope ever crossed my radar was in the movie *Easy Rider,* which Mom and Dad took us to. I thought Peter Fonda and Dennis Hopper were incredibly cool. I wanted in.

I was so anxious about my pending marijuana experience that I did what an actor does: I rehearsed. I took some pencil shavings from my pencil sharpener, rolled up a joint, and sparked it. I took a few drags and coughed up a storm. I can report with certainty that there is no such

thing as a pencil-shavings high. All I got was the harsh taste of fireplace smoke and possibly some lead poisoning.

But finally, along came the big day. My buddy had scored a couple of joints, and a few of us gathered in a Toluca Lake alley to partake. I took my first couple of puffs and immediately thought to myself, *When does the shit hit you?* A couple of minutes later, we were all giggling. This laughter was stifled somewhat when one member of our group was gripped by a brief bout of paranoia.

I loved the high and I tolerated the comedown reasonably well. I must have been a little paranoid, too, because as soon as I got home, I hopped into the shower and scrubbed myself raw for twenty minutes to ensure that Mom and Dad wouldn't suspect anything.

Overall, my maiden voyage smoking weed was a success. I'm someone who likes to laugh, and weed made me laugh even more. It was my boon companion. I was not having success with girls. In the sixth grade, I had a heavy-duty crush on a classmate named Paulette Fraconi, and in the seventh grade some of my buddies started pairing up with girls our age. One of my friends fell so hard for his first steady that he crudely carved her initials in his hand. I found that nuts, though I understood his passion. I really wanted a girlfriend but I couldn't work up the nerve even to ask someone out.

By high school, I managed to score a few dates, but they never developed into relationships. I yearned for what Ron had with Cheryl, but no such luck. So pot became my girlfriend. That's how I looked at it.

It was easier to score pot than booze in high school. Weed was in widespread circulation among Burroughs students, whereas alcohol still required trickery and subterfuge: a fake ID or an older person willing to buy on your behalf. So, at the beginning, I was more often stoned than blitzed.

But the lure of drinking was too hard to resist for long. When I was little, I became fascinated by the very idea of drinking. It was so

ritualized in the 1960s and early 1970s. Mom and Dad always had martinis when we went out to a nice restaurant like the Smoke House. And what did Ron and I drink? Shirley Temples. A Shirley Temple offers everything but the alcohol: sugar for a high, crushed ice, a swizzle stick, and a tiny parasol. This drink is, I believe, society's way of training kids to participate in cocktail hour. Named for a child actor, no less.

So I became curious about what it must be like to drink a real cocktail. I resolved to find out. It started with me in my midteens going into our parents' liquor cabinet when they weren't around and having a few pops of brandy, straight out of the bottle. To a kid, that stuff tastes putrid. Funny how that didn't dampen my curiosity.

Pretty soon thereafter, I started having friends come over to drink beers in the rec room out back of our house when Mom and Dad weren't home. Yes, the very same rec room that Mom didn't want Ron and Cheryl canoodling in. We paid an older kid who worked in a liquor store to sneak us six-packs of tallboys out the back door. We didn't sip these beers as we played a game or two of pool. No, we liked to shotgun them. That's where you poke a church key in the side of the can, crack open the flip-top, and guzzle the beer through the keyhole in one go. Right away, this was my approach to drinking beer. Is that normal? Is that somebody socially enjoying a beverage? I don't think so.

My belief is that I came preloaded with alcoholism and drug addiction. I don't think I "developed" a problem—I was born with the disease, like my granddad Butch. All I was waiting for was access and opportunity.

We never spoke of Butch's condition as a sickness when Ron and I were kids; society didn't use that kind of vocabulary back then. But we saw him act strangely, stubbing out his cigarettes on the sides of Mom and Dad's cars, leaving burn holes in the paint. We heard Dad's stories about him downing a pint in the supermarket parking lot. And we knew that Butch's sister, Aunt Julia with the pinned-up blue hair, ran

the family's business affairs in Duncan because her brother was not up to the task.

My parents became aware of my new habit when Mom picked me up from a ninth-grade party at a classmate's house where there had been no parental supervision. I had consumed ridiculous amounts of cheap wine and vodka, and it wasn't sitting well. In the car ride home, I puked all over the interior of Mom's yellow Plymouth. Rainbow colors. The next morning, Dad gave me a talking-to, though it was more firm than ferocious. He simply laid out the dangers of overindulging in drink. Honestly, I don't remember much of what he said because I was too hungover.

Mom spoke to me, too, in measured tones. She never specifically mentioned her father, but something about her vibe—the worry in her voice, the fear in her eyes—suggested to me that she was making the connection. After all, I looked like young Butch.

Neither Dad's warnings nor getting sick from binge-drinking scared me straight, though. Perversely, even as I was still clammy and wobbly from hurling, I couldn't wait to drink again. A person who has an allergic reaction to something he has eaten isn't eager to try that food again. A person who burns his hand on a hot stove isn't eager to touch a burner again.

But an alcoholic is different. I thought to myself, *Wow, I feel terrible—but when can we do this again?*

THIS EXPERIMENTATION COINCIDED with a professional downturn, the same shitty wake-up call that Ron experienced after *Andy Griffith*. At the time that I completed *The Red Pony*, I regarded that film as a beginning: the kickoff of my next, more mature phase as an actor. But it turned out to be an ending: the last hurrah of

my juvenile performing career. Soon after, my fortunes changed for the worse.

I first felt the slippage when I was cast in an ABC series called *The Cowboys,* based on a 1972 John Wayne movie of the same name. To outward appearances, it looked like a great job—Bob Totten was directing the pilot and was involved in the casting. It was my first TV series since *Gentle Ben.* And the show was right in my comfort zone, given my track record in westerns: it was about seven teenage boys who are pressed into service as ranchers in the New Mexico Territory in the 1870s. I was one of the seven boys, acting alongside talented guys like Bobby Carradine and A Martinez, who were several years my senior. It felt good to be the young-gun actor on the set, the veteran who could act with the big boys.

But Totten was unceremoniously let go after the first episode. And then, as soon as the scripts started rolling in, I became demoralized. My character—Steve; I can't believe I even remember his name—had only a couple of lines per show. Nothing plot-related. This would be the case for all twelve episodes of the brief, ignominious life of *The Cowboys.* I was basically a bit player.

Shortly before I landed the series, I had been appointed editor of the David Starr Jordan Middle School yearbook. Journalism was the first elective class that I had ever taken in school. I fell under the tutelage of a terrific teacher named Steve Campbell, who lit a fire under me and made me realize that I was a good writer. I started winning awards with my pen rather than with my face. Being the yearbook editor played to my strengths and was the sort of socially validating post that would have helped me get through the awkward ordeal of early adolescence.

But I had to give up the editorship for *The Cowboys.* And then I found myself in TV purgatory, the seventh banana in a cruddy eight-banana western that was destined to fail.

On top of that, I was losing my little-kid looks. My face was physically changing. My brows were getting bigger and darker. Acne descended upon me—pimples everywhere. Clint the cute towhead vanished seemingly overnight, his straight blond hair turning brown and frizzing into curls. I looked at myself in the mirror and thought, *What the hell just happened? Who will ever go out with me?*

This is not atypical stuff for a kid going through puberty. But it's brutal when you're a child actor and you're known for a certain look. When that look is gone, and your hormones are doing a number on your body and your brain, you start to feel the uglies, inside and out. And it sure as hell doesn't help that your career stalls. Or that you like to get loaded.

IT'S IMPORTANT FOR me to point out that I am not in any way attributing my substance abuse to my struggles in my midteens as an actor. I'm simply saying that these two phenomena arrived in my life at the same time and made for a toxic brew. No work plus access to booze and pot equals trouble.

But here's the thing: Initially, I thought I could handle it. I was good at keeping up appearances. I still received good grades and had good friends. It was a while before my habits and conduct were problematic enough to cause my family concern.

RON

I was no longer a full-time member of the Howard household when Clint started drinking and getting high, so I wasn't there to bear witness to his overindulgence. Even when I learned that Clint was smoking pot, it didn't bug me. Between USC and *American Graffiti*, I had

become totally acclimated to environments where marijuana was a constant. My generation believed that smoking pot was actually less detrimental to one's health than drinking. And I didn't yet know that Clint was drinking.

Beyond all that, I knew that Clint had an active social life and I was rooting for him to have fun at Jordan Middle School and Burroughs High School. In some ways, I envied him. Growing up, I had always regarded myself as something of an outsider. I thought that I was inordinately square and Clint was normal. Now, I was *comfortable* being inordinately square—it hadn't held me back from meeting and falling for Cheryl—but I didn't want that for Clint. I admired that he wasn't hampered by social inhibition. It took me a long while to suspect that anything about Clint's life was amiss.

BESIDES, I WAS consumed by my own drama. In my first semester of college, I remained preoccupied by the thought of getting drafted. Then the '72 election was decided in favor of President Nixon. Say what you will about Watergate and his many other transgressions, but Nixon kept his promise to end the draft. The last draft call that required young men to report for military duty was on December 7, 1972. The following July, the United States officially made the switch to having an all-volunteer armed forces. I can't convey the magnitude of the relief I felt, for me and for my friends such as Noel. My draft-lottery number, 67, wasn't as scarily low as his, but it was low enough to keep me up at night.

I was fortunate to escape the fate of the many young American men who were killed, injured, or, like my *American Graffiti* castmate Paul Le Mat, traumatized by their time serving overseas. I took that folded-up notice out of my pocket and tore it into pieces.

At USC, I hedged my bets about my future. I enjoyed taking classes,

in particular one that was devoted to reading classic books, plays, and stories, and then watching and analyzing their film adaptations: *The Grapes of Wrath, Summer and Smoke, An Occurrence at Owl Creek Bridge.* The last is an Ambrose Bierce story that the French director Robert Enrico turned into an Oscar-winning film short. It inspired me to adapt another Bierce story, "A Horseman in the Sky," about a Union soldier who kills a Confederate spy—who turns out to be the soldier's own father.

Cheryl's dad was a gifted amateur photographer and documentarist who owned an early 16 mm Bolex, a Swiss camera that he carried with him when he climbed Mount Fuji in 1947. After a tutorial, he lent me the Bolex, which came with three Zeiss lenses that were perfect for capturing the period look I was going for. We shot the film in Malibu Canyon. Dennis Weaver's son Robby played the Union soldier and Dad played the Confederate.

But after the positive experience of *American Graffiti,* I decided to keep on acting, lest my trail go cold like it had when I turned down those *Bonanza* and *Mod Squad* jobs in the late '60s. It's not like any prime parts were coming my way, though. One of the few decent ones I got was in a forgettable exploitation thriller theatrically released as *Happy Mother's Day, Love George* and later retitled *Run Stranger, Run.* No matter what it was called, those titles alone are red flags, should you wish to hunt down the movie and watch it.

The actor Darren McGavin directed the movie, which was set in a sleepy New England fishing village. I played a drifter named Johnny who returns to this town in search of the father he never knew—a different kind of role for me. I barely remember the plot, except that my character got blamed for a series of gory murders that had actually been committed by his teenage cousin, played by Tessa Dahl, the daughter of Patricia Neal and Roald Dahl.

For such a tawdry movie, we had a surprisingly strong cast. Darren used his charm and charisma to bring his actor friends on board and will the movie into existence, setting an example that I would emulate a few years later, when I began trying to launch my own passion projects. Neal herself was in it alongside Tessa, as was the singer Bobby Darin, and, just a year removed from winning an Oscar for her astonishing performance as a lonely Texas housewife in *The Last Picture Show,* the great Cloris Leachman.

Cloris was to play my mother, a diner owner who had long ago given up Johnny for adoption. Before I was awarded the role, I was told by my agent that Cloris wanted to meet with me for a read-through, just to make sure that the chemistry was there. I was given her address and a time to report for the meeting.

On the designated day, I left my dorm room and drove to Cloris's house. I arrived at the front door to find a note taped on it. It read: MEETING WILL BE IN THE BACKYARD. COME ON IN.

As I entered, I expected to hear voices: Darren McGavin, Cloris, maybe some other people involved in the production. But all I encountered was silence and empty rooms. Finally, through the back door, I caught a glimpse of Cloris, completing some laps in her pool and then pulling herself out of the water. She saw me and waved me over.

Cloris was, at the time, forty-seven years old. She had an amazingly taut, athletic body. I know this because she was wearing nothing but an extremely skimpy black bikini and was dripping wet, and in no hurry to dry off or get dressed. "Ron, hello!" she said, flashing that broad, luminous grin for which she was known. "Can I get you an iced tea?"

I accepted her offer. But first, she told me that she had just wanted to meet with me one-on-one, to make sure that we would hit it off. I was starting to feel nervous and uncomfortable. Then Cloris asked me to follow her into the kitchen, sashaying in her bikini bottom while I

stared but tried not to *really* stare. It occurred to me in this moment that she had won an Academy Award for playing a middle-aged woman who had an affair with a teenager.

As Cloris poured us two glasses of iced tea out of a pitcher, I was gripped by fearful anticipation, akin to what I used to feel in school when I thought I was about to get into a fight. Was I being put to some kind of test? Was she going to make a move on me? Was I not going to get the part if I demurred? Could I turn up my hands and say, *Sorry, I have a girlfriend?* Should I turn on my heels and simply make a run for it?

Cloris handed me my iced tea and held hers. We were standing no more than a foot apart. She flashed me another smile and leaned in ever so slightly, as if she was about to initiate something. I took a big slug of iced tea. She seemed to be enjoying my nervousness. "Um, it's, uh . . . it's quite the script!" I said, trying to drum up some banal shop talk.

She held her stance and her gaze for just a moment longer. Then she said, "It is! Let's read through some of this." Only then did she slip on a robe and invite me back outside, where we sat down and read a few scenes, very professionally.

I drove back to USC to catch an afternoon class, wondering what the hell I had just experienced. Later that day, I got a call from Darren, saying that Cloris had loved meeting me and that I was in.

When we shot the film, there were no further flirtations. In fact, my conversations with Cloris on set were relaxed, professional, and creatively inspiring. She was a dream colleague and highly intelligent artist. *Happy Mother's Day, Love George* also happened to mark my debut as Ron Howard; even in *American Graffiti,* I was still billed as Ronny. At last, I was unveiled to the filmgoing public as a man!

Less than a year later, I again got a job playing the son of a character played by Cloris, this time in a prestigious TV movie called *The Migrants,* with a teleplay by Lanford Wilson. I wasn't even asked to

audition—I'm pretty sure that I got the part because Cloris had recommended me for it.

AMERICAN GRAFFITI WAS released in August 1973, a year after we wrapped. I expected it to get some good reviews, and it did. The *New York Times* posited that it was arguably the most important American film since *Bonnie and Clyde*. Roger Ebert called it "not only a great movie but a brilliant work of historical fiction."

But the film became so much more: a word-of-mouth hit with staying power. It played in movie houses for more than two years after its initial release. I missed out on the premiere because I was on location for another film, but when I got back home, I drove past theaters where there was a two-hour wait to get into the next showing. Cheryl and I caught the movie at the Avco Theater in Westwood, near UCLA, and were astonished to come across a multigenerational audience that, as one, clapped along enthusiastically as Bill Haley's "Rock Around the Clock" played over the title sequence. George Lucas's little $700,000 picture went on to gross more than $100 million, at the time the greatest return on investment in the history of cinema.

All of us in the cast benefited from our association with the movie, a phenomenon that I refer to as the "*Graffiti* glow." Candy received an Academy Award nomination for Best Supporting Actress. Rick and Paul were signed up to star in multiple movies by Steven Spielberg and Jonathan Demme, respectively. Harrison landed a role in George Lucas's next movie, an off-the-wall, long-shot sci-fi flick called *Star Wars*.

But some of us benefited less than others. Like me. I just wasn't able to parlay my participation in *American Graffiti* into film stardom. I did Darren's movie, and Charlie and I had supporting roles in one of Lee Marvin's weaker outings, an uninspired western called *The Spikes Gang*. I wasn't devastated, though. This lack of traction only reinforced my

ambition to stay the course at USC and become the master of my own creative journey.

Unbeknownst to me, however, something was percolating in TV-land that was to affect my life profoundly. The *American Graffiti* juggernaut had come in the wake of some similar phenomena: the success of the retro vocal group Sha Na Na, which had played Woodstock and was selling out major rock venues, and the original Broadway production of *Grease,* which opened in 1972 and proved so popular that it ran for the rest of the decade. This so-called '50s craze set off a scramble among the broadcast networks to develop 1950s-themed series for television.

It was at this point that Garry Marshall politely raised his hand and notified ABC that they had a pretty promising pilot for a '50s show in their vaults already. As a matter of fact, it starred one of the leads in *American Graffiti.*

CLOCKING IN TO THE NOSTALGIA INDUSTRY

RON

ABC wasted little time in putting together a new version of Garry's 1950s show. *American Graffiti* took off in the summer of 1973. The network was determined to get its '50s program on the air no later than January 1974.

This fast-track process forced me to do some fast-track thinking. Should I compromise my education at USC by joining a series again? Could I reduce my course load and do college and TV at the same time? Would signing a seven-year contract—the wildly optimistic but standard length of a commitment that an actor made when he joined a new show—postpone or even unravel my dreams of directing?

I decided to go for it. *Happy Days,* which is what ABC was calling the new show, had much to recommend it. The pay was good, $3,500 per episode. The program was being built around my character, Richie Cunningham. Isn't that all that anyone in my business could ask for?

"Yes," I told my agent, Bill Schuller, "I'm in."

Then Bill dropped a bomb. I wasn't a shoo-in. They wanted me to screen-test for the Richie role. This exasperated me. I hadn't even tested

for the original pilot! I mean, come on! I was one of the damn stars of the movie they were trying to emulate! What does a guy have to do?

My competitive juices flowing, I agreed to the test. I was once again paired with Anson Williams, who reprised his role as Potsie. We were given a four-page scene to read, with Garry Marshall directing; the footage would be screened for various suits at ABC and Paramount Television. Garry later told me that he allotted Anson and me a generous three hours to work out our scene, as opposed to one hour apiece for the other paired actors, to tip the scales in our favor; he wanted us all along. The only other serious candidate for the Richie role was a handsome, talented newcomer named Robby Benson, who, like me, was a budding multihyphenate. A few years later, he starred in a terrific movie that he wrote with his father, *One on One*.

Anson and I thankfully recaptured our roles. A few weeks later, I drove my VW Bug to the Paramount lot, where I gave my name to the guard in the gatehouse and he told me that I was on the list, with a reserved parking space awaiting. To this day, hearing this always gives me a rush of satisfaction.

After I found my spot, we did the first read-through of the first *Happy Days* episode. I reconnected with Marion Ross and shook hands with Tom Bosley, our new Howard Cunningham. I instantly had a good feeling about Donny Most, a jovial fellow redhead who was playing the new character Ralph Malph, one of Richie's and Potsie's friends.

I was really curious about who would be playing Fonzie, another new character, who had six lines in the first episode. He was a likable tough guy modeled after Paul Le Mat's character in *Graffiti,* John Milner, and Danny Zuko in *Grease,* as well as the haimish hoodlums who Garry knew growing up in the Bronx. Fonzie's real name was Arthur Fonzarelli—like Garry himself, whose father changed the family name from Masciarelli to Marshall, he was Italian American.

This fact notwithstanding, I expected Fonzie to look like Steve

McQueen, rugged yet pretty, a glamour biker. But no one in the room fit that physical description. Then one of *Happy Days*'s executive producers, Tom Miller, took me aside and said that he wanted to introduce me to an amazing actor who had blown everyone away at the auditions.

He was not what I expected: more of an Al Pacino–Dustin Hoffman type, on the small side (five foot six), with floppy, center-parted dark hair and a scruffy beard. He was a worldly, educated native New Yorker who had earned an undergraduate degree at Emerson College in Boston and a Master of Fine Arts at the Yale School of Drama.

He offered his hand and smiled. "Ron, it's so nice to meet you," said this man, who was almost twenty-eight and seemed so much more gracious and grown up than me. "I'm Henry Winkler."

I shook Henry's hand, and so began a relationship that, in unexpected and sometimes complicated ways, would transform my career—and, indeed, my life.

CLINT

We were happy to see Ron stay in the acting business. Work is work, and a series could be a lucrative job. Directing could wait for a while. We were happy to see Ron, period. Though I seized the opportunity to claim his old bedroom, the best one in our house, I missed having my brother around every day. Still, he checked in fairly often—our place was close to Cheryl's—and he sometimes met with Dad to work on scripts.

The year that Ron got *Happy Days,* he came by to hang out when Dad was away on a location shoot, leaving Mom and me by ourselves. Dad was in North Carolina, working on a movie called *Where the Lilies Bloom*. It was a great gig, one of the best of Dad's career. The film's producer, Robert Radnitz, was riding high on the critical and commercial

success of his previous film, the Oscar-nominated *Sounder,* and this was his follow-up.

Like *Sounder, Where the Lilies Bloom* was a family-friendly movie about poor folk in the South: in this case, a widower and his four kids who work as sharecroppers in the Great Smoky Mountains. Dad played the widower, Roy Luther, a sickly man who instructs his children to bury him in an unmarked grave when he dies. By concealing his death, the kids will not be made wards of the state and split up. Roy meets his maker relatively early in the film, but for Dad, who was accustomed to being Mr. Two Lines, this was a substantial role, a lot to sink his teeth into. And it was a substantial film, well received upon its release in 1974.

Ron and I were contentedly lounging around in our house when we heard unusual noises coming from Mom, who was downstairs in the kitchen. She was on the phone with Dad and she was yelling. This was not normal. Our folks had occasional spats, but these never upset us much because every married couple does. One thing Mom and Dad definitely did not do was yell at each other. So this attracted my and Ron's attention. The way our house was laid out, we could station ourselves at the top of the stairs in such a way that Mom didn't see us.

The call went on for a distressingly long time. Mom would get agitated, calm a bit, and then build steam back up to a point where she was even more wound up than before—it was like a little earthquake that progressed into the Big One. Ron and I silently cast glances at each other, trying to get the picture of what was going on. It was like listening to a ball game on the radio, only there was nothing remotely entertaining about it.

RON

Little by little, the contours of the argument became clear. Dad was nearing the end of his trip, but he had told Mom that he needed to stay

a little longer than expected. Mom had received this news poorly. She kept saying the name "Vera." As in, "You're with *Vera,* I know you are!"

Vera . . . as in Vera Miles . . . who had played Clint's mom in the movie *Gentle Giant* and was the mother to both of us in *The Wild Country.*

I was confused. And rattled. Mom hung up on Dad at one point, only to pick up the phone when it rang again, to resume their arguing.

When she hung up for the last time, Mom was in tears. We wandered down to the kitchen. I said, "What's wrong, Mom?"

She exploded. "He's in North Carolina and Vera is there and she's got her eye on Rance! And I'm not going to stand for it!"

It was true that Vera Miles was in North Carolina on location with the *Where the Lilies Bloom* crew. She had recently divorced her husband and was newly partnered with Dad's friend Bob Jones, who was serving as the movie's assistant director: the same Bob Jones who lent me his two horses for my film *Old Paint.*

The *Lilies* shoot had run over schedule, and the production had chosen to extend Dad for an extra week. To Mom, this had shades of "Don't wait up for me, honey, I'll be working late." But it just didn't make sense. Films run over schedule all the time. Mom and Vera had been such fast friends on the set of *The Wild Country.*

Then came an unburdening that knocked me sideways. "I was happy in Duncan," Mom said, referring to her Oklahoma hometown. "I've put in all these years. I've been taken for granted. Well, I'm not putting up with that! I've had it. I'm just going to pack my things and go home."

The sting of her words was compounded by how uncharacteristic they were. Mom's default behavioral mode was chipper, chatty optimism. I recognized that there were things that upset her, like those times in public when people approached her and Dad and thoughtlessly asked, "Is that your son?" I was old enough to understand that no marriage is perfect and that every partnership that endures must weather some adversity.

But I was unprepared for something like this. The force of it was so great and unexpected that my mind went into instant worst-case-scenario mode, projecting forward. *This is what it looks like when a family begins to fall apart. This is what happens to show-business families. Now it's happening to us. Things will never be the same.* Having witnessed my share of kids and family units damaged by the stresses of our business, I had nevertheless assumed that the Howards were immune. We had made it this far. We had always lived in a bubble of safety, love, and mutual trust—or so I had believed.

My next thought was to protect Clint. I was already on the cusp of adulthood, out of the house, but at fourteen, he still had a ways to go. He wasn't finished growing up. Now what was going to happen to him?

I grabbed Clint and said, "Let's get out of here." We drove to Cheryl's house. I reported to her what had happened. Cheryl was a child of divorce and talked a little about her parents' breakup. We were both sensitive to Clint, not wanting to alarm him. But what to do in the meantime? I decided to drive the three of us to Glendale, the next town over, where they had batting cages. For a quarter, you could buy twelve swings at pitches shot out by machines at various speed levels. For $3.50, you could buy half an hour's worth of unlimited swings. I went for the deluxe package, figuring that it would burn off a lot of the anxiety and stress that Clint and I were feeling.

CLINT

Given that I was fourteen, I had not fully developed the emotional capacity to process what was going on. My gut instinct was to giggle. Not at Mom, but at the whole scene, in an *Isn't this all kinda nutty?* way. I saw how upset Mom was, and I was thrown by the venom coming out of her mouth. But I also thought that it would all pass. Ron was more affected

because he was so deeply in love with Cheryl and better understood the stakes, the gravity.

Don't get me wrong; I was freaked out when Mom declared she was moving back to Duncan. We were so settled in the greater Burbank area that I couldn't imagine us ever living anywhere else. The thought flashed through my mind that if Mom really did move back to Oklahoma, I, at least, would stay in California with Dad.

But as bad as that day was, I just couldn't see a horrible development like that happening. I thought that Mom and Dad would be okay.

RON

The "moving back to Duncan" thing really disturbed me. Yes, I was almost out of my teens, but in the moment, I worried about the heartbreak and destabilization this could bring to our nuclear family. My concerns for Clint were really concerns for both of us. It threw me that Mom referred to Duncan—a place I'd only been to a few times—as home. Wasn't her home with us, her kids, in the San Fernando Valley? Wasn't that what we were all about?

When we got the batting cages, I calmed down a little, if only because Cheryl had offered some soothing words, and taking swings with Clint was a nice distraction. But then I noticed that we had been recognized and were attracting a few young onlookers, some of whom were using the O-word.

"Look, Opie and Mark are having batting practice," some kid said. "Hey, Opie, where's Barney Fife? Hey, Mark, where's your bear?" Even when Clint made solid contact and drove the ball, the compliments were framed as needling remarks: "Mark's a better hitter than Opie!"

We had always been taught to be gracious in public, so we didn't engage with these kids. But I came close this time. Clint and I were trying

to get through something heavy and these assholes wouldn't just let us be. To top it off, they approached us when we were done hitting to ask us for autographs, thrusting some wrinkled napkins in our faces to sign. We obliged because, well, that's what our folks would have expected us to do. But in my mind, in that moment, I was cursing the very fact of public life.

We returned home with some apprehension. Mom had not entirely regained her composure, but she was palpably de-escalating. She hadn't taken a return to Duncan off the table, she said, "But I haven't called to get a flight yet. Maybe I will tomorrow." She was talking herself off the ledge.

Mom shut down my attempts to have a conversation about what went down, though. She needed to work through her feelings by herself.

CLINT

Dad flew home a few days later, after his filming was complete, and they were fine, as loving as ever. Ron and I both asked him what had happened. He said he really didn't know. He assured us that there was nothing going on between him and Vera Miles.

"There's no reason for your mother to be afraid," he said. "Vera is with Bob Jones. That's what she was doing in North Carolina. I don't know what got her so upset."

Being an immature wiseass, I made some ill-considered crack about menopause. Dad gently but firmly shut me down. He wasn't the type to sweep things under the rug and pretend that their fight had never happened, but he made it clear to me, in no uncertain terms, that Mom's pain was nothing to joke about. Her fuse had been lit, and Dad's needing to stay on location longer than anticipated was the thing that made her combust.

Now that I'm older and a little wiser, I think that the fight was really about love. Mom and Dad had sparks flying between them from the moment they met. I don't mean that they had a tempestuous relationship, because they didn't. But it was a passionate one. When you love someone that much and don't feel like you're receiving reciprocal love, you're capable of being more deeply hurt by that person than by anyone else.

RON

This marked the *only* time that we ever saw Mom truly crack under the pressures that life placed upon her. For two decades, hers was the voice of optimism and good cheer in our family, and her sense of self was linked to her husband's and children's careers. I suspect that she felt emotionally vulnerable in '73 because, as a family, we were in a period of transition. Clint and I were growing up and becoming less reliant upon her; the empty nest loomed. Dad wanted to reclaim his life as an actor, rather than as his kids' manager and mentor. Remember, one of the reasons Mom gave up acting is that she didn't want to be apart from Dad for extended periods. So Dad's long location shoot came at a bad time in that regard.

I also suspect that Dad must not have handled what she was saying with his usual patience and grace. It takes two people for a blowup like that to happen. In fairness to Mom, we only heard her side of the telephone conversation. Whatever Dad was saying on his side, he was not soothing her.

I don't think Mom meant all those comments she made about regretting her life choices. It was heat-of-the-moment stuff, not unlike when young parents at their most exasperated question why the hell they had kids in the first place. The talk that Mom and I had fifteen

years later in her hospital room—before her open-heart surgery, where she revealed her conversations with the *Cocoon* actresses and spoke of her idyllic Duncan childhood—was like a bookend to this episode. She chose positivity over negativity.

In her final year, as her body was failing her, she demonstrated this philosophy by asking Dad to help her revisit the places they had cherished in their younger years: Sequoia National Park in Northern California, with its mighty trees; the Grand Canyon; and her beloved New York City. In a twist out of Dickens, just as she and Dad pulled up in a yellow cab to look at the old apartment building on Riverside Drive where they had shacked up as young lovers, a wrecking ball swung through the building's brick facade. They hung around to observe the demolition of their love nest. I asked Mom if she found the scene upsetting.

"No, just lucky," she said. "We got there just in time. It's like they waited for us."

I THOUGHT A lot about my own life's arc when I got *Happy Days*. I was pleased to have landed the role that I considered to be rightfully mine in the first place. But I was ambivalent. I questioned whether my pragmatism was getting in the way of my passion. I was replaying scenes from my childhood, of Dad sitting by the phone, and of him and his character-actor buddies hanging out on weekdays as they struggled to find work. I thought to myself, *Who are you to turn down the lead in a network sitcom?*

I was also hardened by the unsatisfying experience of having done *The Smith Family*. My first time out on a series, I was on a hit that ran for eight seasons. My second time out, I was on a dud. Now I was at the point where I believed that the good fortune that I'd experienced on

The Andy Griffith Show was a once-in-a-lifetime blessing. *Happy Days* might go for a season or two and that would be that. When it died its inevitable death, I would collect my last paycheck, go back to film school full-time, and resume my quest to become a director.

THIS CALCULUS CHANGED in my very first read-through with Henry Winkler. Instant chemistry. Fonzie was only a supporting player in our first official *Happy Days* episode, which centered around a date that Potsie had set up for Richie with Mary Lou Milligan, a girl reputed to be "fast." Anson and I had by far the most dialogue, but there was a scene near the end in which I had to screw up the courage to tell the Fonz that I had lied to him: I had not gone "all the way" with Mary Lou.

"I'm gonna fuh-get it this time," Henry-as-Fonzie said. "But no more lyin'. *I'll* do all the lyin.'"

Henry's conservatory training was evident from the start. *Happy Days* was far from fully formed that first season. At the beginning, it was flagrantly lifting ideas from *American Graffiti,* with vintage cars everywhere and a prominent soundtrack of oldies like Bobby Darin's "Splish Splash" and Elvis's "Hound Dog." But Fonzie arrived fully formed. He already did the thumbs-up gesture. He already had that magical wordless bit where he pulled his comb from his back pocket, checked himself out in the bathroom mirror, and acknowledged with a confident shrug that he looked perfect as he was. Off camera, Henry had a menschy, almost professorial manner of speaking, but as Fonzie, his speech assumed a jabbing, edgy cadence. "Don't *knock* it 'til you've *tried* it, Cunning-*ham*."

Above all, he knew how to find laughs that weren't on the page, that came through pauses, gestures, and improvisation. Henry later told me

that part of this approach came from being dyslexic; he had trouble reading from a script, but if he absorbed its gist in advance, he could come up with a performance that worked.

Henry crackled with the same energy, intellect, and creative inventiveness as Rick Dreyfuss. They reminded me of each other in a lot of ways: short Jewish guys a few years my senior who were generous of spirit and had a lot to teach me. And they were both so inherently *funny*.

I was surrounded by comedy savants: Tom Bosley, who was a Tony-winning musical comedy star on Broadway; Marion Ross, who had done sitcoms since the 1950s; Anson, with whom I had already developed a buddy-comedy rapport; and Donny, a Brooklyn guy with vaudevillian timing.

You know who I didn't find particularly funny? Me. I brought this up with Garry Marshall right before we began shooting, as we were doing camera tests. Garry was a relentlessly upbeat man, with a wide smile of Chiclet teeth and a sweet, Jewish-mother-like way of talking, even though his background was Bronx-Italian. He specialized in two things: getting laughs and putting people at ease.

I approached him in all earnestness and declared, "Garry, I've been thinking about this, and I want you to know: I'm really not very funny."

Like the truly funny person he was, Garry hit me with an instant comeback. "*Now* you tell me?" he said.

Then he gently talked me off the ledge. He explained that my role was to be like Andy in *The Andy Griffith Show:* the leading man as straight man, behaving sensibly when everyone around him is kind of nuts. He had an even better metaphor for what I was doing from a comedic standpoint. "You're the Bob Cousy," he said. Cousy was the Boston Celtics' point guard at the beginning of their dynasty years, the Houdini of the Hardwood. His great gift was for dishing out assists to the talented players around him, guys like Bill Russell and Tommy

Heinsohn. But Cousy was also adept at taking the shot himself when the situation called for it.

I loved this metaphor. Later on, when we started filming *Happy Days* before a live studio audience, Garry sometimes warmed up the crowd before the show by doing introductions, and mine was, "Here he is, folks: Ron Howard, the Bob Cousy of Comedy!"

Garry was a good Red Auerbach to my Cooz. He instilled in me a sense of pride in what I was accomplishing. I hadn't completely banished my belief that I should really be honing my chops as a director. But in the moment, I had to acknowledge how awesome it was: one of the Big Three networks had made me the lead of a prime-time show. The Andy, not the Opie.

HAPPY DAYS MADE its debut as a midseason replacement program, on January 15, 1974. Our time slot was Tuesday at 8 P.M. We found a dedicated audience right away, finishing our half-season ranked number 16 in the Nielsen ratings, good enough to guarantee us renewal for the 1974–75 season.

The demographic breakdown of the show's viewership was telling. In the 18-to-49 category, we ranked even higher, seventh place, attracting young viewers and their parents. We were second overall in our time slot because we were up against *Maude,* Norman Lear's audacious, very adult-themed sitcom starring Bea Arthur, which had spent two years in the top ten. But we took a significant bite out of *Maude*'s ratings, so much so that CBS decided to move the show from Tuesday to Monday nights.

None of us fully grasped how popular *Happy Days* was until the summer of '74, when, ahead of our second season, ABC sent Henry, Donny, Anson, and me on a promotional tour. To maximize the show's exposure, they deployed us in teams of two: Henry and Donny were one

team and Anson and I were the other. A lot of it was cheesy and depressing: appearances in department stores, signing crappy, insta-published *Happy Days* YA novels that separated impressionable kids from their cash.

Kids is the operative word. Live, we were drawing a primarily teenage audience, throngs of rabid girls of high school age and younger. I wasn't prepared for this; it seemed like a throwback to the era when I struggled to write out my autograph at the Roosevelt Hotel. In Detroit, ABC partnered us with *Seventeen* magazine, making us pose for pictures with teen models, which was uncomfortable for Anson because he was twenty-four and for me because I had Cheryl. I confided in Anson that I hated this PR tour—it was tiring, it kept me from home, and, as my inner Rance Howard was telling me, it had nothing to do with acting or directing.

But our experience was nothing compared to what Henry and Donny were going through. We kept getting field reports that wherever Henry went, huge crowds were gathering. Fonzie, we were learning, had captivated viewers more than any other *Happy Days* character. The Neiman Marcus flagship store in Dallas was completely overwhelmed by a turnout of over twenty thousand people, most of them screaming girls, most of them screaming "Fon-zeee!" The security team there was unprepared, and Henry and Donny were trapped at one point, separated from their limousine by an unregulated mass of humanity. Crisis was averted only when Henry put on his Fonzie voice to address the crowd. "I want to *tell* you something *now*," he said. "You're going to *part* like the *Red Sea*." He snapped his fingers, the same way he did on the show to summon chicks. The crowd obediently opened up a pathway to the car.

When all four of us met up in Philadelphia, Anson and I got a sense of how intense Fonzie-mania had already become. Our appearance at Wanamaker's department store was like Beatlemania: girls screaming at us, throwing themselves at our limo, tearing our clothes. I chased

down a girl who grabbed my ballcap. Sorry, no Richie Cunningham souvenirs—even when I still had a full head of hair, I loved my caps, and by god, I was not going to let anyone steal them from me.

I had made my share of public appearances for *The Andy Griffith Show*. But they were always agreeable and low-key, not unlike the show itself. This was something else entirely—and pretty terrifying. But on some level, it was fascinating, being at the eye of a teenybop storm. It was apparent that *Happy Days* was becoming something bigger than us, a cultural phenomenon. It was not about any single one of us.

Well, maybe one of us more than the others. We finished up our stay in Philly by appearing on *The Mike Douglas Show,* the nationally syndicated daytime talk show. After a pleasant interview, Mike opened up the floor to questions from the audience. The first was from a young woman. "My question is for Henry, who I think is super," she said. "Do you believe in sex before marriage?"

FONZIE-MANIA

RON

Henry, Donny, Anson, and I were fast friends. Four guys who had not previously known one another, apart from my filming the earlier pilot with Anson, discovered that they were simpatico not only on the set but off the lot.

On Monday nights, Cheryl and I took to dining out with Henry. It was our way of socializing and trying out new restaurants on a quiet night; already, weekend dining was a nonstarter because our newfound popularity precluded us from getting through a meal unhassled by throngs of fans. Henry called us the Monday Marauders. As time went on, our group expanded to include his girlfriend and future wife, Stacey Weitzman, and, when *Three's Company* became a hit on ABC, John Ritter and his wife, Nancy Morgan.

Donny gamely agreed to play the lead in a naturalistic indie movie that I was making on weekends. It was called *Leo and Loree*. I was trying to emulate the improvisational style of John Cassavetes. Donny was Leo. Loree was played by Linda Purl, who *Happy Days* fans know as Richie's girlfriend Gloria in the show's first season and Fonzie's steady,

Ashley, in the later seasons. (I never finished the film, though it was later reshot by Jerry Paris, *Happy Days*'s main director, and received a limited release through United Artists.) As for Anson, he and I hatched plans to produce films together. Eventually, we actually made one, a TV movie called *Skyward*.

So, from an interpersonal standpoint, *Happy Days* was a terrific place to work. I couldn't have asked for a better group of colleagues. If *The Andy Griffith Show* was my de facto hometown, where I felt safe among the set's kindly grown-ups, *Happy Days* was college and the army rolled into one, where I met my once and forever confidants and drinking buddies. (Not that I've ever been much of a drinker.)

An added benefit to working on the show: the early 1970s were a cool time to be on the Paramount lot. In my wanderings, I happened upon a private advance screening of Roman Polanski's next film, *Chinatown,* and was waved in to catch it before it hit the theaters. I caught glimpses of Francis Ford Coppola, who was busy putting the final touches on *The Godfather, Part II*. I felt the same electric excitement in these moments that I had experienced while making *American Graffiti*—the next wave of American culture was upon us, and I was surfing it in real time.

I needed this boost, because *Happy Days* was wearing me down physically and mentally. Initially, it was a single-camera rather than three-camera show. This means that it was shot more like a feature film, with no studio audience and each scene's various angles and takes captured by the same camera. It's a laborious way to work that requires long days with hardly a break between camera setups—and I was in nearly every scene of *Happy Days*. This was gratifying, but I was also still trying to carry a course load at USC while coaching Clint's intermediate-level baseball team. To better situate myself for this peripatetic way of life, I moved out of my dorm and rented an apartment in Glendale. I was clueless about how to live as an adult. My cupboard contained nothing

but boxes of Wheat Thins. When I got home from work, I ate half a box for dinner.

What remained of my free time was spent working on scripts, and, of course, being with Cheryl. I was stressed to the hilt—completely running on fumes.

But the biggest stressor of all was Fonzie. Not Henry, but Fonzie. It did not escape my notice that as the season went on, the Fonz was getting more and more screen time. I had perceived Fonzie-mania to be an outside force, a phenomenon generated by the fans. Now I was becoming suspicious. It almost seemed as if the network was trying to marginalize me on my own show. *Could this be true? Nah, it can't be. I'm imagining it.*

I didn't handle my stress particularly well. I probably would have benefited from seeing a psychotherapist, but we Howards were stoic Oklahomans who didn't have any history with that sort of thing. Instead, I kept everything inside. Then I started breaking out in eczema rashes all over my body, most acutely on my eyelids, which stung with itchiness. I took to calling this condition "stress eye." And my hair started thinning. Looking at the men on both sides of my family, I knew it was inevitable that I would not hang on to my hair forever. But it started coming out in alarming clumps during this time. Whether or not this was caused by my feelings of overload, it certainly contributed to my unease.

To top things off, *Happy Days,* to everyone's surprise, was floundering in its second season. Rather than building on the momentum of our debut season, we slipped precipitously, finishing at Number 49 in the Nielsen ratings.

This was partly attributable to the sitcom *Good Times,* a *Maude* spinoff in its second year. In 1974, CBS's hard-charging head of entertainment, Fred Silverman, moved *Good Times* from Fridays to Tuesdays so that it could go head-to-head with *Happy Days.* What we had done to

Maude in the previous season was now being done to us: Silverman's revenge. Like *Happy Days, Good Times* was a breakout midseason hit with a breakout star. While we had Henry as the Fonz, whose catchphrase was "Ayyy!," *Good Times* had Jimmie Walker as J.J. Evans, whose catchphrase was "Dy-no-MITE!" Unlike Fonzie, who was still a supporting character, J.J. was front and center in *Good Times*. His "Dy-no-MITE!" was heard with more frequency than our show's "Ayyy!" Walker was having a major cultural impact.

It was a wake-up call when "Dyno-MITE!" demolished us in the ratings. We needed to up our game. As our second season neared its end, ABC decided to conduct an experiment. We temporarily became a three-camera show, with an open, stagelike set and a live studio audience. (The three cameras maneuver around within a "pit" area in front of the set, capturing the action from three different angles simultaneously.) Garry Marshall brought in a hotshot young writing duo from *The Odd Couple,* Lowell Ganz and Mark Rothman, to write a special episode for the occasion. It was centered around—Guess who?—Fonzie.

In this episode, Fonzie, the consummate ladies' man, shocks Richie, Potsie, and Ralph by telling them that he is getting married. But when he and his bride-to-be come to the Cunninghams' house for dinner, Howard Cunningham recognizes the Fonz's fiancée. Far from being the virtuous librarian Fonzie believes her to be, she is a burlesque-show stripper who Mr. Cunningham remembers as "the entertainment" at a hardware convention that he attended in Chicago. At episode's end, the engagement is sundered and the Fonz, to the relief of every girl in America, remains single.

In our cast, I was the absolute neophyte in terms of working in front of an audience. Apart from those low-stress county-fair appearances with Andy and Don and one little summer-stock play that I did with my dad up in Shasta Lake, California, when I was eight, I had not performed in front of living, breathing spectators. I had become accustomed to the

safety net of the second take. Now I had to memorize and rehearse every scene with the expectation that I would nail it in one pass, with strangers watching! It was a daunting prospect, especially given that all the other principals in *Happy Days* had theater experience.

I almost threw up before we started filming. But Henry, Marion, Tom, and our show's director, Jerry Paris, worked with me all week, teaching me how to play to an audience. Once we were rolling, I found my rhythm and acquitted myself well. Still, if you watch the episode "Fonzie's Getting Married," you can see how pale and clammy I am from nerves.

When we were done, though, I was exhilarated. I loved feeding off the audience's energy and getting real laughs instead of anticipating the spots where the laugh track would be dropped in.

ABC liked what it saw and *Happy Days* was renewed for a third season—on the condition that it was now going be a three-camera show with a studio audience. I was creatively excited by this development, but I wasn't prepared for the other big change they had in store. Fred Silverman had recently been lured from CBS to ABC. Our old tormentor was our new boss. In this capacity, Silverman was keen to do to *Good Times* what he and *Good Times* had done to *Happy Days* just a year earlier. As he put it with characteristic bluster, "I think Fonzie can knock J.J. out."

Fonzie. Not Richie or Potsie or Ralph. That didn't upset me, though. What shook me to my core was when I was notified that the network was planning on changing the name of our show. They were now going to call it . . . *Fonzie's Happy Days*.

Nope, I wasn't imagining it. I *was* being marginalized by my own show.

IN MOMENTS OF crisis, you assess. You take stock and figure out what really matters to you. When I did this, I realized that

what mattered to me most were directing, my family, and, above all, Cheryl.

Though I proclaimed my love for her within weeks of our first date, Cheryl was slower to make a definitive declaration—or maybe she was just more sensible than I was. In our first year together, when I ventured an "I love you," she responded, "I really like you, but I don't think I can love you yet."

A few months later, we had graduated to Cheryl saying, "I think I *might* love you." Once we had been together a year, I tried it again. We were making out in the VW Bug.

"I love you," I said.

"I love you, too," she responded.

Not a proactive declaration, but . . . *she said the words!*

"I've known that for a long time," I said.

We played out a similar process in terms of agreeing to get married. I popped the question, after a fashion, when we were still in high school, saying, "I think we should get married." She politely put me off, telling me it was way too early to talk about stuff like that.

I tried again a couple of years later, when she was at Valley College. Didn't get on bended knee, just floated the idea: "What if we—" She cut me off. She told me she needed to focus on getting her credits so she could transfer to Cal State-Northridge.

By the spring of 1975, we had both turned twenty-one. Cheryl had successfully transferred, so that was no longer a card she could play. And the chaotic, boy-band-like scenes that I had experienced doing promo for *Happy Days* drove home how much I truly loved her. Being on the road presented all manner of opportunities for casual flirtations, which I indulged, and casual sex, which I avoided. There was no one else I wanted.

Still, I was only twenty-one. My parents had gotten married young, but this was a different era. I was momentarily paralyzed with self-doubt.

So I presented my dilemma to Anson. "Cheryl is the one for me, but I don't know," I said. "Do you—do you think I should get married?"

Anson had been my partner on the road. He had partaken in the opportunities that came his way while I moped in my hotel room, pining for Cheryl. He couldn't help but laugh.

"Howard, you're married already!" he said. "What are you waiting for?"

Thus emboldened, I resolved to propose—again.

I never fully thought it out. We were simply driving to a movie, both of us in casual clothes. Smooth guy that I was, I chose a moment when we were on an on-ramp to the Ventura Freeway to say, "Do you want to get married?"

"Really?" said Cheryl. In my peripheral vision, I could see that she was smiling.

"Yeah. Yeah. I've been really thinking about it," I said. "I think it's time. So: Do you want to get married?"

"Okay," she said tentatively.

We drove smiling in silence for a few minutes. Then Cheryl piped up.

"Does this mean we're engaged, Ron?"

"Yeah, I think that's what it means."

"Okay!" Cheryl replied.

It was probably the most romantic proposal and acceptance ever to take place on a Southern California on-ramp. We decided to bag the movie. Instead, we turned around and headed back to my place in Glendale, where we made love.

OUR WEDDING TOOK place on June 7, 1975. We were married at Magnolia Park United Methodist Church in Burbank. The officiant was a man named Bobs Watson. Bobs was a former child actor who had appeared with Spencer Tracy and Mickey Rooney in the 1938

movie *Boys Town* and then, in adulthood, became an ordained Method-
ist minister. The resonance of being married by a former child actor was
too good not to take advantage of.

Mom and Dad didn't understand our hurry to get married, but they
were by then fans of Cheryl and understood that our love was real. And
they knew they had no standing to raise objections to getting married at
a young age; they were Exhibit A of its benefits!

Ours was as low-budget and rudimentary a wedding as you could
ever picture. The total cost was $800, including the price of Cheryl's
dress. We had no reception, just a simple ceremony followed by cake
and nonalcoholic punch in the church's courtyard. Cheryl and I hung
around for twenty minutes to pose for pictures and cut the cake before
a smaller group of friends and family migrated to my parents' house in
Toluca Lake, five minutes away. Mom had made champagne punch and
put up some helium balloons. That was it.

Aunt Julia, now in a wheelchair, came all the way from Duncan, her
hair as blue and tall as ever. Granddad Beckenholdt, my last surviving
grandparent, did not make the trip, but he had given our union his
blessing the previous Christmas. As a surprise to Dad, Clint and I had
pooled some of our money to secretly fly Granddad out—his first and
only trip to California, which he very reluctantly signed on for.

We built up the suspense to Dad like the actors we were. "Your
Christmas present this year, Dad—you won't believe it," we kept saying.
"It's going to *blow . . . your . . . mind.*"

"What is it?" Dad asked.

"Oh, it's big," I said. "But it'll fit. You'll appreciate it."

I was playing chess with Dad by the fireplace when Clint returned
from the airport with our guest in tow. Granddad wore an old sport coat
and a dress shirt buttoned to the collar—a farmer dressed for church.
He walked in and silently shook Dad's hand. It was the only time that I
ever saw Dad stunned and at a loss for words.

As reticent as Granddad was, he was taken with our setup on Clybourn Avenue. About half an hour into his visit, having had a look around at the four bedrooms, the living room, the dining room, the den, and the spacious yard, he said, "Well, Harold, it looks like the show bidness has been pretty good to you after all." It was the biggest affirmation that Dad ever got from his father.

Of equal importance to me, Granddad was really impressed by Cheryl. Before he flew back to Kansas, he took me aside and said, "Seems to me a feller like you'd probably oughta go 'head and wind up marryin' a girl like that."

MY GROOMSMEN WERE three of my Cordova Street buddies, Noel, John, and Bob, plus Anson, Donny, and Charlie Martin Smith. Our matching rented tuxedos were the apotheosis of mid-1970s men's fashion: wide-lapeled and powder blue, with ruffled tux shirts in the same color. All us guys sincerely thought that we looked incredibly cool. At least Cheryl looked timelessly beautiful in her traditional white wedding dress with a flowing train.

The only reason Henry wasn't officially in the wedding party was because he was away on location, filming a TV movie. He implored the production to let him hop on a plane to attend the ceremony. He arrived early, with a George Harrison mustache and hair down to his collar, and we put him to work as an additional usher. The network's machinations and favoritism had done nothing to strain our friendship.

Andy Griffith and Don Knotts also came, which moved me no end. I no longer saw much of them, but, like the de facto family that they were, they showed up when it mattered. So, too, did *People* magazine, which dispatched a reporter and a photographer to the church. They must have been baffled by our completely unglamorous affair, but to their credit, they were respectful.

The getaway car was driven by my best man, sixteen-year-old Clint. He was charged with driving the very grown-up new vehicle that Cheryl and I had bought together, a boxy maroon Volvo 240 station wagon. My groomsmen decked it out with the traditional accoutrements: streamers, tin cans dragging from the back, and a JUST MARRIED placard.

I was a little worried about being driven by Clint that day—he couldn't stop giggling and burned rubber the whole way. Fortunately, it was a short drive and we all got there fine. But I suspect he was high.

CLINT

Yes, I was high. I took a couple of pipe-loads before the festivities kicked off, and as far as I was concerned, I was going to be perfectly fine behind the wheel. By age sixteen, I had fully integrated marijuana into my life. I was smoking weed morning, noon, and night. It was so damned accessible through my classmates who were dealers—one played on the Burroughs football team and another was the most popular guy in auto shop. I could score a four-finger bag of Colombian for thirty or forty bucks, and that would hold me for a couple of weeks.

Ron, living as he did in Glendale, was oblivious to how much I was smoking. But Dad was starting to get the picture. I had gotten into trouble a couple of years earlier when I helped myself to a couple of cigarettes from a pack that Mom had left lying around. I didn't particularly like them, but my curiosity had gotten the better of me. Dad smelled the smoke on my clothes and lost it. He didn't want me to experience the same health issues as Mom. I got the hardest spanking of my life.

Dad could still get away with that when I was thirteen or fourteen, but by my midteens, I wasn't going to take it. It's just sort of hardwired into a boy's DNA, that at a certain age, he feels like he's ready—or even eager—to tangle with his old man. So, when he challenged me about my

pot-smoking one day, around the time that Ron and Cheryl got married, I challenged him right back.

It started with him telling me that he could smell it on me. He called me a dopehead. He said the word *dope* with disgust. He was from that generation that had no problem with alcohol but believed marijuana to be morally beyond the pale. I made the case that this was hypocritical—I saw no categorical difference between booze and pot. With no small measure of bravado, I said, "You should try it, Pop. You might actually enjoy it."

Dad was too tough to act shocked. He gave as good as he got. "You know, maybe I will. Maybe I will try it!"

So I went upstairs to get my bong. "Come on, Pop," I said when I came back down, "let me see you do it. Do a bong-load. You're gonna love it."

I was provoking him but I was also sincere: I thought that if he just took a hit, he would enjoy it and see the error of his ways. I miscalculated.

I had never seen him so angry. "Dope won't get you anywhere. Get that out of my sight!" he said. "I don't want that shit in my house."

I didn't quite sense that his fists were balling up in preparation to give me a pummeling, but this was definitely an escalation. If I hung around, there was a chance that things could get ugly. So I just bolted. I ran out the door and spent a few hours at a friend's house, allowing time for the tension to defuse.

When I returned, the bong was still there—he hadn't smashed it up like a southern sheriff demolishing a moonshiner's still. He chose to remain my loving, supportive dad. But now I knew that he knew.

AT THIS STAGE of my life, weed wasn't getting in the way of things at school. To the contrary, I was a pitcher on the varsity

baseball team and a dedicated correspondent and photographer for the Burroughs High newspaper, *The Smoke Signal*.

RON

Burroughs's sports teams were all called the Indians, and the *Smoke Signal* was an extension of that. This was a good three decades before schools, leagues, and other institutions began to realize how offensive these culturally exploitative names were. The girls in the cheerleading and twirling corps, Cheryl among them, were known as the Injunettes. Some of them wore feathered headdresses. That name is no longer in use, and the community is currently debating whether or not to retire the Indians name.

The journalism supervisor for the *Smoke Signal* was a brilliant woman named Betty Trempe. Ron had thrived under Mrs. Trempe, so she was already well-disposed toward me when I reached high school. I loved her intellect and attitude. She didn't shy away from letting us do controversial stories that might ruffle the administration. My friend Gig Kyriacou and I pushed for a special issue of the paper devoted to teen smoking, complete with a magazine-style photographic cover. She was on board.

Competition was always a part of my student journalism career. In junior high, Gig and I won national recognition in a Columbia University competition. We wrote a feature article on the Jordan Middle School alum Rene Russo's inspiring trajectory from bullied outcast to fashion model on the cover of *Vogue*. (Later on, she became a successful actress, starring in Ron's *Ransom,* among other movies.) Rene graciously gave us an interview and I turned it into a strong piece. I had a knack for writing and enjoyed it.

At Burroughs, I started working for the *Smoke Signal* as a sophomore. In 1976, my junior year, Mrs. Trempe entered her selections of

the paper's best work into a journalism contest held by Pepperdine University. The college, located in Malibu, hosted dozens of California high schools in the daylong event. I was the paper's sports editor that year and won Pepperdine's top prize in page design. The award came with a special prize: automatic admission to the university and one year's paid tuition. Talk about a sweet deal! Pepperdine had a great communications program and an even better setting, on a hill overlooking the blue Pacific. Just like that, I didn't have to worry about the grueling two-minute drill that most of my comrades were dealing with to get into a college. I could just cruise through my senior year.

That felt great, but I was still laid low by other aspects of my life: no girlfriend, not much in the way of acting work, the hormonal swings of ongoing adolescence. I simply didn't feel comfortable in my own skin. So I anesthetized myself with weed, which made me feel comfortably numb, like the song says. In fact, my high school journalism career facilitated my ability to do this. If you worked on the school paper, you were given a ton of autonomy to roam free, "on assignment." You could even pick up a gas voucher or two. There were days where I spent only two periods in a classroom and most of my time getting high. Me and my stoner buddies called this doing the "Summertime Gumby."

But anyone who is keeping himself numb for that long, for that much of the day, is postponing a reckoning. Because, while you're ignoring your bad feelings, all manner of shit is building up inside of you. And at some point, it's going to come out. Eventually, it did.

RON

So what *did* I think about ABC's suggestion to rename our show *Fonzie's Happy Days*? First off, I thought it was a desperately gimmicky attempt to cash in on the character that Henry had created, and I

believed that the move would be viewed as cheesy. I was also incredibly insulted.

My parents, normally calm, sage dispensers of guidance, could offer no help in this predicament. Mom was simply outraged at the network. Dad had no ready advice. He understood hard work, quality story-telling, and not letting the business side of things wreck one's love for acting and creating. But I also recognized that in his mind, mine was a quality problem to have. Hell, I was still going to be the lead straight man on a popular TV show. He would have killed for that himself. Dad was also not a hardball-playing show-business tactician. The way he saw it, I had signed a contract, my deal had nothing to do with the title of the show, no one was asking me to relinquish my top billing, and I had no enforceable say in the matter.

I can't blame them for this, but Mom and Dad had no way of grasp-ing the emotional toll of this situation. Or, for that matter, the true depth of my passion for chasing my primary dream of becoming a film-maker. I was a young adult but an adult nonetheless. These pivotal de-cisions were now mine to make.

I kept my cool and tried to view the *Fonzie's Happy Days* situation as an omen. Maybe this lousy turn of events was actually an opportunity. I decided to tell the network brass that if this title change was what they wanted, I was happy to go back to film school.

I had pulled out of USC during my sophomore year, once I realized how busy the show was keeping me—how exhausted I was and how lit-tle I was taking advantage of my precious slot at a great college. I wasn't learning enough in the measly amount of time that I spent on cam-pus, and I kept having to drop classes. I didn't completely give up on school—I took two night classes at Valley College, where Cheryl had gone, in world history and business law, to keep my mind sharp. But hey, if ABC was turning *Happy Days* into *The Fonzie Show,* I was ready to apply for reinstatement at USC.

Two of *Happy Days*'s executive producers, Tom Miller and Ed Milkis, asked me to come in for a meeting on the Paramount lot. They weren't corporate hatchet men; Tom, in fact, was someone I considered a friend. He had worked as a young man for the great director Billy Wilder and happily obliged me when I pestered him for behind-the-scenes stories about *Some Like It Hot* and *The Apartment*.

But they were the ones deputized to handle my "situation." Tom cut to the chase: "Ron, Fred Silverman wants to pour a lot more money into the show, and he wants the audience to know that it's a fresh version of what we've been doing. So he is very committed to adding 'Fonzie' to the show's title."

After a period of uncomfortable silence, I collected myself and mustered a response. "I think you both know that I didn't leave film school to be in someone else's show."

"Well, your billing wouldn't change," Tom said. "And by the way, if you agree to this, I know that the network would be open to improving your episode fee."

Money wasn't really the issue, though. My concerns were (a) that this was a transparent and cheesy exploitation of what Henry and the writers had organically developed; and (b) the title change would represent a very public demotion for me.

"Look, I love what Henry is doing, and I don't want to limit the way Garry and the writers are developing the episodes. But if you're changing the title, then I would prefer to leave the show and go back to USC."

Tom tried another tack. "If you had a choice between being the next Paul Newman or the next Francis Coppola, which would you choose?"

"Coppola," I said.

"Well, we could arrange for you to direct an episode every year, Ron," Tom said. "That could be a great jumping-off place for you."

This didn't interest me. "Thanks, but the whole point is that Jerry Paris is so good at his job," I said. "His episodes are head and shoulders

above the ones where we have guest directors. I feel the difference when it's someone else directing, and I wouldn't want to put the other actors through that." What I didn't say was that even Jerry had the occasional clunker—it happens in the unforgiving grind of series television—and what if my one episode totally sucked? Then Hollywood's view of me would be, *Why hire that loser? He can't even direct HIS OWN SHOW!*

"Will you at least think about it, Ron?" Tom said. "Talk to your agent. Talk to your folks. And let us know by tomorrow."

I got up and politely said goodbye to Tom and Ed. As I exited their offices, Garry surprised me. He had been hovering outside the whole time. He asked me what I thought of ABC's idea and their offer. I told him, bluntly. He paused for a moment and then said that if I didn't support the title change, he, as the creator of the program, would never allow it. End of story.

So the title of the show remained *Happy Days*. Richie Cunningham returned for the third season. The issue never came up again.

In a way, this incident served me well, in that I was reminded, as I had been after *The Andy Griffith Show,* that the entertainment industry had no investment in my well-being. It's a cold business, and no one in Hollywood felt sentimentally obligated to advance my career and keep me happy. I also came to grips with the idea that, even if *Happy Days* ran for years, I needed an exit plan. Sitcom stardom was a gilded cage for most actors, rarely a springboard to better things. In a couple of years, *Welcome Back, Kotter*'s John Travolta would defy this trend and become a major movie star, and Robin Williams, whose show *Mork & Mindy* began its life as a *Happy Days* spin-off, would follow suit a few years after that. But they were still outliers, exceptions to the rule.

When we started the third season, Garry approached me. "You know, Ron, I go to a shrink sometimes," he said. "I talked to him about what you're going through. He said something smart and I'm going to pass it along to you. It's what Nietzsche wrote: 'What does not kill me

makes me stronger.' You'll come out of this a stronger person." Garry, and Nietzsche, were absolutely right. I still regard Garry as the most remarkable leader and manager of talent that I have ever known. He was a natural teacher and a man of many adages, his favorite being, "Life is more important than show business." Time and again, he gave us all lessons in how to abide by that motto.

FOR A FEW weeks, my mind was clouded by revenge scenarios—how would I ever get back at ABC and Fred Silverman? But as my nerves settled, I decided upon a more constructive strategy: undeniable achievement. I started to take concrete steps to determine how I might make my first full-length feature film: who would finance it, who would give me the green light to make it. With some of my *Happy Days* money, I splurged on a yellow Volkswagen Pop-Top Camper, a version of the famous VW Bus whose retractable roof came with a tent attachment and a cot, creating a nice little loft space. This was going to be the vehicle that I would use when Cheryl and I took to the road to make independent films, sleeping "upstairs."

I went to the DMV to get a special vanity plate for the Bus. It had the word *film* on it, but with four *m*'s: FILMMMM.

ROGER THAT

RON

I said the word *filmmmm* with ostentatious relish when I spoke with friends, drawing out those *m*'s. I was simultaneously mocking the lofty *Cahiers du Cinéma* approach that aesthetes take to the cinematic arts and acknowledging that filmmaking had become a kind of religion for me. *Filmmmm* was my mantra. Come hell or high water, I was going to make movies.

But how? It was no easy goal to achieve, even for someone with a track record in the business and a hit TV show. Actors are often thought to be striving above their station when they display the ambition to be filmmakers. It's a long-running industry joke: the pretentious, delusional kid who says, "What I really want to do is direct."

From a distance or a quick scan of my IMDb page, it seems like it was a foregone conclusion that I would transition effortlessly from acting in sitcoms to directing major films for the big studios. In reality, it was an arduous grind that required hustle, determination, and luck. I carried a lot of worry with me in my *Happy Days* years. Did I stand a chance of

having a fulfilling adult career? Would I ever be taken seriously enough for someone to give me a chance?

Dad and I had written a screenplay together called *'Tis the Season*. I really wanted it to be my first feature as a director. The script was based on the experiences of a USC friend of mine. He was a troubled guy from Columbus, Ohio, who had a difficult family life back home and wanted to stay in L.A. for Christmas break. He somehow scratched together a few bucks and rented a fleapit apartment in the seediest, druggiest part of Hollywood, the same Western Avenue–area stretch where my friend Doug and I had edited *The Initiation*.

This inspired me to write a coming-of-age story about a young man who, while living amid Hollywood's dens of iniquity, falls for a prostitute. It was a very slice-of-life, Tom Waits–like exploration of that Skid Row milieu, with the characters humanized rather than flattened into two dimensions. Dad had the idea to give the prostitute a protective older brother who happened to be gay, which made the script both more nuanced and more provocative—you rarely saw gay characters in mainstream films in the mid-1970s.

I was convinced that *'Tis the Season* would be a great movie, if only I could make it. So I tapped my inner entrepreneur. A short time after our wedding, Cheryl and I flew down to Sydney for a *Happy Days* promotional trip. Strangely enough, Australia was the first country where the show took off in dominant fashion. In the U.S., we attracted the teen audience early on, but it really wasn't until the third and fourth seasons that *Happy Days* became the ratings juggernaut and cultural phenomenon that people remember it as. In Australia, we were an instant smash. Our benefactor in that country was Reg Grundy, a media baron who had made his fortune inventing and producing TV programs.

Grundy was a hardy and gregarious man with a white grandpa mustache: a shorter, Australian version of Ted Turner. He hosted Cheryl and me on his speedboat and seemed to take authentic interest when I

spoke of my directing ambitions. He loved *Happy Days* for the record-breaking ratings it received down under, but he was even more effusive in describing Australia's burgeoning homegrown film and television industry. I thought that perhaps I stood a chance of becoming a part of it.

So I pitched *'Tis the Season* to Grundy, with the idea that I would direct it. I planned to cast Charlie Martin Smith in the lead and hoped to cast Candy Clark or Teri Garr opposite him. Grundy liked what he heard. We reached a verbal agreement that if I could secure distribution for my film in the United States, he would kick in $150,000 for the world rights outside of the United States. Finding a U.S. backer-distributor would be a tall order, especially for a twenty-one-year-old novice director still best known for being Opie. But my talk with Reg was a promising start.

THE THIRD SEASON of *Happy Days* proved Fred Silverman right. The three-camera format, the studio audience, and the more pronounced emphasis on Fonzie made the show bigger than ever. Lowell Ganz and Mark Rothman wrote a sharp script for the season opener, "Fonzie Moves In," which set up the circumstances for the Fonz to become the Cunninghams' tenant, living in a little apartment above their garage. Now it was plausible for him to be in our house all the time, not just at Arnold's, our local hangout.

Happy Days did indeed knock out J.J. and *Good Times*. We beat them in our shared time slot that season, finishing eleventh in the ratings. They slid to number twenty-four. The following season, CBS moved *Good Times* to Wednesdays and *Happy Days* became the top-rated show on television. We entered our imperial phase, ranking in the top five for three seasons in a row.

In the mid-1970s, Henry was not merely a TV star but one of the biggest stars in the world, period. In 1976, his annus mirabilis, he, his

ducktail hairstyle, and his iconic black leather jacket were all over the newsstand. Henry's face was on the cover of *People,* the music magazine *Crawdaddy,* the kids' magazines *Dynamite* and *Bananas,* the teen magazine *Young Miss,* and even *Mad,* where the famous illustrator Jack Rickard drew him wearing a false nose, mustache, and glasses.

TV Guide paired Henry with me for one of its covers that year, both of us dressed in character as we flanked a hot rod. There was no doubt that the Fonz was good for all of us on *Happy Days.* It was like being on a baseball team with a slugging young superstar batting cleanup—why wouldn't you want your manager to play him every day? Especially if this slugger was a considerate, collaborative man who was impossible not to love. Marion, Tom, Anson, Donny, Erin Moran, me—none of us begrudged Henry for becoming so popular or the show's creatives for running with what worked. I was particularly impressed by Lowell Ganz, a tall, rail-thin guy who had a facility for writing fun, playful scenes for Henry and me. Lowell made me laugh off camera, too; he told me he came from an area of Queens that he pronounced "more Jewish than Tel Aviv." We became good friends, and, eventually, creative partners; Lowell cowrote four of my first seven features, *Night Shift, Splash, Gung Ho,* and *Parenthood.*

But sometimes, the changes to the show made me feel a little out of my depth. *The Andy Griffith Show* was built on heart and gentle, idiosyncratic humor. That was where my skills and taste lay. Apart from a few set pieces for Don Knotts or Howard Morris, we seldom went for hard laughs. The first two seasons of *Happy Days* were like that, too. The new format, by contrast, was *predicated* on getting hard laughs: framing up jokes, setting them up beat by beat, and building to an explosion. Playing to that live studio audience, going for the comedy throat.

Garry Marshall expanded the writing staff to include sharper, hipper minds from the '70s comedy scene, some of whom were working as stand-ups. Jerry Paris, our director, was absolutely in his element. He

had made his name directing *The Dick Van Dyke Show,* one of the first sitcoms to have a live studio audience. Jerry was a tall, manic man who always wore a bright red V-neck sweater on shooting days and kept a motormouth Don Rickles–style patter going at all times. When I expressed worry about nailing a comedy beat, he grabbed me by the face and said, "Look at this cute little punim! How can someone with a punim like this act so neurotic and Jewish? We should just bar mitzvah you and get it over with!"

Jerry was a master at comedic staging and energizing a scene, and he loved the dynamic between Henry and me. He said that I reminded him of Dick Van Dyke, a conventionally attractive goy who was expert at playing off funny Jewish guys like Carl Reiner and Morey Amsterdam. (Henry, Anson, and Donny are Jewish.) That comparison is monumentally unfair to Dick, a comic genius in his own right. But it shows how much the creative side of *Happy Days,* people like Jerry, Garry, and Lowell, appreciated me and what I had to offer.

OUR SET WAS loose and playful. On rehearsal days, we often broke out in tape-ball fights, which are the same thing as snowball fights, only with balls made of wadded-up gaffer tape. We liked to gang up on Jerry Paris, an avid gambler, as he placed bets on the set's pay phone, literally taping him to the phone stand as he barked to his bookie, "Put two hundred dollars on the Rams!"

This camaraderie carried over into our private lives. We consulted with each other on buying our first homes. We attended each other's weddings. We toasted the births of our respective firstborns. *Happy Days* was a happy place.

It was the network side that continually disappointed me. Just ahead of our Christmas break that third season, the cast was hanging around on Stage 19 at Paramount, comparing notes on the holiday gifts that we

had received from corporate. "Hey, Howard, I got a wallet," said Anson. "How about you?"

I opened my gift. I, too, had received a wallet. Tom Bosley and Marion Ross opened their gifts: wallets! Pretty soon we realized that we had all received the same wallet. It was a quality wallet: fine-grain leather, nice and smooth. No complaints.

Then Henry spoke up. He had not been given a wallet. With some sheepishness, he disclosed to us what he had been given: a VCR.

In 1975, a VCR was a new toy, hard to get and very expensive, worth about five grand in today's dollars. Henry's state-of-the-art U-matic three-quarter-inch videocassette recorder cost exponentially more than our wallets. The disparity was outrageous. None of us was in desperate need of a VCR—or a new wallet, for that matter—but the thoughtlessness with which management singled out one person and rendered the rest of us second class was galling. We were all displeased. Henry was a little embarrassed.

That's when I became Shop Steward Howard, designated by the cast to be the point man in making our feelings known. No one wanted Henry to forfeit his VCR, but we wanted to hold management accountable. Using the pay phone on the set, I called ABC corporate, demanding to speak to whoever was in charge of talent relations. A young executive named Bob Boyett came to the phone. I gave him the third degree.

"This is about our Christmas gifts, Bob," I said. "I feel a little uncomfortable even complaining about them, but it's about fairness. Here's the thing: all of us are happy for Henry's success. It's fantastic for the show. We all love him. But on the stage, we are an *ensemble*. That's what Garry preaches. And that gets undermined when you give Henry a VCR and the rest of us a wallet. So I'd like ABC to think about what they've done. And by the way: I'm sending my wallet back."

"You don't have to do that," said Bob, in measured, friendly tones. "I didn't know that your Christmas gifts mattered so much."

"Yeah, well they shouldn't but they do!" I said, now with a full head of steam. "So with all due respect, I am returning mine."

Poor Bob was not culpable in all this; he was a sweetheart who went on to become a successful TV producer in the 1980s, creating such shows as *Bosom Buddies* and *Full House* in partnership with Tom Miller. He just happened to be the person stuck with taking my call and absorbing my tirade. The network higher-ups, though, were another story, and this would not be the last time that they brought me low.

I really did mail my wallet back. I'm pretty sure I was the only member of the cast to do so. Henry still has his VCR.

I OBLIGINGLY DID tons of interviews for *Happy Days,* but I couldn't get through a single one of them without a reporter asking me some version of the question, "So how does it feel that Fonzie has taken over your show?"

As much as I tried not to let this get to me, sometimes it did. The eczema on my eyelids flared up. Some mornings I awoke in a funk. Driving in my camper van to Paramount, I'd sometimes feel my throat tightening with anxiety and fantasize about playing hooky. I noted the freeway signs indicating San Diego to the south. *Hmmm, Tijuana is just over the border. What if I just keep going and I don't stop until I get there?* I wasn't tempted by debauchery so much as disappearance.

Garry Marshall was astute in recognizing that he needed to take action to keep us all feeling like an ensemble. His masterstroke was to establish a *Happy Days* softball team. We started out casually, playing Sunday games in the Valley against the talent agencies and the casts and crews of other TV shows. Even some of the movies that were filming on the Paramount lot got involved. One of our early opponents was the *Marathon Man* team, whose lineup included Dustin Hoffman and William Devane—though not, unfortunately, Sir Laurence Olivier.

Gradually, our softball exploits commanded bigger and bigger stages. We did promotional tours of Major League Baseball stadiums, including Wrigley Field, Shea Stadium, Dodger Stadium, Candlestick Park, and Milwaukee County Stadium. Our opponents were usually teams of local celebrities and former pro athletes. Making us travel as a team was such a brilliant idea on Garry's part, because we developed real camaraderie on the road and bonded over something that had nothing to do with the show.

Donny was speedy and a good athlete, so he became our center fielder. I played in left. Anson could play any infield spot. Second base was a rotating position—sometimes Tom Bosley, other times Erin Moran or Marion Ross. Garry, Jerry, and a few of the writers played. Even big Al Molinaro got his uniform dirty.

Henry had not grown up playing team sports, though he was a good water-skier—as *Happy Days* fans would come to know in a soon-to-be-infamous episode. But we couldn't play softball without him. That's where our secret weapon came in: my brother Clint.

CLINT

Ron gave Henry the first baseball glove he had ever owned. Henry had obviously never played the sport, but he was a gamer who didn't want to let his mates down. I was in my heyday as a ballplayer, pitching for the Burroughs High School team, so I did my level best to turn Henry into the *Happy Days* team's starting pitcher.

Stage 19 at Paramount, where *Happy Days* was shot, had a large, long open stretch of space between the audience bleachers and the sets. It was where the cameras operated on shooting days. But on nonshooting days, this space made for an ideal bullpen. So that's where I held my lessons with Henry, directly in front of the interiors for Arnold's and

the Cunningham family's living room. The roster that Garry assembled from the crew had several ringers, and we all worked to mold the Fonz into a capable hurler.

Henry was an eager, humble student who happily gave himself over to coaching. What I taught him was actually a modified fast-pitch throwing motion, with no high arc or windmilling. I recognized that his natural arm action made the ball move, and, just like Greg Maddux, he could really hit his spots. His best pitch floated up and inside, tying righties up in knots. Garry Marshall was so pleased with the work I'd done with Henry that he invited me to join the *Happy Days* team as its catcher.

When we played in front of stadium crowds, the throng wanted to see the Fonz make hitters look foolish. I knew how to oblige. I set up inside and got the majority of overstriding hitters to meekly pop up. Calling for an outside pitch was risky, both in the game and for the show—with the ball over the plate, someone might hammer it up the middle and smack Henry square in the chompers. The poor guy was a great actor but he couldn't field a lick.

Henry was open about his limitations. If there was a comebacker, he'd turn his body sideways to absorb the blow, trading a potential bloody lip for a body bruise. If there was an infield pop-up, he scurried off the mound and left the putout to the *Happy Days* staff writer Fred Fox or the dialogue coach Walter von Huene, who were two of our better defensive infielders.

In the beginning, we played the Hollywood equivalent of intramural ball, squaring off on Sundays against other teams assembled from L.A. show-business folk. I was in awe when we went up against a squad that included a beer-drinking left fielder named Alice Cooper. He couldn't hit Henry, either.

· · ·

THE SOFTBALL LEAGUE satisfied my yen for competition and success at a time when acting didn't. And traveling first-class to play in Major League stadiums wasn't so bad. I'll never forget seeing my name up on the scoreboard at Veterans Stadium in Philadelphia in front of fifty thousand fans as I stepped to the plate: an unbelievable feeling. The whole experience gave me a sense of purpose I might have otherwise lacked. I was never going to be good enough to become a professional ballplayer, but coaching and playing like this scratched an itch.

Still, I loved acting. I was proud to have made it as far as I had. Most of the kids with whom I'd come up, going on casting calls for westerns and cop shows in the '60s, had already fallen away and returned to civilian life.

Maybe it was now my turn to fall away. I didn't know. But I wasn't going to let that happen without a fight. I was haunted by the same question as Ron: Did I stand a chance of having a fulfilling adult career in show business?

As scarce as good parts had become for me, I never stopped going out on auditions. But the process sometimes worked my nerves. In 1975, I joined every other young guy in town in reading for an ambitious new "space opera" called *Star Wars,* the brainchild of Ron's *American Graffiti* director, George Lucas. In those days, before casting directors could simply watch an actor on videotape or digitally, they called in pretty much every dude in the teens-to-twenties age range to test for the part of Luke Skywalker. I already knew that I didn't stand a chance—Luke was written as this dashing young hero, and at age sixteen, I was already starting to lose my hair. But shit, I was a working actor. You don't *not* go to an audition when you're called.

Star Wars casting was held on the Fox lot in Century City. I showed up and milled around outdoors with a couple dozen other young guys who were waiting to be called in. One of them, standing right behind me, was a dude named Mark Hamill. Then I heard my name. Go time.

Auditions get my juices flowing. They're a form of competition and I approach them confidently, determined to be the last man standing. But *Star Wars* was different—not because of its genre or sweep but its timing. Luke Skywalker was a romantic male lead, most definitely an adult role, of a kind I had never played in my short life. My palms were sweaty when I entered the audition room, an office. My nervousness skyrocketed when I saw that George Lucas wasn't the only person for whom I would be auditioning. Francis Ford Coppola, who I held in the highest esteem, sat there, smiling at me. He was helping George cast *Star Wars*. As was Geno Havens, assisting George as he had during the casting of *American Graffiti*. But no sign of George. Weird.

Francis and Geno flanked an imposing mahogany desk. Behind it was a big leather swivel chair, its back to me, obscuring its occupant. Abruptly, the chair swung around and there was George. He took a beat to give me the once-over. Then he said with a flourish, "Commander Balok! 'The Corbomite Maneuver!'"

It totally threw me. Here I was, a young actor trying to get an adult part, and there he was, making a reference to something I did as a seven-year-old! America was only in the earliest days of the *Star Trek* revival, when reruns of the show were not yet widely in syndication and Trekkies were only beginning to be a thing. So I should have been flattered that George was familiar with what was then just another job on my résumé. But because I was in a slump and entering my Angry Young Man phase, what I thought in my head was, *Get a fucking life, George.*

I stumbled through the audition. I knew in the moment I didn't stand a chance, reading the way I read and looking the way I did. I did not receive a callback.

Still, I learned something. George's friendly overture represented the beginning of a phenomenon that follows me to this day: being admired for work I did as a kid. But I just wasn't ready at sixteen to appreciate that. It seemed less like recognition and more like belittlement. It had

the same ring as "Hey, where's your bear?" I guess I had some growing up to do.

RON

I wasn't exactly landing choice movie roles, either. One day during the third season of *Happy Days,* I was sitting in the Paramount commissary, reading a script over lunch. My agent had sent it to me. I thought it was terrible: a broad, zany car-chase comedy with weak jokes and cardboard characters. Its title, which will tell you everything about my reflexive revulsion, was *Eat My Dust!* It was depressing: *this* was the level of the film projects that were coming my way.

But *Eat My Dust!* had one thing to recommend it: it was a Roger Corman production. Corman was known as the King of the Bs, a prolific director and producer of cheaply made movies that went straight to drive-ins and regional theaters via his distribution company, New World Pictures. He had famously shot the original, 1960 version of *The Little Shop of Horrors* in only two days, helping to launch the career of one of its stars, Jack Nicholson. He had adapted several of Edgar Allan Poe's stories into campy horror films, one of which, *The Pit and the Pendulum,* was a childhood obsession of mine thanks to its repeated airings on *Million Dollar Movie.*

Roger had a reputation in Hollywood. Well, several reputations. He was a shrewd, fiercely intelligent businessman who had come up with an efficient, assembly-line approach to production that turned a tidy profit. He was also an emotionally mercurial man who was charming when in a good mood and best avoided when grumpy. And he was notorious for his wildly eclectic taste, pumping out exploitation flicks but also serving as the U.S. distributor for such European arthouse directors as Federico Fellini, Ingmar Bergman, and François Truffaut.

Most pertinent to my interests, Roger had an awesome track record for nurturing young filmmakers. Among those who had served apprenticeships under him were Francis Ford Coppola, Martin Scorsese, Peter Bogdanovich, and Jonathan Demme. I yearned for a shot to join their ranks. Plus, Roger's distribution company could potentially secure my agreement with Reg Grundy for *'Tis the Season,* which was contingent on my lining up a distributor in the States.

So, rather than toss the script for *Eat My Dust!* in the garbage, I called my agent, Bill Schuller, and told him that I wanted to meet with Mr. Corman. This pleased Bill, because the offer was a firm one, for good money: $75,000 for a four-week shoot, Corman's top rate. He generally used no-name actors, so, by his standards, I was a good get.

On the day of the appointment, as I stood outside the building on the Sunset Strip where Corman kept his office, I was surprised to see Bill show up. He had been my agent since my childhood, a dashing man with a pencil mustache who now appeared small and diminished. "I'm coming in with you," he said.

"No, Bill—I really want to do this alone," I said. His face fell. I can't blame him. Imagine having some twenty-one-year-old client basically tell you on the sidewalk, "Get the hell out of here, go home!" I knew the play I was going to make, and I feared that Bill would have been freaked out by my plans to go off-script and negotiate with Corman. Had he been present, he might have interrupted me and undercut my strategy.

Roger was a tall man of surprisingly patrician bearing. We shook hands and I very quickly got down to business. "I'm well aware of what you've done for young filmmakers and also of the films you have made. I loved *The Pit and the Pendulum,*" I said, going on to heap praise on more of his movies: *Boxcar Bertha* with Scorsese, *Targets* with Bogdanovich, *Dementia 13* with Coppola.

Then, in the most grown-up voice I could muster, I said, "As for *Eat My Dust!,* I didn't care for it very much. It's not the kind of work that I'm

looking to do as an actor. But I have a script. It's called *'Tis the Season,* and I believe I have half the money for it out of Australia. If you'll read my script, put up the other half, and distribute my film, I'll do *Eat My Dust!*"

Roger arched his eyebrows. "You're a filmmaker?" he said.

"Uh, I've just made some short films and I used to go to film school at USC," I said. "But I'm also on *Happy Days,* and—"

He cut me off. "I'll read the script," he said. "And send over any film work of your own that you can show me."

We shook hands again, and as I was leaving, Roger said, "You know, I like to think that I turn out directors for Hollywood the way USC turns out running backs for the NFL."

"I'd very much like to be one of those running backs," I said.

A FEW DAYS later, Roger called me. "You and your father have written a very good script," he said. "But it's a character piece. An arthouse film. That's not the kind of film that I make. But look, I watched your shorts and I can see that you can direct. So I have a counterproposal for you."

On paper, what Roger suggested looked like one of those comically lopsided trades in baseball, with him the savvy GM and me the sucker. There were a ridiculous number of hoops for me to jump through. If and only if I agreed to be in *Eat My Dust!,* Roger would pay me a whopping $2,500 to write an outline for a new film. I could write it by myself, with Dad, however I wanted—I just couldn't resubmit *'Tis the Season* or anything like it. Then, if Roger liked the outline, I could turn it into a screenplay for $12,500. Then, if Roger liked the screenplay, I could direct the movie—but only if I also starred in it.

And here was the kicker: failing all that, if he didn't green-light a feature for me to make, the consolation prize was that he would assign me

to direct the second unit on one of the many low-budget action flicks he churned out each year.

This was hardly a situation where some beneficent financier was saying, "Yes! I shall back your movie and it shall premiere at next year's Cannes Film Festival!" But it was as close as I was going to get to a real chance.

RANCE TO THE RESCUE

RON

Eat My Dust! turned out well for a film called *Eat My Dust!* It was a quick, zany car-chase flick written and directed by Chuck Griffith, who had also done the screenplay for Roger's *The Little Shop of Horrors*. I played the renegade son of a sheriff who steals a race-car driver's jacked-up '68 Ford Fairlane. My love interest was played by Christopher Norris, a blond beauty who had been one of the stars of *Summer of '42*. She was outfitted for the occasion in an exploitation-flick-ready ensemble of white micro-shorts and go-go boots. I wore a blue windbreaker and a Union Army–style kepi cap.

In what was now a familiar pattern, Clint and Dad participated, too: Clint as one of my goober buddies hanging out in the back seat of my stolen wheels, Dad as one of the sheriff's incompetent goober deputies. Chuck cast them of his own volition—I never pushed him. There were also a bunch of great character guys in the movie: Dave Madden, better known as Reuben Kincaid on *The Partridge Family*; the wiry Warren Kemmerling, so good in *Close Encounters of the Third Kind* and

countless westerns; and Peter Isacksen, a gawky comic actor who played Seaman Pruitt in Don Rickles's navy sitcom *CPO Sharkey*.

Making the movie damn near killed me, not because it was unpleasant to do but because, miracle of miracles, a prestige acting role came my way right after I reached my agreement with Roger. I was cast as John Wayne's young protégé in *The Shootist,* his final film, directed by Don Siegel. So, for a short period, I shot *Eat My Dust!, The Shootist,* and *Happy Days* at the same time. The production side of *Happy Days* was, as ever, gracious—they kindly accommodated me so that I only had to show up to Paramount two days a week, rehearsing on Thursdays and filming on Fridays. Corman crammed my *Eat My Dust!* workload into just eleven days of the four-week shoot, which took place near Lake Piru, an hour northwest of L.A. For the rest of my time, I was in Carson City, Nevada, where *The Shootist* was filming on location.

I don't know how I shouldered this workload except that I was twenty-one and had the physical stamina not to collapse in exhaustion—barely. *The Shootist* was a trip, because it starred not only Wayne but also Jimmy Stewart and Lauren Bacall. The Duke was dying of cancer and the old gang was rallying around him for one last adventure.

That's what he preferred to be called, Duke. When I first arrived in Carson City, Don Siegel met me downstairs in the hotel where we were all staying and suggested that we go straight up to Wayne's suite to meet the great man. On the way to the elevator, we passed the gift shop, and there was the latest *TV Guide* magazine with Henry and me on the cover. Siegel laughed and bought a copy. "Duke will love this," he said. I wasn't so sure.

When we knocked on the door, we were greeted by an instantly familiar figure: tall, imposing, rugged, and . . . bald? "I hope you don't mind, I didn't bother to put on my wig," said the sixty-nine-year-old Wayne. He reached out to shake my hand, which disappeared into his

like a ten-year-old's. Siegel held up the issue of *TV Guide* for Wayne to examine. He looked down at it, looked up at me, looked down at it once more, and then said in a pointedly drawn-out John Wayne drawl, "Ah! Big shot, huh?"

Thanks a lot, Don, I thought.

But Duke and I got along well from that moment onward. He admired my professionalism. Sometimes, I noticed, he struggled with his lines. While Ms. Bacall kept to herself and most of the other people on the set were too much in awe to comfortably engage with Wayne, I asked him if he wanted to run his lines with me; that's what I always did between takes. To my delight, he welcomed the suggestion. I went to school on this opportunity—me, rehearsing one-on-one with the most iconic western star of them all!

Working on *The Shootist* was an eye-opener for me because, as legendary and decorated as Wayne, Bacall, and Stewart were, they worked harder than anyone else on set, putting in the hours and doing as many takes as necessary to nail a scene. I had observed this same trait in Henry Fonda, even on a project as half-hearted as *The Smith Family*. I would see it again when, in the years to come, I would direct Bette Davis and Don Ameche. It wasn't the studio system or their distinctive looks that had made these actors the giants of Hollywood's golden age. It was— surprise, surprise!—their common work ethic and commitment to quality. They simply outhustled everyone else.

Still, *The Shootist* afforded us a fair amount of hang time. I pumped Duke for John Ford stories, and he happily obliged. "Jack Ford always taught me to keep things moving," he said, "and to only give the audience a maximum of 80 percent of your emotion, even for the most dramatic scenes. It's more powerful for the audience to complete the feeling themselves." Another Ford-ism he imparted: "If you give 'em all you can on a picture and the audience doesn't go for it, then hell—give 'em their nickel back and git on to the next one!"

Duke and I also played lots of chess during our breaks. I am a decent player, but he had a bullish attack style that you would have expected of him. I never once beat him.

I WAS WRONG to have been so haughty about deigning to star in *Eat My Dust!* I learned a lot from observing Chuck Griffith's fast, nimble, low-budget approach to filmmaking, and I just liked the indie vibe around the Corman machine. The movie performed surprisingly well at the box office, on its modest New World Pictures terms. Who'd a thunk it? So Roger was now especially inclined to let me make a movie. I was in the game! Not since *American Graffiti* had I felt so fulfilled by my work. My eczema started to clear up.

I bounded into Roger's office for a pitch meeting, excited to enter the directing phase of my life. We were joined by Frances Doel, the beloved head of the script department at New World Pictures. She was a slim Englishwoman who, like Roger, struck me as surprisingly elegant for a gatekeeper of grindhouse. As Frances took notes, I sketched out a few different ideas I'd developed. One was a suitably gritty and provocative noir picture about a detective who cracks a case in the world of snuff films, movies that depict actual murders. I also pitched a dystopian sci-fi movie in which warring countries, rather than sending in troops to battle, resolved their disputes by having teams of futuristic gladiators fight.

Roger patiently listened to these pitches and a couple of others and then politely told me that I had struck out. "It's wonderful to hear actors pitch," he said. "It's so much more entertaining. Ron, you tell these stories very well, but I'm not interested in any of them. They're just not the type of film I make."

I was preparing to skulk out of his office in defeat when Roger threw me a lifeline. He told me that New World Pictures had a process for testing titles to see if they held appeal to filmgoing audiences. The

methodology was hardly scientific. He sent out interns to canvass people waiting in line at movie theaters, with mock-up posters for films that did not yet exist.

"Ron, when we were testing *Eat My Dust!* as a title, there was another title that came in a close second," Roger said. "It was *Grand Theft Auto*. Think about that. If you could come up with a car-crash comedy called *Grand Theft Auto,* sort of like *Eat My Dust!* but different from *Eat My Dust!,* I'd probably make that picture. Provided that you also star in it."

This was well before video-game consoles were commonplace, so *grand theft auto* was best known as a term used by lawyers and policemen. I had to admit, it did have an appealing ring. I left Roger's office on Sunset grateful for the opportunity but also drawing a total blank. *Grand Theft Auto:* the movie. What the hell could it be? I knew that Roger liked to move fast, and therefore I needed to think fast.

I wasn't getting very far by myself, so I sought out the help of my most recent screenwriting collaborator: Dad.

UP IN DAD'S office in the guesthouse in Toluca Lake, we spitballed. I paced around the room while Dad took notes on a pad. Then it occurred to him to pull out from a drawer an outline he had already written.

Dad was on friendly terms with Burt Reynolds and had been trying to hatch a project with him. Burt was red-hot in the mid-'70s, but Dad had known him prefame. Burt had done a guest spot on *Gentle Ben* in 1967, and a decade before that, he and Dad had first crossed paths when both were in a stage revival of *Mister Roberts*. Dad was keen to do a car-chase picture with Burt. Car-chase movies were at the apex of their popularity in the 1970s; *Eat My Dust!* was Roger's way of cashing in on a trend popularized by such films as *Vanishing Point, Gone in 60 Seconds,*

and *Dirty Mary, Crazy Larry*. Tough guys, hot babes, and muscle cars: the can't-miss formula of the Nixon-Ford years.

Burt had already been in a smash-'em-up called *White Lightning* and was the logical choice to star in another. And he did—but not Dad's. Instead, he committed to *Smokey and the Bandit,* a movie developed by the stuntman Hal Needham. Dad's misfortune suddenly became my good fortune.

"I think we could adapt this, make it younger and funnier," Dad said, showing me the outline. It wasn't a youth-oriented plot, but I liked that it involved a car chase that stretched from L.A. all the way to Las Vegas. Dad and I started pooling our thoughts and film references. I came with the idea of taking inspiration from *Bonnie and Clyde* and *The Graduate:* antiestablishment young people on the run, defying the wishes of the older generation. The lead female character, whom we named Paula Powers, defies her wealthy parents' wishes to stay away from my working-class character, Sam Freeman, by stealing her parents' Rolls-Royce so that she and Sam can gun it to Vegas and elope.

From Dad came the idea to incorporate some of the broad, over-the-top humor of *It's a Mad, Mad, Mad, Mad World,* the very same movie I took Cheryl to on our first date. Paula's father and his minions take off in pursuit of the runaway lovers via helicopter. An even crazier chase is set into motion when the young man Paula's parents want her to marry, a rich twit named Collins Hedgeworth (Dad loved coming up with kooky names), announces on a radio program that he is offering a $25,000 reward to whoever catches Paula and Sam. This triggers all manner of idiotic bounty hunters to hit the road in pursuit of the lovers and the cash prize. Given the conventions of the genre, I don't think it's much of a spoiler to say that Sam and Paula ultimately elude their captors and get married.

Dad and I pounded out a draft of this story and turned in a script to Roger with the title *Grand Theft Auto*. Frances Doel came back to us

with a few notes. We made adjustments accordingly. A day after receiving our revision, Roger called me.

"Ron, Roger here!" he said, his voice full of cheer. "We like your second draft of the script and we've budgeted to produce the film for $602,000, which is a lot of money for New World Pictures. We've already designed the poster. Your first shooting day will be March the second. Congratulations. You're going to direct your first film!"

All I could muster in my relief and shock was a wobbly "Thanks." It was the fastest green light I have ever received in my filmmaking career, up to and including the present day.

In the moment, I was too euphoric and future-focused to see the parallels. My career as an actor began with a providential nudge from Rance Howard. "By the way, I have a son who is a fine actor," he told the receptionist at MGM. Had Dad not come through twenty years later—basically saying, *By the way, I have an idea for a fine screenplay*—I'm not sure I would have been given this first opportunity to direct.

THE *HAPPY DAYS* gang was ecstatic at hearing my news. Henry, Anson, and Donny told me they were proud of me. Marion Ross agreed to take a part in the movie, working for scale and playing against type as the pushy, entitled mother of Collins Hedgeworth. Garry Marshall requested a cameo, so I gladly gave him a small role as a gangster. Jim Ritz, one of the show's writers and a friend of mine, signed on to play a bumbling cop and has since appeared in a dozen more of my movies.

They were all well-versed in my ambition to direct because . . . well, because I never shut up about it. I'm sure my nonstop babbling annoyed the folks on Stage 19 sometimes. But none of them ever cast aspersions on my dream. Their spirit was best summarized by Garry, who more or less bestowed a benediction upon me as I was about to

undertake the project. "Go get 'em, Ron," he said, a hand on my shoulder. "Go get 'em."

I really appreciated this support because I felt that ABC was continuing to heap indignities upon me. At the start of the fourth season, Henry signed a new contract. He had them over a barrel because his original contract, unlike mine, was for only three years. When he signed it, Fonzie was just a supporting character. If *Happy Days* hadn't made it as a series, Henry would have happily returned to New York and acting in the theater. Now he was the hottest star on television. The network gave him a huge raise, to somewhere in the neighborhood of $20,000 a week. Meanwhile, I was still under contract for another four years and had been offered only incremental raises. I was making $5,000 a week and still putting in the same amount of work as my friend.

Season Four of *Happy Days* began in 1976 with a three-part episode entitled "Fonzie Loves Pinky," in which the Fonz competes in a demolition derby against two hoods known as the Malachi Brothers and rekindles a romance with an old flame named Pinky Tuscadero. Instead of following our usual routine and starting out the season at Paramount, we reported first to a movie ranch in Malibu Creek State Park to shoot the derby scenes. Henry called me and asked if he could hitch a ride out to Malibu. He wanted to have a talk.

As we rolled west in my Bug, I could sense that he was uneasy, avoiding eye contact and restlessly bouncing his knee. "Ron, I gotta ask you a question," Henry said. "How do you feel? Because look, I know what's happening. The Fonz is taking off and the show was designed for you to be the star. And they just gave me a big raise."

He told me about the terms he had reached with ABC. "I don't know what's going on with your contract, but I want you to know how much I respect you," he said. "You've handled this all incredibly well."

I made plain to Henry that whatever beefs I had were not with him.

"You're not doing anything wrong, Henry," I said. "You're not letting this go to your head or change who you are. You're a great team player. What you've created is incredible and great for the show. But I have to admit that the whole situation bothers me in some ways."

We talked about the *Fonzie's Happy Days* fiasco. Henry revealed that the idea had come from the very top. He had been approached about it by Leonard Goldenson, the president and founder of ABC. Henry had pushed back against the title change. Goldenson then suggested that maybe Fonzie should have his own show. Henry pushed back against that, too—"I'm successful because I'm in the middle of *this* show," he said.

I had not been waiting for Henry to come to me and clear the air. We were friends; whatever anger I had in me was never directed at him. But it was so gracious and thoughtful of him to make this conversation happen.

"I don't want anything to change about our friendship," Henry said. "I love you, Ron."

"I love *you,* Henry," I said.

We still do. He is the godfather to all four of my children.

CLINT

The 1976–77 school year was my last at John Burroughs, and I treated it like a victory lap. I had piled up a bunch of summer-school credits so my workload was minimal. In the fall, I wrote for the *Smoke Signal* and convinced the athletic department to let my friend Gig and me take over the public-address duties for the home football games, a task we carried out with relish and a little ham. During the spring semester, I was left with only two real classes, leaving me plenty of time to enjoy my final season on the varsity baseball team.

All that, and my scholarship to Pepperdine was locked in! So I was really in cruise control. Dad and Ron knew that I was willing to work cheap, so they wrote me a funny role in *Grand Theft Auto*.

I turned eighteen a couple of months before I graduated from high school. As he had with Ron, Dad honored this birthday as another kind of graduation, to adulthood and financial independence. The money that had been stashed away for me by Mom and Dad (and the Jackie Coogan Law) wasn't as big as Ron's, but it was still a significant chunk of change.

I had already splurged at age sixteen and a half on my first car, a copper-colored 1975 AMC Pacer. My friends razzed me about buying a soap bubble on wheels, but hey, I thought that all that glass looked space-age cool. I was an idiot. Without air-conditioning, in the Southern California sun, the car's interior became hot as blue blazes. The four-cylinder engine was too small for my tastes, lacking the giddyap teenage drivers require. The only saving grace? The hand-operated emergency brake located to the right of the driver's seat. I learned from the stunt drivers on *Eat My Dust!* how to use it as a tool for screech-'n'-slide halts, a skill I showed off while making donuts in the student parking lot at Burroughs. I drove my Pacer into the ground in less than a year. I traded it in for a Pontiac Firebird. The dealer spotted me $500 for the old car, or one-sixth of what I had spent on it in the first place.

This gives you an idea of my maturity level at that time. Life was a baked joyride. I experienced just one minor hiccup: Pepperdine revoked my scholarship when they realized they had made a mistake—it was supposed to be a needs-based tuition award, and I clearly had the means to pay my own way. I was a little pissed off, as I had done nothing to mislead the school, but the matter was easily resolved. The university still guaranteed me a place in its Class of 1981, as long as I whipped out my checkbook and paid them a few hundred bucks per semester.

I also got to hang with Ron at Dodger Stadium. One nice thing that

he did with his *Happy Days* money was get season tickets. I bought in with him, so we spent a lot of quality time at the ballpark, enjoying the Steve Garvey–Davey Lopes–Ron Cey lineup. The nights that he was tied up with work or busy with Cheryl, Ron would flip me his ticket and I'd take a beer-drinking buddy with me.

About this time, I discovered cocaine. My weed connection came up to me one day during my senior year at Burroughs and said, "Hey, you wanna try some blow?" Count me in!

At first, I experienced only the upside of the drug. The reason that people get hooked on coke is the quick joy it brings. The first couple of lines opened up a magical window of creativity for me. I was a writer, and suddenly I had a ton of ideas, every one of them the most brilliant ever! I put pen to paper to capture them all: storylines for scripts, novels, articles. Whereas before I'd had difficulty getting started on any given project, my chemically enhanced brain was unencumbered by inhibition.

The catch is that this window of euphoria inevitably slams shut. And when it does, it slams hard, with your head caught between the sash and the sill. You go from unstoppable force to self-doubting loser. And the only way to alleviate this comedown is to do another couple of lines.

Let's see, pot, booze, coke—not the ideal path for Clint College. It was a very slippery slope, and I was throwing down the Crisco. But the wheels didn't fall off right away. I had a few years of using without serious consequences, probably due to a combination of a youthful constitution and an equally youthful naïveté.

Still, my drug use did not escape the notice of my favorite teachers and coaches. While my grades held up and I never missed a deadline for the school paper, I smelled like bongwater and was a poster boy for Visine. Merle Stone, a social studies teacher and my old JV-football coach, flagged me one day as I was leaving class and asked me, gently but point-blank, "Why do you show up stoned all the time, Clint?"

I told Coach I didn't know what he was talking about. Graduation was around the corner and my ticket was punched to Pepperdine, so I feared no repercussions, and Mr. Stone never pressed the matter.

A year after I graduated, Ron paid a visit to Burroughs High for an event. To his surprise, Mrs. Trempe, my wise and beloved journalism teacher, cornered him and asked for a word in private. She expressed her concern about the direction in which my life was headed.

Ron has told me that he blames himself for not being more aware of the extent of my drug and alcohol intake, and for not doing more to save me from my own twisted judgment. I appreciate the sentiment, but it's ridiculous. He has nothing to be sorry for. He was giving me jobs when no one else was, for God's sake! I was the one who chose to become a toxic Peter Pan, unwilling to grow up.

Maybe things had come too easily for me. Even when the regular acting work stopped, I still had my childhood-acting money and my Pepperdine opportunity. While my friends were all grinding senior year and fretting about college admissions and next steps, I was kicking back and blazing up.

I was on good behavior for *Grand Theft Auto,* though. That movie was a blessing to me in more ways than one. I was in hot water with my baseball coach over an article I wrote for the *Smoke Signal* that critiqued the team's performance. We had been a great team my junior year, a playoff team. But then our best players graduated, and in my senior year, we sucked. Halfway through the season, I said so, in writing. I didn't have a byline on the article because my name was listed on the masthead as the paper's sports editor. Our coach called a team meeting and angrily declared that the article was yellow journalism because it had no credited author and certain information had clearly been leaked, such as the fact that our defense was averaging an error an inning. (This hardly constituted a leak; anyone who kept a scorecard could have figured out that stat.)

The coach's tirade was no big deal. But then he glared at me and said that whoever was responsible for the article should quit the team. Well, sorry, Coach, must run, I have a film to be in!

Ron involved the whole family in *Grand Theft Auto,* and we all wanted to deliver for him. On top of cowriting the script, Dad was an associate producer and had a role in the film as Ned Slinker, an overly confident private detective hired by the runaway girl's father. Mom helped round up extras for crowd scenes. Cheryl was a production assistant.

Dad and Ron tailored a role for me as one of the yahoos trying to chase down the young lovers. Ron cast me along with Pete Isacksen from *Eat My Dust!* as a pair of dumbass grease monkeys named Ace and Sparky. We "borrow" the classic Bugatti open-wheel race car that we're working on and join the crazy pursuit. Pete stood more than a head taller than me, so we were funny on sight. We weren't a bad comedy team, either.

Did I sometimes catch a buzz during production? You betcha. I brought a small canister of weed with me on location in Victorville, California. But I made sure to keep the nose candy back in Burbank.

RON

It's true that I carry around some residual guilt about how oblivious I was to Clint's addictions. Or maybe I mean that I didn't take the warning signs seriously enough. When Mrs. Trempe spoke to me about Clint, I heard her out and appreciated how much she cared about him. But I also kind of dismissed her worry as a generational overreaction by an older person who didn't get how commonplace pot had become. Like I said, my college roommate grew it and my *American Graffiti* castmates smoked it.

I had no idea at that point that Clint had started to use cocaine. Even if I had, I don't know that I would have taken drastic action to stop him. In the 1970s, cocaine was still considered a party drug. I remember a somewhat frothy *New York Times Magazine* trend piece whose headline was COCAINE: THE CHAMPAGNE OF DRUGS. There was a prevailing notion that coke was naughty but not *that* naughty or even particularly dangerous.

Cocaine was all over show business in the *Happy Days* era. I never saw anyone take it, at least not knowingly, though I did notice that some people had grown out their pinky fingernails for scooping and snorting. And in various bathrooms at parties, I saw the remnants of rails on the counters and spent vials on the floor. People were careful around me, though—I always got treated like Father Ron with the collar, the person you wouldn't dare take a toot in front of.

I never once tried cocaine. I had a vivid dream about trying it, though. This was right at the peak of its late-'70s popularity. It was like the Al Pacino version of *Scarface* before that movie existed: I was at a party, surrounded by girls in gold-lamé miniskirts and guys with shirts open to their navels, and there were mounds of cocaine being passed around on trays. People kept offering me some and I kept saying "No thanks." But my fellow partygoers were so persistent that I finally said, "Okay, all right, screw it." I dipped my nose into one of those mounds and took a good snort. I actually, in the dream, felt a euphoric rush. Someone next to me was waiting to hear my reaction, saying, "Well?" And what I said was "Yeah, I know that feeling. That's the feeling I get every time I roll the camera and say 'Action!'"

I guess you just heard my film-nerd TED talk. At any rate, you can imagine how excited I must have been in real life when, on March 2, 1977, the day after my twenty-third birthday, I shouted "Action!" for the first scene of *Grand Theft Auto*.

FILMING, FLYING, CRASHING, BURNING

Ron, here's the way it works at New World Pictures," Roger Corman said to me a few days before we began shooting. "I'm going to come to the set the first day and maybe the second day. If things are going well, you won't see very much of me after that. But if things are not going well, you're going to see one hell of a lot of me."

As ominous as this declaration sounded, Roger had taken care to surround me with his finest Cormanites. My second-unit director was Allan Arkush, a still-young but already seasoned guy who, with his friend Joe Dante, had directed a $60,000 kitsch-comedy classic for Roger called *Hollywood Boulevard* that repurposed footage from other New World movies. Dante was tapped to serve as *Grand Theft Auto*'s editor. Joe, you probably know, went on to direct the *Gremlins* franchise, while Allan's next step was to make the Ramones movie *Rock 'n' Roll High School* for New World; he is now a major TV producer-director. Our cinematographer was a fascinating, intellectually astute man named Gary Graver. Gary had been a combat photographer in Vietnam and had worked with Orson Welles on his later films, *F Is for Fake* and *The*

Other Side of the Wind. He also had a thriving career, under a pseudonym, as a director of porno films.

I did a ton of prep work to make sure I was worthy of this crew—and because I didn't want to blow this chance. A couple of months before we started, Roger ordered me to compose a complete shot list for the movie, instilling a habit that I retain to this day. I was no good at storyboarding because I can't draw, but he told me that I also needed to diagram the car chases on paper.

"How do I do that, Roger?" I asked.

"Treat the cars like characters," he said. "They're characters in conflict, just like actors." It was great advice that I put to use again nearly four decades later when I made *Rush,* my film about the Formula One racers Niki Lauda and James Hunt.

I was finishing up the fourth season of *Happy Days* while doing all this prep. One day on the Paramount lot, I was intercepted by Jonathan Demme, who had just graduated from the Corman school to making his first studio picture, *Handle With Care,* a C.B. radio comedy starring my *American Graffiti* castmates Paul Le Mat and Candy Clark. Demme dressed like a 1950s private eye on vacation: straw Panama hat, Hawaiian shirt, and two-tone spectator shoes.

"I hear you're doing a movie for Roger," he said. "Lemme give you a few tips." In the most gracious way, Jonathan reminded me that a Corman movie is supposed to be *fun.* "Find the fun and don't get caught up in logic or technique." It was a nice way of saying, "Don't be pretentious." Another big tip was "Make your days," meaning complete a minimum of twenty camera setups a day. By "setup," I mean the positioning of the camera, the lights, and the actors, followed by the execution of the shot. Setups vary in their complexity, depending on the demands of the scene, the number of actors, and the angles involved. A formulaic TV drama can hack its way along at a rapid clip, but most of the studio pictures I had worked on to that date completed about eight to ten setups a day.

A Corman film required twice that pace. That's common now, in the digital age, but it was crazy-rapid for the mid-'70s.

Demme's last tip was "Get your sleep." Fat chance on that one. My days were already jam-packed: wake up, work on the shot list, and diagram; go to work at *Happy Days;* zoom to the production office to meet with Dad and Allan. I got the one and only speeding ticket of my life while busting ass to get from *Happy Days* to a *Grand Theft Auto* pre-production meeting. I was pulled over for passing someone on the right. I should have written off the ticket as research for my part.

Dad was obsessed with making sure that Sam and Paula's route from L.A. to Vegas was visually and geographically correct. He had road maps spread out all over the office, trying to figure out locations true to the scenes in our script: a dirt road; a two-lane highway; a street with potholes. He talked me into taking a scouting trip along the screenplay's route. We went in two cars, and a good thing we did; at one point, my Volvo wagon got stuck in some soft, silty sand in the desert. We had to use Dad's Ford Bronco to push my car, bumper to bumper, out of its potential automobile grave. It would've made a hell of a Bronco commercial.

TRUE TO HIS word, Roger showed up on our first shooting day. As ever, he wore attire more befitting a Stanford-educated industrial engineer, which he actually was, than a producer of car-crash flicks: smart chinos, loafers, and a button-down shirt.

We had rented a house in Beverly Hills to stand in for the home of Paula and her family, from whom she escapes with the Rolls-Royce, setting the plot in motion. I cast Nancy Morgan, soon to marry John Ritter, as Paula. We had gotten our hands on a two-tone, gold-and-black 1959 Silver Cloud for her to drive. We could only afford to rent it on the days when we needed simple wide shots of Paula driving unevent-

fully. For chases and stunts, we used a series of clapped-out old Bentleys, which had a body shape similar to the Silver Cloud, and disguised them as Rollers by attaching a grille and a winged-woman ornament to their hoods. I still have that ornament. It's all that survived of the Bentleys we totaled.

I needed to get twenty-seven setups done that first day. By the time we broke for lunch, I had completed six. My first morning as a director was a disaster. As we shot the interior scenes, the ones in which Paula argues with her parents, I methodically tried to get the lighting correct. But I was working at a snail's pace. No way was I was going to get a further twenty-one shots done that day.

Roger had spent the morning parked in a chair next to the camera, watching the proceedings without expression or comment. I was convinced that he would fire me at day's end. A lifetime of yearning, swirling down the drain. My stomach knotted up as I headed to my dressing room, unable to eat. Then Gary Graver knocked on my door. I imagine that either the production manager or Roger himself had sent him in to buck me up. Very calmly, Gary helped me plot out the rest of the day, simplifying the remaining setups so that we could go faster.

After lunch, we powered through and miraculously caught up. "Make your days," Jonathan Demme had said. We did! Gary and the crew had rescued me. What I learned in that single afternoon, and would come to understand even better as the shoot went on, was that a director needs to communicate and ask for help. The crew can set up the next few scenes while you're focused on the one you're shooting. The cinematographer and assistant directors can advise you on efficient ways to achieve your creative ambitions with little compromise. The director can humbly defer to the opinions of others and actually increase, rather than diminish, the respect he commands on set.

Roger was beaming at day's end. He shook my hand and didn't even show up for Day Two.

I have never felt more physically tired than I did at the end of that first day. The combination of acting, directing, and carrying the burden of being in charge of everything had utterly depleted me. My feet hurt, my back was sore, and my hair was matted with sweat. But you know what? I couldn't wait to wake up the following day and do it all over again.

AS THE SHOOT went on, I discovered that the less I was in the movie, the more I enjoyed directing—a crucial distinction that would soon come to bear on my acting career. I really got a kick out of directing the *Grand Theft Auto* cast. There was a warm, loving Old Home Week vibe to the proceedings because so many of the players came from different parts of my life: Dad, Clint and Pete, Marion, Garry, Jim Ritz.

Dad and I created a part especially for Hoke Howell, his pal and frequent writing partner, as a sleazy preacher who steals a police car to pursue the young lovers and get the $25,000 reward. Hoke, a native of South Carolina, was in his element, gleefully chewing the scenery like it was pulled pork.

As it happens, food became a major issue during the shoot: the subject of my first managerial crisis. By our eighth day, the crew was in open revolt about the quality of the grub they were being served. Our production was feeding them a steady diet of McDonald's and Kentucky Fried Chicken. Unlike the old-timers on *The Andy Griffith Show,* who were all too happy to subsist on cigarettes, stale coffee, and donuts, my young crew actually cared about its health and well-being. The unyielding onslaught of greasy fast food was bringing down morale, something that Cheryl, more than anyone else, had picked up on.

She went to our line producer, a man named John Davison, and

asked him what the daily budget was for catering. The number she got was two dollars per person. "Ron," she told me, "for that amount, I can feed everyone a whole lot better than what we're settling for."

At that point, we had finished shooting our L.A. scenes and were about to head out to the hinterlands of Victorville, California, on the edge of the Mojave Desert, where the majority of our smash-'n'-crash action sequences would be filmed. It so happened that Cheryl's maternal grandparents, Les and Lillian Schmid, owned a one-room, cinder-block vacation cabin—so spartan that its bathroom was an outhouse—in the same area. Cheryl got their permission to use the house's kitchenette and began to compose a menu with my blessing.

Mom was worried about this scheme and made her feelings known. "Cheryl, men and their stomachs are monsters," she said. "You are setting yourself up for disaster. For the love of God, don't do it!"

But Cheryl was determined. She went food shopping with her grandparents and set to work in their little kitchen. Our first day in the desert was cold and windy, with gray skies. Yet all workplace discontent evaporated when, shortly before lunchtime, our maroon Volvo wagon appeared from over the horizon with twenty-three-year-old Cheryl at the wheel. She had prepared a lunch of rack of lamb, roasted vegetables, and a fresh green salad! The members of our crew were beside themselves with gratitude. Mom dove in to help bring service with a smile to the catering line. She happily conceded that she was wrong to have doubted her can-do daughter-in-law.

Allan Arkush and Joe Dante still talk about how Cheryl saved my ass by feeding the crew properly. But I was so caught up in every last detail of the film that I was not sufficiently partaking of the quality catering. *Grand Theft Auto* had only twenty-three shooting days, with Sundays off. Yet in that short span, I was wasting away. I began the shoot at 150 pounds, which suited my five-nine frame. A few weeks later, Joe,

concerned for my well-being, confronted me about my gaunt appearance and urged me to take better care of myself. When I got on a scale, I discovered that my weight was down to 136 pounds. Yikes.

ROGER RETURNED FOR a visit when I was working on the last big set piece for the film, in which nearly every car in the movie gets totaled in a demolition derby. (Between the Malachi Brothers and *Grand Theft Auto*, I was the face of the mid-'70s demolition zeitgeist.) We were shooting at Saugus Speedway, a stock-car racetrack and former rodeo arena in Santa Clarita, half an hour north of Burbank.

Roger arrived with a separate filmmaking crew in tow; he was the subject of a documentary-in-progress and was being followed around by a camera. He was in good spirits and was pleased with how *Grand Theft Auto* was going. I tried to leverage this into a request. The demolition derby was supposed to end in a riot, with people jumping out of the stands and running onto the midway. We had only been budgeted to hire fifty extras for this scene, which struck me as stingy. I wanted to at least create the illusion of thousands of people wreaking havoc and causing chaos. Nowadays, my team can accomplish this by using digital extras, but that wasn't an option on the table then. Besides, on such films as *Far and Away, Cinderella Man, Backdraft,* and *Rush,* I have used anywhere from five hundred to two thousand extras on certain days.

"Roger, we're coming in on schedule and under budget, so I was wondering if we could hire a hundred extras instead of fifty," I said. "I could do a much better shot where I pan across the crowd and make it seem like it's huge."

He was unmoved. "Why don't you just do a cut of the fifty people getting up?" he said. "They all run in at once and you have what you need."

"Well, yeah, but I could do something much more fluid and believable with more extras," I said. "Even if I had seventy-five, I could have them sit in the stands in a pie-wedge shape and frame the shot so there's a bigger sense of scope and scale."

Roger clapped a hand on my shoulder and smiled. "Ron, let me tell you something. You finish up this picture and do a good job with it, and you'll never have to work for me again," he said. "But all you're getting from me are fifty extras. Make it work."

And so I did, more or less. I framed a series of tight shots of my "crowd" and explained away the vast tracts of empty seats in my wide shots by having the speedway's PA announcer say, "Due to the extreme danger of this event, *remain clear of the north section of the bleachers.*"

The derby sequence took two days to shoot. Allan Arkush and I apparently combined to hold what was, for a time, the Guinness World Record for the greatest number of camera setups ever executed in a single day, eighty-one. That's a dubious distinction, though I must sheepishly admit that I have since exceeded that number, and I bet Allan has as well.

As the sun went down on our last day of shooting, I still had to capture the scene of our fake Rolls-Royce getting wrecked at the derby, and of Nancy and me gleefully fleeing the vehicle. The final setup had four cameras covering our sprint and a slow-motion shot of the iconic Rolls-Royce grille falling off the ruined car. Frustratingly, the timing of the grille-fall was off and needed to be reshot. Using just one camera, Gary Graver and I oversaw a retake in which a rival car bumped the Rolls' grille and our effects team perfectly timed their yank on the hidden wire rig. The grille bounced to the ground in slow motion, twisting in the air like the stricken gunfighters whose balletic deaths I had so admired in *The Wild Bunch.* If you're going to steal, steal from the best!

Once we had that shot, we followed the usual protocol, in which the

camera assistant checks the camera's gate to make sure it hasn't been compromised by hair or dirt. After a beat, the assistant shouted, "The gate is good!"

At that, the entire production team cast its eyes toward me. I had the presence of mind to savor the moment before I called out the words I had been waiting the better part of my life to say: "That's a wrap!"

A cheer went up and my shoulders went down, relaxed for the first time in weeks.

That night, we had a spontaneous wrap party at a dive bar nearby. There was a band playing rockabilly music and we were all doing flamers—shots of vodka that you light on fire and then tip back into your mouth while they're still burning—to celebrate.

I held Cheryl tight on the dance floor, my head slightly buzzed and my lip slightly singed. I looked over her shoulder and saw Mom, Dad, and Clint with huge smiles on their faces. I saw the members of the cast and crew clinking glasses. As an actor, I had known what it was like to wrap a project, breathing a sigh of relief after weeks of spikes and plummets in confidence. No matter how rocky the ride, the job was done. As a director, it felt different. Every day, from dawn to dusk, I had been compelled to make what seemed like thousands of decisions. Thousands more awaited in postproduction. The sheer breadth of my responsibilities was daunting and occasionally terrifying. But now I also knew the satisfaction of being at the center of things, charged with rallying the troops, winning their trust, and solving our collective problems. When the solutions revealed themselves, in one little eureka moment after another, I felt a high I had never before known.

I whispered to Cheryl, "I love directing even more than I thought I would."

This remains one of the top-three moments of my life connected to a film. The only other two that compare are when I screened *Apollo 13* for the NASA people in Houston and received their enthusiastic blessing,

and when I won Best Director and Best Picture at the Academy Awards for *A Beautiful Mind*.

LIKE CLINT SAYS, no filmmaker ever sets out to make a B picture. In my mind, when we began shooting *Grand Theft Auto*, I thought we were making a movie that might rival the recent work of Robert Altman and Hal Ashby. I knew that we stood no chance with the Motion Picture Academy during awards season. But the Golden Globes had a comedy category and our script was funny. If I brought my A game and really executed, hell, why not us?

This cockeyed optimism vanished, along with my wrap-night euphoria, when we put together our first cut of the movie. Joe did a great job, and Allan and Dad were pleased with how well the comedy played. But once I watched it through, it hit me: *This ain't no Golden Globes–worthy movie. This is a Roger Corman movie.*

On the sidewalk outside the editing facility, on McCadden Place in the heart of old Hollywood, I confided my disappointment to Dad. He did not share my dejected feelings. He told me that the film was exactly what it was supposed to be. He advised me to buck up and work with him, Joe, Allan, and John Davison on making *Grand Theft Auto* the best fucking Roger Corman movie it could possibly be. Which was something I needed to hear.

Roger liked our cut, but he wanted to hold a test screening for it. He booked a place in L.A. that was better known for testing commercials and TV shows than feature-length films. We brought a black-and-white work print of our color film, with no music or sound effects added in yet, to the testing center. It was a place unlike any I had ever seen before, with each seat in the house equipped with a dial that the viewer could turn to the right when she experienced a moment she liked and to the left when she saw something she didn't like.

Then the test audience marched in: a parade of blue-haired old ladies, some of whom were probably born in the 1890s. *What the hell?*

I turned to Roger and said, "This isn't the audience for *Grand Theft Auto*! They can't evaluate it!" Roger merely shrugged. John Davison pulled me aside to explain: the testing center agreed to screen Roger's films for free as long they could piggyback the screenings on tests for TV commercials. The day we were there, the center was screening ads for . . . Geritol, the dietary supplement marketed to elderly people. I was mortified—about my film's future *and* about offending these women with our movie's off-color humor.

But damned if Roger didn't know exactly what he was doing. We were seated directly behind a few of the old ladies in the screening room. We saw and heard them guffaw at the movie's more raw gags, such as the moment where Marion Ross's character backhands Jim Ritz's policeman in the groin. I looked at Dad to my left and Cheryl to my right and stage-whispered, "It's working!"

As soon as the movie was over and the house lights went on, one of these old ladies—who I distinctly saw laughing her head off—turned to her friend with a stern face and said, "Well, that was *disgusting*!"

The testing center provided us with printout graphs of the audience's reactions. They looked like sine waves: peaks for the fun parts, dips for the dull parts. Roger announced that we needed to cut every dip from the picture.

Once again, I spiraled into despair: *How will I even end up with a coherent film?* Joe Dante talked me off that ledge, explaining that Roger's comments were general marching orders, not edicts to be followed to the letter.

One last personal crisis reared its head when Roger decided that the movie wasn't quite zany enough to wow a New World Pictures audience. I was powerless to object to this, and, against my wishes, he had Allan direct two new action sequences. Through most of the movie,

Sam and Paula are pursued not only by bounty hunters but also by a ratings-hungry disc jockey named Curly Q. Brown, who was played by a legendary L.A. deejay known as The Real Don Steele. Roger wanted Curly to receive a comeuppance, so he added a new scene in which the deejay decamps from his news helicopter and pursues the couple in a car, only to lose control of it, drive clear through a house, launch into the air, and crash into an aboveground swimming pool.

The other addition was an embellishment of a brief chase scene in which two hillbillies throw sticks of dynamite at Sam and Paula's car. Roger and Allan expanded that moment into a rootin'-tootin' farcical routine in which the hillbillies start heaving the sticks willy-nilly, including at a roadside fruit stand, resulting in a multicolored melon explosion. I hated this idea with a passion. The chase and explosion scenes that Dad and I had written were grounded in some version of reality. This? This was Wile E. Coyote shit. I was so upset that I briefly considered taking my name off the movie and threatening not to promote it.

Fortunately, cooler heads—mainly, those of Dad, Allan, John Davison, and my new agent, Larry Becsey—prevailed. They explained to me that adding new scenes after principal photography has been completed is, in the movie business, *normal*. I have since done it many times. The twenty-three-year-old redhead with the unearned auteur complex still had a lot to learn.

BUT HERE'S THE thing: that redhead had succeeded in making a film—an honest-to-God, theatrically released film. His benefactor, Mr. Corman, was mighty pleased with it. A small premiere was held for *Grand Theft Auto* at an independent theater in Beverly Hills. The *Happy Days* people and the New World Pictures people all turned out in support. And the movie and its director were the beneficiaries of a ton of goodwill. The press lapped up the story—Richie Cunningham

grows up to be a filmmaker!—and everywhere I walked on the Paramount lot, I was heartily congratulated.

We received remarkably positive reviews upon the movie's release on June 18, 1977. Though I consider the making of *Grand Theft Auto* to be one of the formative experiences of my adult life, I have to admit that I can't get through a viewing of the film. I see all the rookie mistakes and hear all the corny jokes and I just have to shut it off. But in Roger Corman terms, the film was a success. It cost $650,000 to make and earned $6 million at the box office. In Ron Howard terms, it was a beginning. I knew that I was still a babe in the woods, but now I had something to build on.

Cheryl and I went to see the movie on the night of its release at one of the finer theaters it played at in the greater L.A. area, the Pickwick Drive-In in Burbank—where we had steamed up the windows of my VW Bug many a time back in our high school days.

Five long years later, we steamed them up once more.

And I never did work for Roger again.

CLINT

The funny thing is, *I* did. In fact, I've got a dozen Corman movies on my résumé. About a year after *Grand Theft Auto,* I was cast in *Rock 'n' Roll High School,* which Allan directed with Joe's help. I played Eaglebauer, the slick, wide-lapeled, medallion-wearing fixer of Vince Lombardi High School. Operating out of a plush office located in a stall in the boys' bathroom, Eaglebauer did a bang-up trade in fake IDs, bootleg liquor, and the discreet arrangement of romantic assignations.

If you set aside my appearance as Balok in *Star Trek,* this marked the beginning in earnest of my career as a character actor. Towhead Clint had disappeared into a swirling vortex of adolescence and self-doubt. But out of that vortex shot Character Clint, the versatile, eccentric guy

you could cast as a psycho in a horror movie, a comic supporting player in an Adam Sandler movie, or a flight controller in a Ron Howard movie . . . you name it, I'll give it a spin.

A light bulb went on over my head when I saw Dennis Hopper's turn in *Apocalypse Now*. I so admired his performance: he was completely over the top yet completely committed, so that you believed him within the context of his lunacy. I said to myself, *I can do that*.

I still had a lot of personal issues to deal with before I found my groove, though. I lasted less than a semester at Pepperdine. NBC gave Ron and me the go-ahead to write a TV movie we had pitched called *Cotton Candy,* about a nerdy teen who starts a high school rock band. Charlie Martin Smith played the lead, and the film ended up being the second that Ron directed. To me, this break made me think I was wasting my time sitting through courses about Kierkegaard and comparative religion. Before I withdrew, though, I used the lawn of my dormitory as my screenwriting "office," camping out in a folding chair with a notepad, with the Pacific in glorious view. When I needed a change of scenery, I drove down to Straw Hat Pizza in Malibu's commercial district, my writing efforts lubricated by a pitcher of beer.

As beautiful as this setup was, I concluded I had better things to do in Burbank. I was already driving back there three or four times a week to see my drug buddies and fortify my stash. So I disenrolled, thinking no further down the line than *Cotton Candy* and the paycheck it promised. I'm not sure I would have necessarily benefited from a college education, but I regret that I never gave college a fair shake. By the way, *Cotton Candy* was my first and last major screenwriting credit to date.

I did myself no favors by entering adulthood free of the regimented structure of school or series television. By the 1980s, my boozing and using were no longer the merry, consequence-free habits I had perceived them to be as a teenager. I wasn't content merely to snort cocaine, for example. Most people had never heard the word *freebasing*

until Richard Pryor burned his face trying to smoke vaporized coke in 1980, but when I heard about his accident, I thought, *Yeah, I know exactly how that happened.*

I spent the 1980s skidding along bedrock. In one particularly terrible bout of drug-induced paranoia, I pieced together some facts that, to me, irrefutably proved that I was the Antichrist: (1) I shared a birthday with Adolf Hitler; (2) When I was ten, I played a boy who predicted the end of the world in the anthology TV series *Night Gallery;* and (3) when I was twenty, I played an outcast cadet at a military academy who becomes possessed by Satan and murders his tormentors in the horror movie *Evilspeak.*

There was a period when I didn't even have keys to Mom and Dad's house in Toluca Lake, my childhood home, because they couldn't trust me in my behaviorally compromised state. I can't blame them. I scared the hell out of myself. I also scared the hell out of my neighbors. One day in 1988, I was so wigged out on speed and liquor that I literally tried to jump out of my body, my very being. In so doing, I jumped over a property wall and into the yard next door, where my unglued presence terrified the guests at what had been a sedate, pleasant gathering. They called the cops on me.

RON

I sensed something amiss with Clint as the 1970s turned into the 1980s. He had taken to arriving late for events and appointments, not his normal style. When he did this on Dad's birthday, his voice ragged and his eyes puffy as he finally joined us for a celebratory dinner at the Smoke House, I could no longer rationalize his drug use as recreational. I had by then witnessed enough behind the scenes in show business to know that Clint couldn't keep living the way he was if he wanted to survive into the next century. I confronted him with my concerns in 1980,

when we went together to Super Bowl XIV, which was played between the Pittsburgh Steelers and the Los Angeles Rams at the Rose Bowl in Pasadena. "It's one thing to use drugs and another thing to let drugs use you," I told him.

CLINT

Ron gave me a kindhearted big-brother talk. He does those well. He always begins with the words, *Now I'm going to give you some unsolicited advice.*

Over the years, I have sometimes gotten irritated when Ron uttered those words. *Oh, jeez, here it comes again, The Talk.* But I've also always appreciated his efforts and loved him for trying. He's never approached things subliminally. He's never tried to couch what he was doing in some sort of BS parable or metaphor. He addresses the subject straight-on.

I politely received Ron's admonition. But I was at the Super Bowl, for crying out loud, not on a psychiatrist's couch. I told Ron that he had made some good points. But I wasn't ready to act on them. I was still having too good a time and had no idea how worried my family was.

RON

Clint's behavior weighed heavily on my mind during one of my last acting jobs, in a 1980 TV film called *Act of Love*. Mickey Rourke and I played brothers. In the movie, his character has been rendered quadriplegic by a motorcycle accident. He begs his younger brother, my character, to end his life. The younger brother heeds the older's wishes. Then he has to stand trial for his actions.

I had an emotional monologue to perform on the witness stand,

explaining how much I loved my brother, how much he meant to me. Truth be told, it had been years since I had gone to a deep emotional place in a scene; somewhere in my adolescence, I had closed off my access to raw feelings. I resorted to fake tears and ammonia capsules, show-business crutches that were supposed to be anathema to us Howards.

But on the day we shot the courtroom scene, I began to connect the speech I had memorized with my worries about Clint: my barely acknowledged fear that I could possibly lose him to addiction. In the wide master shot, I could feel my face flushing hot with emotion. The director, Jud Taylor, was sensitive to actors. He whispered in my ear that I should go somewhere quiet and hang on to whatever I was working with.

Within minutes, the crew had hustled a camera into position for my close-up. When Jud quietly called "Action!," I let images of Clint, loaded and straight, flood my mind as I spoke. I was no longer recalling Gulliver the dog's death; I was connecting to my mature fears about my vulnerable little brother and what he was going through.

That's the take that the director used. It's the last time that I wept real tears on-screen.

CLINT

I tried to get sober a few times, the first in 1984, of my own initiative. I opened up the Yellow Pages and found a listing for Beverly Glen Hospital, which offered a twenty-eight-day inpatient program for treating drug and alcohol dependency. Little did I know how fortunate I was to happen on this of all places. A mere two years earlier, Beverly Glen had hosted the very first meetings of Cocaine Anonymous—it was ground zero for what is now a worldwide organization.

Mom and Dad did their best to help me. Throughout my dark decade, they were the one consistent positive in my life. They went to

meetings of Al-Anon and Nar-Anon, fellowship programs for the loved ones of people experiencing addiction. (These are distinct from Alcoholics Anonymous and Narcotics Anonymous, which are twelve-step programs for addicts pursuing recovery.) That first time I went into treatment, Dad, in solidarity, quit drinking, too. He never took another drop. Like a normie, which is what we in the recovery community call those who aren't afflicted by addiction, he remarked to me that he didn't miss it at all. For Mom, my troubles were especially hard to bear because she viewed my problems as an inheritance from her side of the family. But that didn't make anything her fault.

Like a lot of addicts, I needed a few tries before recovery took. Ron, bless him, consistently cast me in his movies throughout my using years. I prided myself on delivering for him and carrying myself with the utmost professionalism on his sets. In 1990, though, when we were making *Backdraft,* his movie about professional firefighters, he made a strange request of me.

I played an autopsy technician in the film and had a scene to do with Robert De Niro, who played a Chicago F.D. captain. De Niro, Kurt Russell, and Billy Baldwin researched their roles by shadowing real firefighters. Ron suggested that I do the same in my character's field. So I went to the L.A. County Morgue to observe the professionals there. I saw victims of overdoses, drug-related murders, and drunk drivers. Nearly every cold body lain out before me on a slab represented a life cut short, directly or indirectly, by drink or drugs. That was a huge wake-up call.

On June 14, 1991, I cried uncle. I was no longer deriving any joy from drinking or taking drugs, though lord knows I kept trying to the bitter end. This time, there was no expensive treatment program, no getaway to a gated rehab center. I found a home group, the AA term for a meeting one attends on a regular basis, and a sponsor. One day at a time, my life started to improve.

Dad really stepped up for me in this shaky period of recovery. Ron and Cheryl had moved to the East Coast in 1985, after their twins Paige and Jocelyn were born, and were understandably busy raising small kids. In his firm but loving way, Dad helped me along my path without any of the hair-trigger anger he displayed the day that I thrust my bong in his face. He and Mom laid down firm guidelines for me as I rebuilt my life. Gradually, I regained their trust and my own sense of self-worth. I reconnected with the Clint who didn't need a drink, a toke, or a toot to get through the day.

I'M HAPPY WITH my lot as a character actor and my place in the industry. It isn't the exalted place where Ron lives, but it suits me just fine. I'm more like Dad: a working actor who waits for the phone to ring. Sometimes there are moments of profound frustration, but hey, that's the life that I signed up for. The pisser about being an actor is that you can't *make* anyone hire you; all you can do is suit up, apply what you know, and do the best you can.

My phone has never rung off the hook, but it has rung enough to keep me going. I have well over two hundred TV and movie credits to my name. Some of these are horror pics you've never heard of unless you're a dedicated consumer of the genre. Lots of my jobs have paid me no more than scale or just a hair above. You know what? I'm damned proud of them all. How many people have sustained an acting career from their toddler years to their sixties?

It's fair to say that I have entertained literally millions of people over the years, in movies ranging from *Rock 'n' Roll High School* to *Evilspeak* to *Austin Powers* to *The Waterboy*. That, along with still being alive and still working, is a testament to my resilience and the support and guidance I was privileged to receive from Rance and Jean Howard.

Oh, and being Ron's brother is pretty cool, too.

RICHIE GROWS UP

RON

I could say the same of being Clint's brother. As different as we are and as divergent as our paths have sometimes been, I can't get enough of his unique, brilliant Clint Howard brain. There is no one else like him. I adore listening to him speak and watching him act.

I'm far from alone in this. Clint has routinely received significant parts in my films: as the flight controller Sy Liebergot in *Apollo 13*, for example, and as the floor manager in *Frost/Nixon*. The fans love him and want to see more of him. A question I frequently get from strangers when I meet them in public places is, "Will Clint be in your next movie?" There's always a happy glint of recognition in viewers' eyes when he shows up on-screen.

MY ACTING CAREER was winding down when I decided to visit Clint on the set of *Rock 'n' Roll High School* in 1979. I wanted to check out what he was doing with my old compadre Allan Arkush and the other Cormanites with whom I had worked.

When I showed up, Roger himself happened to be around. He was in a good mood. "Ron, how fortuitous that you would be here today!" he said. "Come to my office."

When we got there, he asked me to take a seat. "I just sold the TV rights to *Grand Theft Auto* to CBS for $1.1 million," he announced. "That makes your 7.5 percent of the net profits look pretty good. And it makes my 92.5 percent look fucking *fabulous*."

I was still a ways from being anything resembling a Hollywood player, but this was a start. I was learning to be more assertive, to advocate for myself more. When the sixth season of *Happy Days* was about to begin in 1978, I decided that enough was enough and played hardball with the network. On a lawyer's advice, I held out from the first day's shooting, demanding a salary commensurate with my workload and the show's level of success. Cheryl and I spent the day at Disneyland instead of Stage 19 at Paramount, to keep me distracted from the proceedings.

But I couldn't help but be nervous. As soon as we got off the Pirates of the Caribbean ride, I scooted to a pay phone to check in and see how negotiations were going. The news was good: ABC agreed to redo the final two years of my contract so that I was paid more, $15,000 per episode for the next two seasons and $20,000 per episode for my final season.

The deal didn't close until the following morning, though, so I arrived at work two hours later than the call time. When I walked in, the whole cast applauded.

I loved my *Happy Days* family, but I was nearing the time to move on. I was fond of the show's original premise, that it was about a family living in Milwaukee in the 1950s. This became less of a guiding principle as the seasons progressed. Anson was trying to launch a singing career and stopped cutting his hair short. The extraordinarily gifted Robin Williams joined us for one amazing episode as the shaggy-haired, center-parted Mork. He had traveled to Milwaukee from a place called

Ork, which I guess meant "the late '70s." This guest appearance quickly evolved into a hit series for Robin and Garry Marshall.

And in the show's fifth season, we opened with an implausible three-episode arc in which the whole gang traveled from Milwaukee to Southern California, where a pompous local bully challenged Fonzie to a waterskiing competition. We shot the exterior scenes in Malibu. My biggest concern that day was how sunburned I was getting—we pale redheads are helpless at the beach. But my fellow redhead Donny Most, also hiding from the sun, was more concerned by the script. We were sitting next to each other as he paged through it.

"This script, Ron. Uh, what do you think of it?" Donny said.

"I don't know, Donny. The writers know what they're doing. I'm sure it will work," I said.

Donny paused and then held the script open, pointing to a specific page. "So Fonzie, he's . . . he's jumping a shark now?"

He actually said those words, years before they became a cultural catchphrase. Donny innately sensed that something was conceptually amiss, that maybe, just maybe, the storylines were going a little too far. It must be noted, however, that the "jump the shark" episode was a ratings juggernaut and that *Happy Days* remained a roaring success, lasting six seasons beyond that one.

When my seven-year contract was up, I didn't rule out staying on with *Happy Days* for a little longer. ABC offered me a financially generous new deal. But I had recently made the acquaintance of a remarkable NBC executive named Deanne Barkley, one of the first women to hold real power in the TV industry. Deanne had been impressed by *Grand Theft Auto* and believed in me as a fledgling director. Through her, I struck up an informal relationship with NBC that led me to produce and direct three modestly budgeted family-friendly television movies over the next three years, all made while *Happy Days* was on hiatus.

As such, Cheryl and I never got the chance in this period to take

time off for a real vacation. But doing those films helped me further hone my chops and build my confidence as a director. So, when ABC and I were in negotiations to stay on *Happy Days,* I asked them if their offer could be amended to include the opportunity to direct some TV movies and, perhaps, a feature for Paramount, our parent company.

They turned down this request. The response I received was, "We're happy to hear your ideas. But we don't make blind deals like that." NBC, on the other hand, offered me a straight producing and directing deal for three more TV films, a series pilot, and partial financing for a feature film. No acting required. The financial guarantees were paltry compared to ABC's. Paramount's chief of TV, Gary Nardino, couldn't believe I was contemplating NBC's offer. "Ron," he said, "did you do the math?"

I had. But at that point, I knew where my heart lay. My negotiations with the networks went right down to the wire. It wasn't until the day that the *Happy Days* cast reconvened for its eighth season, in the fall of 1980, that the NBC deal went through officially, sealing my future.

I knew the number of the pay phone on the floor of Studio 19 at Paramount. I called it and asked to speak to Henry.

"Ron, where are ya?" he said when he picked up the receiver. "You're supposed to be here!"

"It's going to hit the press in about ten minutes, but I wanted to tell you first, Henry—I'm not coming back. I'm going to direct full-time."

I heard a soft groan. Henry went quiet for a moment. Then he brightened. "You'll be unbelievable at it, Ron, unbelievable," he said. "Go with God."

EPILOGUE

RON

Now that my own children are grown, I have come to believe that one of the most important things a parent can do is learn to let go. Not completely, of course—you can't do that because your children never stop being your children. There will be times when they call upon you to help them raise their own kids, as our parents did for us. There will be times when the stresses of life require you to turn back the clock and be their primary source of comfort and reassurance.

But it's crucial to recognize when it's time to get out of your kids' way. Dad managed this brilliantly. In the late 1970s, we founded a company called Major H Productions that was built around the Howard name and the idea of collaboration between Dad, Clint, and me. We did a few made-for-TV films, including the one that Clint and I wrote, *Cotton Candy,* and an Emmy-nominated kids' movie entitled *Through the Magic Pyramid* that Dad wrote and I directed. Major H served its purpose for a time, but I craved more ambitious projects and the opportunity to helm a big studio picture.

In the early 1980s, I met a bright, hustling young TV-movie producer

on the Paramount lot named Brian Grazer. We hit it off both person-ally and creatively. Brian was bursting with ideas, and he conceived the stories for what became my second and third feature films, *Night Shift* and *Splash*. I watched in awe and gratitude as Brian fearlessly navigated the Hollywood studio system to get these movies produced and dis-tributed by major studios. *Night Shift* was a sleeper success for Warner Bros. *Splash,* a Disney production, was my first bona fide hit, landing in that year's box-office top ten and receiving Golden Globe and Oscar nominations. My working relationship with Brian was clearly *working*. He and I decided to stick together and create our own independent pro-duction shop, which we named Imagine Entertainment.

This marked the end of Major H Productions, a changing of the guard. Dad had no stake in this new company. Yet he never guilt-tripped me for seeking out other collaborators and business partners, nor did Mom pressure me to continue working with Dad. They let me follow my instincts—instincts that they themselves helped hone—while main-taining our familial closeness.

What a gift that was: to let me fly away, the way Opie let his baby birds fly free at the end of "Opie the Birdman." It was their final act in raising me and positioning me for success in our shared field of work—a tremendous act of love and grace.

I WASN'T THE only Howard to take flight. In the 1980s, Mom returned to acting for the first time since Dad pressed her into ser-vice for the shows that he directed on the air force base. It started with me putting her in *Cocoon* as a featured extra who worked on the film for several weeks. Then Henry Winkler cast her and Dad in small parts in a Dolly Parton holiday movie he was directing, *A Smoky Mountain Christmas.* (Henry had already done me a major solid by agreeing to star alongside Michael Keaton in *Night Shift;* I wouldn't have received

the necessary financing for the film without someone of his status attached.)

Newly alive to performing, Mom started going out on auditions. Before long, she had effectively cornered the market on little-old-lady roles in sitcoms, appearing in *Roseanne, The Wonder Years, Married . . . With Children,* and *Grace Under Fire.* One day in 1994, when I was preparing *Apollo 13,* Dad called me.

"Ron, I want to ask you something about your casting," he said. I immediately began to wonder if he had a role for himself in mind, which would have been unlike him; he had never, ever promoted himself to me.

"I see that in the latest *Apollo 13* rewrite, there is a terrific little role for Jim Lovell's mother, Blanche," he said. "I think Jean would knock that out of the park."

Okay, now I was in a bit of a dilemma. Dad was leaning on me to cast Mom, but this part wasn't a casual walk-on. Blanche has a major scene in which her daughter-in-law breaks the news to her that there has been an explosion in the command module, putting her son in danger. Blanche, far from breaking down in tears, displays a steely resolve. She reassures her crying granddaughter by saying, "If they could get a washing machine to fly, my Jimmy could land it."

I acceded to Dad's request to give his thought some serious consideration. But I couldn't play favorites or assume Mom was a natural for the part. I made her audition. I drove to their house nervous as a cat and fully prepared to have an awkward, let-them-down gently conversation. I had been through a version of this before, with Dad. In a couple of my films, his best scenes had hit the cutting-room floor during the final editing, and I had to break the news.

But Mom came prepared. She was immediately and undeniably excellent from a performance standpoint. There was just one problem. For the first time in her adult life, Mom looked too *young* to be believable. When I expressed this concern, Dad pointed out that makeup could

enhance the lines in her face. Then Mom went in for the close. She popped out her false teeth, smiled wide, and said, "Don't you think this would do the trick?"

"Okay, Mom, okay!" I said. "Put your teeth back in. You got the part."

We put her in a wheelchair, and the hair and makeup people did fantastic work to make Mom appear convincingly frail and elderly. She nailed the scene in just a couple of takes—it's a favorite of many *Apollo 13* fans.

CLINT

Being the boy who stayed local created a different dynamic for Dad and me than it did for him and Ron. In Dad's later years, he and I were best friends as much as we were father and son. We went to ball games together, hung out together, engaged in shoptalk. When I was cast in something, I ran the material by him and sought out his thoughts. Not his *guidance,* which is what he gave me when I was a kid, but any useful ideas he might have.

I didn't always take his suggestions on board, but I treasured our ritual of discussing the work and Dad clearly appreciated that I solicited his input. And one day in 1998, he came through with a truly great piece of advice.

Just a few weeks before I turned thirty-nine, my agent called me with a strange piece of news. He told me that MTV wanted to honor me for lifetime achievement at that year's MTV Movie Awards—the raucous, looser, sillier cousin of the network's higher-profile MTV Video Music Awards. The statuette that they gave out to the winners was a gold-plated bucket of popcorn.

This phone call happened to come on April 1, a fact that was not lost on me. A lifetime achievement award? *Me?* Ha! But even after my agent

persuaded me that MTV's offer wasn't an April Fools' joke, I wasn't a total idiot about their intentions. The previous two years' winners had been Godzilla and Chewbacca, and the whole thing was tongue in cheek. I got it completely that they had picked me because I am a so-called cult actor with a funny look and a résumé of weird parts, from Balok and Eaglebauer to the psychos I played in *Evilspeak* and *The Ice Cream Man*.

So do I take this offer or not? I weighed my options. I knew that MTV wanted to have some fun at my expense, but I also saw their awards show as an opportunity for me as an actor. I was always hustling for work, and I thought to myself, *This is better than sending out post-cards to every casting director in town,* which is what Mom did during her renaissance as an actress. With that in mind, I prepared a self-effacing speech that was basically designed to get laughs, with me as the butt of the joke.

I went over to my folks' house and ran the speech by Dad. He listened but took exception to my approach. In his usual straightforward manner, he said, "Those jokes might get some laughs but they just won't stick. You should take your acceptance speech seriously. Because if you take it seriously, people will remember it."

The speech that I actually delivered on May 30, 1998—after they showed a clip montage of my work, including Balok saying, "But first: the tranya!"—was sincere and heartfelt, a genuine lifetime-achievement award speech. I thanked the fans. I thanked the people who hired me. I thanked my family.

Then I said, "You know, people come up to me all the time and they say 'Weren't you the little kid with the bear?' Or they say, 'Oh, I remember you! You were that little guy on *Star Trek* who drank the tranya.' Or, 'I know you, you're the brother of that famous guy.' Or 'Wait, wait, wait, I know you, you're that crazy guy in that horror movie.' And I go, 'Yeah, yeah, I'm all those things.' Well, maybe now

people will come up to me on the street and they'll say, 'Hey, aren't you that guy with the big golden bucket of popcorn?'"

As nervous as I was, I could tell that my sincerity had won the audience over. They laughed in the places where I wanted them to laugh and applauded warmly when I offered them my gratitude. Mike Myers shook my hand and Adam Sandler hugged me. I looked out to see my family in the audience: Mom was too unwell to attend, but Dad, Ron, and Cheryl were there, beaming. The suits at MTV were taken by surprise by this turn of events: a moment designed for kitschy laughs had been transformed into a moment of unironic warmth and love. As a result, MTV retired their Lifetime Achievement Award after I received mine.

I was far from being a child by that point, but that night, I learned that Rance Howard, the child whisperer, still had it.

MOM'S HEALTH WENT into steep decline in the year 2000. Her youthful spirit and sense of humor remained. But between the residual issues associated with being hit by a truck in her teens, her years of heavy smoking, and three major heart surgeries, her body started to break down. A hip-replacement surgery wasn't enough to stem the cascade of health problems. By late summer, she was bedridden and in the hospital, suffering from heart and kidney failure. She was only seventy-three when she passed on the second of September.

Before she died, Mom and I had some final conversations. She knew her days were numbered and was keen to impart advice to me, even though she was having great difficulty speaking. I was preparing to remodel my home. Had she been well, Mom would have been asking me about my plans and talking a mile a minute, offering up suggestions.

She could no longer do that. But she was aware that I was already experiencing some pain in my hips, a condition that she knew all too

well. Summoning every ounce of strength that she had, Mom motioned for me to draw closer to her. Her mouth to my ear, she uttered three words, twice.

"Get . . . a . . . Jacuzzi! Get . . . a . . . Jacuzzi!"

These were sage words, for I have used my Jacuzzi every day, twice a day, since the day I had it installed. Thanks, Mom.

More meaningfully, she told me that the thing I had done that made her the most proud had nothing to do with my acting career. It was putting the plug in the jug: getting sober. She was happy for me and tremendously relieved that I hadn't conceded defeat to drink as her father had.

At Mom's funeral, I placed my nine-year sobriety chip from AA in her coffin. I beat myself up a little for not getting sober sooner—it would have been better to leave her a chip with a nice round number ten on it. But that was just ego nonsense. Mom went to her grave knowing that I was well, and that's what matters.

RON

The last significant conversation that I had with Mom was also at her bedside. By then, her ability to speak was all but gone. I could see from her facial expression that she was burning to tell me something and was frustrated by her inability to do so.

"Mom, do you want to write what you want to say?"

She nodded yes. I found a clipboard and a pen. She labored for a long time over her words—it caused her physical pain even to write.

Once she was done, I took the clipboard from her. It contained a single sentence that was hard to decipher in her crabbed, compromised handwriting. But I figured it out. She had written, "Rance loves to act." In other words, I should keep hiring him and putting him in my movies, whenever I could.

It sounds like a final, funny example of a mother being pushy. But I recognized it as an expression of her deep and abiding love for Dad. She knew more than anyone that he had a need to express himself through his creative work, a desire that had burned in him since they first met in the late 1940s. But Dad seldom had real opportunities to fulfill this desire—most of the parts he got in his career weren't particularly big or juicy. Mom still believed he had time. Acting was the Howard family business. Saying "Rance loves to act" was her way of saying, "Take care of your father."

DAD WAS GUTTED after Mom's death. Were it not for his passion for acting, I don't know if he would have been able to keep going for another seventeen years, working almost to the very end.

While Mom was the love of his life, Dad was a serial monogamist who didn't function well by himself. He was fortunate to find happiness not long after Mom died with a woman named Judy Jacobson, who had also recently lost her spouse. They were married from 2001 until Judy's Alzheimer's disease–related death in 2017.

Dad's indefatigable drive to keep auditioning should be an inspiration to all working actors. When he was eighty-four, he won a part in a prestige picture, Alexander Payne's *Nebraska,* playing a brother of Bruce Dern's raggedy, ne'er-do-well lead character.

Bruce received an Academy Award nomination for his performance. At one of the awards ceremonies that season, he sought me out on the red carpet. He wanted to convey to me, emphatically, how grateful he was to Dad for his performance. "He was so fucking real, man, that I realized what the movie could be," Bruce said. "I knew that I would have to step up to that level of honesty." This was both gratifying and funny, because back in the 1960s—now it can be told—Bruce had been one of the guys on Dad's "list" of rat-bastard actors who were stealing *his* parts.

Though it's been years since I played a fictional character on TV or in a movie, I did get to act with Dad one last time, in a supermeta episode of *Arrested Development*. I was that show's coexecutive producer and off-screen narrator for the duration of its run. In its final season, there was an episode in which Michael and George-Michael Bluth, the characters played by Jason Bateman and Michael Cera, attend a backyard barbecue hosted . . . by the actual Howard family. Cheryl and I played exaggerated versions of ourselves, as did all four of our kids, Bryce, Paige, Jocelyn, and Reed.

The coup de grâce of this self-referential pageant was a scene in which Dad, at the age of eighty-eight, sent up his role as the all-knowing patriarch. In the episode, Michael Bluth, while sneaking around the pretend Howard mansion, chances upon Rance Howard sitting before a bank of surveillance screens in his office, snooping on his family like Big Brother. The scene is played for laughs, but it's not entirely untrue to who Dad was.

"I like to stay busy. Kind of keep an eye on my son, too," he tells Michael.

"Oh, yeah? You still have to do that?" Michael says.

"That's a father's job," Dad says. "Doesn't start at nine and end at five. It's twenty-four hours a day, seven days a week."

"Even as they get older, huh?"

"That gets even harder," Dad said. "They think they know it all. You still have to be there for them when they make mistakes. Or sometimes they need to cry a little bit. Because sometimes a person needs to cry a little bit—unless that person is a dad."

CLINT

I was also lucky to have one last go-round with Pop on a set. His final film was a little indie road movie called *Apple Seed*. For the first time

in his life, he was indisputably a leading man, playing an elderly ex-con who tries to warn off a younger man from making the mistakes that he made. I was cast as Dad's long-estranged son, who had not seen his father since the older man was incarcerated for murder, a long, long time ago.

I had just one scene in *Apple Seed,* toward the end of the movie. Dad and I got together to rehearse it at his Toluca Lake house the night before he flew east to begin work on the production. I wanted to give him a hero's send-off, so I stopped by the Smoke House to pick up some of their garlic bread, which we Howards consider the world's best, and grilled salmon and asparagus for the two of us. After dinner, we cleared the table and took out our scripts.

My character, Hughie, is the only person in the film who isn't smitten by the charismatic rogue that Dad played. He has no love for his old man. Preparing for this role meant summoning memories of painful experiences in my life, but none of them pertained to Dad, who I loved unequivocally. As we sat there at the table, I was overcome by gratitude for the privilege of working with my father—and regret that we hadn't acted together as adults more often. We managed to read through the scene once before my eyes filled with tears. I was embarrassed—until I looked up and saw that Dad was crying, too. The only other time I ever saw him cry was when Mom passed.

It's an actor's dream to have a well of emotion to draw upon. Dad and I pulled ourselves together and exchanged conspiratorial smiles before I went home for the night. We knew that we were going to kick that scene in the ass.

A few weeks later, I flew to Vermont to join Dad and the rest of the production team on location. It was just one day's work but probably the greatest of my life. This was the first time that the two of us had ever done a dramatic scene together. We had been scene partners in *Gentle*

Ben, of course, and a few other projects here and there, but never in any-thing with such gravity.

The day didn't disappoint. One more time, my old man elevated me to another level. I experienced a slight twinge of sadness, though, when the director, Michael Worth, gently told Dad that he needed to move his script out of the shot. He had been keeping it close by because his memory for learning dialogue was starting to fade—a tough state of af-fairs for the Man Who Was Always Prepared. I knew then that the end was near.

Rance Howard would pass a couple of months later. But on that beautiful fall day in Vermont, I was blessed to spend time on a set, one last time, with my favorite acting partner: my dad.

RON: Clint, I think it would be interesting to discuss what we learned about ourselves and our family in the course of doing this book. You first.

CLINT: Thanks for putting me on the spot, bud! Well, I would say that our childhoods were a much wilder, stranger ride than we realized when we were living through them. You don't stop and contemplate the big picture when you're a kid. But now I'm reminded of something that Gary Sinise's character, Ken Mattingly, says in *Apollo 13* at the start of their moon mission: "It's gonna be one for the books!" Our journey has been one for the books. Or at least *a* book.

RON: Absolutely. I've also come to appreciate more deeply the crazy, potentially unwise leap into the unknown that Mom and Dad made when they ran off together to take their chances in show business. I suspect that because of them, I have been subconsciously drawn to

the stories of people who take on outsize challenges with little regard for the physical or emotional risks. Like astronauts. And race-car drivers. And flawed geniuses listening to what's in their heads more than the advice of so-called normal people.

And what a blast to revisit and reexamine these memories with you, Clint. Granted, they were not all as rosy as I had originally imagined. I used to think of my journey from *The Journey* to the present as a pretty straight line. But it's been much more of an unpredictable zigzag than I thought. Before we did this, I sometimes fell into the highlight-reel mentality: *The Andy Griffith Show, The Music Man, American Graffiti, Happy Days,* directing. Now I get that I was equally shaped by projects that no one remembers, nor would I want anyone to. The mediocrities and stinkers had a damn-near equal effect in determining the path that I followed to adulthood.

CLINT: Ron, I love you and respect your beautiful mind, but I have a different take. From my chair, I have *always* seen life as a zigzag. I was never certain of where I was headed. Look at some of the parts I've played, starting at age seven: a six-hundred-year-old alien, a kid with a pet bear, a boy who predicted the end of the world, a young military cadet possessed by the devil, a twisted ice cream man who terrorizes neighborhood children, a nutty but earnest Cajun, and numerous flight controllers. That's not a straight line. But it sure as hell was interesting.

My life has been no straight line, either. That really came into stark relief when I set it down on paper. But I find myself landing on one thought: I am humbly grateful to God for the life I have lived. Maybe it's my age or my emotions getting the better of me, but I want to sign off by saying, "Sorry, Mr. Gehrig. *I* am the luckiest man to walk the face of this earth."

RON: I second that. Can I ask you one more question?

CLINT: Fire away.

RON: Hey, where's your bear?

CLINT: Oh, you want to play that game, do you? He's on the floor in front of my fireplace, Opie Cunningham.

ACKNOWLEDGMENTS

In many ways, this entire book is an acknowledgment of our love and appreciation for our parents, so it might seem superfluous to thank them again here. But it would be a sin of omission to leave them out of this section. The choices and decisions they made throughout the years—small, medium, and large—are what shaped the story we have to tell. What a gift it is to be able to look back at our lives with such love, respect, and appreciation. So, thanks, Mom and Dad.

Thanks also to our literary agents at Creative Artists Agency, Mollie Glick and Cait Hoyt, to whom we were introduced by Ron's longtime CAA reps Richard Lovett and Risa Gertner. Mollie and Cait shepherded us through the whole process: the first creative discussions, the preparation of the book proposal, and then the business of finding a home for us at William Morrow.

At Morrow, we have been privileged to work with a wonderful and supportive team. We have especially enjoyed working closely with Mauro DiPreta, our editor. Mauro's patience, suggestions, and overall guidance enriched our storytelling at every step. Vedika Khanna was right along there with Mauro, and we thank her as well.

And of course, this book would not be what it is without David Kamp.

He threw his considerable talent and experience as both a journalist and an author into helping us effectively define, shape, and thoughtfully present this story of our journeys through boyhood and into our early adult lives. He listened, asked questions one way and then another, and when our book needed it, he would find a third way to open a window to our self-discovery. We talked, traded emails, and shared documents back and forth, as David sifted through our notes, old articles, and correspondences preserved by our dad. Without David's dogged intent to bring the insights of our stories into a structured narrative, we would still be scratching our heads, or, worse, we'd have given up. Thank you, David. You're an incredible storysmith, for sure.

And now, some personal notes of thanks, offered in order of birth . . .

RON

My wife, Cheryl, has been a remarkable and constant source of love, support, and wisdom for the better part of my life. She has also, project by project, been a creative secret weapon. An author herself, Cheryl not only believed in this book idea but poured hours into it with me, discussing the pages, reading various drafts, and helping me sift through my memory banks.

Son-in-law Dane Charbeneau was an early proponent of the book and also offered feedback on various drafts, as did two of my longtime professional collaborators, the film editor Dan Hanley and the screenwriter and director Bob Dolman. Their thoughts and belief in this project were invaluable.

Two significant champions of taking on this book in the first place were Tom Hanks and Dan Brown. It was Tom who suggested that Clint and I focus on our childhood years in the business. As we worked on various projects together over the years, Tom kept asking me about my

formative times in the business, a subject that always piqued his curiosity. Dan urged Clint and me to pursue the unusual approach of coauthoring this memoir from our individual perspectives. Tom and Dan's encouragement and sage advice nudged Clint and me to take the leap.

Boyhood buddies Noel Salvatore, Bob Wemyss, and John Matheus gathered in a lengthy Zoom session one afternoon to reminisce and lend their perspectives on the Howard Boys, then and now. As did my dear friend Henry Winkler, who took the time to delve into the *Happy Days* era, our personal relationship, and his observations about Clint and my parents. Henry truly deepened my understanding of our shared past.

Tim Abou-Nasr—with the help of my daughter and his fiancée, Paige—not only read drafts of this book to offer comments but also took charge of sorting through our family's scrapbooks and archives to retrieve and supervise the restoration of many images. Tim's dogged efforts stirred our memories and led to some discoveries of moments in our pasts that Clint and I had forgotten about. Tim and Paige, we can't thank you enough.

My other children—Bryce, Jocelyn, and Reed—have been hearing versions of many of these stories all their lives: over family meals, at Christmas gatherings, and, more recently, during COVID-occasioned Zoom meetups. They, along with their partners—Seth, Dane, and Ashley—offered up their reactions, recollections, and encouragement. Thank you, kids.

Lastly, there is my coauthor. He's five years my junior but in many ways, he is the wiser and more clear-eyed Howard brother. And certainly the funnier one. Brudda Clintee, I've loved the experience of going on this very personal journey with you. Despite our differences, the three thousand miles that separate our homes, and the long lapses between in-person get-togethers, we have always remained close. This project has been a profound and welcome reminder of how much we have in common and why the roots of our sibling relationship run so deep.

I love you, Clint. Thanks for all the love you have always shown me and our family. You are a gift.

CLINT

I want to acknowledge Mr. Steve Campbell, my junior high school journalism teacher. He introduced me to the Fourth Estate way back in the early 1970s, sparking my interest in writing and teaching me the magic of constructing a tight lede. I remain his student to this day. He read chapters from this book in its developmental phase and offered helpful feedback. More importantly, he is the best educator I have ever encountered. Thanks, Mr. Campbell, I am forever in your debt.

I must also express my gratitude to my wife, Kat. When Ron and I embarked upon this project, I was an unmarried man, struggling to stay positive. Kat, then my girlfriend, stayed in the pocket with me as I went through the emotional ups and downs of setting down my story on paper, warts and all. And then we got married! As a joyful bonus, I've been privileged to become "Dad" to Kat's brilliant daughter, Erlinda Rafa'ella. Like the Rance and Jean Howards before us, we are a happy Burbank family. Kat and Rafa, I love you both so much.

And now for my coauthor. I've been so blessed to be his little brother. He's warm and compassionate. He's sharp and resilient. His ability to lead is unparalleled, going back to the days of our Howards Hurricanes basketball team. On top of all that, he's a wonderful, creative writer. I have been so blessed to be this man's sibling. I love you, Ron.

INDEX

ABC, 122, 166, 188, 207, 223–24, 242, 267
 Happy Days, 274, 275, 276, 278, 287, 293, 294, 302–6, 312, 329–30, 356, 357–58
Academy Awards (Oscars)
 A Beautiful Mind, 345
 of Ben Johnson, 252
 Bruce Dern's nomination, 366
 Candy Clark's nomination, 271
 of Cloris Leachman, 272
 of Haskell Wexler, 247
 The Last Picture Show, 252, 271, 272
 of Patricia Neal, 271
 Splash, 360
Acosta, Rodolfo, 120–21
Act of Love, 351–52
Airport, 212
Al-Anon, 353
Albin's Drugs, 142
Alcindor, Lew, 172
alcohol and alcoholism, 38, 264–66, 268–69, 352–53, 365
Alcoholics Anonymous (AA), 353, 365
Alda, Alan, 77

Alley, Charles, 209, 210, 213–14, 215–16, 220, 270
Alley, Floyce, 214
Alley, Sondra, 214
Alley, Vivian, 214
All in the Family, 185
"All Ye His Saints" (episode), 119–21
Altman, Robert, 189, 235, 345
AMC Pacer, 331
American Academy of Dramatic Arts, 13, 57
American Graffiti, 194, 244, 245–50, 270, 275, 285
 auditions and casting, 246–48, 317
 budget, 248–49
 "*Graffiti* glow," 273
 plot, 245–46
 reviews, 273, 274
 shooting, 39, 253–60, 291
Amsterdam, Morey, 311
Andrews Sisters, 12
"Andy Discovers America" (episode), 93–95
Andy Griffith Show, The, xiv, 52–62, 64–66, 93–98, 114, 117, 141, 189, 285, 310

Andy Griffith Show, The (cont.)
 "Andy Discovers America," 93–95
 back-door pilot, 52–54
 "A Black Day for Mayberry," 71–72
 dad and Andy, 57–60, 65–66
 Dennis the Menace experience
 compared with, 40–41
 earnings, 101, 167–69
 eighth birthday party, 91–92
 end of, 179–83, 186, 193–94
 "The New Housekeeper," 65–66
 "Obie" name, 64–65
 opening credits and theme song,
 54–55, 181–82
 "Opie the Birdman," 96–97, 98
 promotional appearances, 147–48,
 289
 ratings, 73, 159–60
 schooling with Mrs. Barton, 61–64,
 69, 83
 Season Six, 168–69
 Season Seven, 180
 shared-mission aspect of, 75–78
 truth about, 68–82
 TV Guide photo shoot, 83–84
 wrap party, 182–83
antihero movies, 190
Apartment, The, 304
Apollo 13, 214, 232, 344, 355, 361–62,
 369
Apple Seed, 367–69
Apple Valley Inn, 102
Arkansas Wipeout, 190
Arkush, Allan, 341, 343, 346–47, 348,
 355
Army Air Corps, U.S., 78
Arnaz, Desi, 56, 63
Arness, James, 134, 238
Arrested Development, 367
Art of Dramatic Writing, The (Egri),
 245

Ashby, Hal, 345
Australia, xiii, 308–9
Autry, Gene, 10, 20, 230
Avalon, Frankie, 166
Avco Theater, 273

Bacall, Lauren, 13, 323, 324
"back-door pilot," 52
Backdraft, 342, 353
Baileys of Balboa, The, 123–24, 243
Baker, Mrs., 201–2
Baldwin, Billy, 353
Ball, Lucille, 56, 63
Ballard, Lucien, 65
Ball Game, The, 175–77
Bananas (magazine), 310
Baral, Eileen, 226
Barbera, Joe, 122–23
Barkley, Deanne, 357–58
Barnaby (comic strip), 45–46
Barnes, Joe, 64–65
Barone's Pizzeria, 209
Barton, Katherine, 61–64, 69, 83
baseball, 313–16
 Los Angeles Dodgers, 104, 168–69,
 331–32
basketball, 170–74, 180, 286–87
Bateman, Jason, 367
Bat Masterson, 31
Bauer Super 8 camera, 191, 236–37
Bavier, Frances, 56–57, 78–79, 80, 182
Baylor, Elgin, 170
Bear Facts, The (album), 184, 185
Beatles, the, 179
Beautiful Mind, A, 72–73, 345
Beckenholdt, Engle, 6
 acting aspirations of Rance, 31–32
 early life of Rance, xvi–xvii, 12
 marriage of Rance and Jean, 16–17
 name change of Rance, x, xiii–xiv
 wedding of Cheryl and Ron, 297–98

Beckenholdt, Ethel
 acting aspirations of Rance, 31–32
 death of, 141
 early life of Rance, 29–30, 31
 Los Angeles visit of, 139–41
 marriage of Rance and Jean, 16–17
Beckenholdt, Harold. *See* Howard,
 Rance
Beckenholdt farm, xii–xiv, xvi–xvii,
 9–12, 30, 31
Becsey, Larry, 347
Beery, Wallace, 92
Bel Air, 31
Bell & Howell Zoomatic, 92, 175, 177
Bench, Johnny, 241
Benson, Robby, 276
Bergman, Ingmar, 318
Berle, Milton, 74
Berry, Chuck, 257
Berry, Ken, 182
Beverly Glen Hospital, 352–53
Beverly Hillbillies, The, 53, 84, 184
Beverly Hills, 31, 338
Bierce, Ambrose, 270
"Black Day for Mayberry, A" (episode),
 71–72
Blanc, Mel, 47
Bless the Beasts and the Children, 186
Blocker, Dan, 119–21
Bob's Big Boy, 30
Bogdanovich, Peter, 243, 252, 319
Bolex camera, 270
Bonanza, 119–21, 186
Bone, Jackie, 200–201
Bonnie and Clyde, 189–90, 191, 236,
 273, 327
Born Yesterday, 10
Bosley, Tom, 276, 286, 294, 310, 312,
 314
Bosom Buddies, 313
Boston Celtics, 286–87

Boxcar Bertha, 319
Boy Called Nuthin', A, 200
Boyd, Bob, 172
Boyett, Bob, 312–13
Boys in the Band, The, 189
Boys Town, 296–97
Brando, Marlon, 4, 204
Brickell, Beth, 136, 157
Brickell Towers, 154–55
Bridges, Jeff, 254
Browning, Ricou, 153, 155, 158
Bruno (bear), 100, 132–37, 157–58,
 185, 252
Brynner, Yul, 5, 6–7, 33
Buffy the Vampire Slayer, 93
Burbank, 30–31, 102
Burbank Bantam League, 170–74
Burbank Daily Review, 181
Burbank Public Library, 233
Burns, Ken, 233
Burroughs High School. *See* John
 Burroughs High School
Burton, Bill, 172
Burton, Tim, 172
Butterworth, Donna, 125, 132, 200

Caesar, Sid, 74
Cahiers du Cinéma (magazine), 307
Cahuenga Boulevard house, 56
California State University,
 Northridge, 262
Campbell, Steve, 267
Canon Scoopic 16mm camera, 233–34
Capra, Frank, 51, 73–74
Captain Kangaroo, 93
Cards, Cads, Guns, Gore, and Death,
 191–93
Carradine, Bobby, 267
Carradine, John, 141
Cartwright, Angela, 83
Cash, Johnny, 38

Cassavetes, John, 240, 290
CBS, 2, 7, 32–35, 41, 49, 125, 159,
 184–85, 188, 207, 230, 294,
 356
 The Andy Griffith Show, 52, 56,
 147, 148, 182, 185
 The Baileys of Balboa, 123–24
 Gentle Ben, 159, 184–85
 Good Times, 292, 309
 Maude, 287
 mother's typing job at, 7, 49–50
 Playhouse 90, 32–34, 35, 125
 Rural Purge era, 184–85
 The Waltons, 239
celebrity, downside of, 109–10
Cera, Michael, 367
Champ, The, 92
Chanute Air Force Base, 22
Chanute Service Club, 24
Chaplin, Charlie, 101
Cherokee Indians, 42–43
Chevy Nova Super Sport, 102, 121,
 140, 167
Chicago World's Fair, 214
child actors, xvii–xviii, 2, 4–5, 8–9,
 83–84, 92–93, 101, 114, 186–87,
 268. *See also specific actors*
Child Actor's Bill, 101
child labor laws, 201
Chinatown, 291
Choctaw Indians, 27
Christmas, 113, 137–38, 150, 161–63,
 312–13
Cinderella, 11, 16
Cinderella Man, 342
Cinerama Dome, 209–10
Clark, Candy, 253–54, 257, 258, 273,
 309, 337
Close Encounters of the Third Kind,
 322
Clybourn Avenue house, 166–67, 175

coaching compared with directing,
 174–75
Coca, Imogene, 74
cocaine, 332–33, 335, 349–54
Cocaine Anonymous, 352
Cocoon, 92, 146, 284, 360
Color Purple, The, 92
Columbia University, 301
Conklin, Bill, 234
Connors, Chuck, 84
Coogan, Jackie, 101, 331
Coogan Trust Account, 101, 331
Cooper, Alice, 315
Cooper, Gary, 29
Cooper, Jackie, 92–93, 96, 101
Coppola, Francis Ford, 239, 247, 291,
 304, 317, 319
"Corbomite Maneuver, The" (episode),
 126–31, 348, 363
Cordova Street apartment, 30–31, 42
Cordova Street house, 102, 113, 137,
 164
Corman, Roger, 190, 318–21, 325–26,
 356
 Eat My Dust!, 318–20, 322–23, 325
 Grand Theft Auto, 326, 327–28,
 336–48, 356
 pitch meeting, 325–26
"Corner of the Garden, A" (episode),
 34
Corsaut, Aneta, 93–95
Cotton Candy, 349–50, 359
Courtship of Eddie's Father, The,
 97–98, 197
Cousy, Bob, 286–87
Cowboys, The, 267
Cox, Monty, 135
CPO Sharkey, 323
Crawdaddy (magazine), 310
Crawford, Johnny, 84, 92–93
Creature from the Black Lagoon, 153

Crenna, Richard, 97
Cronyn, Hume, 13
Crowe, Russell, 72–73
Curran, Bill, 14

DaCosta, Morton, 88–90
Dads, xii
Dahl, Roald, 270
Dahl, Tessa, 270–71
Daktari, 133
D'Alquen, Jan, 256
Damiano, Gerard, 240
Damn Yankees, 190
Daniel Boone, 186
Danny Kaye Show, The, 125–26, 200
Danny Thomas Show, The, 48, 52–54, 57, 58, 83
Dante, Joe, 336–37, 341, 346
Darin, Bobby, 271, 285
"Dark December" (episode), 34
Dating Game, The, 223–26
David Starr Jordan Middle School
 Clint at, 267, 269, 301
 Ron at, 114, 179–81
Davis, Bette, 95
Davis, Tommy, 104
Davison, John, 340–41, 347
Dean, James, 4
Death Valley Days, 31
Debord, Vern, 135
Deed of Daring-Do, 230–33
Deep Throat, 240
Degrazio, Doug, 262, 308
De Kova, Frank, 204–5
Dementia 13, 319
Demme, Jonathan, 273, 319, 337–38, 339
De Niro, Robert, 192, 353
Dennis the Menace, 34, 40–41, 92
Denver, Bob, 39–40
Dern, Bruce, 366

Desilu Studios Cahuenga, 56, 61–62, 68, 80, 93, 182–83
 bathroom stalls, 66–67
Devane, William, 313
Dickens, Charles, 209
Dick Van Dyke Show, The, 48, 56, 242, 311
Dillards, the, 69
"Ding-a-Ling Girl, The" (episode), 33
Director's Guild Award, 92
Dirty Mary, Crazy Larry, 327
Disney, Walt, 124, 204
Disneyland, 124, 139, 200, 356
Dodger Stadium, 314, 331–32
Doel, Frances, 325–26, 327–28
Donny & Marie, 224
Douglas, Donna, 84
Douglas, Kirk, 13
Dreyfuss, Richard "Rick," 247, 249–50, 253–55, 259, 286
drinking of Clint, 264–66, 268–69
Driscoll, Bobby, xviii
drug use by Clint, xviii, 268–69, 299–301, 332–33, 335, 349–54
Drysdale, Don, 104, 168–69
Duel, 134
Dumont, Margaret, 57
Duncan, Oklahoma, 10, 13, 14, 17, 23–24, 28, 42–43, 279, 281
Duncan High School, 12–13
DuPont Show with June Allyson, 34
Dynamite (magazine), 310

Eastman Kodak Company, 175, 184
 Kodak Teenage Filmmaker's Contest, 229–33
Easy Rider, 227, 263
eating shots in film, 227
Eat My Dust!, 318–20, 322–23, 325
Ebert, Roger, 273
Eby, Glee, 11, 12, 17

Edmiston, Walker, 130
Ed Sullivan Show, The, 159
education. *See also* David Starr Jordan
 Middle School; John Burroughs
 High School; Stevenson
 Elementary School
 with Mrs. Baker on *The Wild
 Country,* 201–2
 with Mrs. Barton on *The Andy
 Griffith Show,* 61–64, 69, 83
Egri, Lajos, 245
Eisenstein, Sergei, 227–28
Elam, Jack, 198, 204–5, 251
Enrico, Robert, 270
Erickson, Leif, 119–21
Eveslage, Ron, 256
Exorcist, The, 249

Face in the Crowd, A, 51–52
Family Affair, 188
FAO Schwarz, 91
Far and Away, 342
Father Knows Best, 31
F.B.I., The, 186
Fedderson, Don, 223
Fellini, Federico, 318
Fields, Verna, 260
Fields, W.C., 64
Film Director as Superstar, The
 (Geimis), 227, 239
Film Form: Essays in Film Theory
 (Eisenstein), 227–28
F Is for Fake, 336
Fitzgerald, Ella, 87
Five Minutes to Live, 38
"Flapjack for Breakfast" (episode),
 155–56
Flintstones, The, 69, 122–23
Flipper, 133, 134, 153
Fonda, Henry "Hank," 19, 20, 95, 207,
 227–28

Mister Roberts, 2, 19, 226, 252
 The Red Pony, 99–100, 250–52
 The Smith Family, 223, 226–28
Fonda, Peter, 227, 235, 263
"Fonzie Loves Pinky" (episode), 329
"Fonzie Moves In" (episode), 309
"Fonzie's Getting Married" (episode),
 294
Ford, Glenn, 98
Ford, Harrison, 253–54, 257, 260, 273
Ford, John, 134, 227, 235, 324
Ford, Paul, 123–24
Ford Motor Company, 80
Forrest, Steve, 195–96, 203, 204, 205
Fort Sill, 14
Forty Acres backlot, 56, 117–18
Fox, Fred, 315
Frankenheimer, John, 33
Franklin Canyon Park, 54–55, 56, 64
Frick, Ford, 148
Friedkin, William, 189
Frontier Woman, 26–27
Frost/Nixon, 355
Fugitive, The, 101
Full House, 313

GAF Anscomatic, 236–37
Ganz, Lowell, 293, 309, 310
Garr, Teri, 309
"Gary, Indiana" (song), 86–87, 88,
 107
Geimis, Joseph, 227
General Electric Theater, 48, 50
General Foods, 54, 68
Gentle Ben, xv, 116, 132–37, 153–60,
 326
 Bruno the bear, 100, 132–37,
 157–58, 185, 252
 ending of, 184–85
 father's acting and screenwriting,
 155–56, 165–66, 368–69

"Flapjack for Breakfast," 155–56
Florida life, 152, 154–55, 196
 raccoon incident, 158–59
 ratings, 159–60
 screen test, 132–33
 shooting, 134–37, 153, 155–57, 184
Gentle Ben (Morey), 134
Gentle Giant, 132, 134, 195, 279
George Washington Slept Here, 27
Gibson, Bob, 156
Gilligan's Island, 39–40, 64
glycerin, 8, 99, 236
Godfather, The, 247
Godfather, The, Part II, 291
Golden Girls, The, 93
Golden Globes, 345, 360
Goldenson, Leonard, 330
Gomer Pyle, U.S.M.C., 56
Gone in 60 Seconds, 326
Gone with the Wind, 117
Good, the Bad, and the Ugly, The,
 190
Good Times, 292–93, 294, 309
Good Will Hunting, 104
Gould, Harold, 243
Graduate, The, 189, 327
Grand Canyon, 284
Grand Theft Auto, 326–28, 331,
 333–48, 356
Grapes of Wrath, The, 19
Grauman's Chinese Theatre, 139
Graver, Gary, 336–37, 339, 343
Grazer, Brian, 160, 360
Grease, 274, 276
Great Depression, 233, 237
Green Acres, 184
Green Bay Packers, 156
Greene, Lorne, 121
Greenway, Lee, 69, 81
Gremlins, 336
Grier, Rosey, 240

Griffith, Andy, 48, 50–55, 71–81, 223.
 See also *Andy Griffith Show, The*
 back-door pilot, 52–54
 background of, 51–52
 Bavier and, 78–79
 birthday party for Ron, 91–92
 Dad and, 57–60
 A Face in the Crowd, 51–52
 Headmaster, 207–8
 McNear and, 71–73
 opening credits and theme song,
 54–55, 181–82
 shared-mission aspect of show,
 75–78
 Toluca Lake house of, 166
 wedding to Cheryl, 298
 Willson and, 85–86
 wrap party, 182–83
Griffith, Barbara, 81
Griffith, Chuck, 322, 325
Griffith, D. W., 193
Griffith Park, 30
gross points, 231–33
Grumman Gulfstream, 204
Grundy, Reg, 308–9, 319
Gulf + Western, 243
Gulliver (dog), 26, 56, 96, 97, 98, 104,
 352
Gung Ho, 310
Gunsmoke, 134, 188, 196, 198, 238

Hackett, Buddy, 89–90
Hagen, Earle, 54–55
Haggerty, Dan, 199
Hale, Alan, Jr., 64
Haley, Bill, 273
Hamer, Rusty, 58, 83
Hamill, Mark, 316–17
Hamner, Earl, Jr., 237–39
Handle With Care, 337
Hanna-Barbera, 122–23

Happy Days, xiv, 53, 274, 275–77, 284–95, 323, 328
 Christmas gifts, 311–13
 first read-through, 276–77, 285–86
 potential renaming of the show, 302–6, 330
 promotional tours, 287–89, 308–9
 ratings, 287, 292–93
 screen test, 275–76
 Season Two, 292–94
 Season Three, 294, 309–13, 318
 Season Four, 328–30, 337
 Season Six, 356–58
 softball team, 313–15
 studio audience of, 293–94
Harold and the Purple Crayon (Johnson), 46
Harrison, George, 298
Hart, Moss, 27
Havens, Geno, 246–47, 317
Hayward, Leland, 19, 20
Headmaster, 207–8
Hee-Hee Man incident, 43–44
Heindorf, Ray, 87–88
Heinsohn, Tommy, 286
Helfer, Ralph, 132–33
Hennesey, 34, 39
Hershey, Barbara, 166
"Hick-ercise," 143
Hickman, Dwayne, 39–40
High Noon, 29–30
Hired Hand, The, 227, 235
Hitchcock, Alfred, 134
Hitler, Adolf, 350
Hoffman, Dustin, 277, 313
Hogan's Heroes, 56, 117
Holloway, Sterling, 123–24
Hollywood, 30, 31, 55–56
Hollywood Boulevard, 336
Hollywood Hills, 30

Homecoming, The: A Christmas Story, 237–39
homosexuality, 81, 82
honeywagon, 156–57
Hope, Bob, 102, 166
Hopkins, Bo, 253–54, 257
Hopper, Dennis, 227, 263, 349
Horn & Hardart, 149–50
Howard, Bryce Dallas, ix–xii, 13, 162, 202, 367
Howard, Cheryl Alley
 acting of, 230, 231, 235
 dating, 144, 212–24, 265, 273
 dining out with Winkler, 290
 family background of, 214, 280
 family life, 162, 292, 354
 first meeting and date, 206–11
 Grand Theft Auto, 340–41, 344, 346
 marriage proposal, 295–96
 travel, 239–40
 at Valley College, 262, 295, 303
 wedding, 296–99
Howard, Jean Speegle
 acting career of, 17–18, 26–27, 360–62; *Apollo 13,* 361–62; *Cocoon,* 146, 284, 360
 background of, 9–10, 42–43
 Cheryl and, 216–22, 297
 cooking of, 103
 death of, xv, xvii, 365–66
 early life of, 12–13
 family life, 115–17, 137–39, 143–50, 152, 161–63, 164–65, 177–78, 257–58, 266; birth of Clint, 35–36, 41–42; birth of Ron, 23–25; stillbirth of Mark, 22–23
 finances and money, 101–2
 health issues of, 141–47, 165, 364–66
 marital fight with Rance, 278–84

marriage to Rance, 15–17
meeting Rance, 9–10, 12, 13–14
move to California, xiv, 4, 27–30
in New York City, 13, 14–15, 17–19
show-business aspirations of, xiv,
 xvi, 2–3, 9–11, 13
storytelling, x–xi
typing job of, 7, 49–50
at University of Oklahoma, 9–11,
 13–14, 32, 133–34
work ethic of, xvii–xviii
Howard, Jocelyn Carlyle, 354, 367
Howard, Mark Allan, 22–23
Howard, Paige Carlyle, 354, 367
Howard, Rance
 acting career of, 2–3, 17–21, 29–30,
 31–32, 34–35, 60–61, 95, 122,
 136–37, 283–84, 322–23, 360,
 365–69; *Apple Seed,* 367–69;
 Bonanza, 119–20; *Deed of
 Daring-Do,* 230, 231; *Frontier
 Woman,* 26–27; *Gentle Ben,*
 165–66; *Mister Roberts,* 2–3,
 19–20, 29, 226, 252, 326; *Old
 Paint,* 234–35; *Where the Lilies
 Bloom,* 277–79
 acting lessons of, 4–5, 8–9, 33,
 35, 46, 86–87, 119–20, 203–4,
 251–52
 The Andy Griffith Show, 50, 51, 52,
 56–60, 65–66, 73, 78, 79, 95,
 96–97, 136–37
 background of, 9–10
 boxing, 18–19
 Cheryl and, 216–22, 297
 death of, xv, xvii, 369
 early life of, 30
 family life, 102, 105–6, 108–9,
 115–17, 137–38, 144–45,
 161–63, 164, 177–78, 266;
 birth of Clint, 35–36; birth of

Ron, 23–25; Clint's addiction,
 299–300, 350–54; stillbirth of
 Mark, 22–23
finances and money, 101–2, 166,
 167–68
marital fight with Jean, 277–84
marriage to Jean, 15–17
meeting Jean, 9–10, 12, 13–14
military service of, 20–22, 25–26
move to California, xiv, 4, 27–30
name change of, xiii–xiv, 11–13, 21
in New York City, 14–15, 17–19
personality of, 44–45
Ron's first screen test, 1–3
screenwriting career of, 122–23,
 223, 245, 308, 359–60; *Arkansas
 Wipeout,* 190; *The Flintstones,*
 122–23; *Gentle Ben,* 155–56,
 165–66; *Grand Theft Auto,*
 326–27, 334
storytelling, x–xi
at University of Oklahoma, 9–11,
 13–14, 32, 133–34
work ethic of, xvii–xviii
Howard, Reed Cross, xi, xii, 367
Howard Family Road Trip, 27–30
Howards Hurricanes, 171–74, 223
Howell, Hoke, 122–23, 164, 190, 223,
 233, 340
Hundley, Craig, 210, 261–62
Hungarian Revolution of 1956, 6
Hunt, James, 337
Huston, John, 185
Huxley, Craig, 261–62

Idlewild Airport, 6
I Love Lucy, 61
Imagine Entertainment, xiii, 63, 160,
 360
Initiation, The, 261–62, 308
International House of Pancakes, 30

"I Ride an Old Paint" (song), 234
Isacksen, Peter, 323, 334, 340
It's a Mad, Mad, Mad, Mad World, 209, 215–16, 327
It's a Wonderful Life, 46, 51, 73

Jacks, Robert L., 237–39
Jackson, Anne, 5
Jackson Hole, Wyoming, 198–99, 202
Jacobson, Judy, 366
John Burroughs High School
 Clint at, 269, 300–302, 314, 330–31, 332–34
 Ron at, 114, 171, 181, 206–7, 212–13, 233, 242
Johnny Ringo, 34
Johnson, Ben, 252
Johnson, Crockett, 46
Jones, Bob, 234, 279, 282
Jones, Shirley, 38–39, 84, 88, 91, 98
Jordan Middle School. *See* David Starr Jordan Middle School
Journey, The, 3, 5–7, 27, 35, 143, 238
Journey to the Center of the Earth, 190–91
Judd for the Defense, 186
Jungle Book, The, 124

Kanin, Garson, 10
Kaufman, George S., 27
Kaye, Danny, 125–26, 200
Kazan, Elia, 51–52
Keaton, Michael, 360
Keesler Air Force Base, 26
Keesler Playhouse, 27
Kelley, DeForest, 129
Kelly, Grace, 13
Kelton, Pert, 88, 91
Kemmerling, Warren, 322–23
"Ken Burns effect," 233
Kennedy, John F., 63–64

Kennedy, Robert F. "Bobby," 202
Kerr, Deborah, 5
Ketcham, Hank, 40
Kid, The, 101
Kid's Eye View of Washington, A, 148
King, Martin Luther, Jr., 202
King and I, The, 5
King Kong, 190
Kings Arms, 103
Knight, Bobby, 173
Knotts, Don, 56–57, 78, 79–81, 182, 298, 310
Kodak Brownie Super 8 camera, 175–77, 229, 232
Kodak Teenage Filmmaker's Contest, 229–33
Korean War, 20, 34, 241
Koufax, Sandy, 104, 168–69
Kramer, Stanley, 29, 209
Kunkle, Peggy, 159
Kyriacou, Gig, 301, 330

Lackland Air Force Base, 20
Lahr, Bert, 46–47, 52, 58, 79, 208
Lancaster, Burt, 200–201
Lancer, 186, 188
Land of the Giants, 186
Landon, Michael, 119
Lassie, 83, 92, 159, 186
Last Picture Show, The, 186, 243, 252, 271–72
Las Vegas, 29
Lauda, Niki, 337
Lawton, Mrs., 16
Leachman, Cloris, 271–73
Lear, Norman, 287
Leave It to Beaver, 31, 84, 92–93
Le Mat, Paul, 249–50, 253–54, 257, 269, 273, 276, 337
Lemmon, Jack, 2
Leo and Loree, 290–91

Leonard, Sheldon, 48, 50–51, 52, 56, 65–66, 73–74, 91–92
Leone, Sergio, 30, 190, 191, 230–31
Les Brown and His Band of Renown, 182–83
Levin, Henry, 190–91
Life and Times of Grizzly Adams, The, 199
Life and Times of Judge Roy Bean, The, 185
Li'l Abner, 91
Lindley Hospital, 23–25
Lindsey, George, 78, 81–82, 182
Linkletter, Art, 148
Little Shop of Horrors, The, 318, 322
Litvak, Anatole, 5
Lockheed Aircraft Company, 31
Logan, Joshua, 19–20
Los Angeles Dodgers, 104, 168–69, 331–32
Los Angeles Lakers, 170
Los Angeles Memorial Sports Arena, 170
Los Angeles Rams, 351
Los Angeles Times, 103–4, 168
Los Angeles Valley College, 262, 295, 303
Love, American Style, 242, 243, 244
Lucas, George, 239, 248, 273
 American Graffiti, 39, 244, 245–50, 254–58, 260, 273
 Star Wars, 273, 316–18
Lucas, Marcia, 260
Lumet, Sidney, 33
Luther Burbank Middle School, 215

Mad (magazine), 310
Madden, Dave, 322–23
Maddux, Greg, 315
Magnolia Park United Methodist Church, 296–97
Major H Productions, 359–60

Malibu Creek State Park, 329
manager fees, 101–2, 166, 167–68
Mankiewicz, Joe, 51
Manson Family, 202
Many Loves of Dobie Gillis, The, 34, 39–40
Marathon Man, 313
Marcus Welby, M.D., 189
marijuana, 263–64, 268–69, 299–301, 302, 332–33
Marks, Sherman, 45–46
Marshall, E. G., 5
Marshall, Garry, 313, 328, 340
 Happy Days, 274, 275–77, 286–87, 293, 304–6, 310–11, 313–14, 315, 357
 New Family in Town, 242–43
Martinez, A, 267
Marvin, Lee, 273
Marx Brothers, 57
*M*A*S*H,* 77, 185, 189
masturbation, 137–38, 220
Mathers, Jerry, 84
Matheus, John, 113
Matlock, 59
Maude, 287, 292–93
Mayberry R.F.D., 182
May Company, 161
McBride, Mrs., 207, 208
McCabe and Mrs. Miller, 235
McCloud, 9, 134
McCormick, Maureen, 148
McGavin, Darren, 270–71, 272
McGovern, George, 259
McNear, Helen, 69–70
McNear, Howard, 69–72, 78
Mel's Drive-In, 256–57
method acting, 4, 97, 203
#MeToo, 202
MGM Studios, 1–2, 3, 5, 38, 98, 238, 328

Miami Dolphins, 155
Migrants, The, 272–73
Mike Douglas Show, The, 289
Miles, Vera, 134, 136, 279, 282
 The Wild Country, 195–96, 199,
 203, 205
military draft, 216, 241–42, 243–44,
 249–50, 259, 269–70
Milkis, Ed, 304–5
Milland, Ray, 240
Miller, Tom, 304–5, 313
Milligan, Mary Lou, 285
Million Dollar Movie, 190, 318
Minnelli, Liza, 98
Minnelli, Vincente, 97–98, 197
Mister Roberts, 2–3, 19–20, 29, 226,
 252, 326
Mitchell Camera, 1
Mitts (cat), 104
Mod Squad, The, 186, 187–88, 270
Molinaro, Al, 314
Monday Marauders, 290–91
Monroes, The, 165, 166
Moran, Erin, 310, 314
Morey, Walt, 134
Morgan, Nancy, 290, 338–39, 343
Mork & Mindy, 305, 357
Morris, Howard, 74–75, 310
Most, Donny, 276, 286, 287–91, 298,
 310, 314, 328, 357
Motion Picture & Television Fund, 233
Mount Fuji, 270
Mr. Deeds Goes to Town, 73
Mr. O'Malley, 44–48, 50, 79
MTV Movie Awards, 362–64
MTV Video Music Awards, 362
Murphy, Eddie, 33, 160
Music Man, The, 38–39, 84–91, 107,
 247
 voice lessons with Mrs. Webber,
 86–90

Myers, Mike, 364
My Three Angels, 27
My Three Sons, 92, 223

Nabors, Jim, 78, 82
Nanny and the Professor, 189, 226
Nar-Anon, 353
Nardino, Gary, 358
Nash, John, 72–73
National Geographic (magazine),
 239–40
NBC, 9, 45, 126, 148, 250, 349, 357,
 358
Neal, Patricia, 270–71
Nebraska, 366
Needham, Hal, 327
Nelson, Gary, 243
New Family in Town, 242–43
"New Housekeeper, The" (episode),
 65–66
New Loretta Young Show, The, 84
Newman, Paul, 4, 185, 212, 304
New World Pictures, 190, 318–19,
 325–26, 328, 336, 346
New York City, 13, 14–15, 17–18,
 148–50, 284
New York Times, 73, 78, 273, 335
Nichols, Mike, 189, 203
Nicholson, Jack, 318
Nietzche, Friedrich, 305–6
Night Gallery, 189, 350
Night Shift, 310, 360–61
Nimoy, Leonard, 127
Nixon, Richard, 148, 259, 269, 327
Norris, Christopher, 322
North, Jay, 34, 40–41, 58, 83
No Time for Sergeants, 56–57
Nutcracker, The, 161

Oberon, Merle, 65
Obie light, 64–65

Occurrence at Owl Creek Bridge, An, 270

Odd Couple, The, 188, 293

Ogg, Marguerite, 189

O'Hara, Maureen, 251, 252

Oklahoma State Troopers, xvi–xvii

Old Paint, 234–36

Olivier, Laurence, 313

One on One, 276

"Opie the Birdman" (episode), 96–97, 98

Oscars. *See* Academy Awards

Other Side of the Wind, The, 336–37

Our Gang, xviii

Pacino, Al, 335

Painted Desert, 28

Paramount Television, 243, 276, 311–12, 358

Parenthood, 5, 176, 310

Paris, Jerry, 291, 294, 304–5, 310–11

Parton, Dolly, 360

Partridge Family, The, 322

Party of Five, 166

Patys Restaurant, 166–67

Payne, Alexander, 366

Peale, Norman Vincent, 145

Pearl River Reservation, 27

Peckinpah, Sam, 190, 191, 196, 203, 236

Penn, Arthur, 33, 189, 236

Penthouse Productions, 11, 14, 15–16

People (magazine), 298, 310

Pepperdine University, 302, 331, 333, 349

Petrified Forest National Park, 28–29

Petticoat Junction, 53, 184

Pit and the Pendulum, The, 318, 319

Pittsburgh Steelers, 351

Playhouse 90, 32–34, 35, 50, 125

Please Don't Eat the Daisies, 101

Plymouth Barracuda, 206, 215

Plymouth Cranbrook, 28, 41, 102

Poe, Edgar Allan, 318

Polanski, Roman, 291

Pontiac Firebird, 331

porno films, 240, 252, 337

Power of Positive Thinking, The (Peale), 145

Presley, Elvis, 285

Preston, Robert, 38–39, 86, 88

Provost, Jon, 83, 92

pro wrestling, 105, 106–9

Pryor, Richard, 350

psychotherapy, 81, 292

Purl, Linda, 290–91

Radnitz, Robert, 277–78

Rambo, Dack and Dirk, 83–84

Ransom, 301

Reagan, Ronald, 48

Red Pony, The, 99–100, 250–52, 266–67

Red Skelton Show, The, 34, 125

Reiner, Carl, 48, 74, 311

Republic Pictures, 20, 230

Return to Mayberry, 59, 82

Reynolds, Burt, 326–27

Richardson, Susan, 261–62

Rickard, Jack, 310

Rickles, Don, 323

Rifleman, The, 84, 92, 196

Ritter, John, 290, 338

Ritz, Jim, 328, 340, 346

Robards, Jason, 5

Robert Louis Stevenson Elementary School, 61, 84–85, 103, 104, 109–14, 116, 128

"Rock Around the Clock" (song), 273

Rock 'n' Roll High School, 336, 348, 354, 355–56

Rockwell, Norman, 179

Roddenberry, Gene, 128
Rogers, Roy, 10, 20, 102, 230
Rogers, Wayne, 77
Rookies, The, 122
Rooney, Mickey, 296–97
Roos, Fred, 247
Roosevelt Hotel, 83, 288
Rose, Pete, 241
Ross, Marion, 243, 263, 276, 286, 294, 310, 312, 314, 328, 340, 346
Rothman, Mark, 293, 309
Rourke, Mickey, 351–52
Route 66, 28
Ruben, Aaron, 52, 56, 73–74, 91–92
Run Stranger, Run, 270–72
Rural Purge era, 184–85
Rush, 337, 342
Rush, Dennis, 93–94
Russell, Bill, 286
Russell, Kurt, 353
Russo, Rene, 301
Ryan, Nolan, 241

Saint Joseph Hospital, 41
St. Louis Cardinals, 156
St. Regis Hotel, 147–48
Salty, 153
Salvatore, Noel, 113, 170, 180, 234, 249, 269, 298
Sandler, Adam, 349, 364
Santa Claus, 161–62
Sardi's, 148
Sargent, Joseph, 128, 129
Saroyan, William, 27
Saturday Night Live, 33
Scarface, 335
Schmid, Les, 341
Schmid, Lillian, 341
Schulberg, Budd, 51
Schuller, Bill, 50–51, 248, 275–76, 319
Scorsese, Martin, 192, 319

Scott, Joey, 93–94
Seinfeld, 230
Selective Service System, U.S., 249–50
Separate Peace, A, 186
Sequoia National Park, 284
Serling, Rod, 34
Seventeen (magazine), 288
sexual assault in Hollywood, 201–2
Shannon Airport, 6
Shatner, William, 126–27, 129
Sherman Brothers, 124
"Shipoopi" (song), 89–90
Shirley Temples, 103, 265
Shootist, The, 323–24
Siegel, Don, 323–24
Silverman, Fred, 292–93, 294, 306, 309
Silvers, Phil, 74, 123
Sinatra, Frank, 87, 102
Sinise, Gary, 369
Sizzler Restaurant, 103
Skyward, 291
Smith, Charles Martin
 American Graffiti, 249–50, 253–54, 257, 258, 259–60, 273
 Cotton Candy, 349
 The Initiation, 262
 'Tis the Season, 309
 wedding to Cheryl, 298
Smith, Hal, 69
Smith, Reggie, 55, 64, 75
Smith Family, The, 207, 223–24, 226–28, 230, 233, 237, 284
Smoke Signal. The (newspaper), 301–2, 330, 333–34
Smokey and the Bandit, 327
smoking, 24, 25, 42, 57, 142
Smoky Mountain Christmas, A, 360–61
Snow White, 11
Some Like It Hot, 304

Somers, Suzanne, 257
Song of the South, xviii
Sounder, 278
South Pacific, 19–20
Spader, James, 169
Special Services, 20–22, 78
Speegle, Butch, 23, 28
 accident of Jean, 13
 background of, 28
 birth of Clint, 41–43
 birth of Ron, 24, 25
 drinking of, 45, 265–66
 early life of Jean, 28, 42, 265–66
 Los Angeles visit, 45
 marriage of Jean and Rance, 16–17
Speegle, Louise, 23, 28, 139
 accident of Jean, 13
 background of, 28, 42–43
 birth of Clint, 41–43
 birth of Ron, 25
 early life of Jean, 28, 42
 Los Angeles visit, 45
 marriage of Jean and Rance, 16–17
Speegle Hall, Julia, 28, 39, 265–66,
 297
Spewack, Sam and Bella, 27
Spielberg, Steven, 92, 134, 260, 273
Spikes Gang, The, 273
Splash, 75, 310, 360
Stanislavski, Konstantin, 4
Stapleton, Maureen, 146
Starr, Bart, 156
Stars and Gripes, 78
Star Trek, 317
 "The Corbomite Maneuver,"
 126–31, 348, 363
Star Wars, 273, 316–18
Steinbeck, John, 99, 250–51
Stevenson Elementary School, 61,
 84–85, 103, 104, 109–14, 116,
 128

Stevenson, Robert Louis, 128
Stewart, Jimmy, 95, 323, 324
Sting-Ray bike, 117–18
Stone, Merle, 332–33
Streaks 'N Tips, 158
Streets of San Francisco, The, 189
"stress eye," 292
studio audience, 54, 287, 293–94
Sturges, Preston, 227
Sugar (monkey), 221–22
Summer of '42, 242–43, 322
Super Bowl XIV, 351
S.W.A.T., 195
Sweeney, Bob, 56, 70, 72, 76, 94–95,
 123
Swit, Loretta, 77
Switzer, Carl, xviii
Sylmar earthquake of 1971, 187–88

Tale of Two Cities, A (Dickens), 209
Tandy, Jessica, 146
Tap-Dancing Mamas, 138, 141–42
Targets, 319
Technicolor, 38–39, 89
Ten Commandments, The, 117
That Girl, 56
Thibodeaux, Keith, 61, 93–94
Thing with Two Heads, The, 240
Thomas, Danny, 48, 52–54, 57, 58, 83
Thomas, Richard, 239
Three's Company, 79, 290
Through the Magic Pyramid, 359
Thunderball, 153
THX 1138, 248
Time Machine, The, 190
Time of Your Life, 27
Times Square, 18
'Tis the Season, 308–9, 319, 320
Toluca Lake, 166–67, 232
Toluca Lake house, 166–67, 175, 177,
 249, 260, 297, 326, 350

Tors, Ivan, 133–37, 153–56, 158
Totten, Heather, 251
Totten, Robert "Bob," 120, 228, 229, 263
 The Cowboys, 267
 The Red Pony, 100, 250–52
 The Wild Country, 196–203, 205
Totten, Sandy, 197, 207
Touch of Evil, 193
Tracy, Spencer, 296–97
tranya, 127–28, 130, 363
Travolta, John, 305
Trempe, Betty, 301–2, 333, 334
Troell, Jan, 240
Truffaut, François, 318
Turner Turnpike, 24
TV Guide (magazine), 83–84, 310, 323, 324
Twilight Zone, The, 34, 37–38, 46

United Artists, 291
University of Oklahoma, 9–11, 32, 133–34
USC (University of Southern California), 239–40, 241, 243–44, 248, 260, 262–63, 269–70, 274, 275, 291, 303, 320
USC Bruins, 172, 320

Van Cleef, Lee, 29–30
Van Dyke, Dick, 48, 56, 242, 311
Vanishing Point, 326
VCR (videocassette recorder), 312
vegetarianism, 151–52
Verdon, Gwen, 146
Verdugo Mountains, 30
Verdugo Park, 103, 117
Vidor, King, 92
Vietnam War, 216, 240–41, 249–50, 259, 269–70
Virginian, The, 101, 188

Viva Zapata!, 204
Volkswagen Beetle, 206, 216, 295
Volkswagen Pop-Top Camper, 306, 313
Volvo 240 station wagon, 299, 338, 341
Von Huene, Walter, 315

Wade Hotel and Café, 28
Walker, Jimmie, 293
Walker, Sig, 153–54
"Walking Distance" (episode), 37–38
Walt Disney's Wonderful World of Color, 159, 184
Waltons, The, 239
Warner Bros., 84–88, 360
Waterboy, The, 354
Watson, Bobs, 296–97
Wayne, John, 95, 230, 267, 323–25
Way We Were, The, 249
Weaver, Dennis, 9–10, 151–52, 270
 Gentle Ben, 133–34, 136, 152, 153–54, 156, 157, 158, 184
Weaver, Robby, 270
Webber, Mrs., 86–90
Weitzman, Stacey, 290
Welcome Back, Kotter, 305
Welles, Orson, 193, 336
"Wells Fargo Wagon" (song), 86, 87, 90
Wemyss, Bob, 113–14
Wexler, Haskell, 247, 256, 262
"What It Was, Was Football" (monologue), 51
Whedon, John, 93
Whedon, Joss, 93
Whedon, Tom, 93
Where the Lilies Bloom, 277–79
Whitaker, Johnny, 188
White, Onna, 89
White Lightning, 327
Who's Afraid of Virginia Woolf?, 247

Wiffle Ball, xvi, 105, 175, 235
Wild Bunch, The, 190, 191, 192, 236, 343
Wild Country, The, 194, 195–206, 251
Wilder, Billy, 304
Williams, Anson
 Happy Days, 243, 276, 285, 286, 296, 310, 311–12, 314, 328, 356; PR tour, 287–91
 wedding to Cheryl, 298
Williams, Cindy, 247
Williams, Clarence, III, 187–88
Williams, Robin, 305, 356–57
Williams, Rusty, 58
Willow, xi
Wills, Maury, 104
Willson, Meredith, 84–88
Willys-Overland Jeepster, 17, 24, 28
Wilson, Lanford, 272–73
Winant, Ethel, 32–34, 35
Winkler, Henry, 298, 360–61
 Cheryl and, 210
 first meeting of, 276–77
 Happy Days, 285–94, 309–10; Christmas gift, 312; first read-through, 276–77, 285–86; potential renaming of show *Fonzie's Happy Days,* 294, 302–4,

330; Ron's departure from show, 358; PR tour, 287–89; softball team, 314, 315; Season Four, 328–30
Monday dinners, 290–91
Night Shift, 310, 360–61
A Smoky Mountain Christmas, 360–61
Wizard of Oz, The, 46, 153
Wood, Murray, 153
Wooden, John, 172
Woodland Hills Fashion Center, 144–45
Woods, Earl, 4
Woods, Tiger, 4
Woodward, Joanne, 212
Woodward, Morgan, 198, 205
World War II, 78, 241
Worth, Michael, 369
WUSA, 212

Yale School of Drama, 277, 286
Young, Gig, 37–38, 46
Young Abe Lincoln, 19
Your Show of Shows, 74

Zane Grey Theatre, 31
Zeiss lenses, 270